# LIVING IN STYLE
# COUNTRY

**Photographs by Andreas von Einsiedel**
**Texts by Jean Nayar**

teNeues

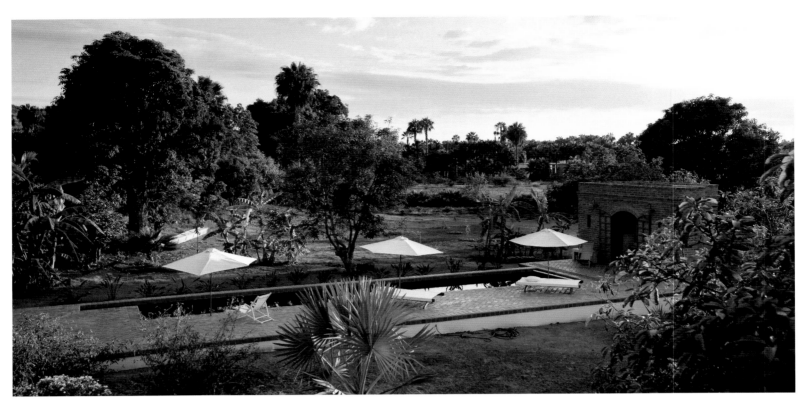

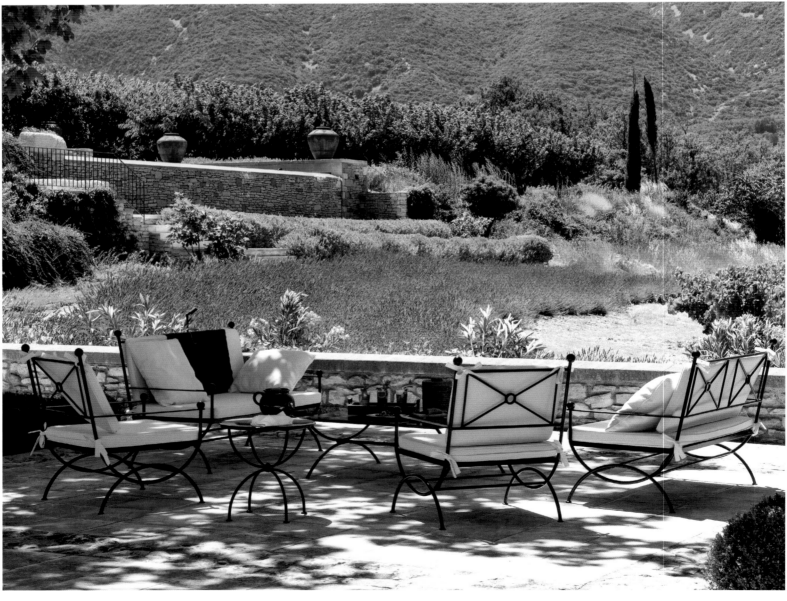

# Contents

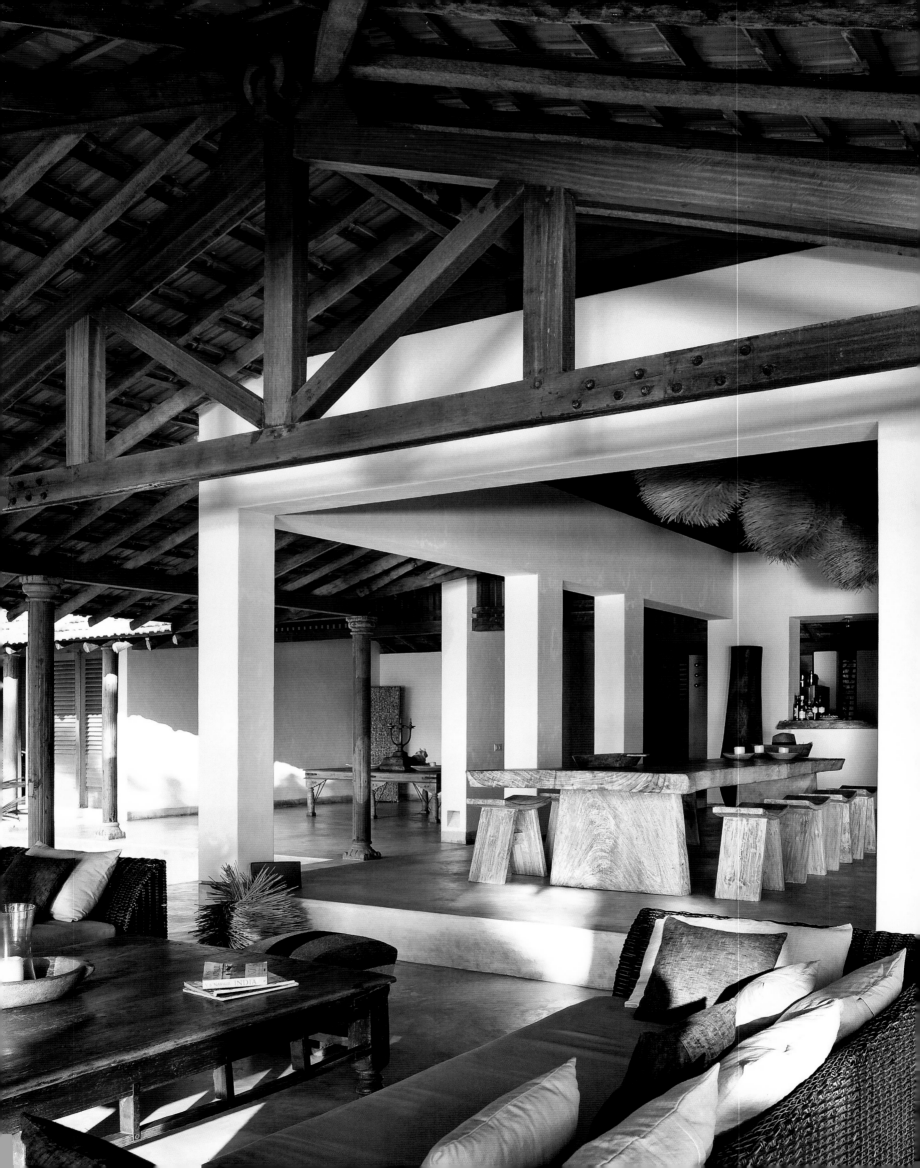

# Introduction

## Jean Nayar

A home in the country. The very words conjure notions of comfort, simplicity, and a connection with nature—no matter where in the world that home might reside. Yet, as consistent as the common threads among country houses may be, rural dwellings are sure to be as unique as the people who live in them. Imagine the purist interiors of an old barn in the English countryside converted into a full-time residence by a classicist architect. Now imagine the motley rooms of an old railway worker's house in Texas refashioned by a dreamy contemporary artist into a studio space with an esoteric palette and offbeat antiques.

Of course, the particulars of its location will invariably influence the character of a country home, too. Local materials, climate, topography, and views collectively bear on the way a country house takes shape—whether it's reconstructed from old ruins in the south of France or built anew from scratch on the coast of Mexico. A steeply thatched roof designed to shed snow from a cottage in Northern Germany may bear little resemblance to a vented teak roof engineered to promote the flow of air through a beach house in India. Yet each is a product of its environment—collaborating with the world around it to coexist in harmony with the elements of nature—rather than standing like a fortress against them.

Still, whatever the differences may be in the form of various rural retreats around the world, the underlying motives for anyone who chooses to reside in one are often remarkably alike. Consider the words that most owners of pastoral homes would use to describe the inspiration that brought them to the country—escape, respite, getaway, quiet, relaxation—and the impetus behind the labor of love that is often a requisite in creating or rebuilding a personal refuge in the country becomes abundantly clear.

Unlike dwellings in a city—whether an elegant townhouse, a cosmopolitan penthouse, or a gritty urban loft—and abodes in the suburbs—whether a modern ranch, a Mediterranean villa, or a Georgian manor—rural retreats offer a respite from the hustle and bustle of daily life with its demands to interact with people and traffic and technology. They also provide a place to commune with the glorious, untamed gifts of nature. Ultimately, a country house affords us an opportunity to craft a setting to our own very personal tastes, and in turn to allow that setting to reshape us from within. It is a place where we can tune out the noise and tune into our own nature—a place where we can be most purely and simply ourselves.

# Einleitung

## Jean Nayar

Ein Haus auf dem Lande. Diese Worte beschwören Gemütlichkeit, Schlichtheit und Naturverbundenheit herauf – egal, wo sich das Haus auf der Welt befinden mag. Obwohl alle hier präsentierten Landhäuser durchaus etwas gemeinsam haben, ist jedes so einzigartig wie seine Bewohner. Man stelle sich beispielsweise eine alte Scheune mit puristischem Interieur in der englischen Landschaft vor, die von einem auf Klassizismus spezialisierten Innenarchitekten in ein neues Zuhause umgebaut wurde. Im Kontrast dazu stehen bunt zusammengewürfelte Räume eines alten texanischen Eisenbahnerhauses, das eine verträumte Künstlerin mit esoterischer Farbpalette und ungewöhnlichen Antiquitäten in ein Atelier verwandelt hat.

Natürlich beeinflussen auch Lage und Umgebung den Charakter einer ländlichen Bleibe. Regionale Materialien, das Klima, die Topografie und die Aussicht – all diese Faktoren tragen zur Ausgestaltung eines Landhauses bei, ob es sich nun um die Totalrenovierung alter Ruinen in Südfrankreich oder einen kompletten Neubau an der Küste Mexikos handelt. So hat ein steiles Reetdach, von dem in Norddeutschland der Schnee rutscht, kaum Ähnlichkeit mit einem ventilierten Teakdach, das für Luftzirkulation in einem Strandhaus in Indien sorgt. Beide Bauelemente sind ein Produkt ihrer Umgebung, interagieren mit der jeweiligen Umwelt und führen eine harmonische Koexistenz mit der Natur.

Bei aller Verschiedenheit sind sich die Motive der Menschen, die sich zum Umzug in ein Landhaus entschließen, erstaunlich ähnlich. Die meisten benutzen Begriffe wie Rückzugsort, Oase, Ort der Ruhe oder Refugium, um zu veranschaulichen, was sie sich nach den oft erheblichen Renovierungsarbeiten erhoffen.

Im Gegensatz zu Stadtresidenzen und Vorort-Domizilen bieten Häuser auf dem Lande Erholung von der Hektik des Alltags und befreien von dem ständigen Zwang, sich mit Menschenmassen, Verkehr und Technologie auseinanderzusetzen. Weder ein elegantes Stadthaus, ein kosmopolitisches Penthouse, ein industriell angehauchtes Loft noch eine moderne Ranch oder eine mediterrane Villa kann es in dieser Beziehung mit der Countryside aufnehmen. Die ländliche Umgebung ermöglicht zudem eine enge Verbundenheit mit der Natur. Wer das Glück hat, ein Landhaus zu besitzen, kann sich ganz nach seinem persönlichen Geschmack ein Refugium erschaffen, das dann seinerseits Einfluss auf den Bewohner ausübt. Hier kann man den Lärm der Großstadt ausblenden, im Einklang mit der Natur leben und sich ganz auf sich selbst besinnen.

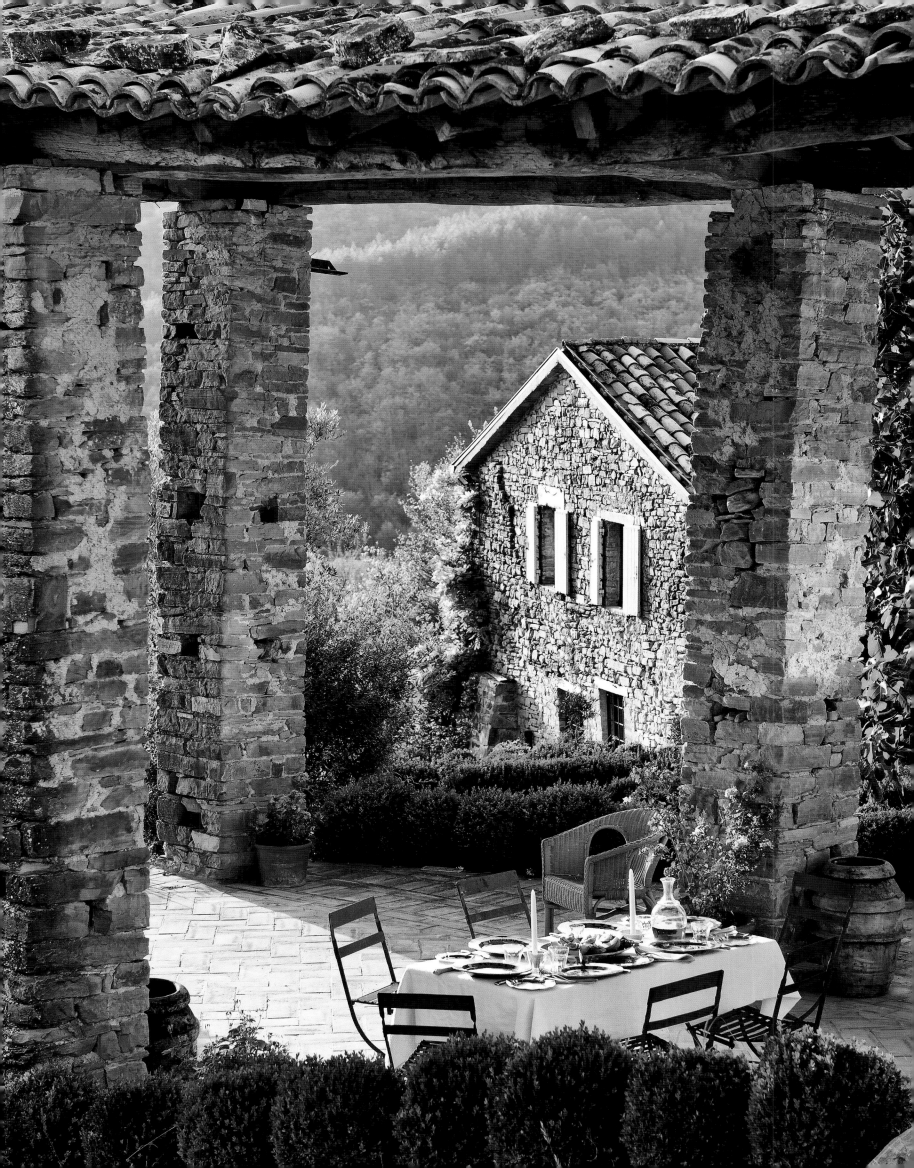

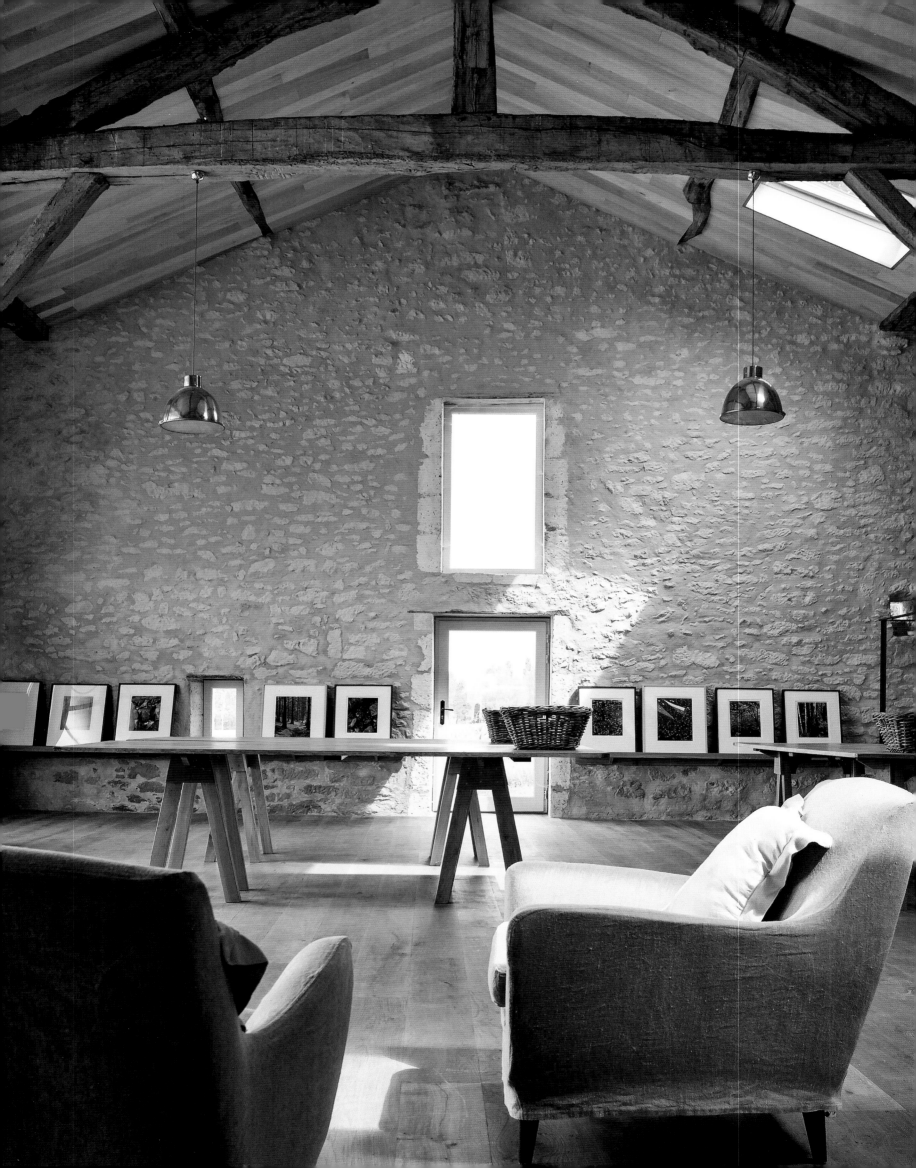

# Introduction
## Jean Nayar

Une maison à la campagne : ces mots évoquent le confort, la simplicité et la communion avec la nature, partout dans le monde. Pourtant, quelle que soit la constance des similitudes entre les maisons de campagne, chacune est assurément unique, tout comme les gens qui l'habitent. Pensez à l'intérieur sobre d'une vieille grange dans la campagne anglaise transformé en résidence secondaire par un architecte classique. Imaginez ensuite les pièces hétéroclites de la vieille maison d'un cheminot texan redessinée par un artiste contemporain rêveur en atelier aux couleurs mystérieuses et aux bibelots décalés.

Les particularités de l'emplacement influencent bien sûr aussi le caractère d'une maison de campagne. Matériaux, climat, topographie et perspectives pèsent tous sur la façon dont elle prend forme, qu'elle soit issue de ruines dans le midi de la France ou bâtie de zéro sur la côte mexicaine. Un toit pentu destiné à débarrasser de la neige une chaumière du nord de l'Allemagne pourra n'avoir que peu de ressemblance avec un toit ventilé en teck conçu pour favoriser la circulation de l'air dans une maison de plage en Inde. Pourtant, l'un et l'autre sont le produit de l'environnement, s'associant au monde qui les entoure pour coexister en harmonie avec les éléments naturels, plutôt que de se dresser contre eux comme une forteresse.

Quelles que soient les différences de forme des lieux de retraite ruraux, les motivations de ceux qui choisissent de vivre dans l'un d'eux se ressemblent étonnamment. Réfléchissez aux mots de la plupart des propriétaires d'habitations champêtres pour décrire l'inspiration qui les a conduit à la campagne – refuge, répit, escapade, calme, relaxation – et l'élan derrière la passion souvent nécessaire pour créer ou reconstruire un refuge personnel à la campagne apparaît très clairement.

À l'opposé des logements citadins – fût-ce une élégante maison de ville, un appartement-terrasse raffiné ou un loft urbain sans fioritures – ou des demeures des faubourgs – fût-ce un ranch moderne, une villa méditerranéenne ou un manoir géorgien –, les refuges campagnards permettent d'échapper à l'effervescence du quotidien qui nous relie aux gens, au trafic et à la technologie. Ces refuges sont aussi un lieu de communion avec les fabuleux dons sauvages de la nature. Enfin, une maison de campagne donne l'occasion de créer un cadre conforme à ses goûts intimes et permet en retour à ce cadre d'influencer notre âme. C'est un lieu où l'on peut s'affranchir du bruit et être à l'écoute de sa propre nature – un lieu où l'on peut être soi-même avec le plus de pureté et de simplicité.

# Valley View
## Upstate New York, USA

ENTHRALLED WITH THE clear lakes, dense woods, and rolling farmland of upstate New York's Dutchess County, English interior designer Selina van der Geest and her husband imagined settling there not long after they married. Inspired by the area's gracious historic farmhouses, they sketched out a plan for their dream home, and set out to make it a reality by locating 18 idyllic acres of an old former farm high on a hillside where they would build it. Although the barn-like, timber-framed house is new, it was clad with old cedar and hemlock barn timbers from Canada to make it look 100 years old. Inside, though, its open spaces support the couple's contemporary lifestyle: A central, double-height living space rimmed with a mezzanine study-cum-library is flanked by a lower wing containing the master suite and a two-bed guest area on each end. The couple's spectacular house now affords them the best of two worlds—a spectacular view of the Valley and easy access to New York City.

VERZAUBERT VON DEN klaren Seen, dichten Wäldern und dem hügeligen Ackerland des Dutchess County in Upstate New York, beschlossen die englische Innenarchitektin Selina van der Geest und ihr Mann in dieser wunderschönen Landschaft bereits kurz nach ihrer Hochzeit sesshaft zu werden. Inspiriert von den anmutigen historischen Farmhäusern der Region, entwarfen sie ihr Traumhaus und erwarben dann ein 7 Hektar großes idyllisch auf einem Hügel gelegenes ehemaliges Farmgelände. Das neue scheunenartige Haus wurde mit alten Latten aus kanadischem Zedern- und Schierlings-tannenholz verkleidet, um es wie ein 100 Jahre altes Farmhaus aussehen zu lassen. Innen unterstützen jedoch offene Räume den zeitgemäßen Lebensstil des Paares: Ein zentraler Wohnraum mit doppelter Deckenhöhe, den ein als Arbeitszimmer und Bibliothek genutztes Zwischengeschoss umrahmt, wird flankiert von einem Flügel in dem sich das Hauptschlafzimmer und zwei Gästebereiche befinden. Ihr neues Zuhause bietet den van der Geests das Beste aus zwei Welten: den spektakulären Talblick und kurzen Weg nach New York City.

FASCINÉS PAR LES lacs limpides, les forêts profondes et les champs vallonnés du comté de Dutchess, l'architecte d'intérieur anglaise Selina van der Geest et son époux ont décidé de s'y établir peu après leur mariage. S'inspirant d'élégantes fermes historiques de la région, ils ont dessiné le plan de la maison de leurs rêves et ont repéré pour les réaliser sept hectares de terrain splendides d'une ancienne ferme à flanc de coteau. Pareille à une grange avec son ossature en bois, la maison neuve a été parée de cèdre et de tsuga du Canada pour lui donner un aspect centenaire. À l'intérieur, les espaces ouverts se prêtent au mode de vie contemporain du couple : le séjour central à deux niveaux limité par un bureau bibliothèque en mezzanine est flanqué d'une aile plus basse comprenant la suite parentale et un espace à deux lits pour les invités à ses extrémités. Cette splendide demeure offre le meilleur des deux mondes : une vue spectaculaire sur la vallée et un accès facile à la ville de New York.

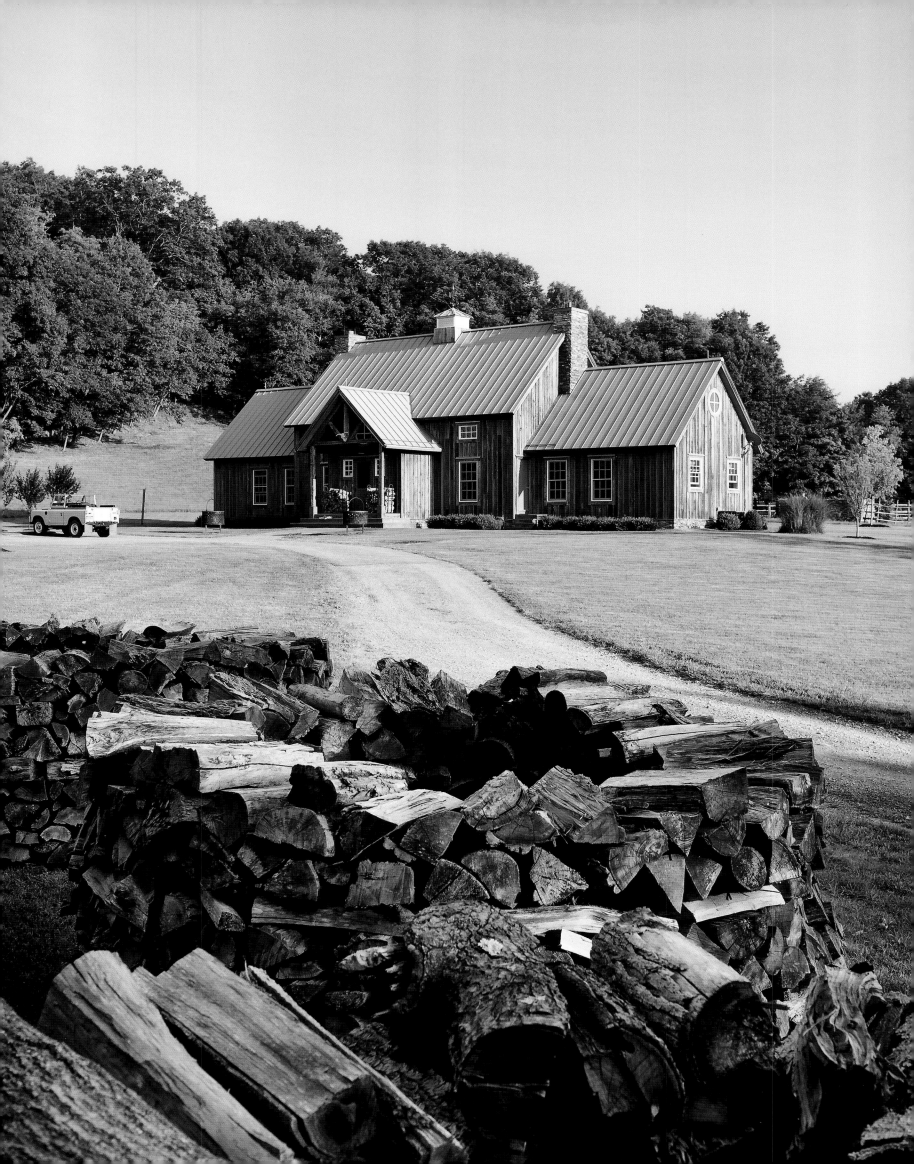

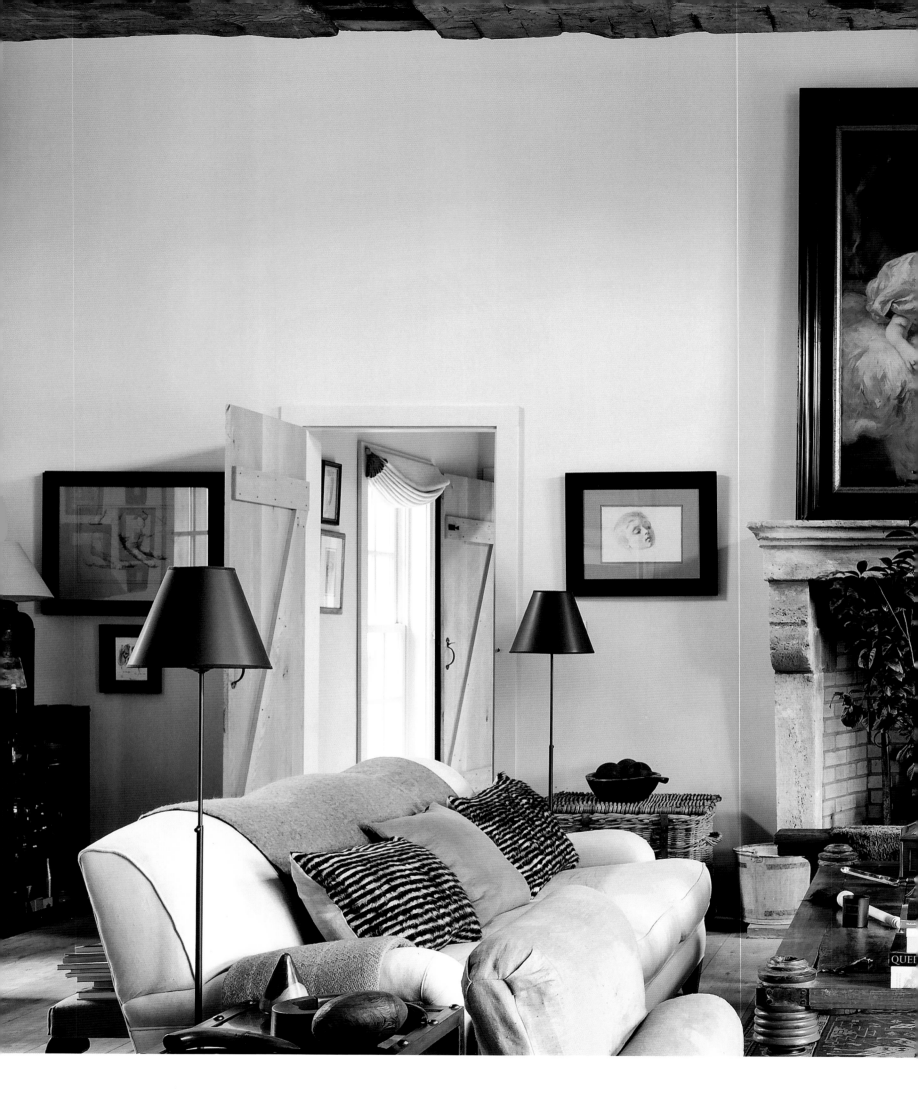

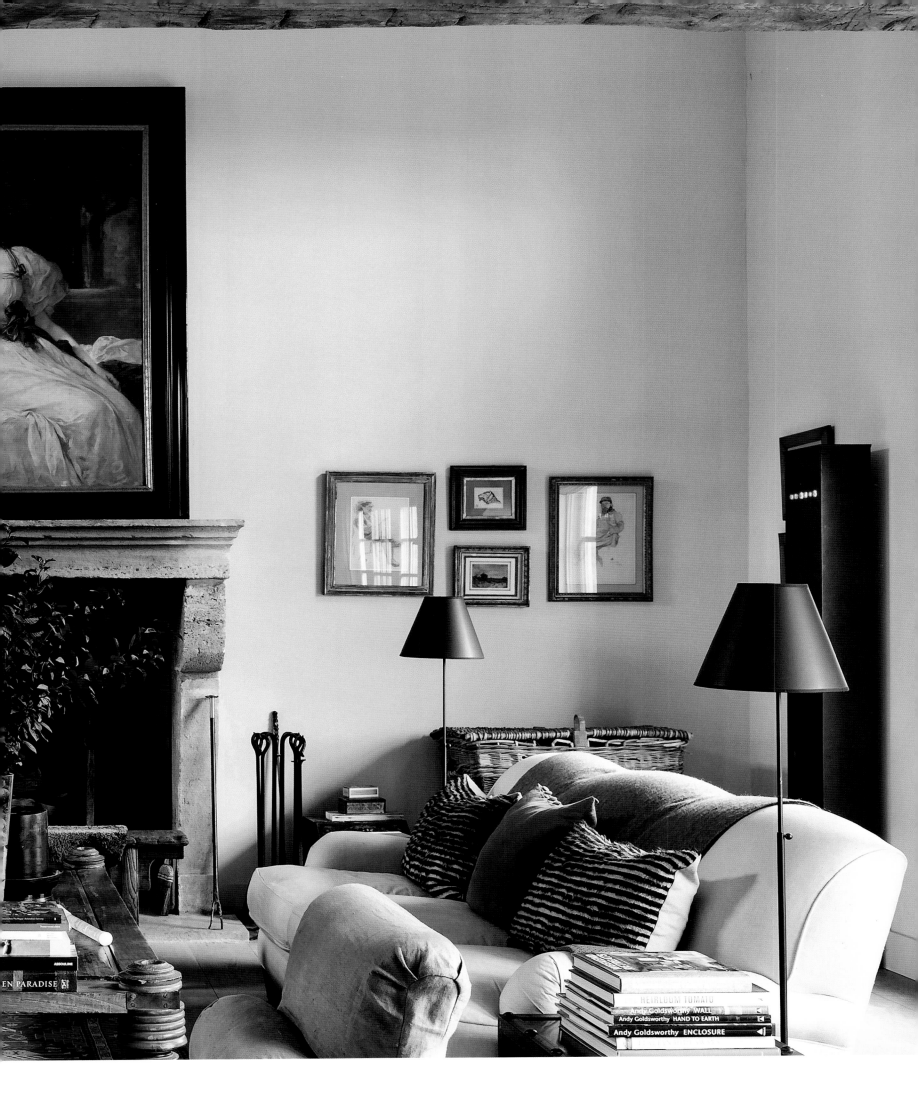

Selina furnished her huge living space with a mix of contemporary sofas, antiques, and old Oriental carpets. A 19th-century family portrait hangs above the 18th-century French fireplace (previous page). Cushions from Robert Kime in England and bed linens from Mia Zia, Paris, dress the bed.

Selina van der Geest hat ihr riesiges Wohnzimmer mit einem Mix aus modernen Sofas, Antiquitäten und orientalischen Teppichen eingerichtet. Ein Familienporträt aus dem 19. Jahrhundert hängt über dem französischen Kamin aus dem 18. Jahrhundert (vorherige Seite). Kissen von Robert Kime aus England und Bettwäsche von Mia Zia aus Paris dekorieren das Bett.

Pour son spacieux salon, Selina a combiné canapés modernes, meubles anciens et vieux tapis d'Orient. Un portrait de famille du XIXe siècle surplombe la cheminée française du XVIIIe (page précédente). Le lit est habillé de coussins de la maison anglaise Robert Kime et de parures de lit en lin de la boutique Mia Zia, à Paris.

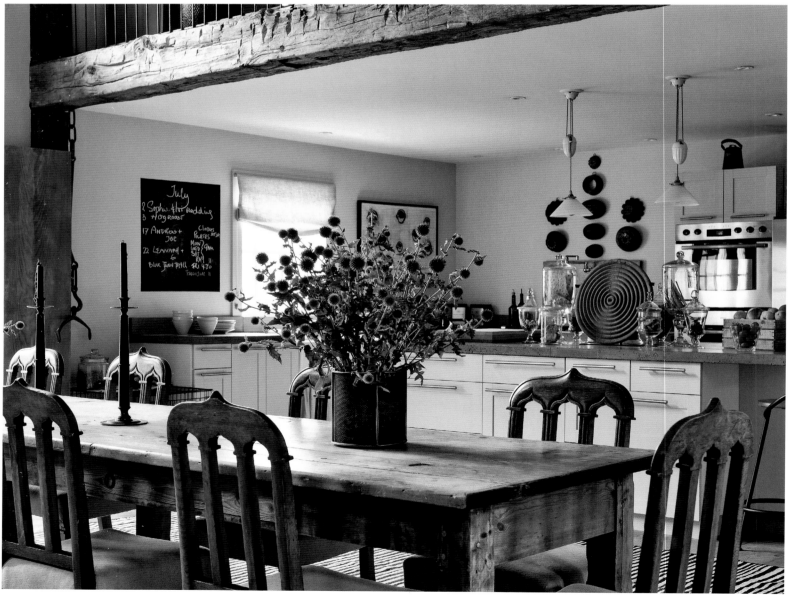

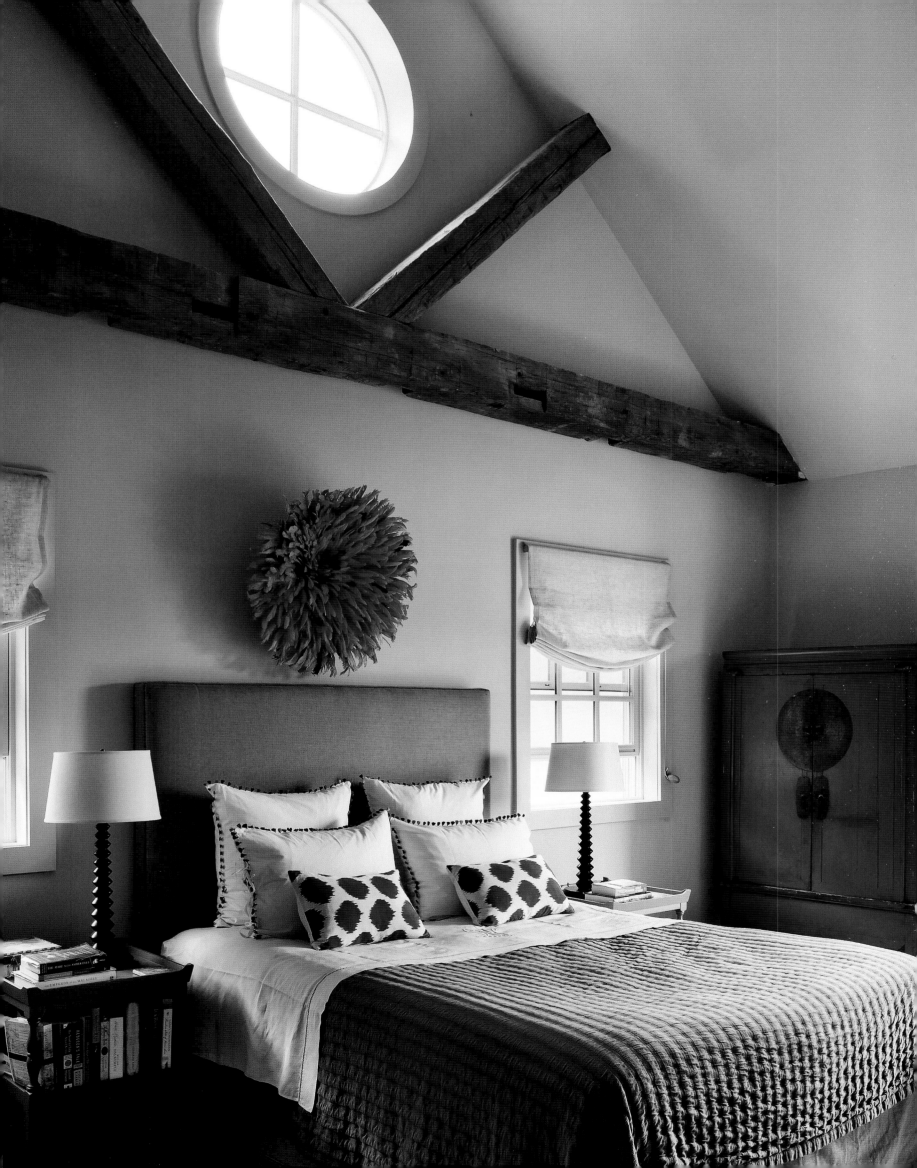

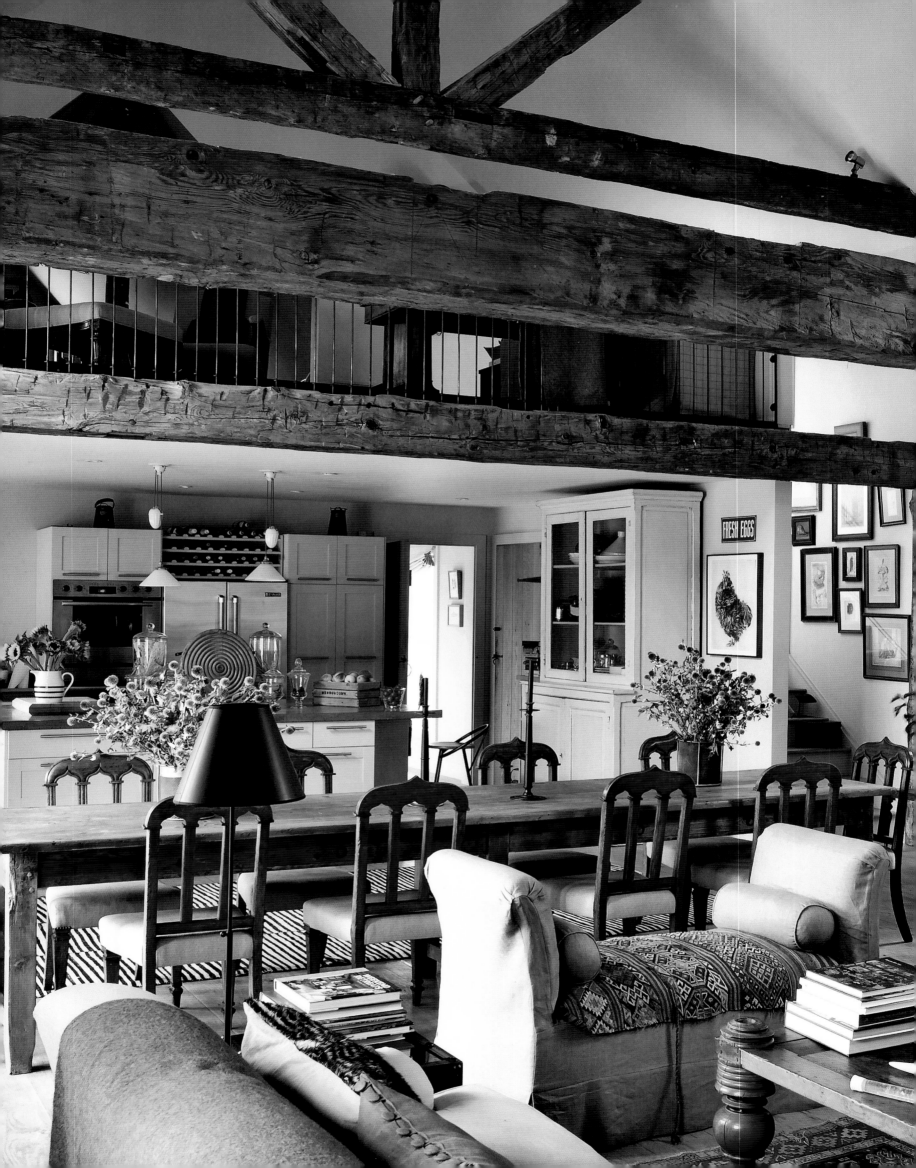

The homey kitchen features poured concrete counters, French pendant lights, and simple, chic elements from Ikea, which Selina repainted to personalize the finish. A large 19th-century French table surrounded by a set of 1850s English, neo-Gothic chairs anchor the open dining area.

Die wohnliche Küche ist ausgestattet mit Arbeitsflächen aus Gussbeton, französischen Hängelampen und stylischen Ikea-Schrankelementen, denen die Besitzerin einen neuen, individuellen Anstrich verpasste. Ein großer Esstisch aus dem 19. Jahrhundert mit neogotischen englischen Stühlen von 1850 dominiert den offenen Essbereich.

L'accueillante cuisine associe plans de travail en béton coulé, lampes à suspension avec contrepoids et de simples éléments Ikea, repeints par Selina pour leur donner une touche personnelle. La salle à manger ouverte s'organise autour d'une grande table française du XIXᵉ entourée de chaises anglaises néo-gothiques des années 1850.

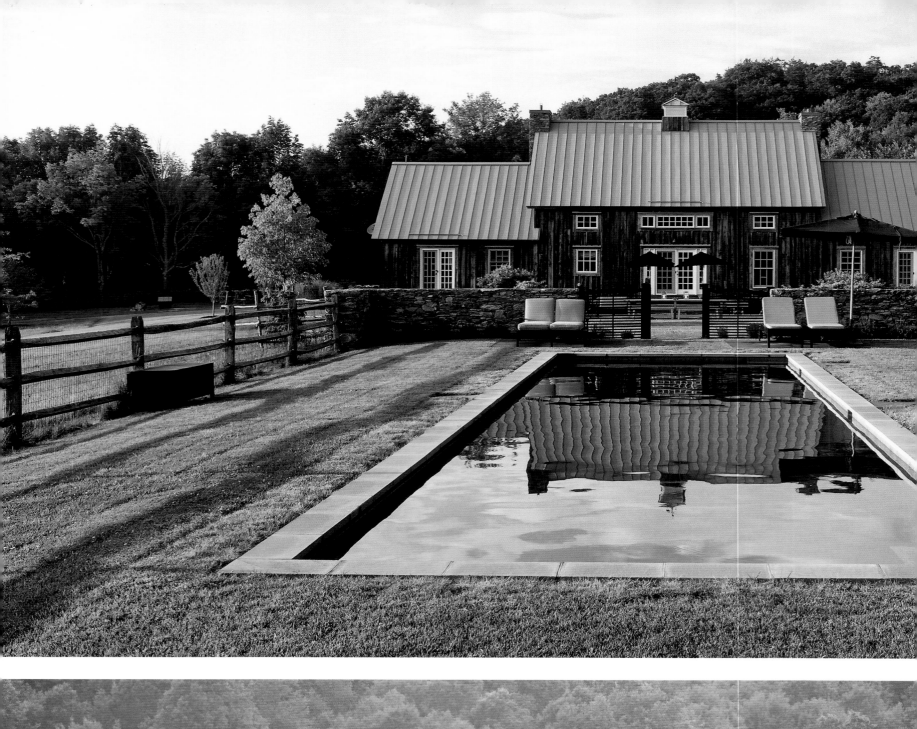
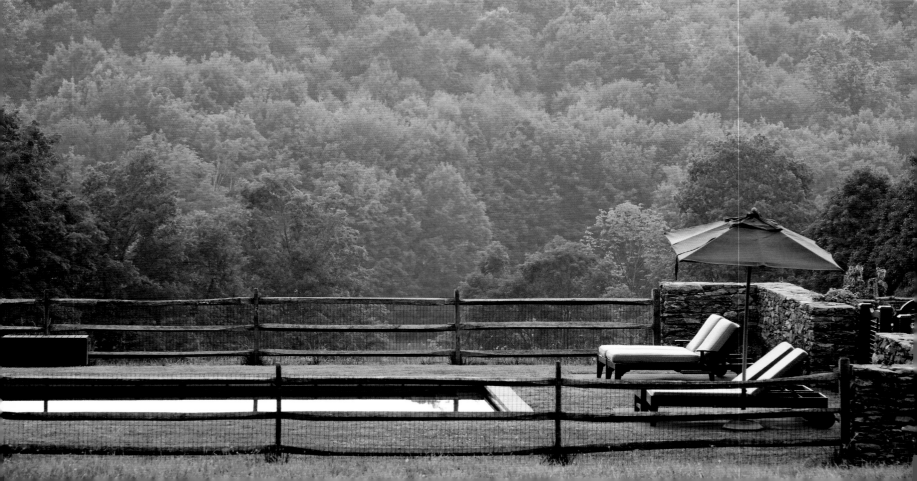

The open-plan living area opens on one side to a pretty stone terrace facing
the long swimming pool and stunning wooded mountain views beyond.

Der offene Wohnbereich führt zu einer Seite auf eine hübsche Steinterrasse, von der
man auf den langen Pool und die atemberaubende Wald- und Berglandschaft blickt.

Le salon décloisonné s'ouvre d'un côté sur la jolie terrasse de pierres bordant
la longue piscine, avec dans le fond une magnifique vue sur les collines boisées.

# Pastoral Idyll
## Dordogne, France

WHEN KENYAN-BORN BRITISH artist Gillian Meijer and her Dutch husband, Sjoerd, first laid eyes on their 17th-century mill house in the Dordogne, its interiors were semi-derelict, yet its setting was idyllic. Nestled at the foot of a stone escarpment with wooded hills rising on the opposite side, the mill was completely reconfigured with the help of Couze-et-Saint-Front-based architect Ingrid Medvidova, who designed a series of free-flowing, informal living spaces with floor-to-ceiling, double-glazed windows and doors devoid of glazing bars to let in light and the irresistible views. The couple also collaborated with two Dutch friends, designer Joris van Grinsven, who helped them design an atelier for Gillian, and landscape designer Dik Bakker, who offered advice on honing the pavilion and paved terrace shaded by plane trees trained to form a pergola. The artful composition of these elements enhances the magical view along the lake.

ALS DIE IN Kenia geborene britische Künstlerin Gillian Meijer und ihr holländischer Mann Sjoerd in der Dordogne die Mühle aus dem 17. Jahrhundert entdeckten, waren die Innenräume halb verfallen, doch die idyllische Lage am Fuße eines Steilhangs mit gegenüber liegenden Waldhügeln begeisterte das Paar. Mithilfe der in Couze-et-Saint-Front lebenden Architektin Ingrid Medvidova bauten sie die Mühle komplett um. Medvidova entwarf eine Reihe von ineinander übergehenden informellen Wohnbereichen mit deckenhohen doppelverglasten Fenstern und rahmenlosen Türen, die viel Licht herein-lassen und unwiderstehliche Ausblicke ermöglichen. Die Meijers arbeiteten auch mit zwei Freunden aus Holland zusammen: dem Designer Joris van Grinsven, der ihnen half, ein Atelier für Gillian zu entwerfen, und dem Landschaftsarchitekten Dik Bakker, der sie bei der Restaurierung des Pavillons und der Gestaltung der Terrasse beriet, die im Schatten einer Pergola aus Platanen liegt. Das kunstvolle Arrangement dieser Elemente verstärkt noch den magischen Seeblick.

LORSQUE L'ARTISTE BRITANNIQUE d'origine kenyane Gillian Meijer et son époux néerlandais Sjoerd ont posé leur regard sur ce moulin du XVIIe siècle en Dordogne, l'intérieur était en partie à l'abandon, mais le cadre idyllique. Niché entre un escarpement rocheux et des collines boisées, le moulin a été entièrement réaménagé avec l'aide d'Ingrid Medvidova. Cette architecte basée à Couze-et-Saint-Front a conçu une série d'espaces de vie décloisonnés avec des fenêtres pleine hauteur à double vitrage sans croisillons pour laisser entrer la lumière et savourer la vue magique. Le couple a collaboré avec deux amis. L'architecte d'intérieur Joris van Grinsven les a aidé pour l'atelier de Gillian, tandis que le concepteur-paysagiste Dik Bakker les a conseillé pour l'aménagement du pavillon et de la terrasse pavée à l'ombre des platanes en pergola. Ces éléments artistiquement composés renforcent la magie de la vue le long du lac.

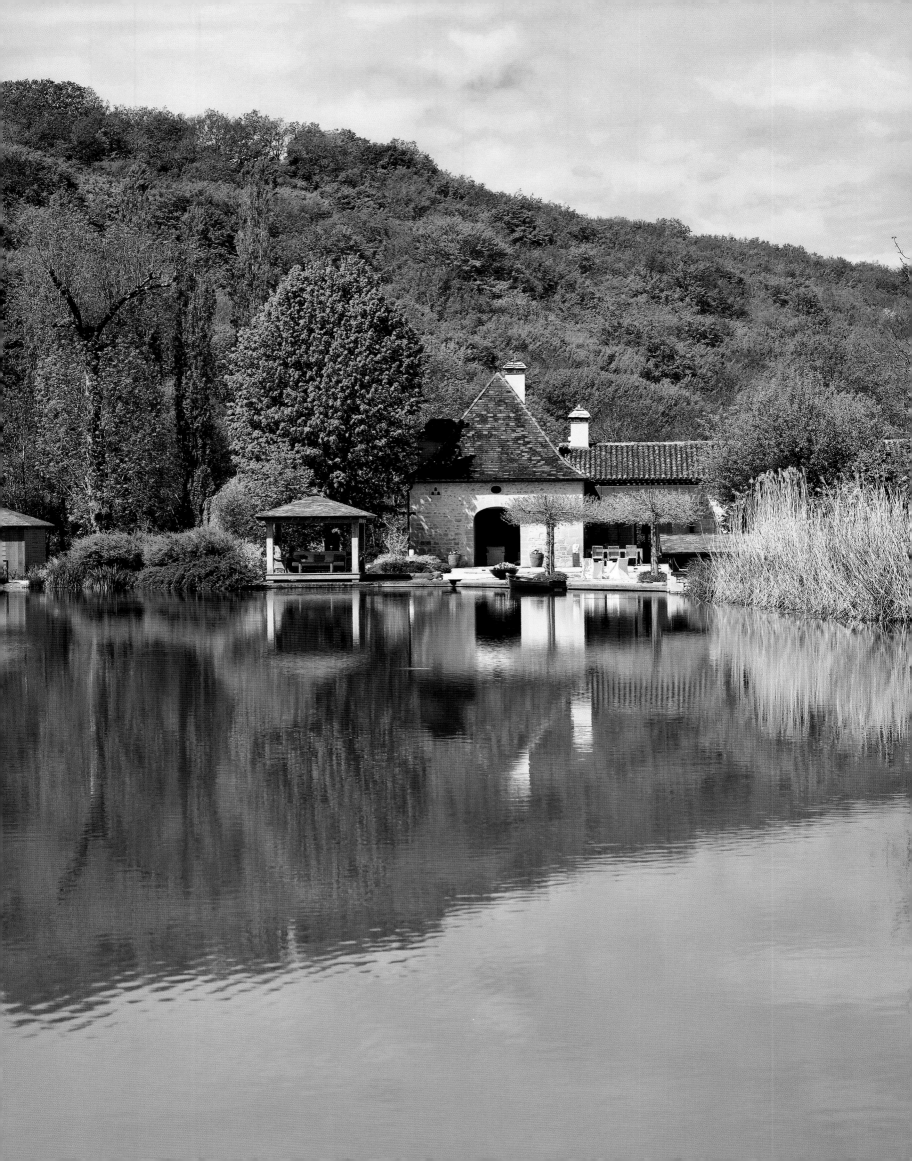

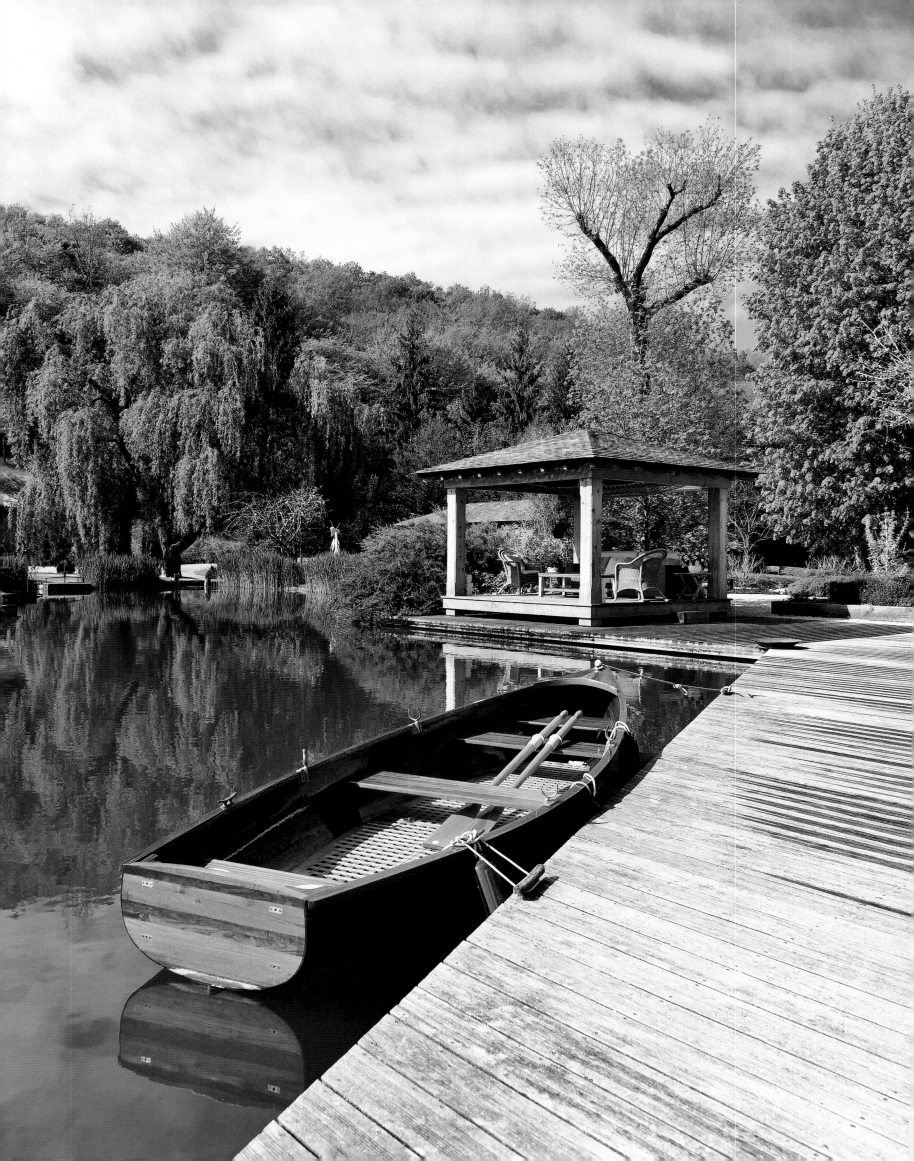

*Sheltered beneath the wooded hillside, the Meijers'
three story, 17th-century mill overlooks a large lake and
a lakeside pavilion, while Gillian's new studio resides
on the property nearby.*

*Die dreistöckige Mühle aus dem 17. Jahrhundert steht
im Schutze eines bewaldeten Hangs mit Blick auf einen
großen See und einen Pavillon. Gillian Meijers neues
Atelier befindet sich nicht weit entfernt auf dem Grundstück.*

*Abrité par le coteau boisé, le moulin des Meijer datant
du XVIIe domine de ses trois étages un grand lac et son
pavillon. Le nouvel atelier de Gillian est situé non loin
dans la propriété.*

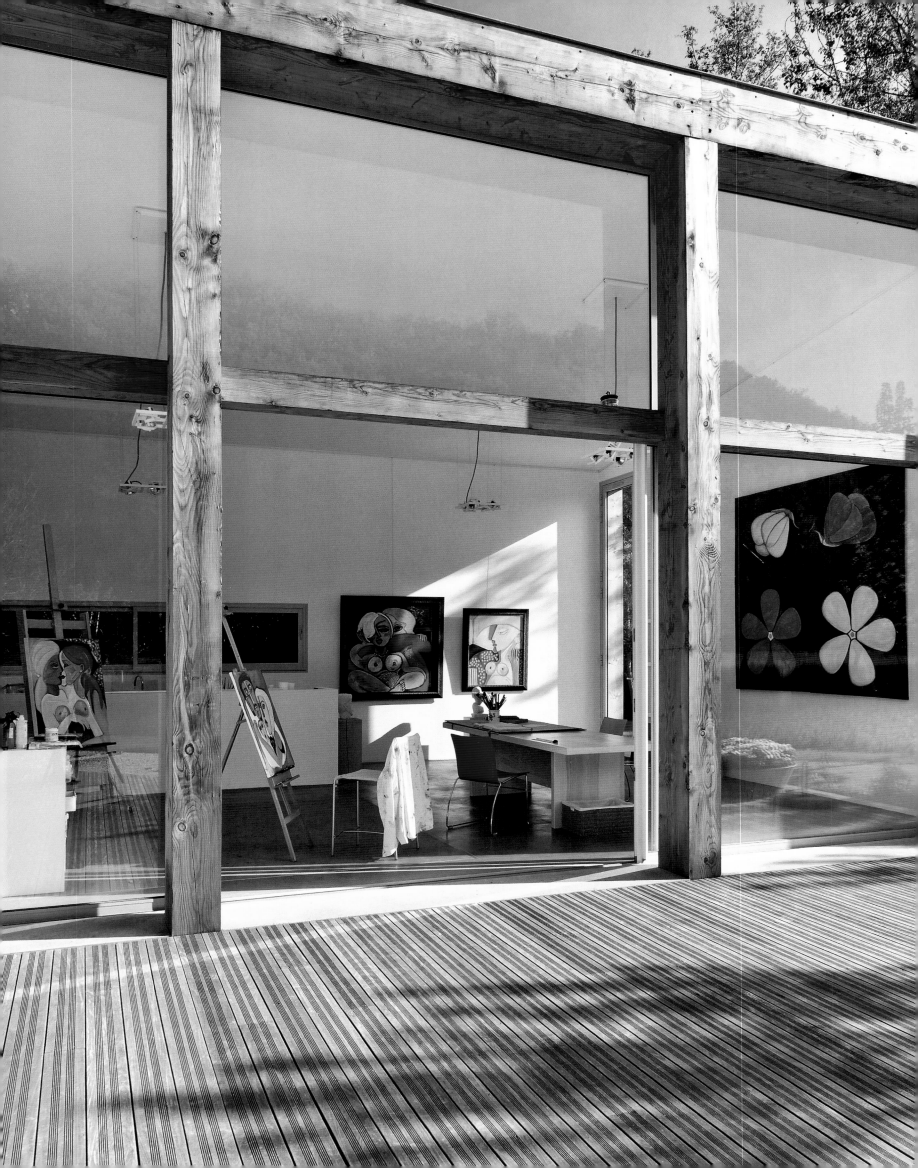

The two central sections of the north-facing wall of glass of the barn-like atelier slide back completely and open onto the decked terrace. Original stone arches open onto a view of the grounds.

Die beiden mittleren Elemente der nach Norden ausgerichteten Glaswand dieses scheunenartigen Ateliers lassen sich komplett zurückschieben und führen auf eine Terrasse. Original-Steinbögen umrahmen die Aussicht auf den Baumbestand des idyllischen Anwesens.

Les deux parties centrales du mur vitré exposé au nord de l'atelier grange coulissent complètement sur les côtés pour libérer l'accès à la terrasse en bois. Des voûtes en pierre d'origine donnent sur les vergers.

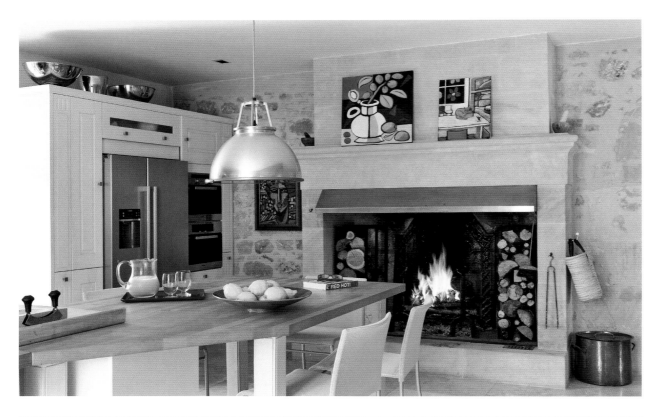

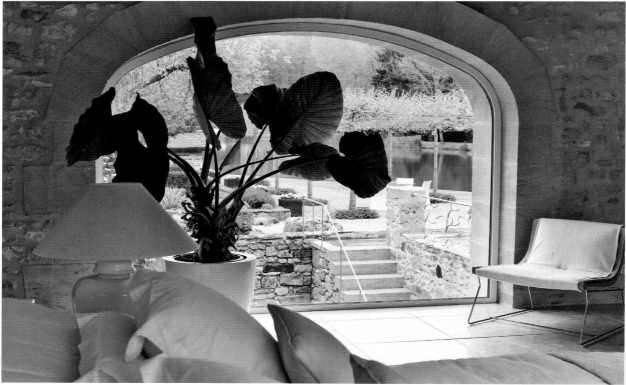

*An open fireplace creates a welcoming atmosphere in the Arthur Bonnet kitchen. In the master bedroom, the bedside tables and headboard were custom-made to Sjoerd's design.*

*Ein offenes Kaminfeuer erzeugt in der Küche von Arthur Bonnet eine gemütliche Atmosphäre. Die Nachttische und das Kopfende im Schlafzimmer wurden nach Sjoerd Meijers Entwurf angefertigt.*

*La cheminée à foyer ouvert crée une atmosphère accueillante dans la cuisine Arthur Bonnet. Dans la chambre de maître, les tables de chevet et le dossier de lit sont du sur mesure d'après un dessin de Sjoerd.*

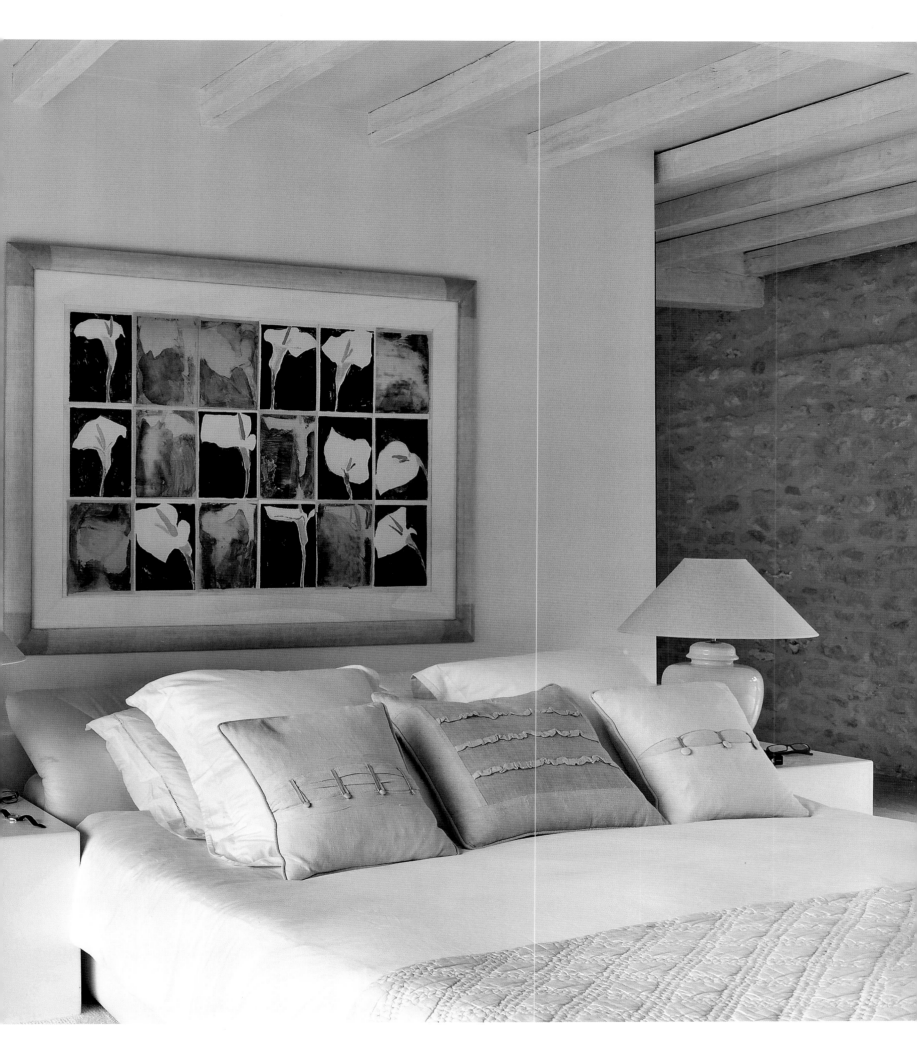

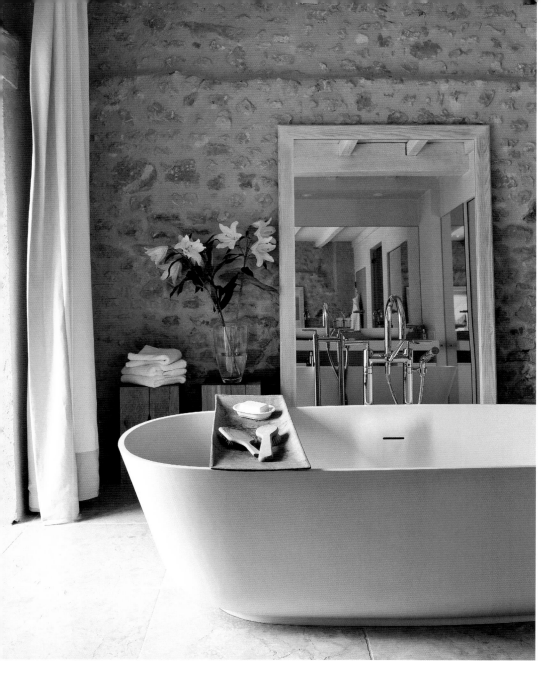

The sculptural lines of a deep tub from Agape stand out against the rough-hewn stone walls. The natural textures and neutral colors in the living room and a bedroom offer a quiet backdrop for Gillian's vibrant paintings, such as Tête-à-Tête on the far wall of the living room.

Die eleganten Linien der Badewanne von Agape heben sich von der Wand aus grob behauenen Steinen ab. Natürliche Materialien und Farben im Wohn- und Schlafzimmer bilden einen ruhigen Hintergrund für Gillians farbenfrohe Gemälde, zum Beispiel dem Bild Tête-à-Tête im Wohnzimmer der umgebauten Mühle.

La grande baignoire Agape aux lignes sculpturales contraste avec les murs de pierre bruts. Les textures naturelles et les couleurs neutres du salon et de l'une des chambres offrent un écrin paisible aux tableaux éclatants de Gillian, comme le Tête à Tête sur le mur du fond du salon.

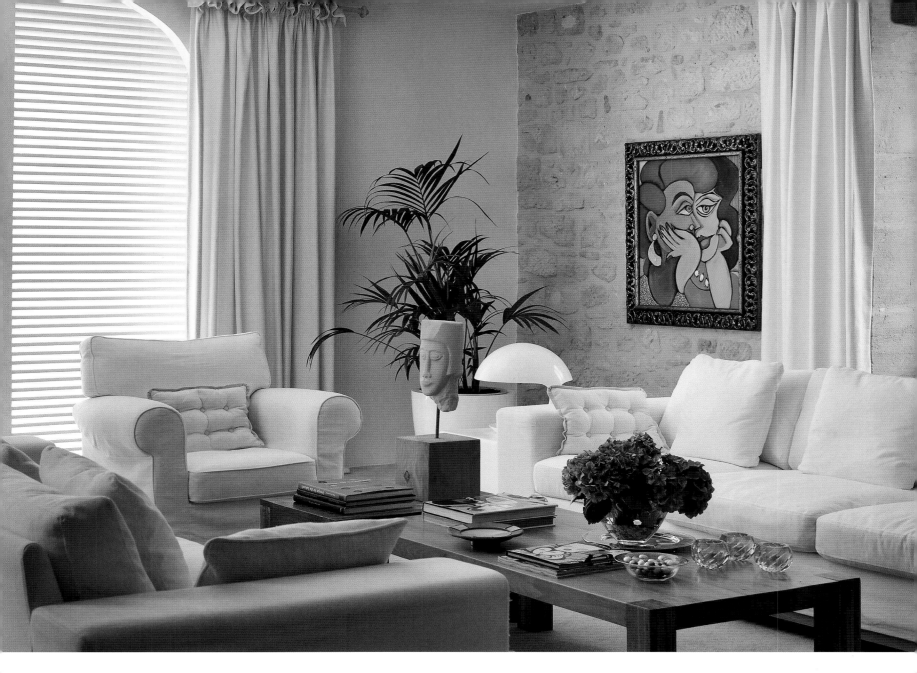
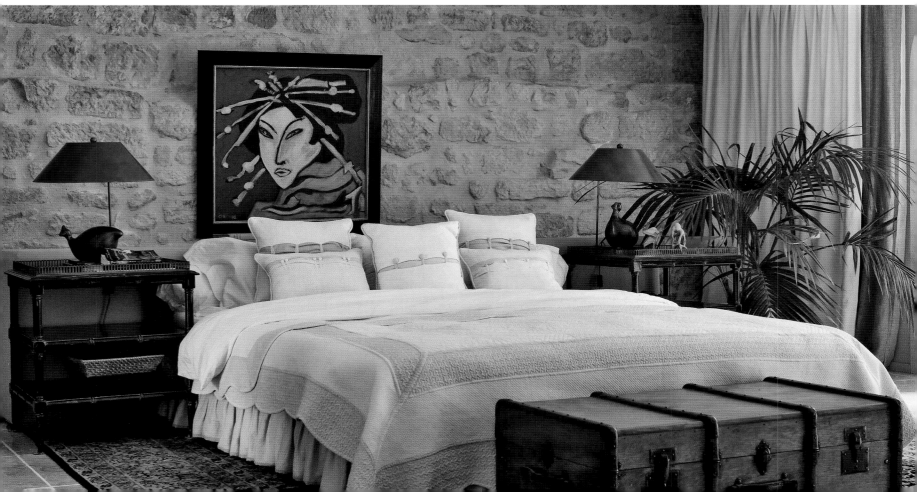

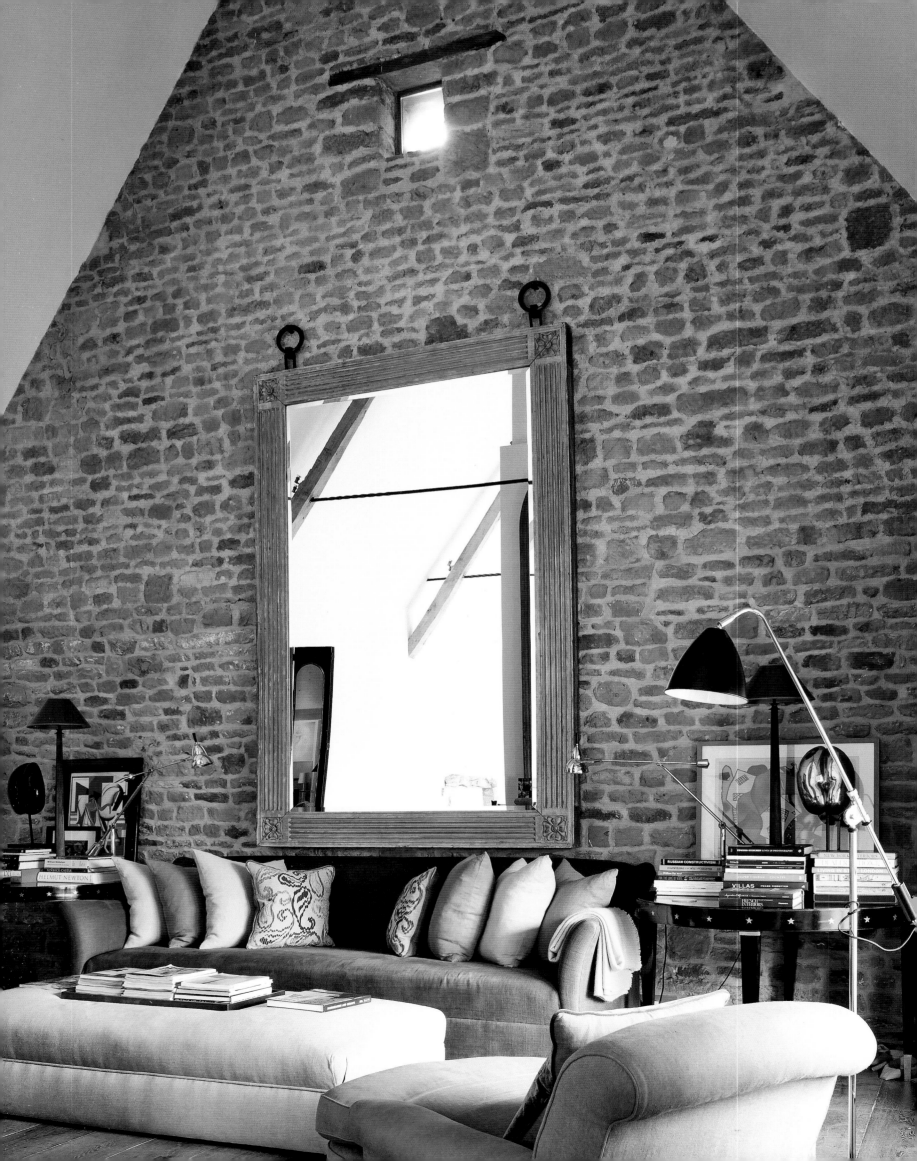

# Country Sophisticate
## England, UK

THEIR FRIENDS WERE surprised at John and Susie Minshaw's move from a London townhouse to a group of rundown barns in the country, especially given John's reputation as one of England's most respected interior architects. Once part of the local manor, the structures had been built of stone from a ruined Norman castle and the main barn offered the double-height living space the Minshaws desired. The additional structures—thatched stables, a two-story 1802 coach house, and a 1960s addition—could be conveniently converted into a guest house, garage, and work studio. The location was also ideal—private, but not too remote. So the couple took the leap and undertook a meticulous renovation, adding a new glass and lead-roofed passage between the stables and the barn, laying stone floors, and introducing a grand staircase hall that leads to the bedroom and bathroom on a mezzanine level. The fine finishes and superb craftsmanship throughout signal the keys to John's repertoire.

FREUNDE WAREN ÜBERRASCHT, als ihnen John und Susie Minshaw mitteilten, dass sie ihr Londoner Townhouse aufgeben und in ein Ensemble heruntergekommener Scheunen auf dem Land ziehen würden. Und dies, obwohl John als einer der angesehensten britischen Innenarchitekten gilt. Die mit Steinen aus einer normannischen Burgruine errichteten Gebäude waren einst Teil des örtlichen Herrenhauses. Die Hauptscheune bot den Minshaws die gewünschte doppelte Raumhöhe. Zusätzliche Baueinheiten wie reetgedeckte Stallungen, ein zweigeschossiges Kutschenhaus von 1802 und ein Anbau aus den 1960er-Jahren, ließen sich wunderbar zu Gästehaus, Garage und Atelier um-funktionieren. Auch die Lage war ideal - privat, aber nicht zu abgeschieden. Also wagte das Paar den Absprung und begann mit der gründlichen Renovierung. Sie konstruierten zwischen Ställen und Scheune einen neuen Durchgang mit Bleiglasdach, legten Steinböden und fügten eine breite Treppe ein, die zum Schlaf- und Badezimmer auf der Zwischen-ebene führt. Die durchgängig extrem sorgfältige Ausführung und die hohe Qualität der handwerklichen Arbeiten trägt eindeutig Johns raumgestalterische Handschrift.

JOHN ET SUSIE Minshaw ont surpris leurs amis en quittant leur maison de ville pour des granges délabrées à la campagne, car John est l'un des architectes d'intérieur les plus réputés d'Angleterre. Jadis intégrées au manoir local, ces structures avaient été construites avec les ruines d'un château normand. La plus grande grange disposait de la double hauteur voulue par les Minshaw pour leur espace de vie. Les autres structures — une écurie à toit de chaume, une remise de 1802 à deux niveaux et une extension des années 1960 — ont facilement été converties en chambre d'amis, garage et atelier. Le cadre était lui aussi idéal — retiré, mais pas trop éloigné. Le couple a donc franchi le pas et entrepris une rénovation méticuleuse, créant un nouveau passage avec verrière à couverture en feuille de plomb entre les écuries et la grange, posant des dalles et insérant une grande cage d'escalier pour gagner la chambre et salle de bains en mezzanine. Les finitions nobles et la superbe facture artisanale omniprésente témoignent de la maîtrise de John.

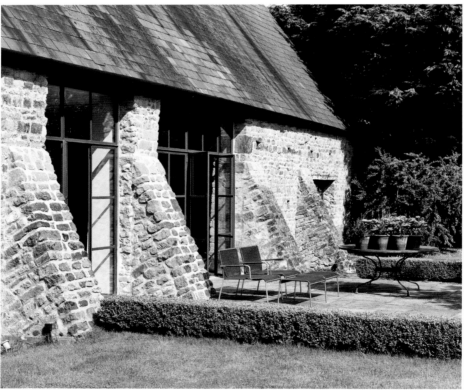

Crittall metal windows and doors recessed into the thick stonework bring light into the interior spaces. Atop the dramatic Belgian black stone and limestone floor, a pair of 18<sup>th</sup>-century English hall chairs grace the staircase hall.

*In die dicken Steinmauern eingelassene Metallfenster und -türen des Herstellers Crittall lassen Licht in die Räume fluten. Dem Treppenflur mit auffälligem Schachbrettmuster-Steinboden verleihen zwei englische Holzstühle aus dem 18. Jahrhundert Eleganz.*

*Les fenêtres métalliques Crittall et les portes montées dans les épais murs conduisent la lumière dans les espaces intérieurs. Sur le sol spectaculaire en moellons noirs de Belgique et pierre calcaire, deux chaises de vestibule embellissent la cage d'escalier.*

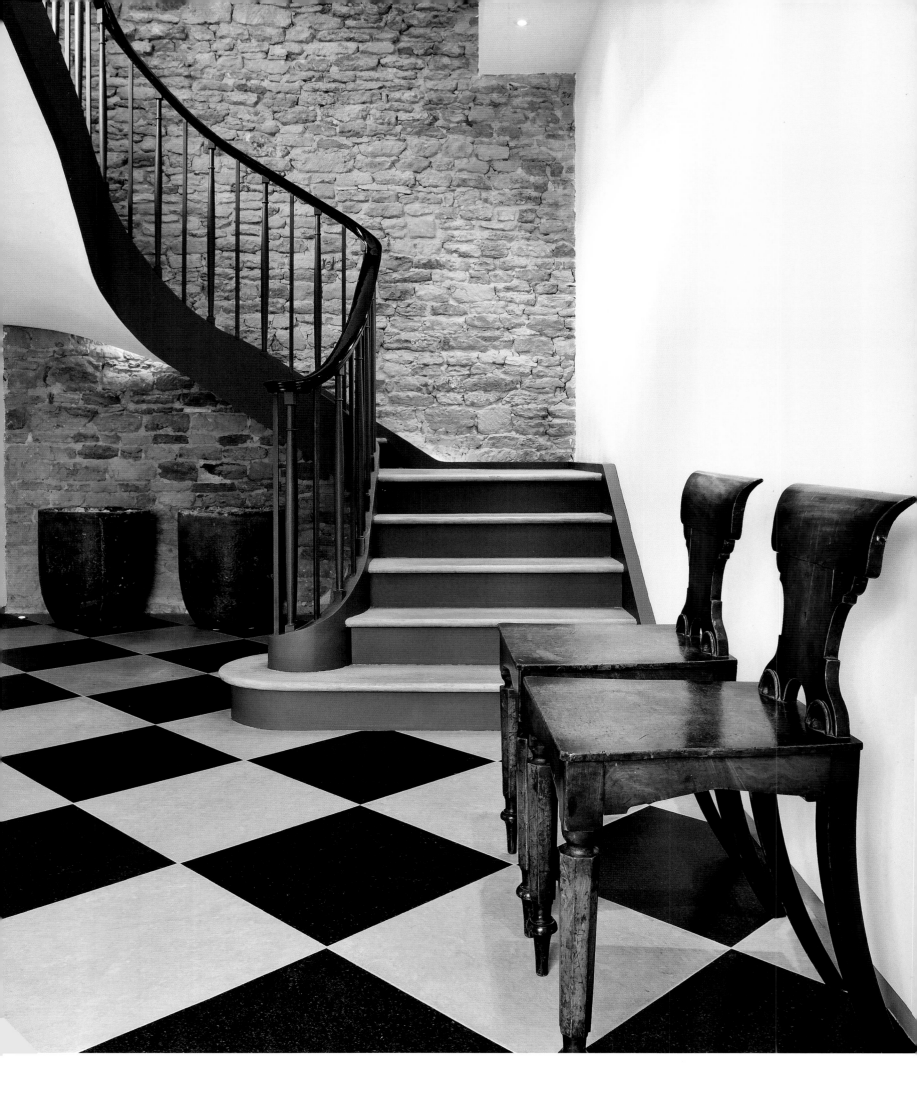

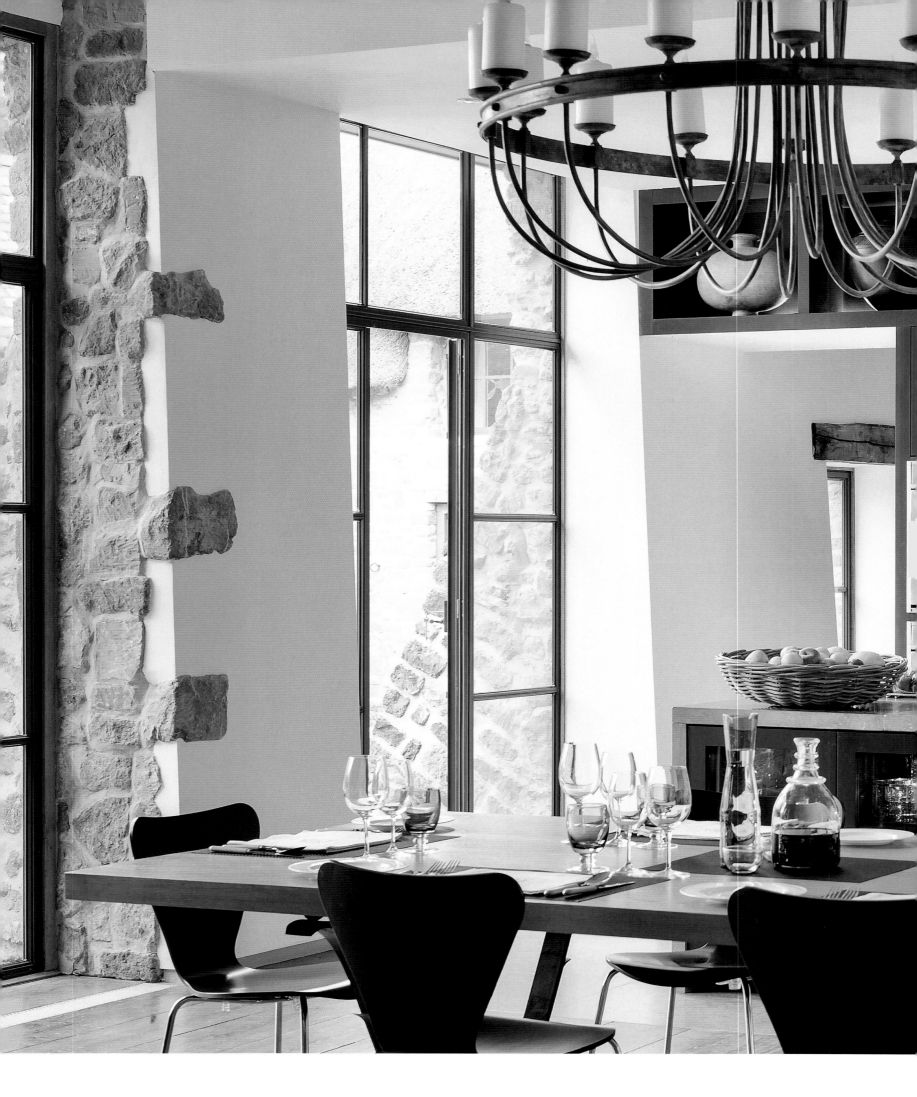

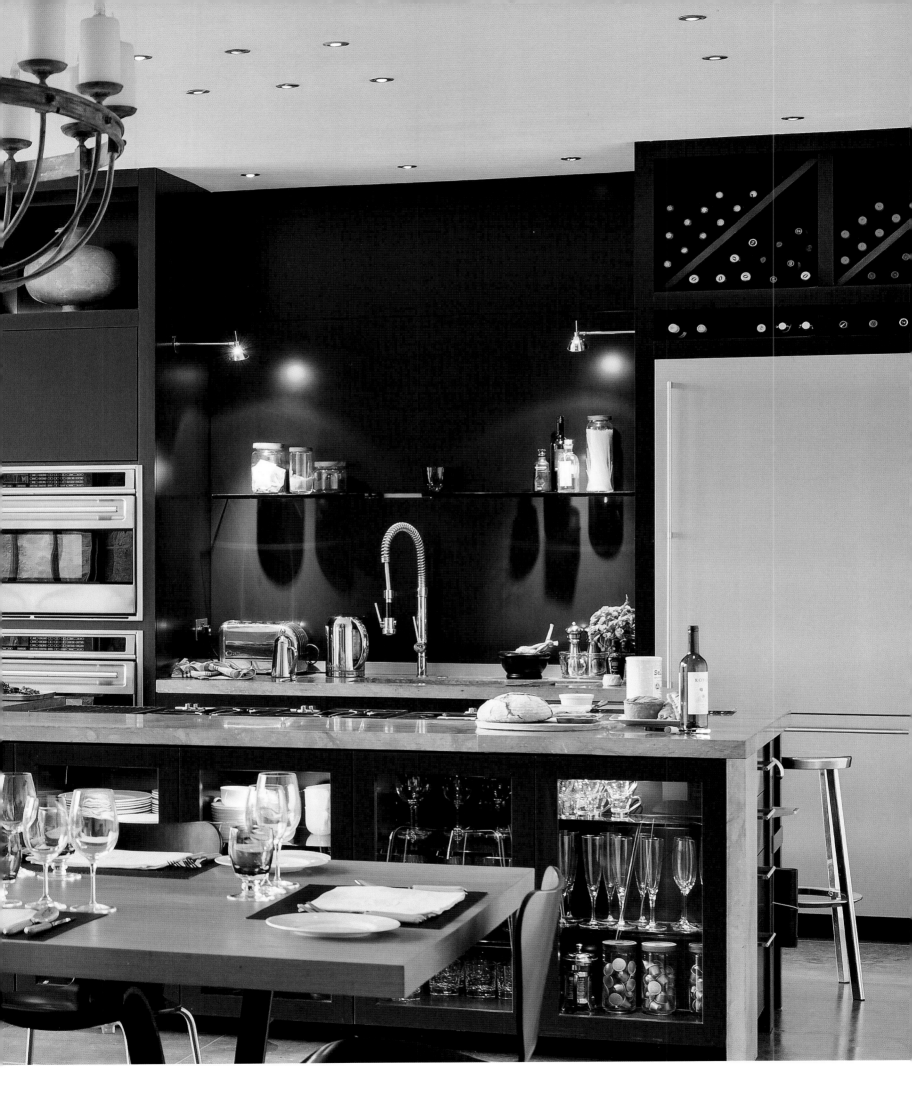

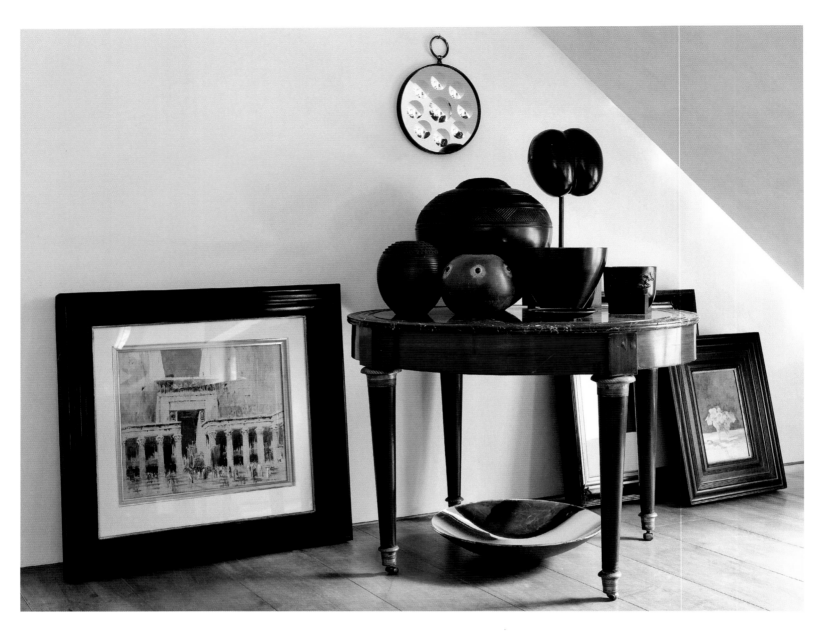

The almost seven-foot-wide chandelier was given a verdigris finish and an iron table base of John's design was topped with pale oak, which ties with the color of the stone floor and worktops (previous page).

*Der Kronleuchter mit zwei Meter Durchmesser erhielt eine Patina-Lackierung. Auf das von John Minshaw entworfene Eisengestell des Tisches wurde eine Platte aus heller Eiche gelegt, die zur Farbe des Steinbodens und der Arbeitsflächen passt (vorherige Seite).*

*Le chandelier de deux mètres de diamètre a hérité d'un fini vert-de-gris, tandis que la base de la table dessinée par John est couronnée d'un plateau de chêne clair, rappelant la couleur des dalles et des plans de travail (page précédente).*

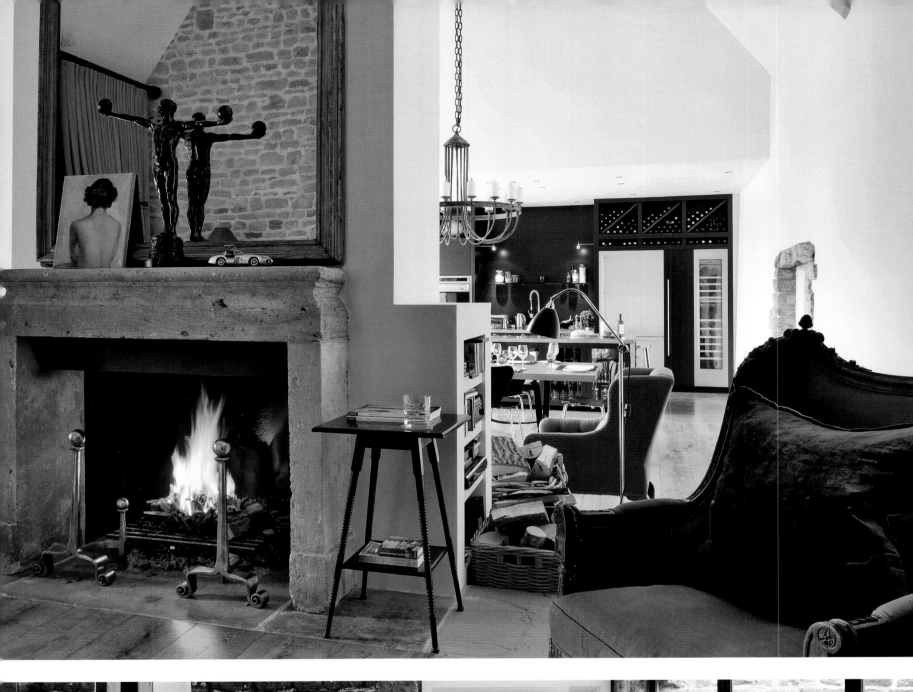
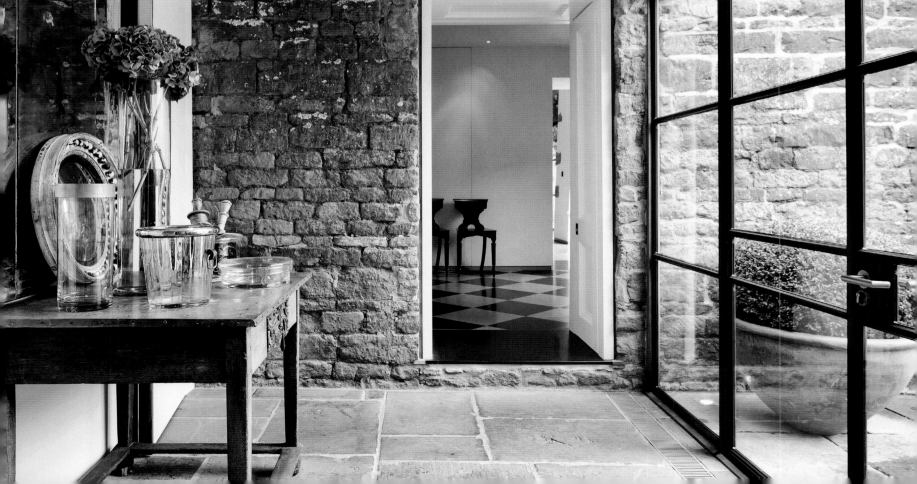

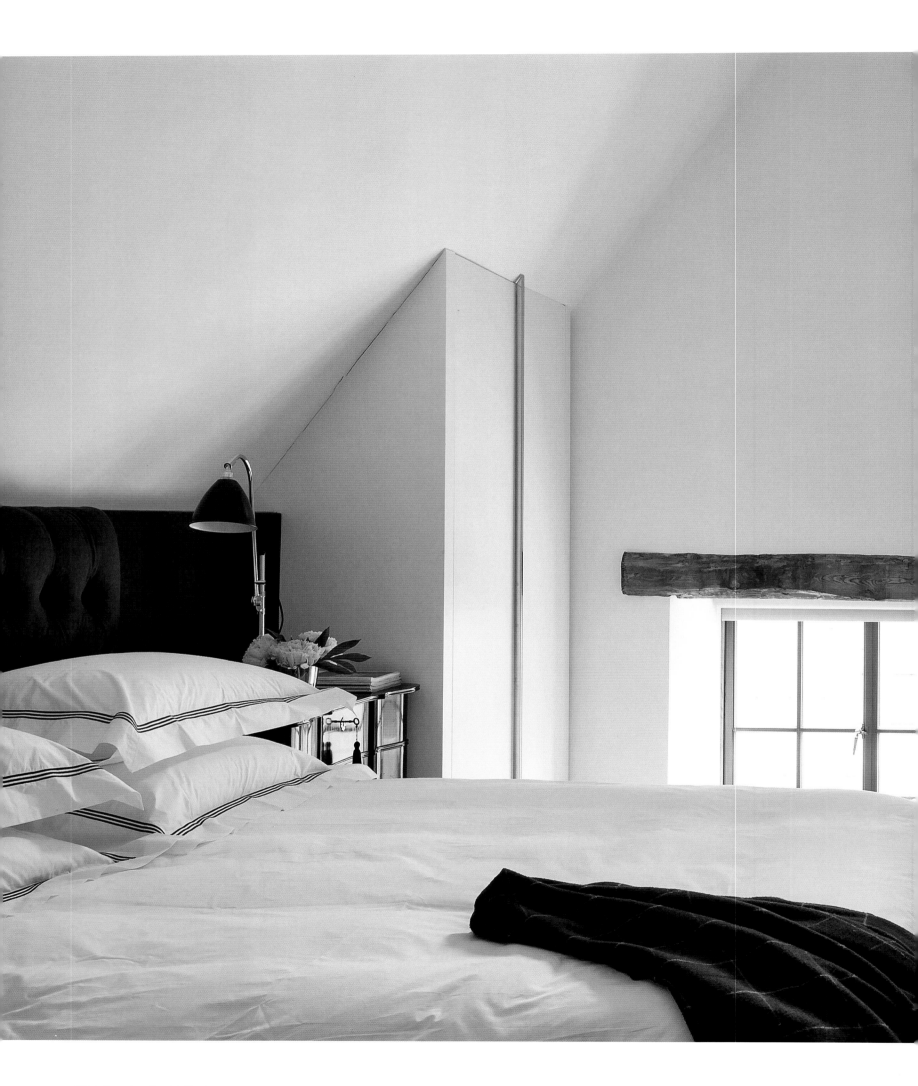

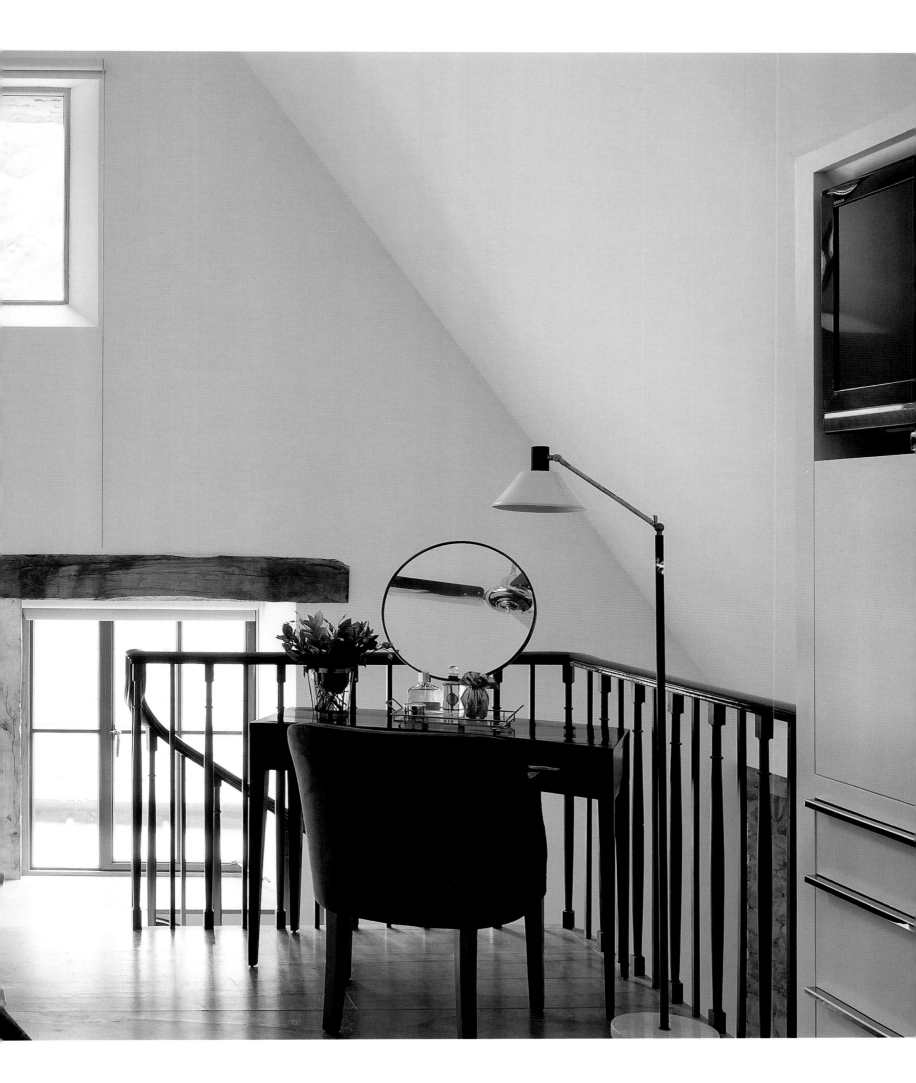

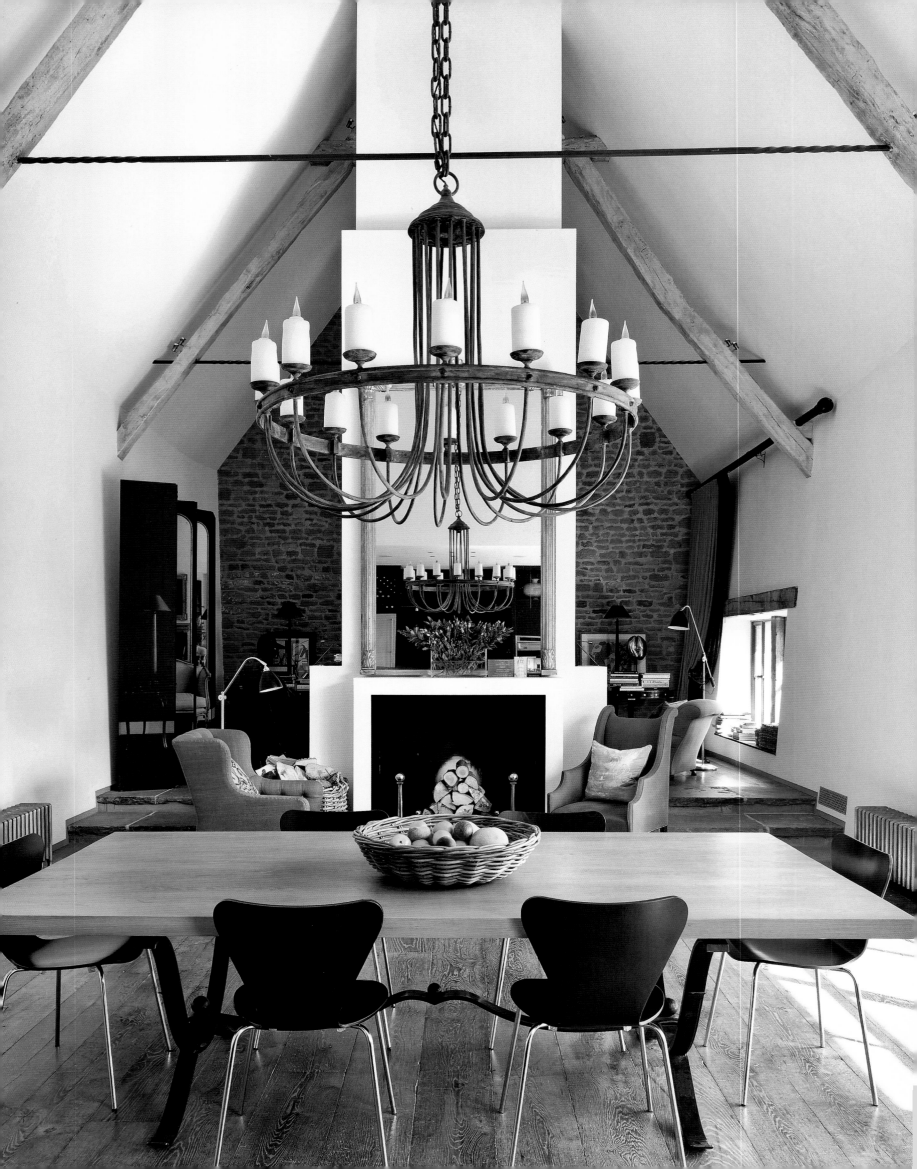

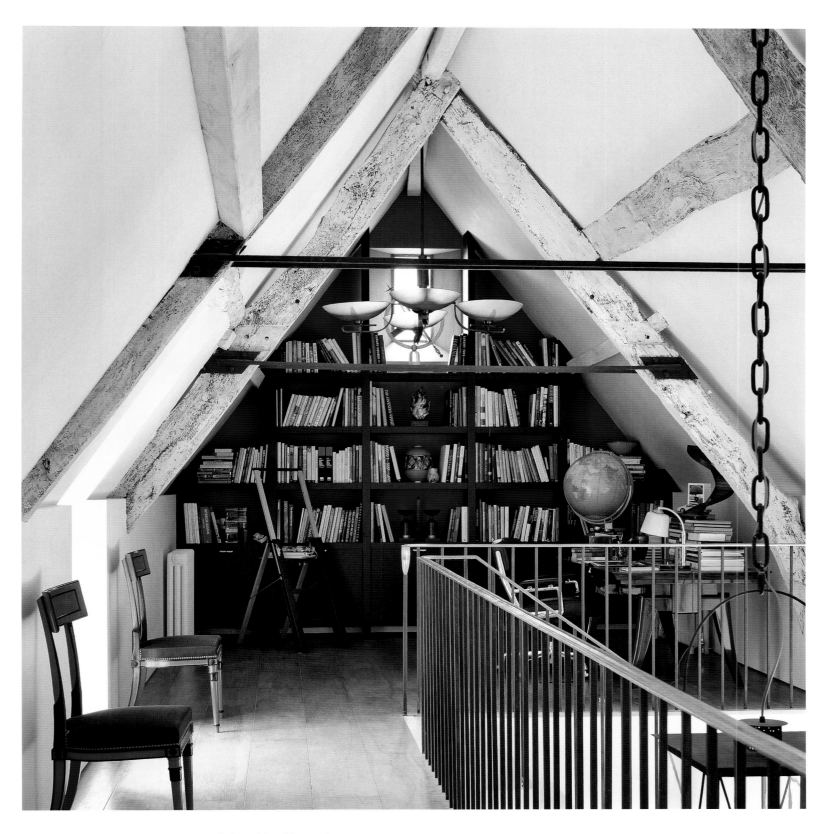

A large gilt mirror resides atop the dining side chimney breast,
flanked with shallow stone steps leading to the raised seating area.

Ein großer Spiegel mit vergoldetem Rahmen steht auf dem Kaminsims.
Zu beiden Seiten des Kamins führen flache Steinstufen zum erhöhten Sitzbereich.

Un grand miroir à cadre doré trône côté salle à manger sur le manteau de la cheminée
que bordent des marches de pierre conduisant à un espace détente surélevé.

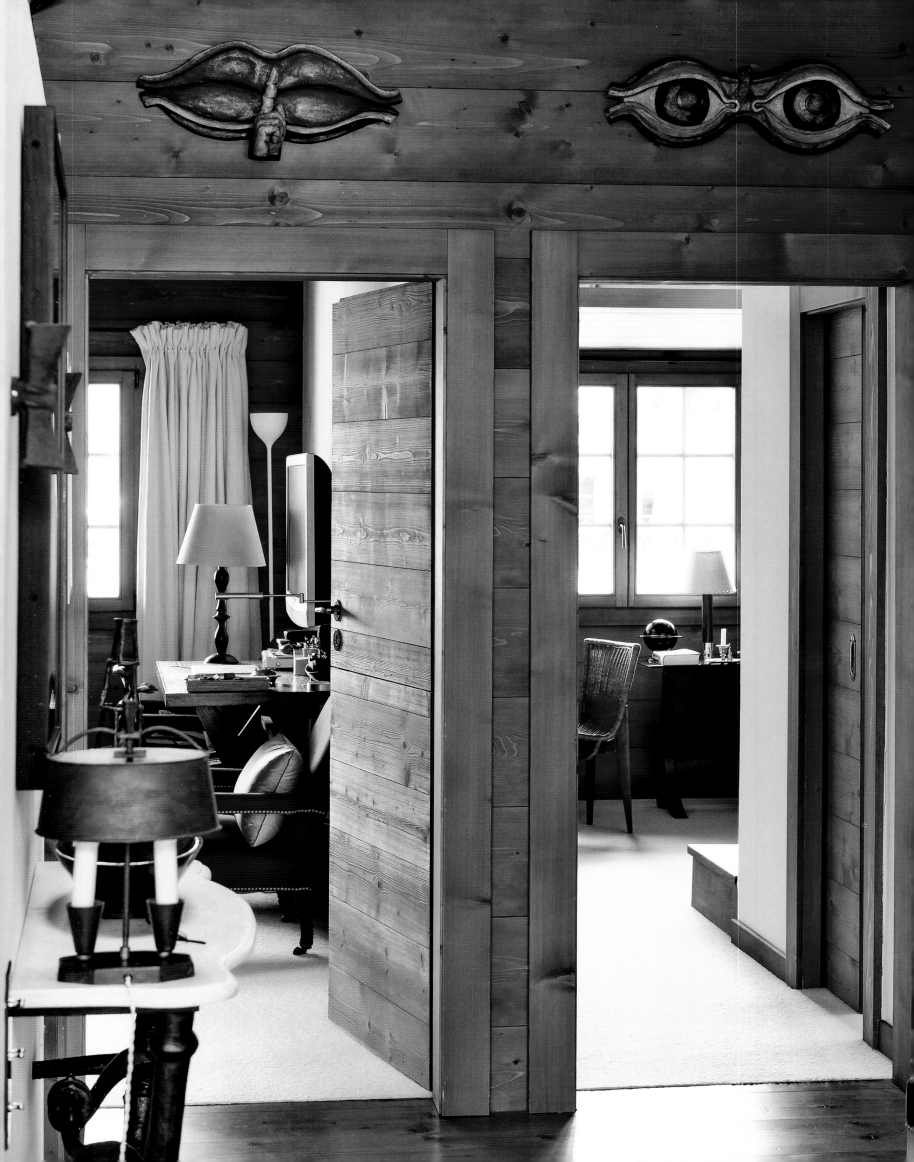

# On Top of the World
## Gstaad, Switzerland

A LIFELONG VISITOR TO Gstaad, Paris-based designer Tino Zervudachi has designed a constellation of chalets for friends and clients there, so it was all but inevitable that he would eventually create his own hillside haven near the legendary ski village in the Swiss Alps. And when an opportunity arose to take on the completion of a newly built apartment outside the center of town, he readily seized it. He started by dramatically changing the floor plan and converting what was to be a four-bedroom, three-bathroom space into an airy abode with just one master bedroom, a study, and two bathrooms. By leaving the interior timber structure open, he allowed the 13-foot-high central gable to present an impressive lofty ambience in the primary living space, while ample windows let in plenty of natural light and offer stunning vistas of the mountains, cattle pastures, and charming little railway beyond.

DER IN PARIS lebende Innenarchitekt Tino Zervudachi war häufig Gast in Gstaad und hatte dort bereits für Freunde und Kunden einige Chalets eingerichtet. So war es nachvollziehbar, dass er schließlich auch sein eigenes Wohnparadies in der Nähe des legendären Skiorts in den Schweizer Alpen entwarf. Als sich die Gelegenheit bot, eine neu erbaute Wohnung am Zentrumsrand zu vollenden, zögerte er nicht lange. Als Erstes veränderte er den Grundriss dramatisch und verwandelte den als Wohnung mit vier Schlafzimmern und drei Badezimmern konzipierten Raum in eine luftige Fläche mit nur einem Schlafzimmer, einem Arbeitszimmer und zwei Badezimmern. Indem er die Balkenstruktur frei ließ, entstand vor allem durch den vier Meter hohen Giebel im Kernwohnbereich eine beeindruckende Loftatmosphäre. Gleichzeitig lassen zahlreiche Fenster viel natürliches Licht einströmen und bieten atemberaubende Ausblicke auf Berge, Almen und eine hübsche kleine Eisenbahn.

ARCHITECTE D'INTÉRIEUR BASÉ à Paris, Tino Zervudachi est un hôte assidu de Gstaad, où il a réalisé une foule de chalets pour des amis et clients. Il fallait donc s'attendre à ce qu'il crée un jour son propre refuge à flanc de coteau, près du célèbre village de ski des Alpes suisses. L'occasion se présentant de finir une maison un peu à l'écart du centre, il n'a pas hésité un instant. Il a radicalement changé le plan intérieur et transformé ce qui devait être un espace à quatre chambres et trois salles de bains en une maison aérée composée d'une chambre de maîtres, d'un bureau et de deux salles de bains. Avec une ossature de bois intérieure ouverte, le pignon central de quatre mètres de haut du séjour principal confère au lieu une étonnante ambiance loft. La lumière naturelle pénètre généreusement par de vastes fenêtres qui offrent des vues saisissantes sur les montagnes, les pâtures et la sympathique petite ligne de chemin de fer.

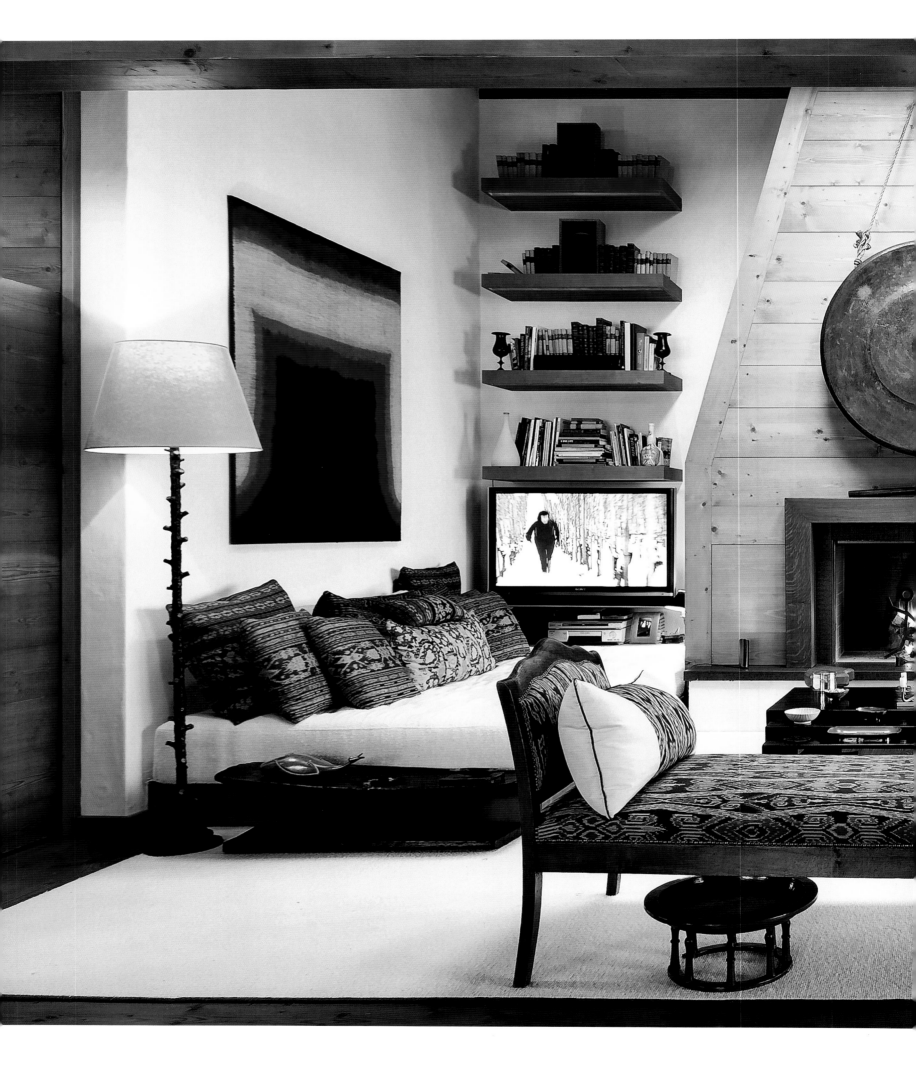

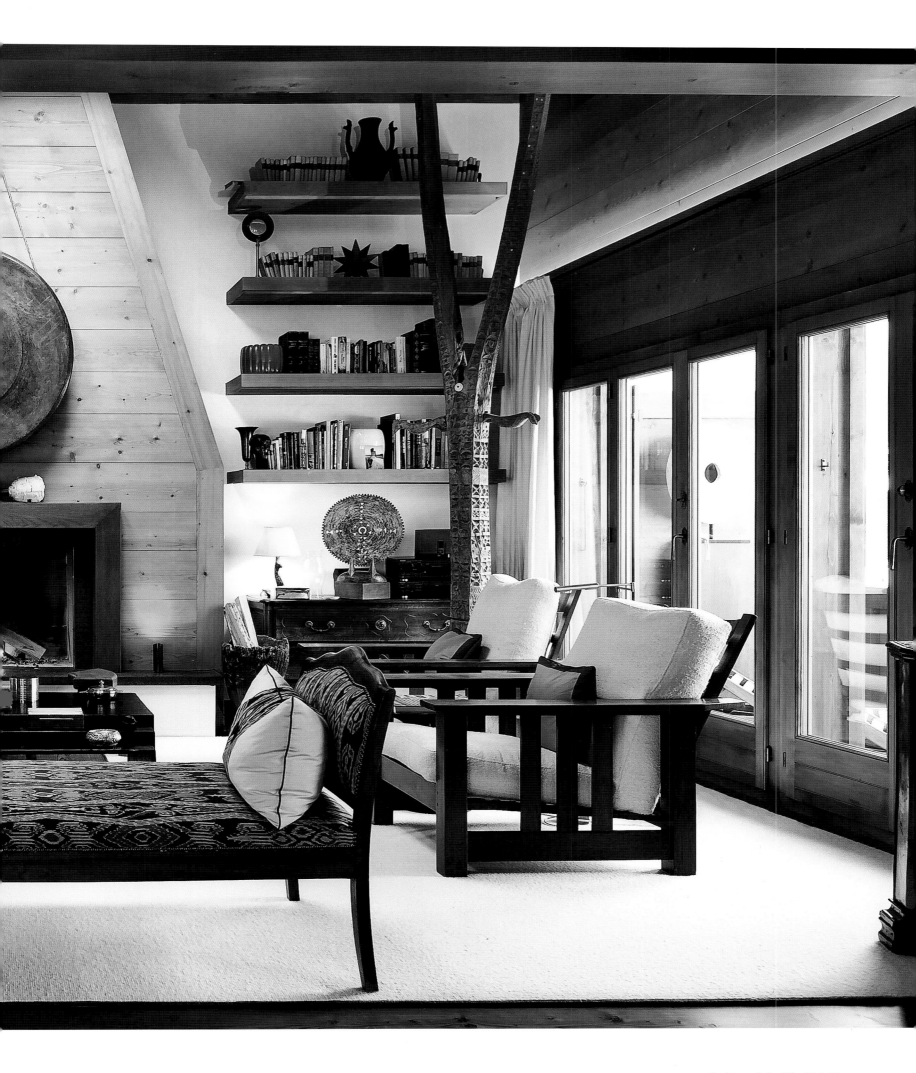

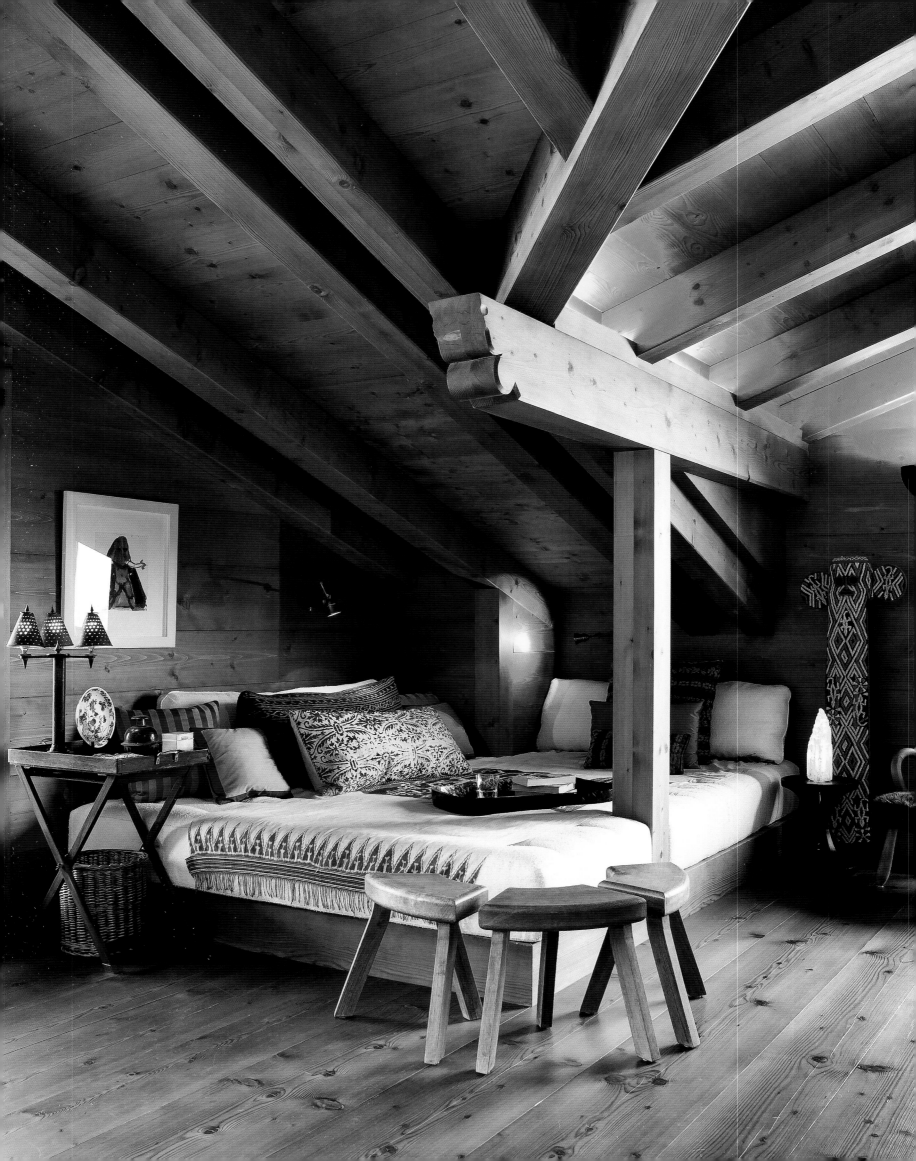

*Instead of furnishing the home with Swiss antiques
or rustic country objects, the designer mixed dramatic
Asian pieces with urban mid-century European furniture
by masters like Le Corbusier and Franco Albini to create
a sophisticated look befitting a seasoned traveler
and collector.*

*Anstelle von Schweizer Antiquitäten oder rustikalen
Möbeln im Landhausstil hat Zervudachi auffällige
asiatische Elemente mit europäischen Designklassikern
von Le Corbusier und Franco Albini kombiniert, um ein
Wohnambiente zu schaffen, dass zu einem erfahrenen
und weitgereisten Sammler passt.*

*Le concepteur n'a pas meublé la maison d'antiquités
suisses ou d'objets rustiques. Il a réuni des pièces
exceptionnelles d'Asie et du mobilier urbain d'Europe
des années 1950 de maîtres tels que Le Corbusier et
Franco Albini pour créer une ambiance raffinée digne
d'un voyageur et collectionneur chevronné.*

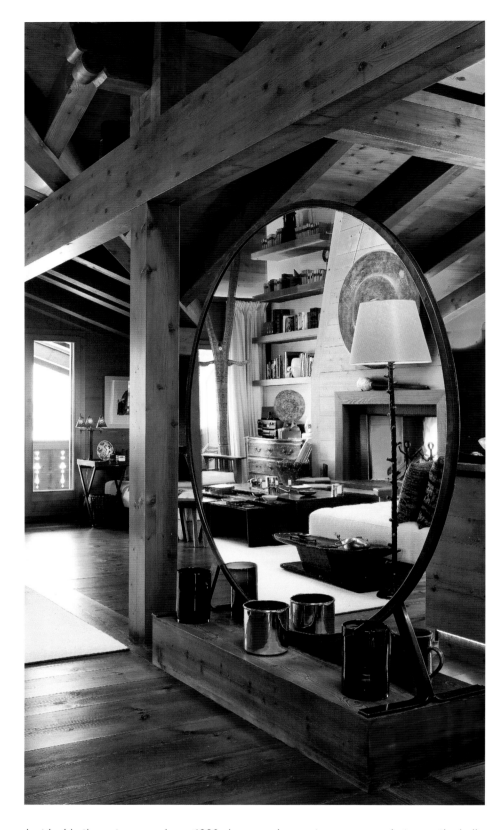

*Just inside the entrance, a huge 1920s bronze mirror acts as a screen between the hall and the sociable open-plan kitchen. The home also includes artwork by Tino's twin sister, Manuela, as well as a curious old iron-wood house column from Sulawesi.*

*Im Eingangsbereich dient ein gewaltiger Bronzespiegel aus den 1920er-Jahren zur Abtrennung von Flur und offener Küche. Im Haus finden sich zudem Kunstwerke von Tinos Zwillingsschwester Manuela sowie eine kuriose sulawesische Säule aus Eisen und Holz.*

*Juste à l'entrée, une énorme miroir années 1920 cerclé de bronze sert de séparation entre le hall et la cuisine ouverte conviviale. La maison abrite des œuvres d'art de Manuela, la sœur jumelle de Tino, ainsi qu'une extraordinaire colonne en bois et en fer d'une maison des Célèbes.*

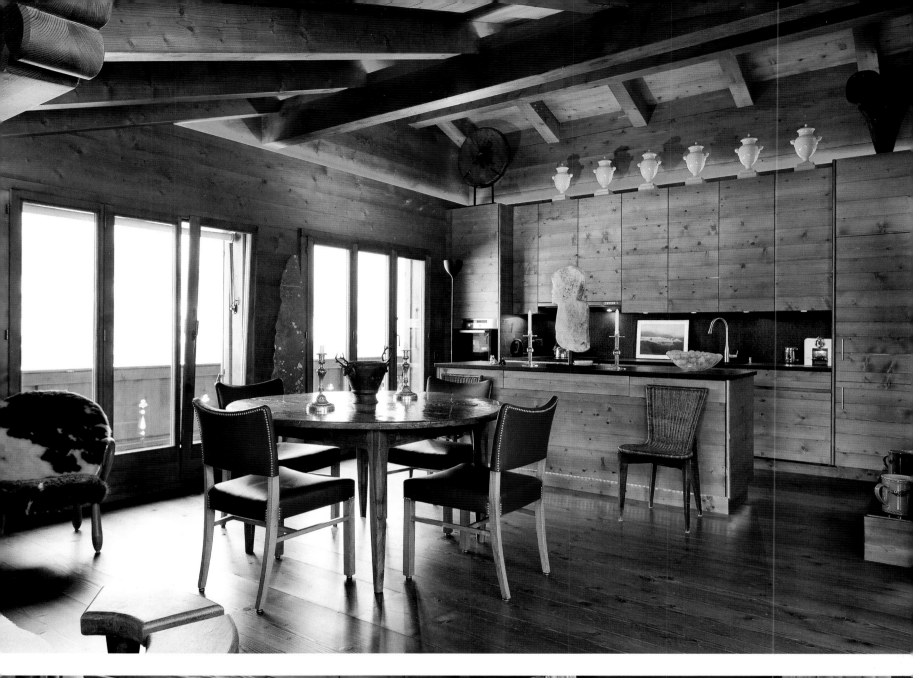

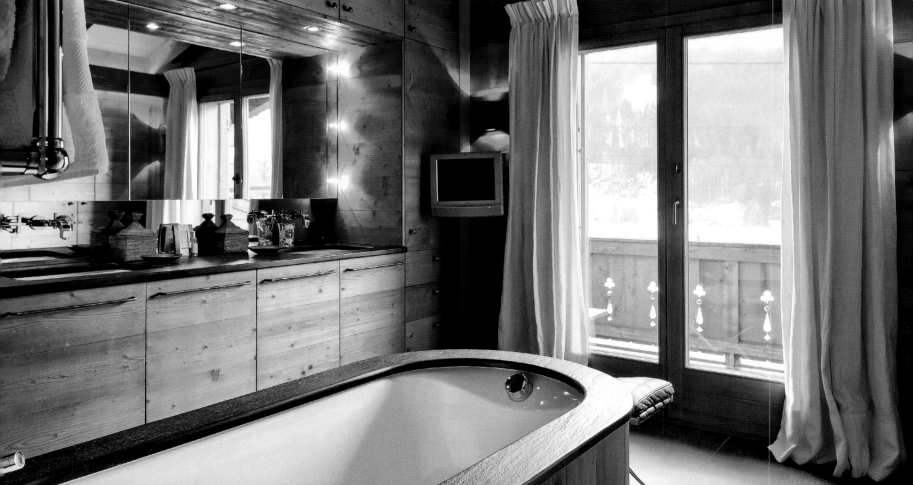

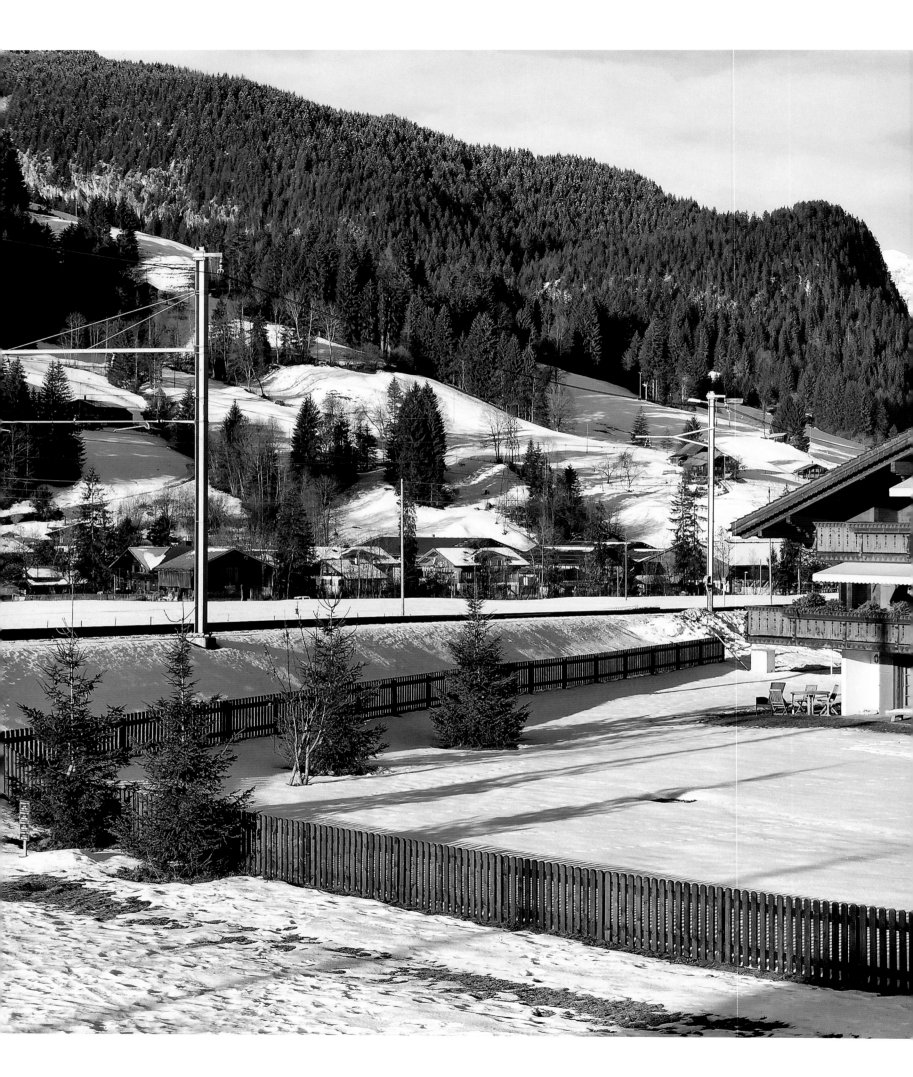

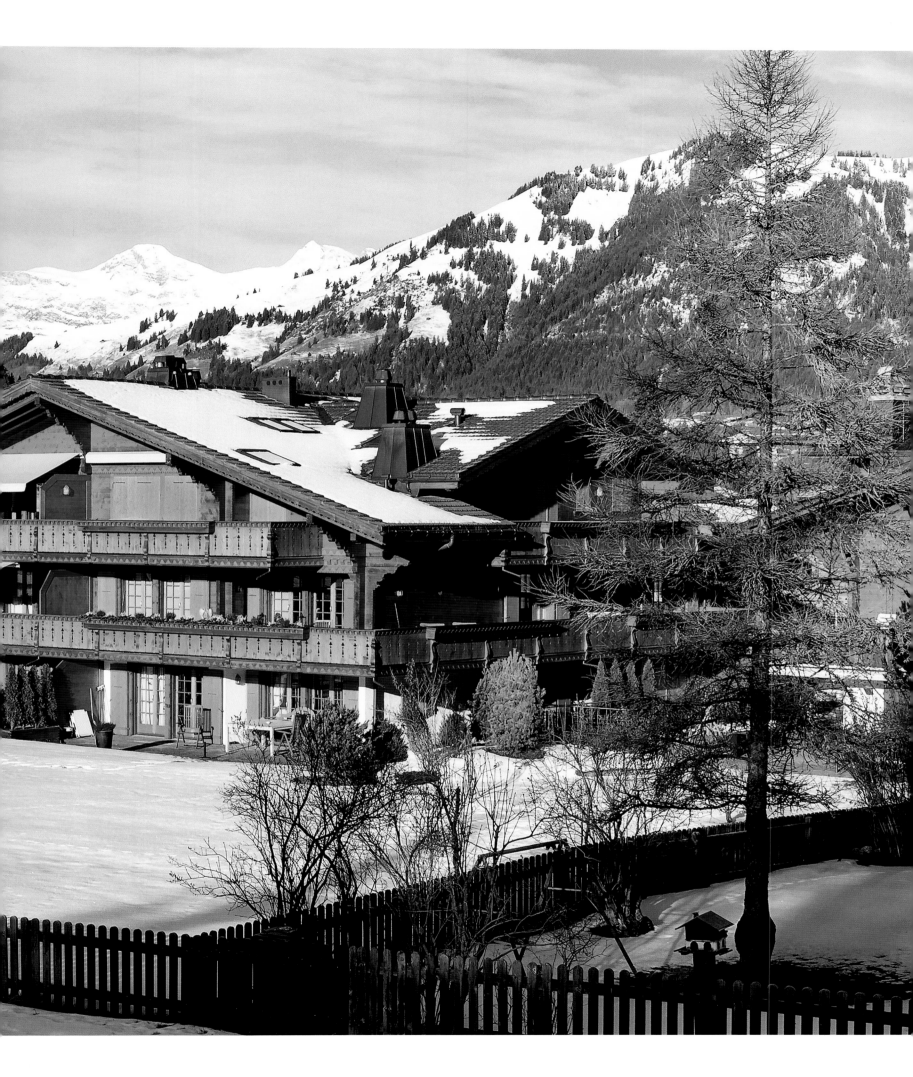

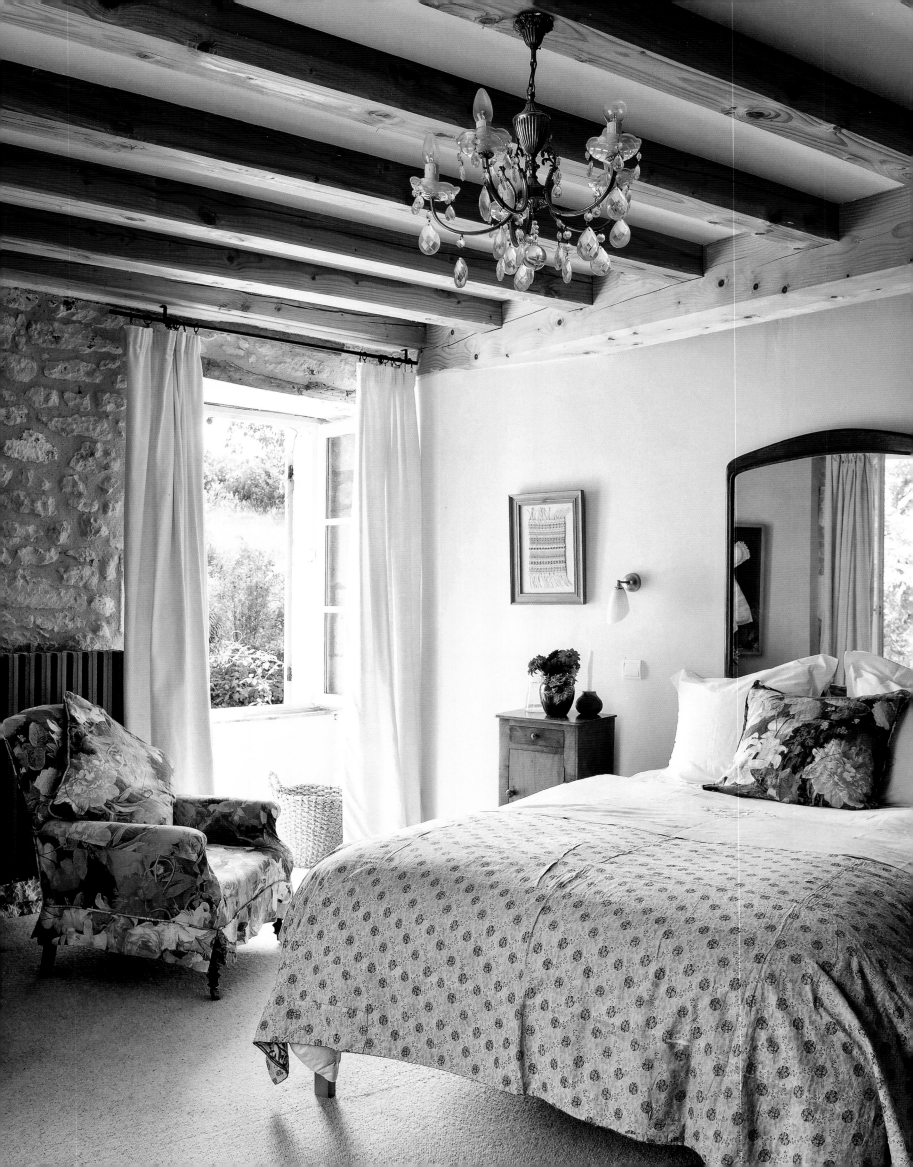

# Past Perfect
## Verteillac, France

ALTHOUGH THEY HAD settled in London, Katie and Mike Armitage are Francophiles. So, to sate their tastes for all things French, they decided to buy a holiday home in France. The plan was to purchase a small place, but when they found a lofty three-story *maison de maître* in the countryside of Aquitaine it was love at first sight and their original idea was history. Though the house had not been lived in for forty years, the couple couldn't resist the romance of its setting or its history—it was originally a 15th-century walnut mill that belonged to the Sieur de Verteillac, a landowner who had married the Princesse de Briançon—and they took it on as a labor of love. Other than preserving the house's rustic stone walls, the remains of its beamed ceilings, and its Empire-period doors, they started from scratch to create new spaces using reclaimed materials that harmonize with its past.

UM IHRE SEHNSUCHT nach allem, was Französisch ist, zu stillen, beschlossen die franko-philen Londoner Katie und Mike Armitage, ein Ferienhaus in Frankreich zu kaufen. Eigentlich sollte es nur ein kleines Haus sein, doch als sie in Aquitanien auf das drei-stöckige loftartige *maison de maître* stießen, war es Liebe auf den ersten Blick, und der ursprüngliche Plan wurde schnell ad acta gelegt. Die ehemalige Walnussmühle aus dem 15. Jahrhundert hatte einst dem Gutsbesitzer Sieur de Verteillac gehört, der eine Princesse de Briançon ehelichte. Das Gebäude war seit 40 Jahren unbewohnt und in entsprechend schlechtem Zustand, doch die Armitages konnten sich dem Charme seiner idyllischen Lage und Geschichte nicht entziehen und nahmen die umfangreichen Renovierungsarbeiten aus Liebe zu dem Objekt auf sich. Sie erhielten die rustikalen Steinwände, die Überreste der Deckenbalken und die Empire-Türen, mussten die Innenräume jedoch ansonsten mit sorgfältig ausgewählten und zur Vergangenheit des Hauses passenden Materialien von Grund auf neu gestalten.

BASÉS À LONDRES, Katie et Mike Armitage n'en étaient pas moins épris de la France et ils ont pour assouvir cette passion décidé d'y acquérir une maison pour les vacances. Ils projetaient d'acheter une petite bicoque, mais lorsqu'ils sont tombés sur une sublime maison de maître à trois niveaux dans la campagne d'Aquitaine, ils ont eu le coup de foudre et ont abandonné leur idée première. L'endroit était inhabité depuis 40 ans, mais le couple n'a pu résister au charme romantique de son cadre et de son histoire — cet ancien moulin à huile de noix du XVe siècle appartenait à sieur de Verteillac, propriétaire terrien ayant épousé la princesse de Briançon — et ils ont mis tout leur cœur à le rénover. Ils ont préservé les murs en pierre rustiques, les vestiges des poutres de bois du plafond et les portes Empire, mais ils ont refait tout le reste à neuf, créant de nouveaux espaces avec des matériaux de récupération en harmonie avec le passé du moulin.

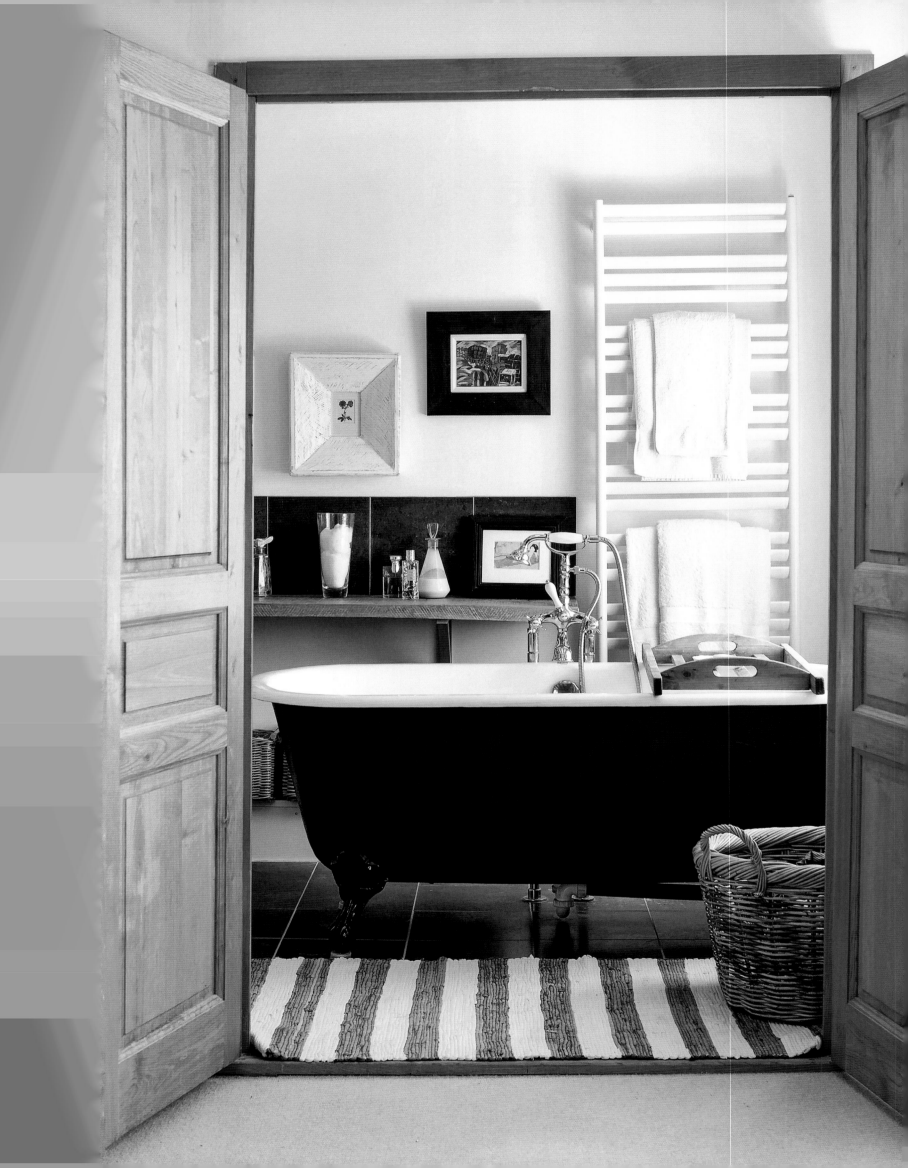

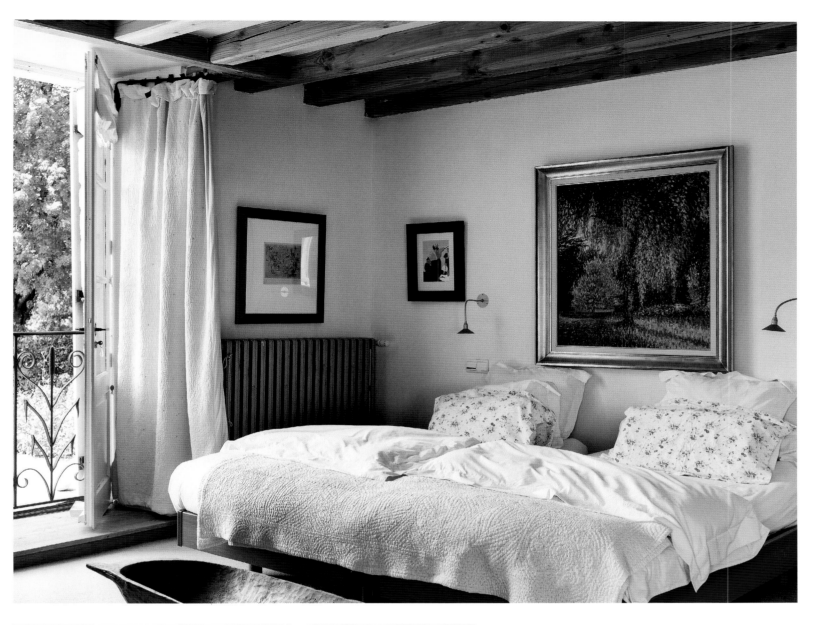

Double doors lead to a bathroom where the tub,
reclaimed from a local chateau, was placed in front
of the window to take advantage of the view.

*Flügeltüren führen zu einem Badezimmer, in dem die
Wanne, die ursprünglich aus einem nahegelegenen
Château stammt, vor das Fenster gestellt wurde,
um auch badend die Aussicht genießen zu können.*

*Une porte à double battant conduit à la salle de bains,
où la baignoire récupérée dans un château de la région
a été placée devant la fenêtre pour profiter de la vue.*

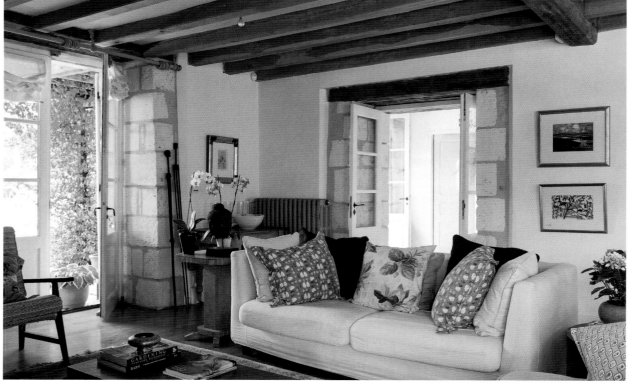

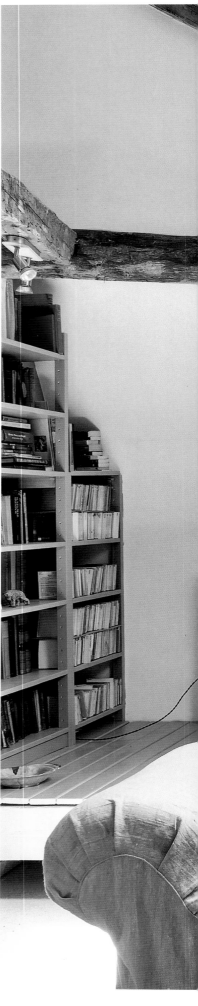

A guest room occupies the attic, as does Katie's sewing studio and an informal sitting area with bookshelves.

Auf dem Dachboden befinden sich ein Gästezimmer, Katie Armitages Nähzimmer und ein informeller Sitzbereich mit Bücherregalen.

Le grenier abrite une chambre d'amis, ainsi que l'atelier de couture de Katie et un coin détente avec des rayonnages de livres.

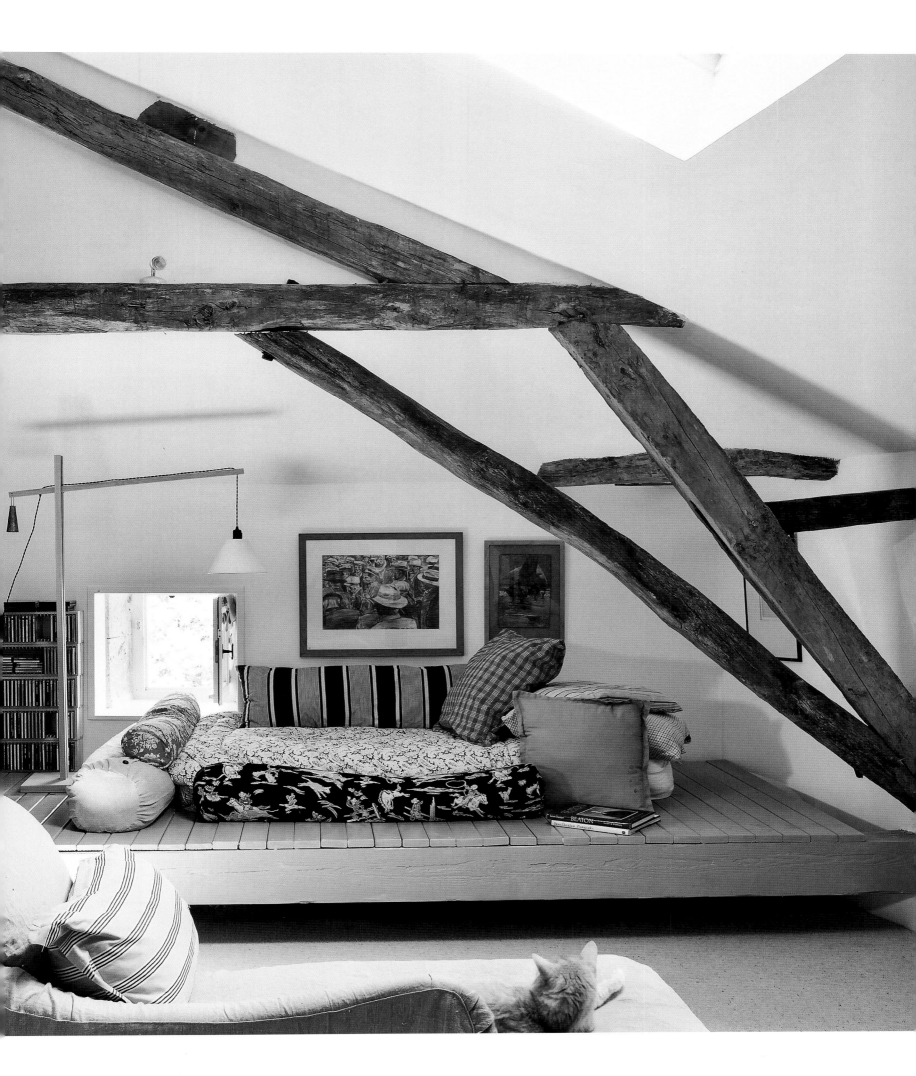

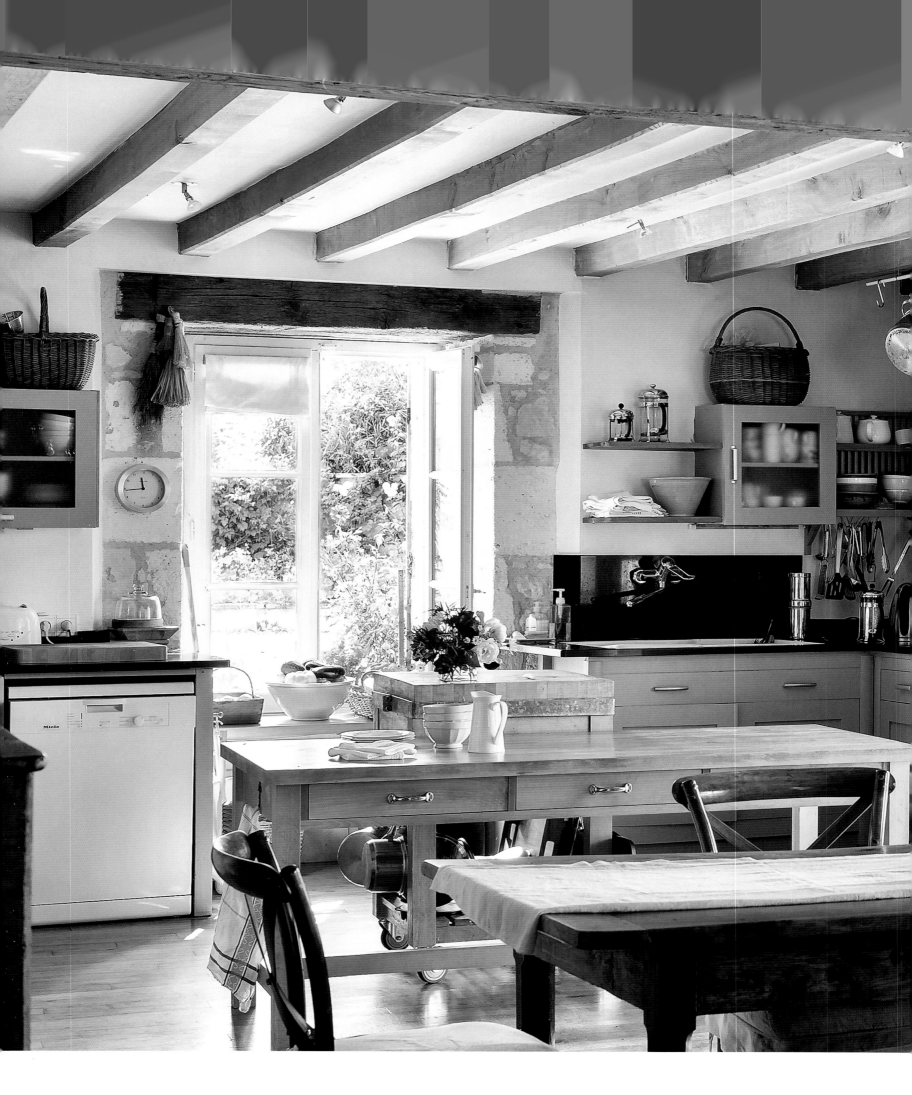

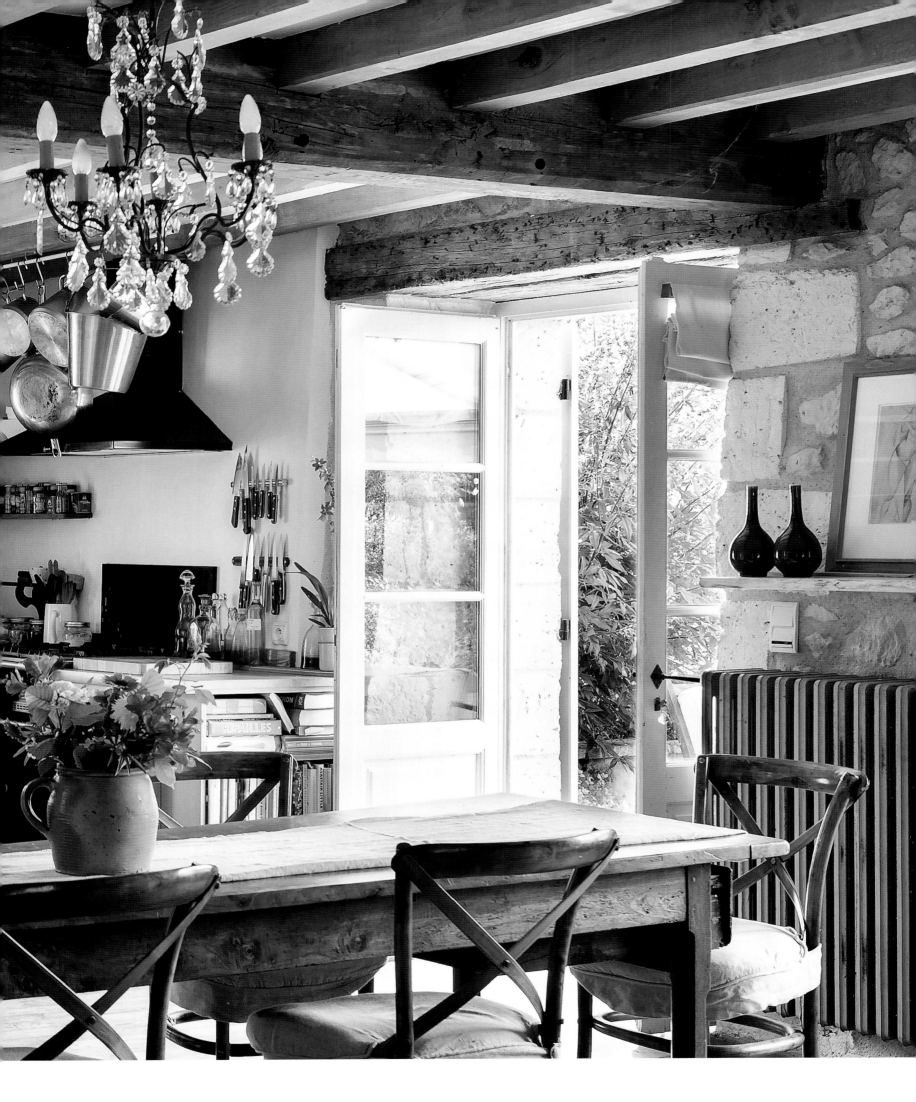

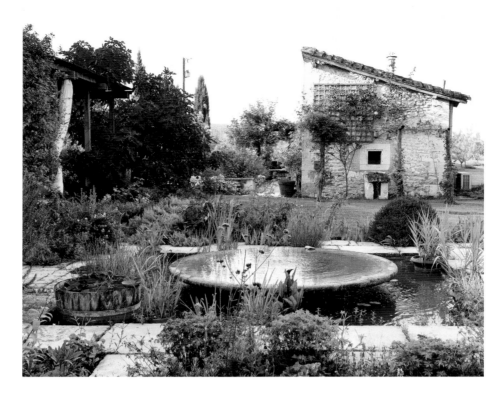

The centerpiece of the rear garden is a water feature consisting of a vast round planter in a square pool. The stone hand was carved by American sculptor Edmund Ashby.

*Kernstück des hinteren Gartens ist ein quadratischer Teich, in dessen Mitte eine große runde Steinschale platziert wurde. Die riesige Steinhand ist ein Werk des amerikanischen Bildhauers Edmund Ashby.*

*L'élément central du jardin à l'arrière est constitué par une grande vasque dans un bassin carré. La main en pierre est l'œuvre du sculpteur américain Edmund Ashby.*

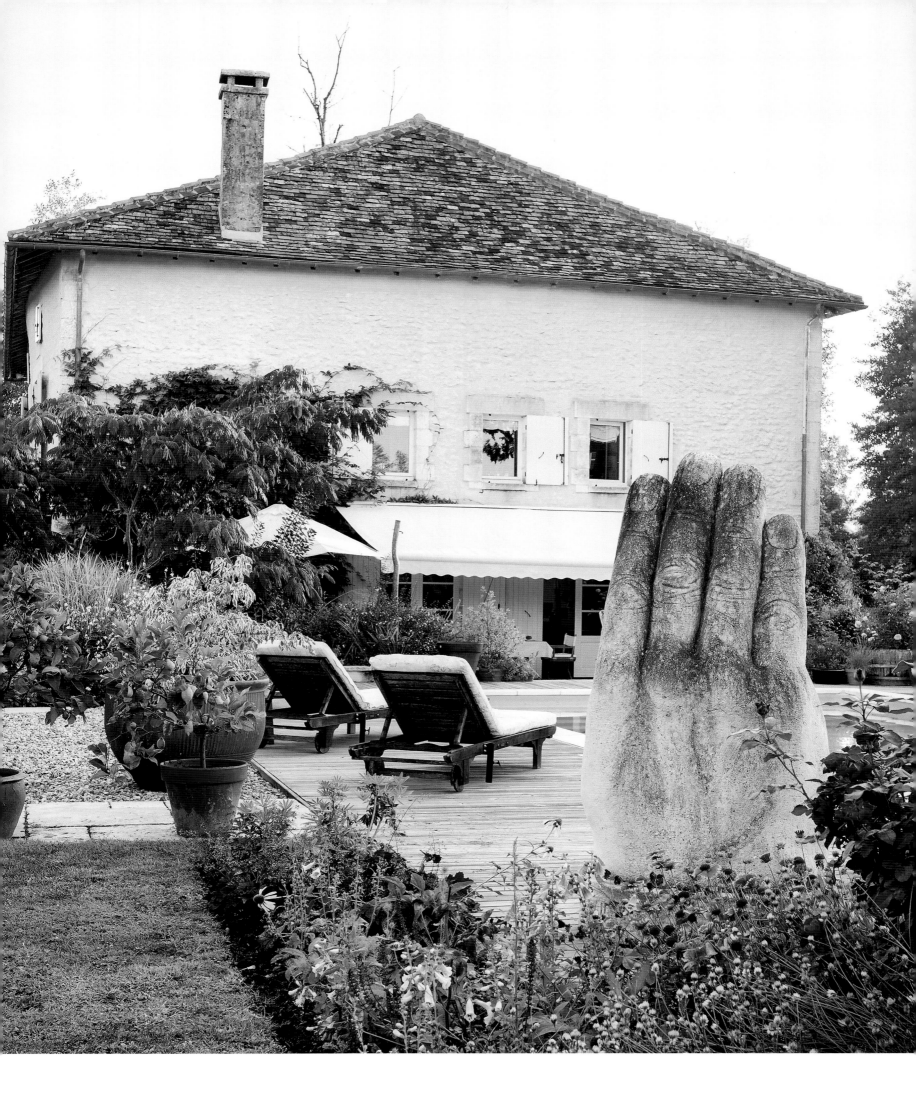

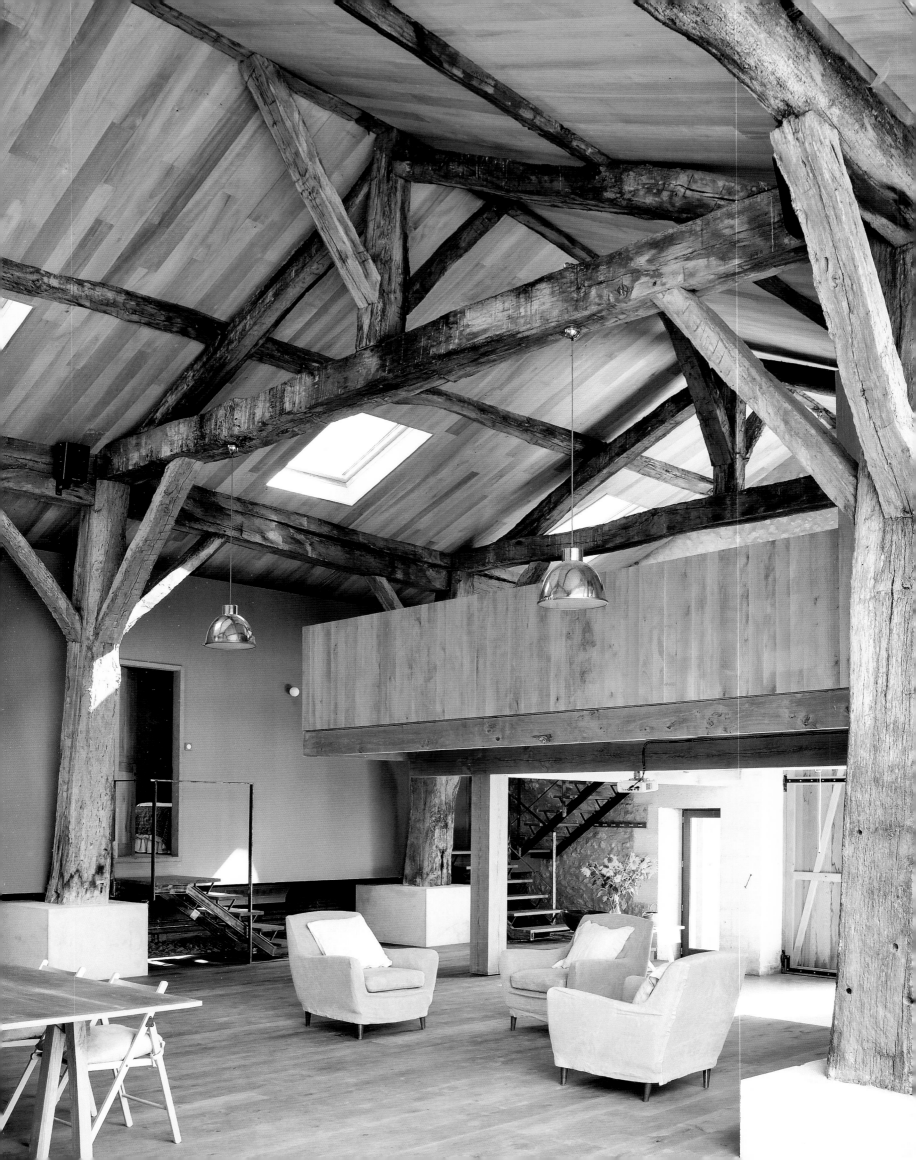

# Crafty Conversion
## Verteillac, France

NOT LONG AFTER Katie and Mike Armitage transformed a 15$^{th}$-century mill in the south of France into their permanent home, they began scheming for ways to put the property's outbuildings to good use. Among the largest of these structures was one of the barns, which Katie readily imagined as a studio for crafts workshops. Les Sœurs Anglaises, a design workshop enterprise, was developed by Katie, her sisters, and Carol Temple, also an expat from London. They started by enlisting a few carefully chosen designers from London to teach their first residential workshops. After word spread about their program and it began to flourish, they commissioned Jeremy Harris, an English architect from Bordeaux, to convert the barn into what they now call L'Espace, a studio workspace along with several bedrooms and bathrooms. The transformed structure was also connected via a walkway to a new cedar-clad extension, which can accommodate sixteen participants, who now come to attend their summer workshops from all over the world.

NICHT LANG NACHDEM Katie und Mike Armitage in Südfrankreich eine Mühle aus dem 15. Jahrhundert zu ihrem festen Wohnsitz umgebaut hatten, fingen sie an, sich über eine Verwendung für die zum Anwesen gehörenden Nebengebäude Gedanken zu machen. Eines der größten Gebäude war eine Scheune, die Katie als Studio für diverse kreative Workshops besonders geeignet schien. Gemeinsam mit ihren Schwestern und der auch aus London hergezogenen Carol Temple gründete Katie Les Sœurs Anglaises, ein Unternehmen, das Design-Workshops anbietet. Die ersten wurden mit ein paar handverlesenen Designern aus London durchgeführt. Nachdem das Programm erfolgreich angelaufen war, beauftragten sie Jeremy Harris, einen britischen Architekten aus Bordeaux, die Scheune in das zu verwandeln, was heute L'Espace genannt wird: einen großen Atelierraum mit mehreren angegliederten Schlaf- und Badezimmern. Die transformierte Struktur wurde über einen Weg mit einem mit Zedernholz verkleideten Neubau verbunden. Dieses zusätzliche Gebäude kann 16 Teilnehmer beherbergen, die inzwischen im Sommer aus der ganzen Welt zu den Workshops anreisen.

PEU APRÈS AVOIR fait d'un moulin à huile de noix du XV$^{e}$ siècle du sud de la France leur résidence permanente, Katie et Mike Armitage ont commencé à imaginer comment exploiter au mieux ses dépendances. Katie a immédiatement pensé à transformer l'une des étables figurant parmi les plus grandes structures en ateliers d'artisanat. La société d'ateliers de création Les Sœurs Anglaises a été fondée par Katie, ses sœurs et Carol Temple, autre londonienne expatriée. Elles ont engagé quelques concepteurs londoniens triés sur le volet pour enseigner dans leurs premiers ateliers résidentiels. Lorsque leur programme a commencé à être connu et à bien marcher, elles ont chargé Jeremy Harris, un architecte anglais établi à Bordeaux, de faire de l'étable ce qu'elles appellent aujourd'hui L'Espace, un atelier et espace de travail incluant plusieurs chambres et salles de bains. Cette structure a été reliée par un chemin à une nouvelle extension à bardage de cèdre qui peut accueillir chaque année 16 stagiaires du monde entier venant assister à ces ateliers estivaux.

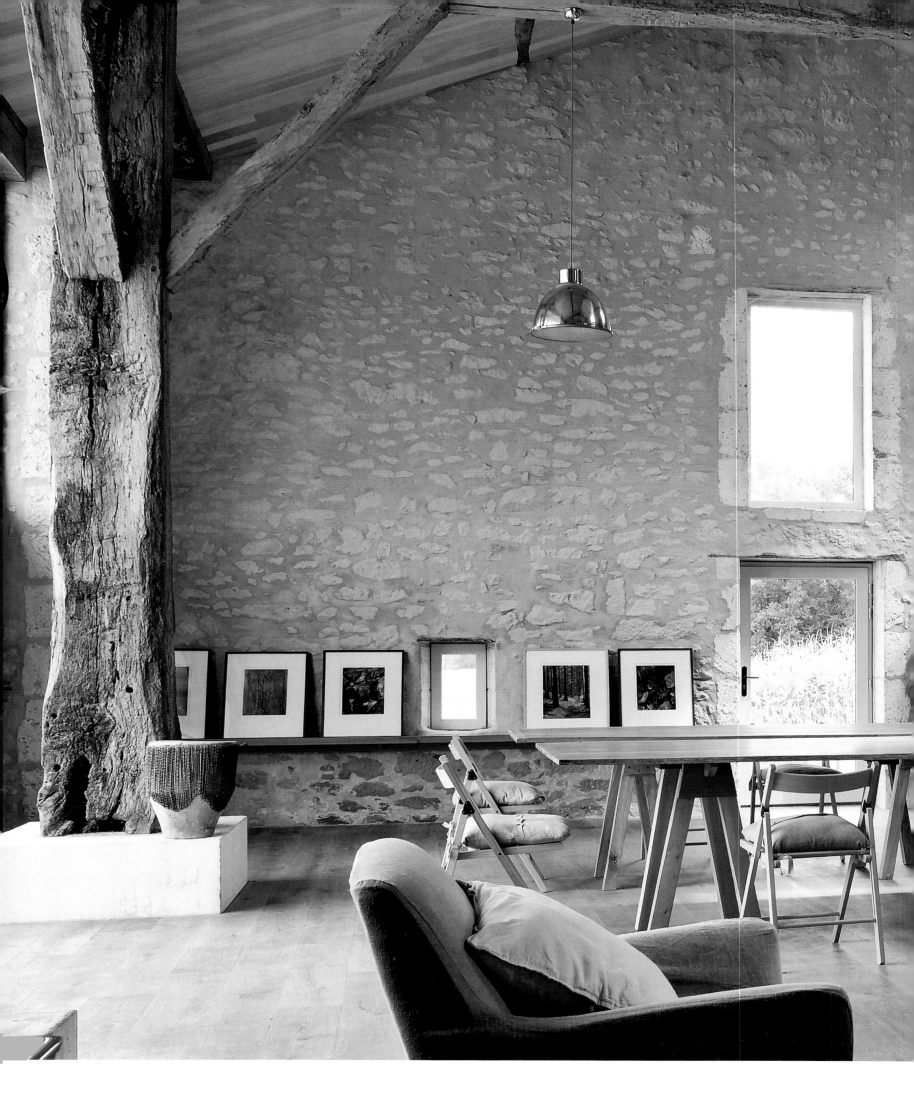

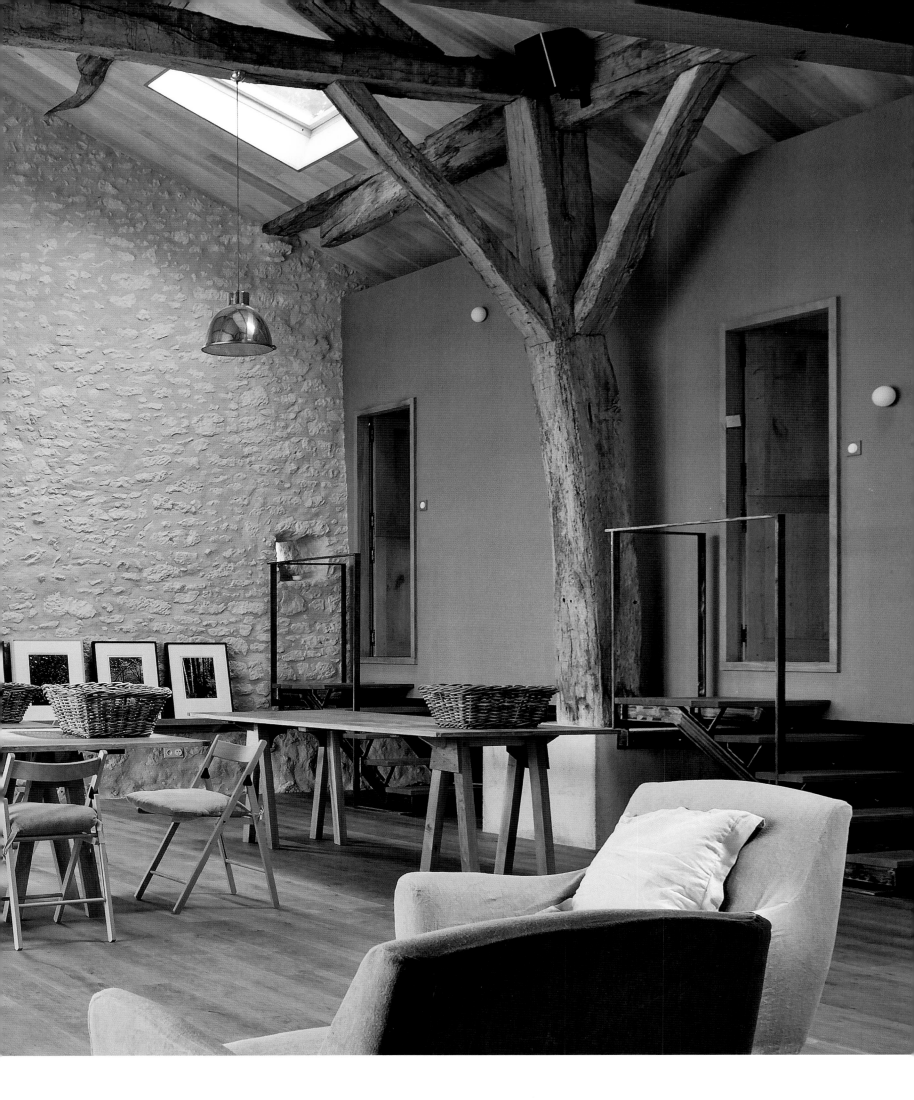

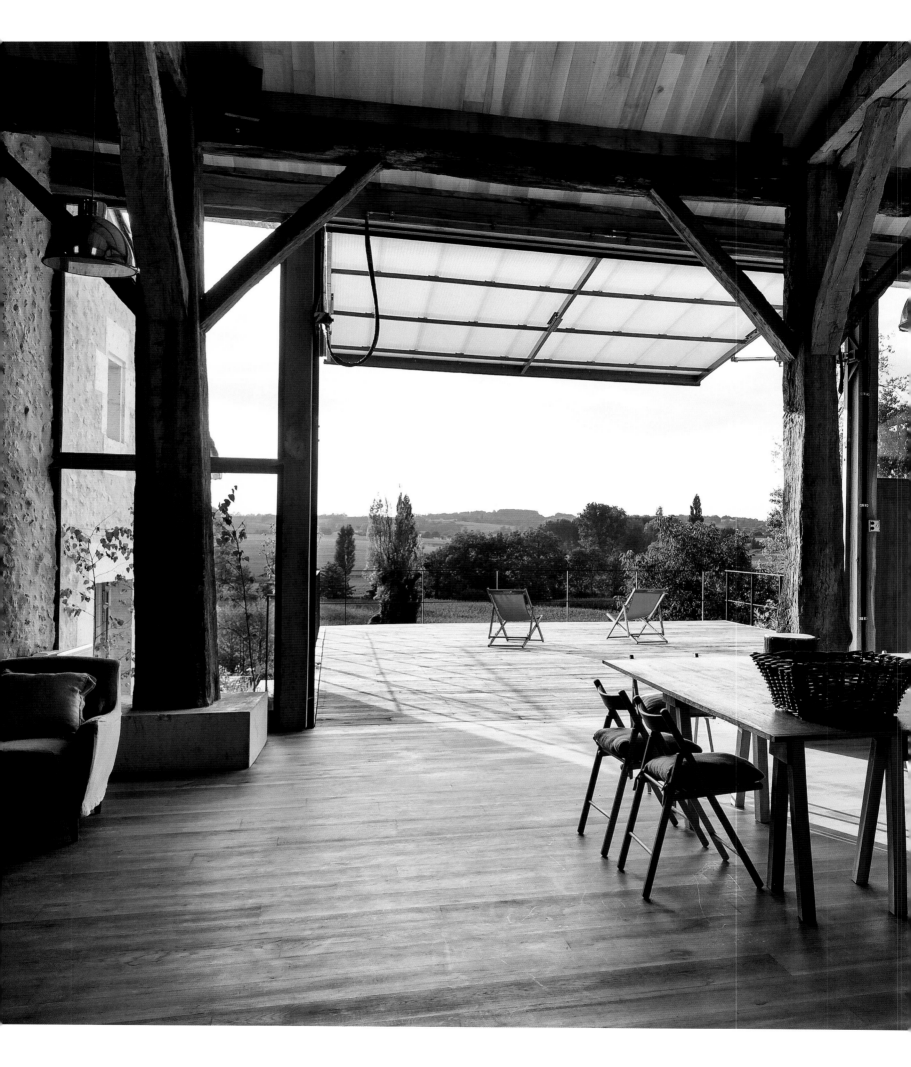

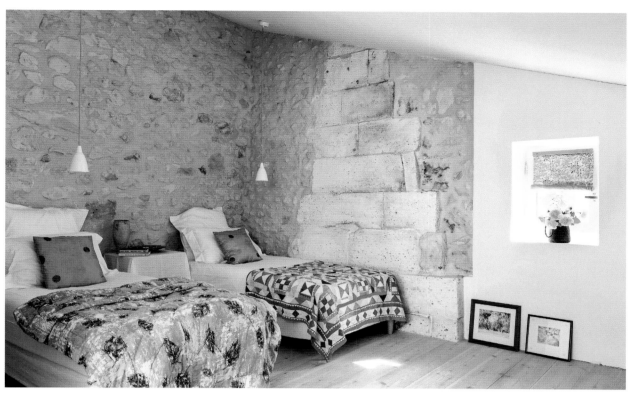
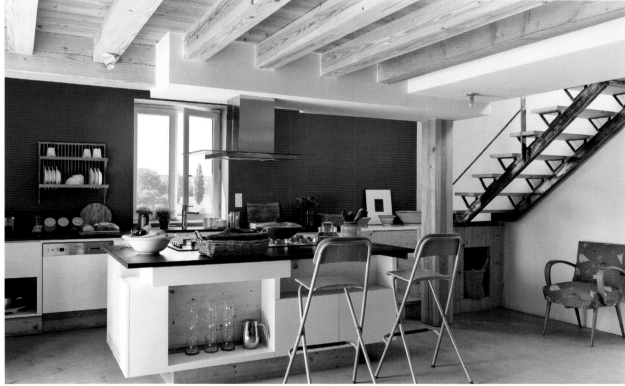

The studio is simply furnished with large timber tables and folding chairs. Skylights and new windows ensure that the interior is well-lit. The vast window that looks onto the terrace opens by means of a hydraulic motor.

Das Atelier ist ganz schlicht mit großen Arbeitstischen und Klappstühlen aus Holz möbliert. Dachluken und neu geschaffene Fenster sorgen für viel Helligkeit. Das riesige Fenster, das sich zur Terrasse öffnet, wird mit einem hydraulischen Motor betrieben.

L'atelier est meublé simplement de grandes tables en bois et de chaises pliantes. Des Velux et de nouvelles fenêtres garantissent un bon éclairage. La grande fenêtre donnant sur la terrasse s'ouvre à l'aide d'un moteur hydraulique.

The new landscaping on the hillside below the barn includes a flight of steps leading down to the new swimming pool, that overlooks the maison de maître, where the Armitages live in the distance.

Zur Umgestaltung des Hangs unterhalb der Scheune gehört ein Pool mit Blick auf das maison de maître, wo die Armitages wohnen. Zum Pool führen neu angelegte Stufen.

La pente douce en contrebas de la grange a été aménagée : des escaliers conduisent à la nouvelle piscine qui donne sur la maison de maître, où vivent les Armitage à une certaine distance.

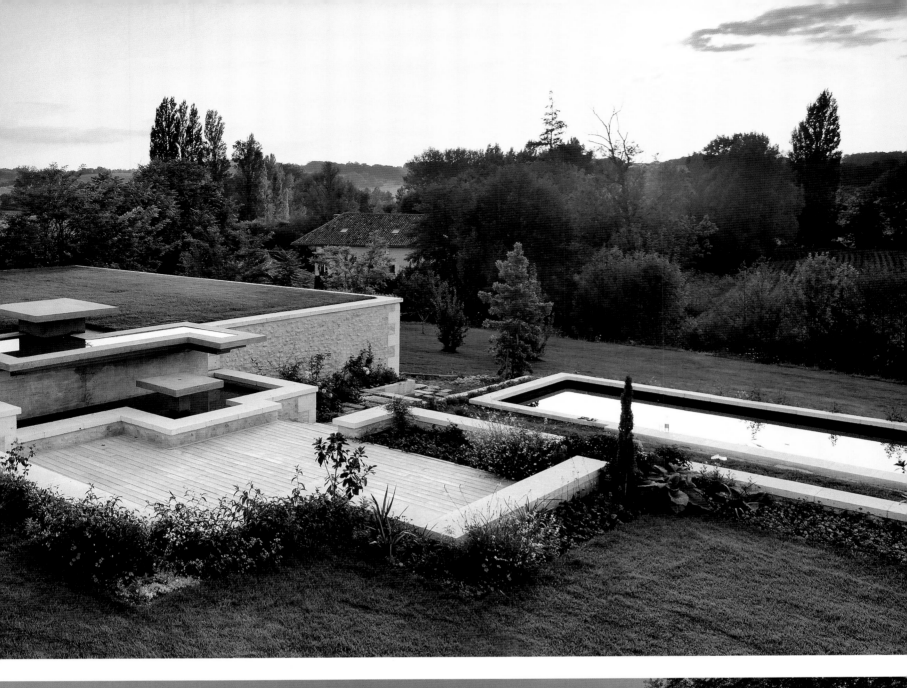
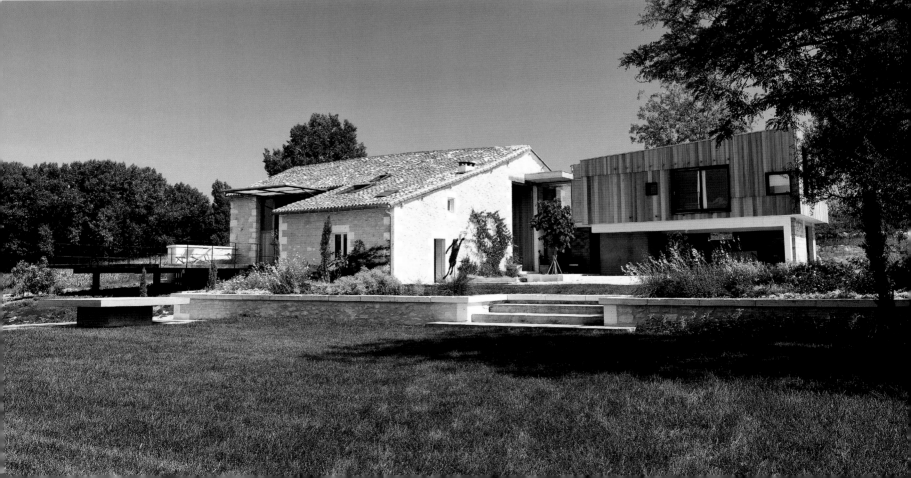

# Colonial Classic
## Massachussetts, USA

AS LUCK WOULD have it, Sandra Wijnberg knew the historic colonial house she found in the Berkshires perfectly matched her criteria for a weekend home from the moment she set eyes on it. Named after its original owner-builder, the three-bedroom center-hall William Ashley House was constructed in 1790 with classic, Georgian proportions and many of its original features, including the handmade nails fixing the exterior clapboard in place, had survived. Furthermore, the previous owners had carried out a ten-year restoration with painstaking care. In the kitchen, all the woodwork and floors had been scraped by hand. And throughout the house, about 100 years of wallpaper had been meticulously peeled off, leaving a lovely distressed quality on original horsehair plaster walls. Sandra and her partner Hugh worked with designer Selina van der Geest to come up with a scheme for the main living room, and gradually furnished the rest of the house with their own collections of antique furniture and art.

ALS SANDRA WIJNBERG das historische Haus im Kolonialstil in den Berkshires sah, wusste sie sofort, dass sie das perfekte Wochenendhaus gefunden hatte. Das nach seinem ursprünglichen Besitzer benannte William Ashley House mit drei Schlaf-zimmern und für den Kolonialstil typischem Mittelflur wurde 1790 in den klassischen georgianischen Proportionen erbaut. Viele Originalelemente, darunter die handgefer-tigten Nägel, die die Außenverkleidung befestigen, blieben erhalten. Zudem hatten die vorherigen Besitzer das Gebäude zehn Jahre lang sehr sorgfältig restauriert. So schliffen sie zum Beispiel in der Küche alle Böden und Holzbalken per Hand ab, und im ganzen Haus wurde, nachdem man mühsam Tapetenschichten aus den letzten 100 Jahren abgezogen hatte, ein wunderbar rauer Rosshaarputz freigelegt. Sandra und ihr Lebensgefährte Hugh beauftragten Innenarchitektin Selina van der Geest, ein Konzept für das Hauptwohnzimmer zu erstellen, und statteten den Rest des Hauses anschließend nach und nach mit ihrer eigenen Sammlung antiker Möbel und Kunst aus.

LE HASARD A voulu que Sandra Wijnberg sache au premier regard que la demeure de style colonial découverte dans les Berkshires ferait une maison de campagne idéale. Dotée d'un grand hall central et de trois chambres, William Ashley House porte le nom de son premier propriétaire et bâtisseur. Construite en 1790 dans les proportions du style géorgien, elle avait conservé maints éléments d'origine, comme les clous fabriqués à la main fixant le bardage. Les anciens propriétaires l'avaient minutieusement restaurée durant dix ans. Dans la cuisine, boiseries et planchers avaient été décapés à la main. Partout, les papiers peints d'un siècle d'occupation avaient été méticuleu-sement décollés, dévoilant le fini délicieusement vieilli du torchis à base de crin de cheval des murs d'origine. Avec l'architecte d'intérieur Selina van der Geest, Sandra et son compagnon Hugh ont élaboré un plan d'aménagement pour la salle de séjour prin-cipale et peu à peu décoré le reste de la maison de meubles et d'objets d'art anciens de leurs collections.

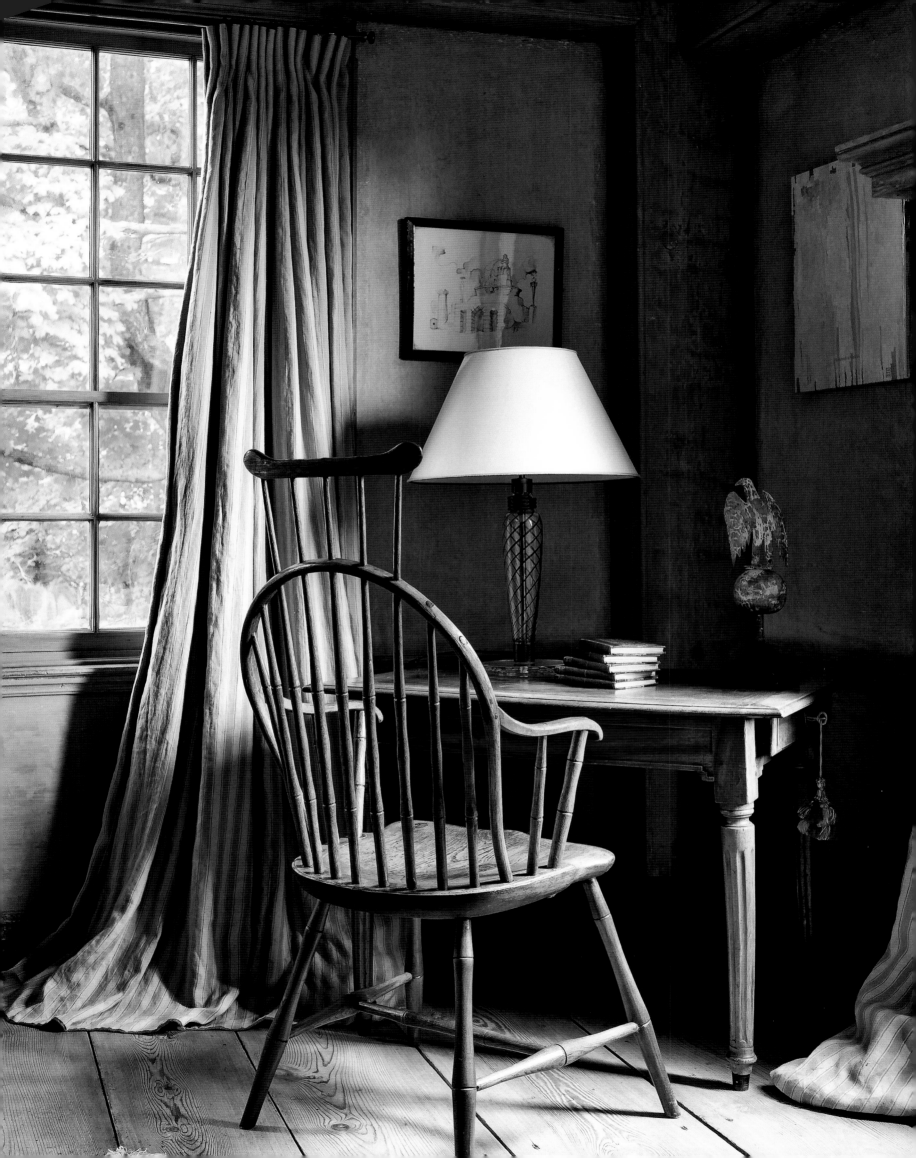

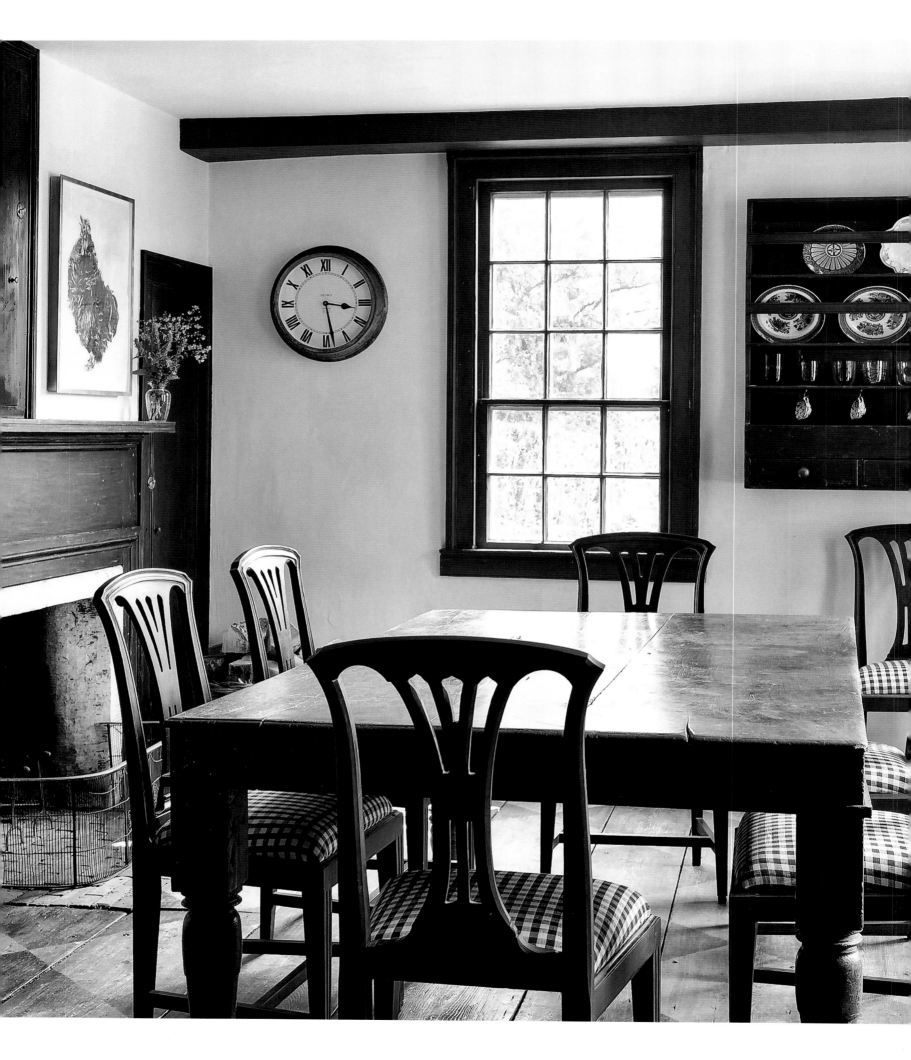

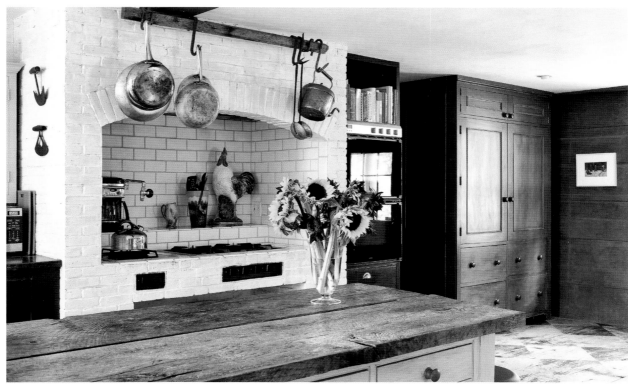

At the rear, the kitchen, which stretches the full width of the house, was probably two smaller rooms.
It still has its original door leading to the cellar.

Die Küchenfläche, die sich über die gesamte Hausbreite erstreckt, war vermutlich ursprünglich
in zwei kleinere Räume aufgeteilt gewesen. Die Originaltür zum Keller existiert noch.

À l'arrière, la cuisine qui s'étend sur toute la largeur de la maison, probablement la réunion de deux petites pièces,
possède toujours la porte d'origine conduisant à la cave.

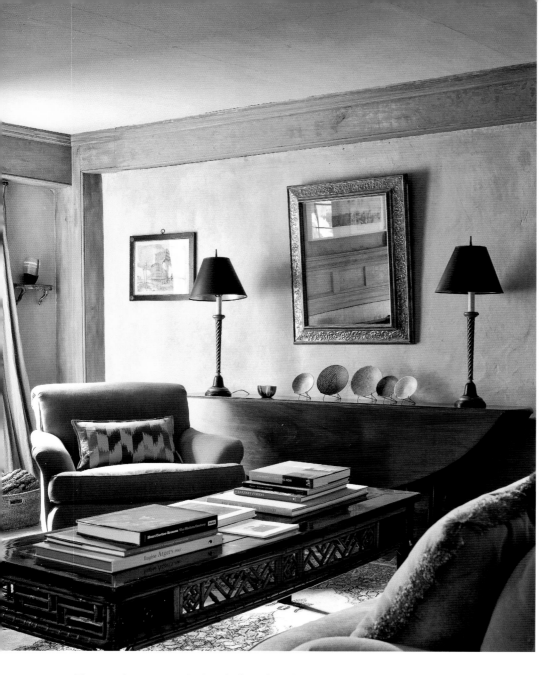
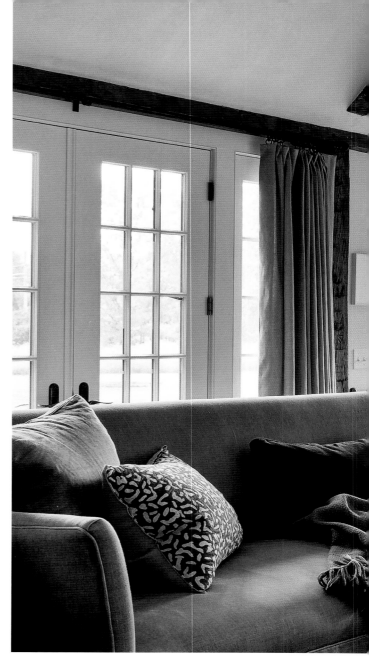

The couple converted a band of carriage barns into what has become the largest living space in the house with views clear to the Berkshire Mountains.

*Das Paar funktionierte die Kutschenremise zum größten Wohnbereich im ganzen Haus um. Von hier aus hat man einen wunderbaren Ausblick auf die Berkshire Mountains.*

*Le couple a transformé un ensemble de remises à calèches pour en faire le plus grand espace de vie de la maison, avec une vue dégagée sur les monts du Berkshire.*

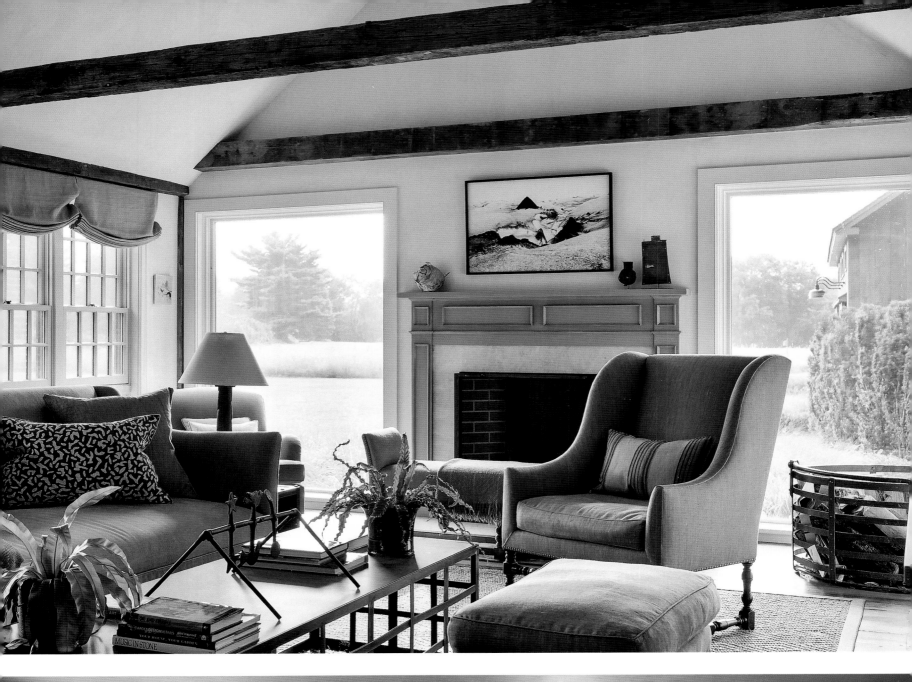
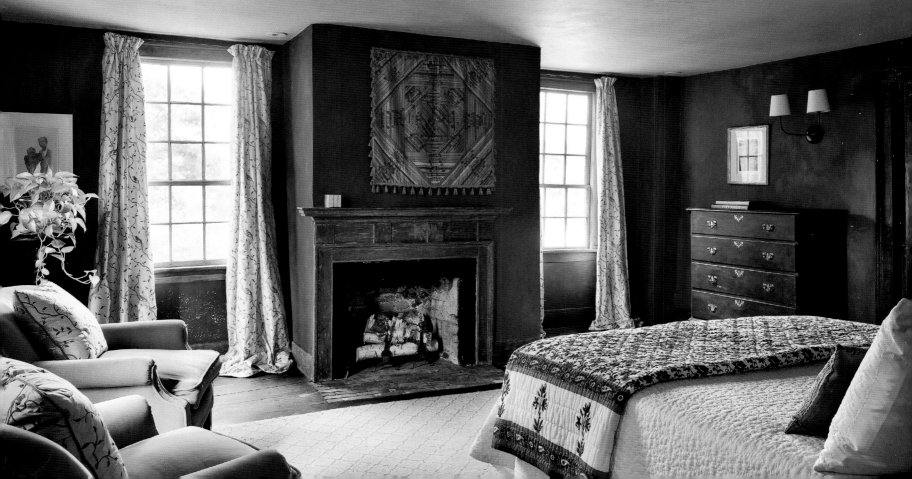

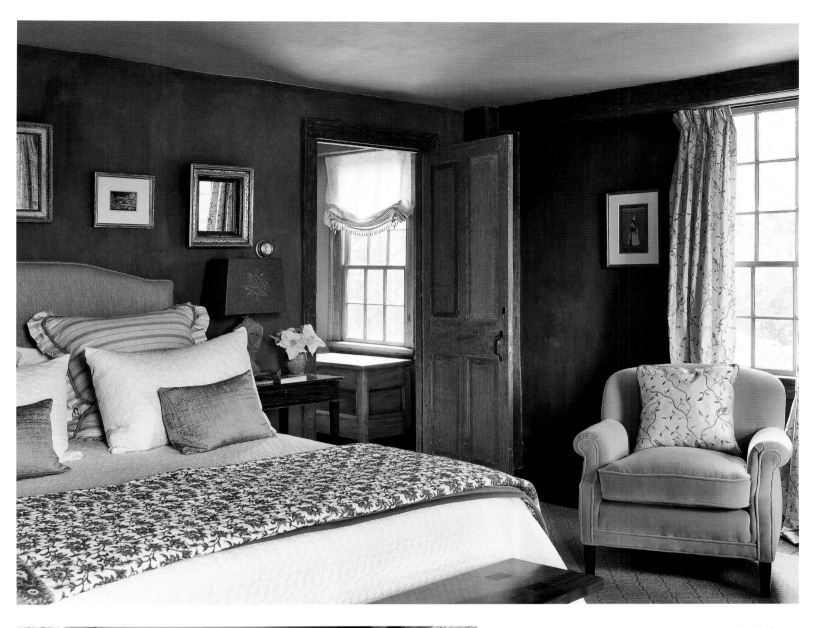

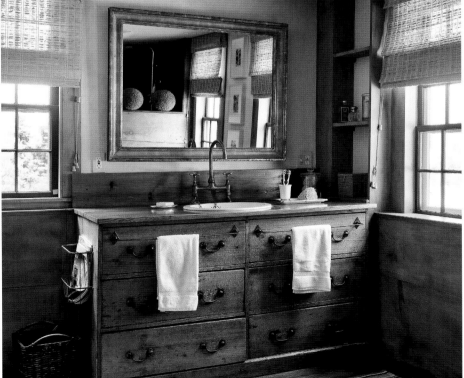

The palette throughout, including the three and a half bathrooms, consists of soft brick, pinky-red, and gray-blue hues.

*Die alle Räume, inklusive der dreieinhalb Badezimmer, bestimmenden Farbtöne sind ein weiches Ziegelrot, ein ins Pinkfarbene gehendes Rot und Graublau.*

*La palette de couleurs de la maison, jusque dans les trois salles de bains, se compose de teintes brique doux, rouge rosé et gris-bleu.*

# Graceful Fusion
## Goa, India

IN KEEPING WITH most dwellings in the Indian coastal town of Goa, this circa 1900 house on a nearby island embodies what its owners call a "culture confrontation." In Goa, the traditional structures meld European and Indian characteristics. Originally, the house was owned by a family of Christian doctors, but for more than thirty years— except for the local farmers, who used it occasionally for crop storage, and the water buffalo that roamed its grounds—it was rarely occupied. When it was discovered by its current owners—they instantly fell in love. To make it livable again, they undertook a three-year renovation, restoring the structure, then modernizing parts of the house to create three bedrooms and bathrooms and a new kitchen, while retaining its original charm. They also hired painters, who mixed paints on site using boiled shells and special pigments, to highlight interior walls with authentic ochre and dusty sherbet hues that underscore the cultural fusion of the home.

WIE DIE MEISTEN Anwesen der indischen Küstenstadt Goa verkörpert auch dieses, auf einer nahe gelegenen Insel stehende und um 1900 erbaute Haus das, was seine Besitzer als „Kulturclash" bezeichnen. In Goa vereint die traditionelle Bauweise sowohl europäische als auch indische Merkmale. Ursprünglich war das Haus im Besitz einer christlichen Ärztefamilie, stand dann aber 30 Jahre weitgehend leer. Es wurde nur hin und wieder von den Bauern der Region als Getreidelager benutzt oder von Wasserbüffeln durchstreift. Als die derzeitigen Besitzer das Haus entdeckten, waren sie ihm sofort verfallen. Um es wieder bewohnbar zu machen, waren drei Jahre dauernde Restaurie-rungsarbeiten notwendig: Drei Schlaf- und Badezimmer sowie eine Küche entstanden völlig neu, ohne dass der ursprüngliche Charme verloren ging. Maler mischten vor Ort Farben mit Muscheln und Spezialpigmenten an, um die Innenwände in authen-tischen Ocker- und Altrosatönen zu streichen, die die kulturelle Fusion noch betonen.

COMME LA PLUPART des habitations de la ville côtière de Goa, cette maison bâtie vers 1900 sur une île voisine incarne pour ses propriétaires la « confrontation des cultures ». Dans les maisons traditionnelles de Goa, les caractéristiques européennes et indiennes fusionnent. Propriété d'une famille de médecins chrétiens, cette maison a rarement été occupée depuis plus de trente ans, si ce n'est par les fermiers locaux l'utilisant parfois pour stocker les récoltes ou par des buffles d'eau en maraude. Lorsque ses actuels propriétaires l'ont découverte, ils sont tombés sous le charme. Pour la rendre habitable, ils l'ont rénovée durant trois ans, restaurant la structure et modernisant certaines parties pour en faire trois chambres et salles de bains ainsi qu'une nouvelle cuisine, tout en gardant le charme original. Ils ont engagé des peintres qui ont mélangé des peintures sur place utilisant des coquilles d'œuf et des pigments spéciaux pour mettre en valeur les cloisons par des nuances d'ocre véritable et des teintes acidulées et un peu passées soulignant la fusion des cultures dans la maison.

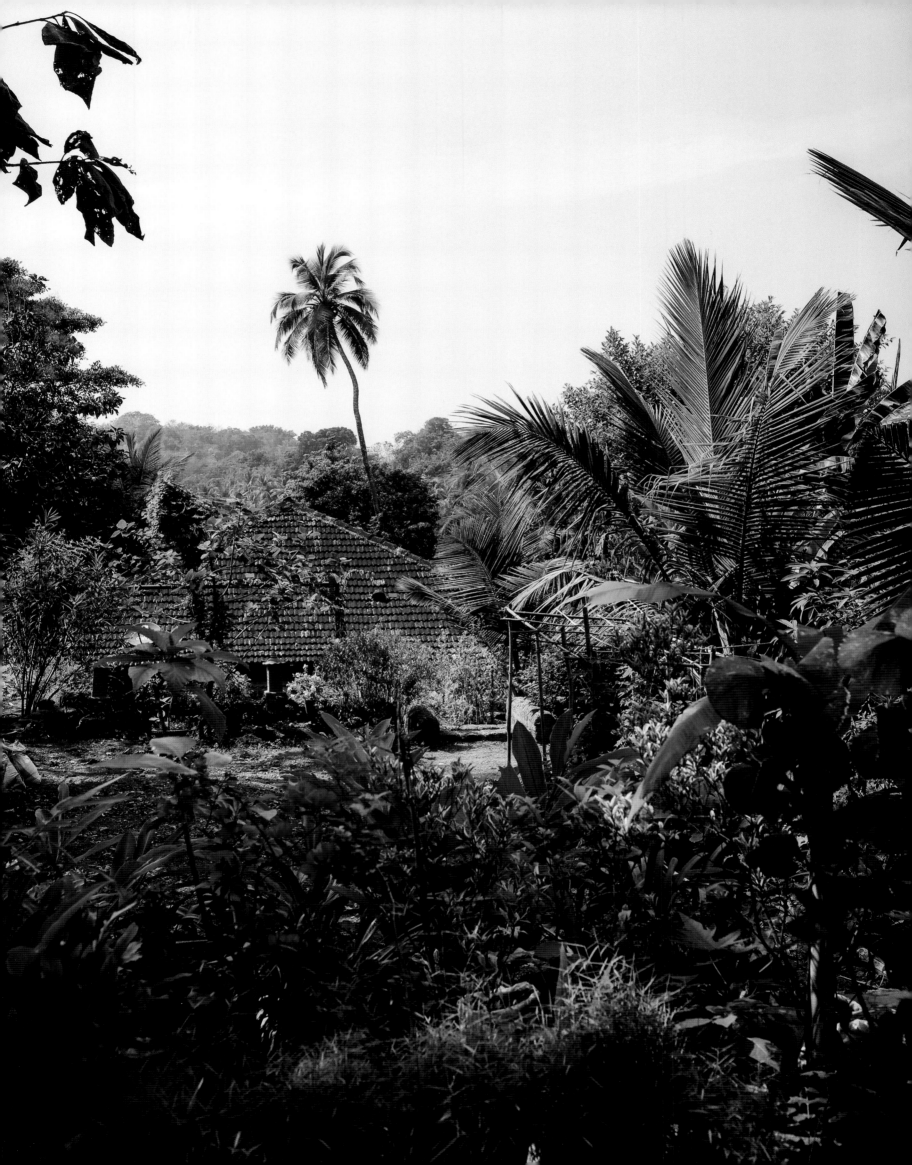

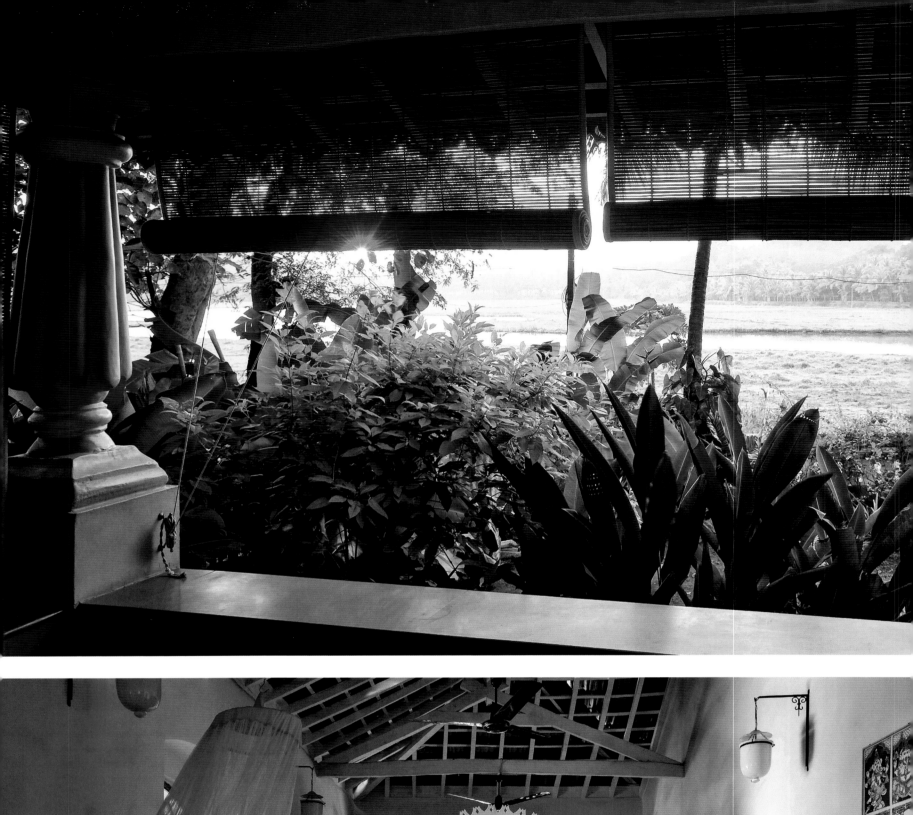
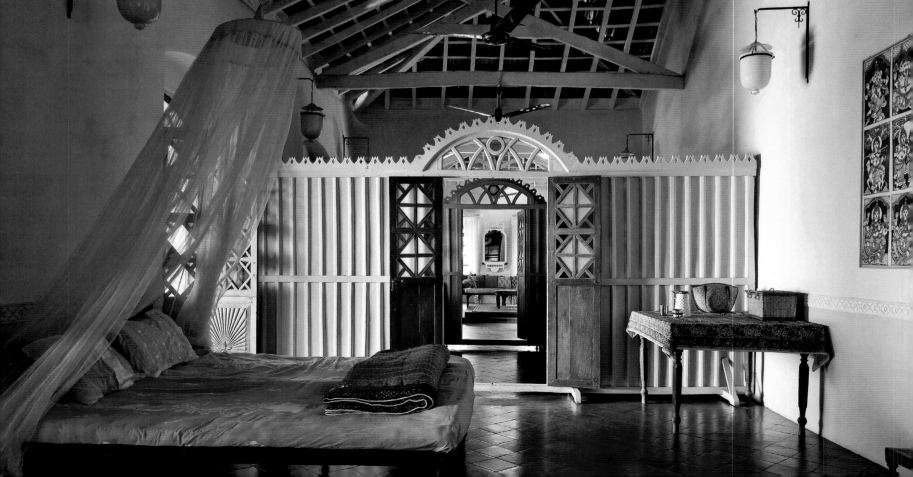

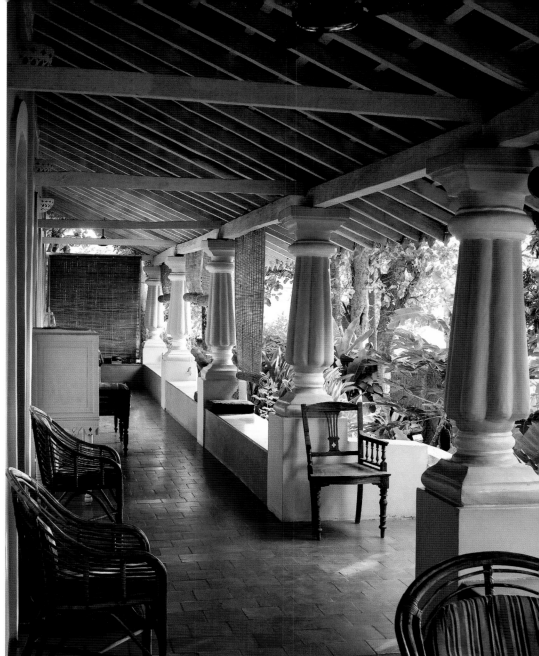

*Much of daily life occurs on the broad veranda, which is defined with massive columns and overlooks rice paddy fields, a tiny church, water birds, and buffalo. A local carpenter made the beds from old teak roof beams. Local materials were used wherever possible.*

*Ein Großteil des Lebens spielt sich auf der von massiven Säulen begrenzten breiten Veranda ab, von der man auf Reisfelder, eine winzige Kirche, Wasservögel und Wasserbüffel blickt. Ein Schreiner aus der Region hat die Betten aus alten Teakholz-Dachbalken hergestellt. Insgesamt wurde so viel wie möglich mit regionalen Materialien gearbeitet.*

*Le quotidien se déroule surtout sur la grande véranda. Flanquée de massives colonnes, elle surplombe la petite église et la rizière avec ses oiseaux aquatiques et ses buffles. Un charpentier local a réalisé les lits avec de vieilles poutres en teck. On a autant que possible privilégié les matériaux locaux.*

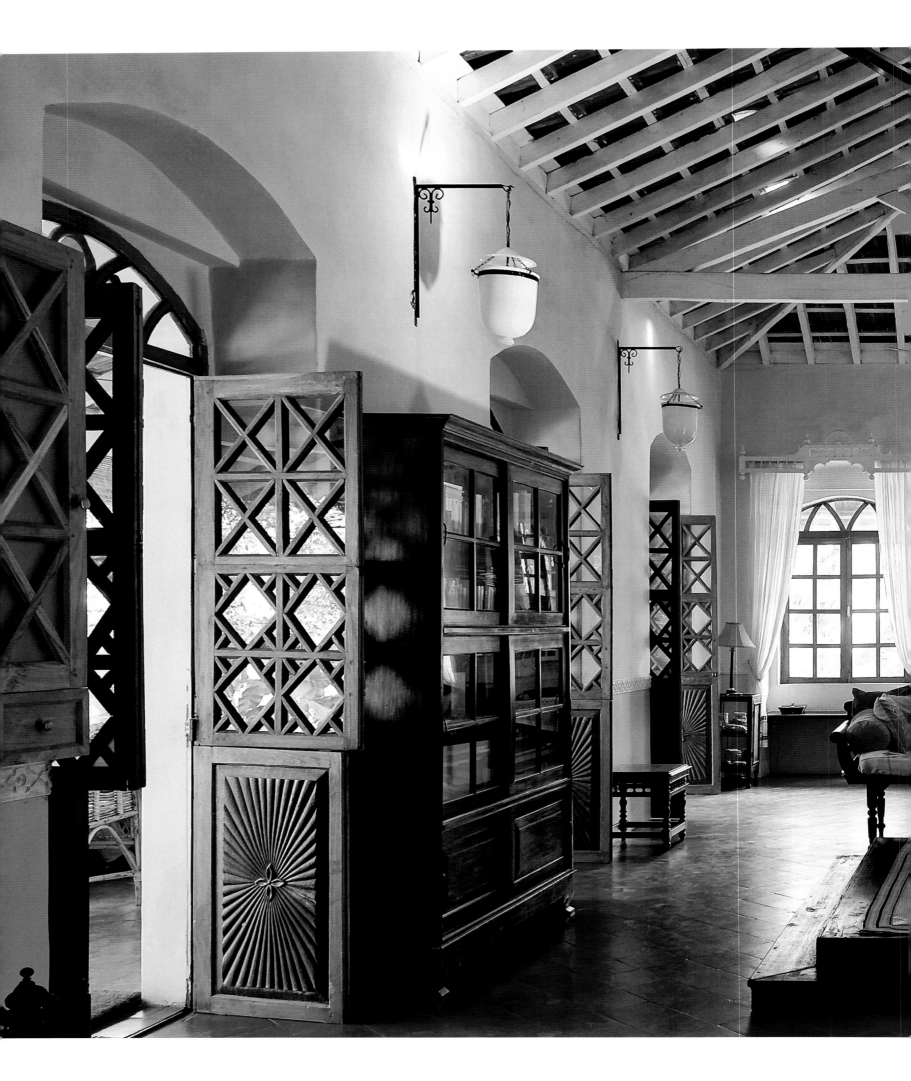

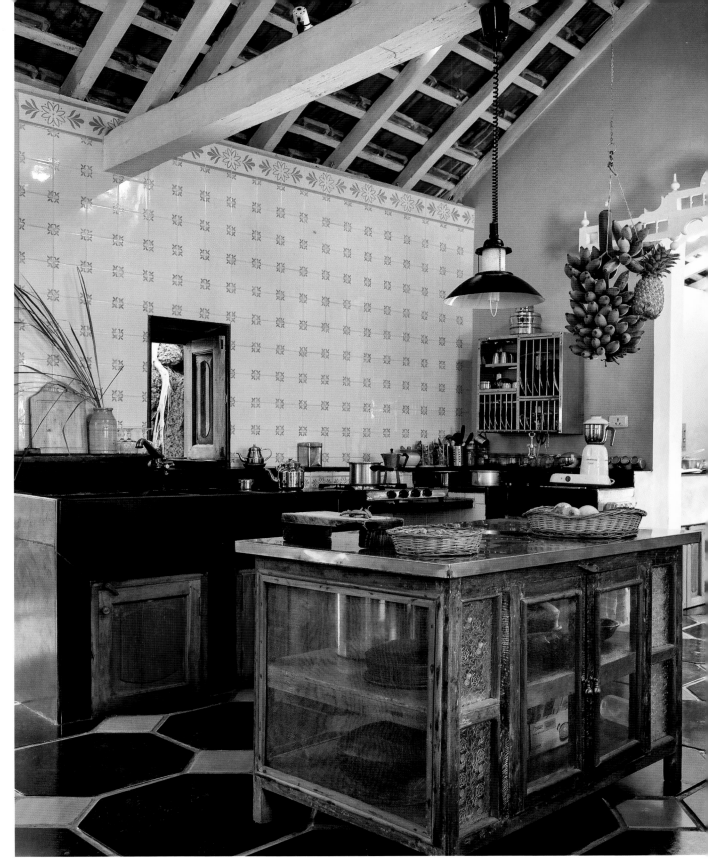

Several sets of wood-and-glass doors open onto the living areas and bedrooms.

*Mehrere Türen aus Holz und Glas führen zu den Wohn- und Schlafbereichen.*

*Plusieurs portes en bois et verre donnent sur les pièces principales et les chambres.*

The previous owners left behind some interesting furniture, including traditional wooden pelmets
and the timber screens, which continue to divide the space inside the front entrance.

Die vorherigen Besitzer ließen einige interessante Möbel zurück, darunter traditionelle Holzschabracken
und Trennwände aus Holz, die den Raum im Eingangsbereich unterteilen.

Les anciens propriétaires ont laissé des meubles intéressants, notamment des cantonnières en bois traditionnelles
et des cloisons en bois ajourées, qui continuent de diviser l'espace situé derrière l'entrée principale.

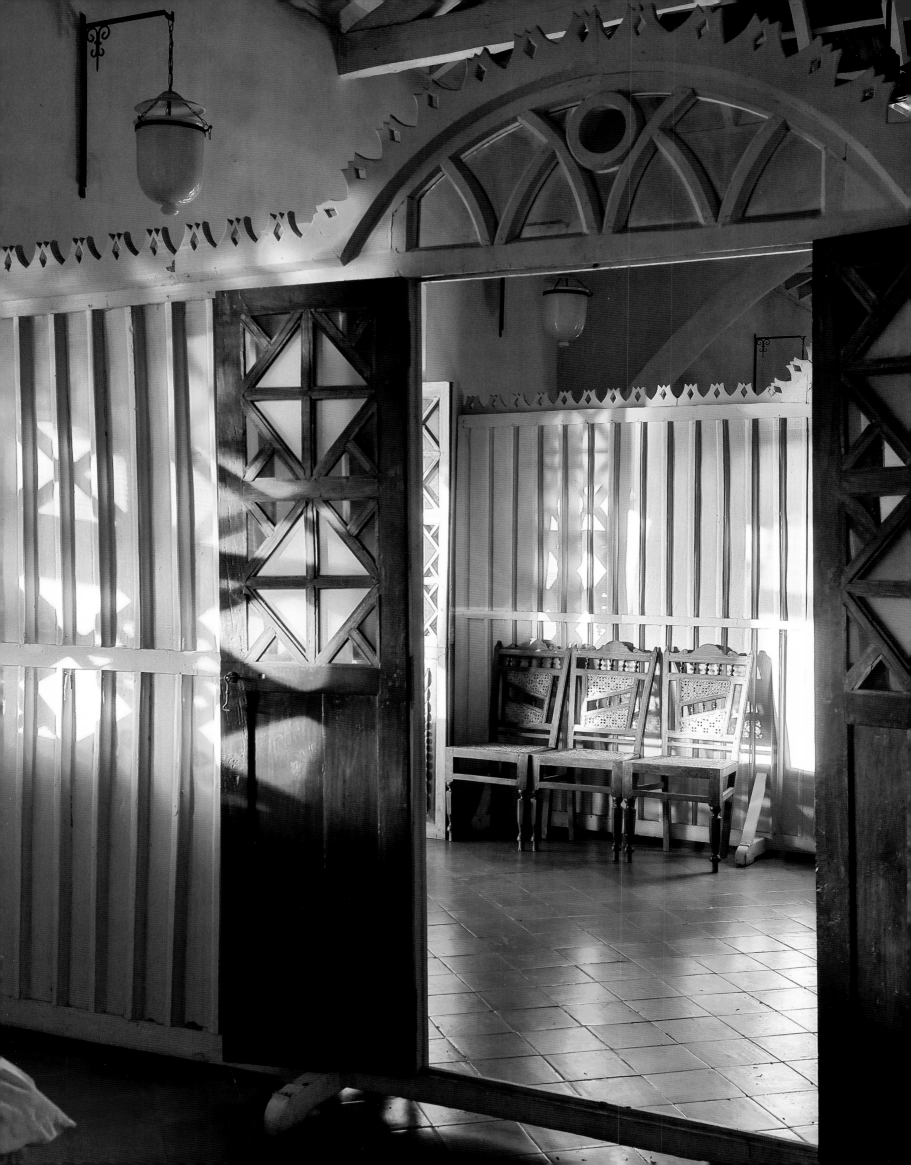

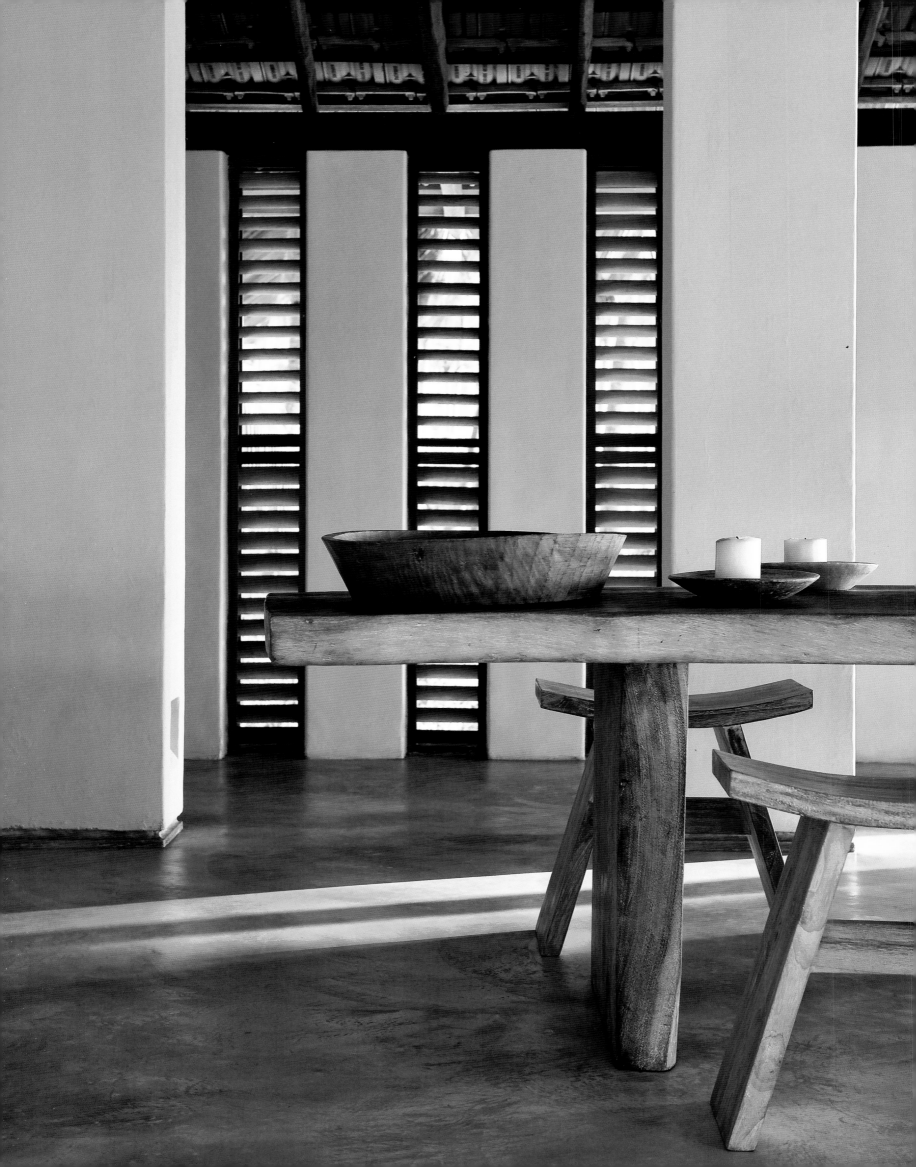

# Perfect Escape
## Goa, India

EVEN IF THEY weren't seeking nirvana when they built their dreamy beach house, Claudia and Hari Ajwani invariably find it there whenever they visit. Owners of the renowned Nilaya Hermitage Hotel, Tiracol Fort, and Sangolda, Goa's premier home furnishings shop, the couple wanted a quiet retreat nearby as a counterpoint to their busy lives. After finding the perfect beachfront property, they worked with their skilled team of craftsmen to create a simple, L-shaped house that sits on a concrete platform right on the sand. Designed to reflect local vernacular building styles and embrace the sound of the sea and the wind, its structure consists of old wooden pillars and carved stone bases that Claudia found while traveling around India. By limiting materials to concrete, wood, and white plastered walls, and screening the openings with hand-made teak shutters with pivoting slats and iron handles, the couple has crafted a refined yet earthy summer getaway with an intimate connection to the outdoors.

CLAUDIA UND HARI Ajwani suchten zwar nicht das Paradies auf Erden, als sie ihr traumhaftes Strandhaus bauten, sie finden es aber immer wenn sie das Haus bewohnen. Die Besitzer des renommierten Nilaya Hermitage Hotel, des Tiracol Fort Resort, sowie des führenden Einrichtungsgeschäfts Sangolda in Goa, suchten dringend einen ruhigen Rückzugsort als Ausgleich zu ihrem hektischen Alltag. Nachdem sie das perfekte Strandgrundstück gefunden hatten, errichteten sie mithilfe eines Teams fähiger Handwerker ein schlichtes L-förmiges Haus auf einer Betonplattform direkt auf dem Sand. Das Gebäude wird von alten Holzsäulen und gravierten Steinsockeln getragen, die Claudia auf ihren Reisen durch Indien fand. Ein luftiges Design entstand, das die einheimische Bauweise widerspiegelt und das Geräusch von Meer und Wind einfängt. Bei der Ausgestaltung der Innenräume beschränkte man sich auf Beton, Holz und weiß verputzte Wände. In Kombination mit handgefertigten Teakholzjalousien mit aufklappbaren Lamellen und Eisengriffen ist so eine elegante, aber gleichzeitig bodenständige Sommerresidenz entstanden, die mit der sie umgebenden Natur korrespondiert.

SI CLAUDIA ET Hari Ajwani ne cherchaient pas le paradis en édifiant leur magnifique maison de plage, à chaque fois ils le trouvent à leur arrivée. Propriétaires du célèbre hôtel Nilaya Hermitage, du fort Tiracol et de la maison Sangolda, meilleur magasin d'accessoires d'ameublement de Goa, ils cherchaient une retraite paisible à proximité pour récupérer de leur vie trépidante. Ayant trouvé le terrain idéal sur le front de mer, ils ont créé avec leur équipe d'artisans spécialisés une maison simple en L posée sur une plate-forme de béton, à même le sable. Conçue pour refléter les styles d'architecture vernaculaire et intégrer le bruit de la mer et du vent, elle s'articule autour de vieux piliers de bois à socles de pierre sculptés dénichés par Claudia durant ses voyages en Inde. En se limitant dans les matériaux au béton, au bois et au plâtre blanc des murs, en protégeant les ouvertures par des volets de teck faits main à lames pivotantes et poignées en fer, le couple a conçu un refuge d'été raffiné et naturel en relation étroite avec l'extérieur.

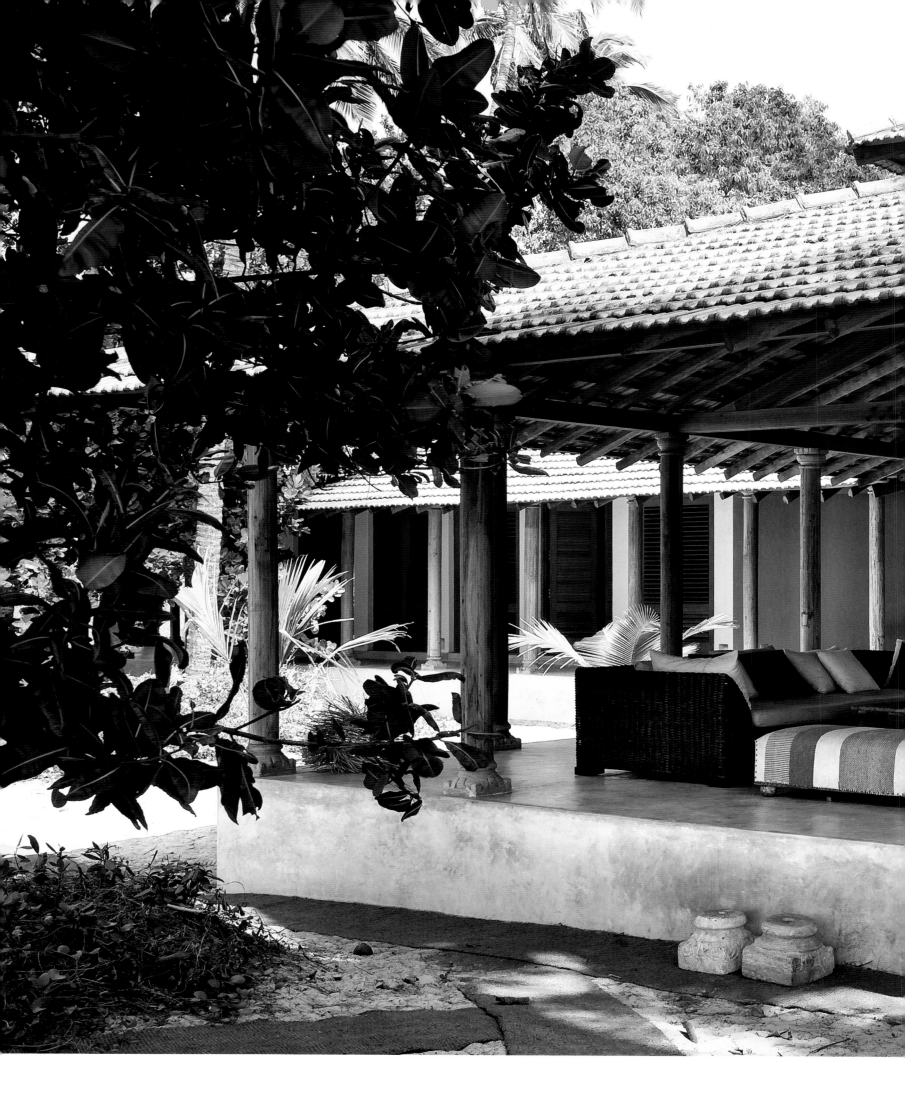

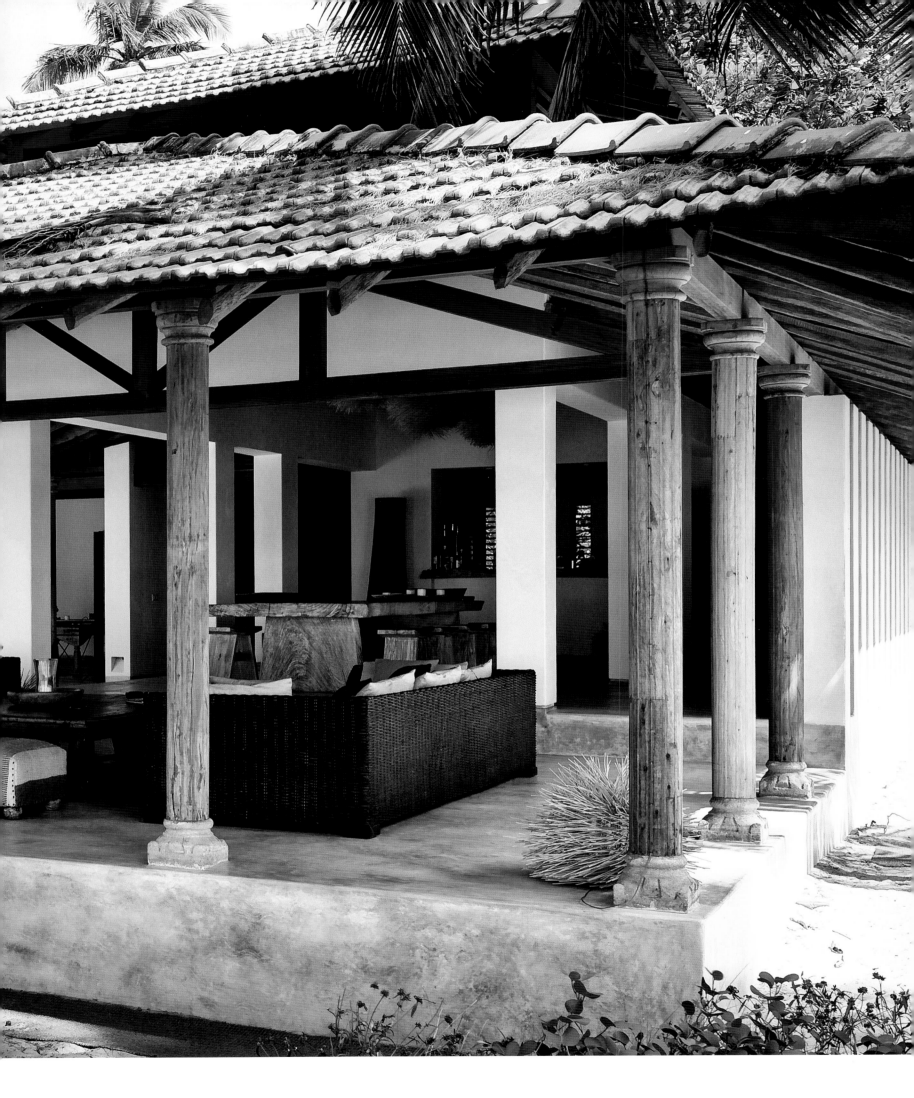

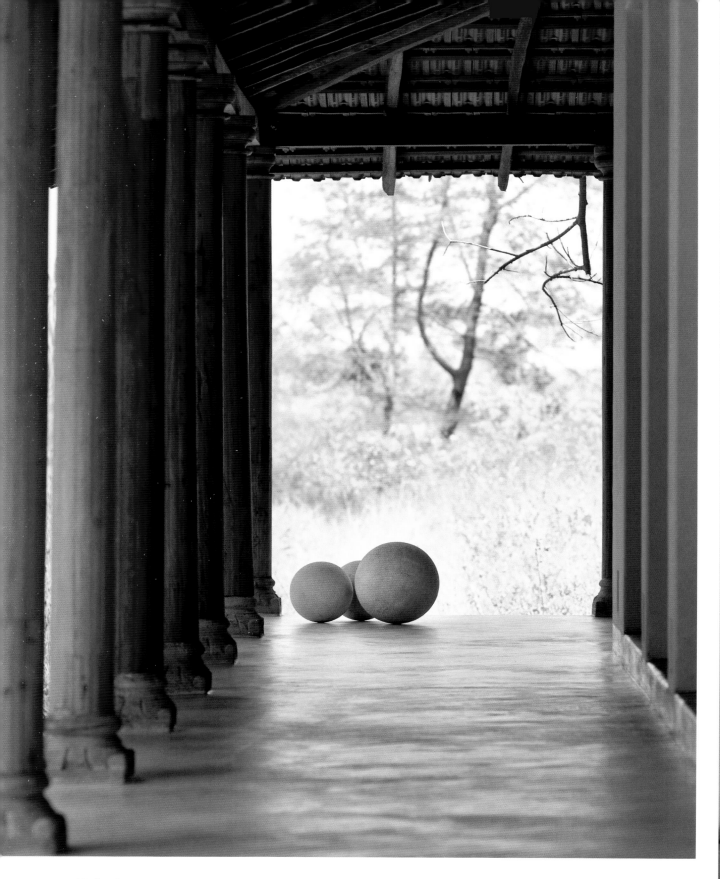
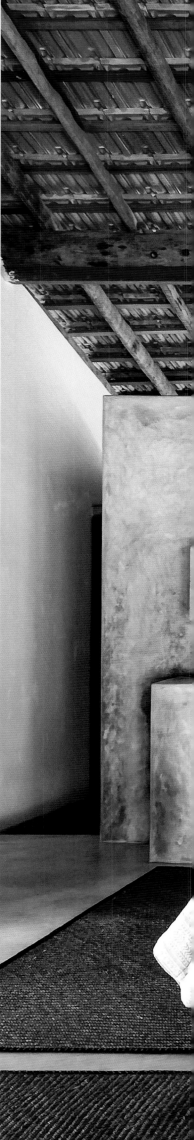

Made of typical Mangalore tiles, the roof is supported by traditional-style beams. In the master bedroom, the locally made teak platform bed sits against a false low wall shielding the bathroom.

Das Dach besteht aus typischen Mangalore-Ziegeln und wird von traditionellem Gebälk gestützt. Im Hauptschlafzimmer steht das lokal hergestellte Plattformbett aus Teakholz an einer niedrigen Zierwand, die das Badezimmer verdeckt.

Le toit en tuiles typiques de Mangalore repose sur des poutres de style traditionnel. Dans la chambre de maître, le lit plate-forme en teck de fabrication locale est adossé à un mur bas factice abritant la salle de bains.

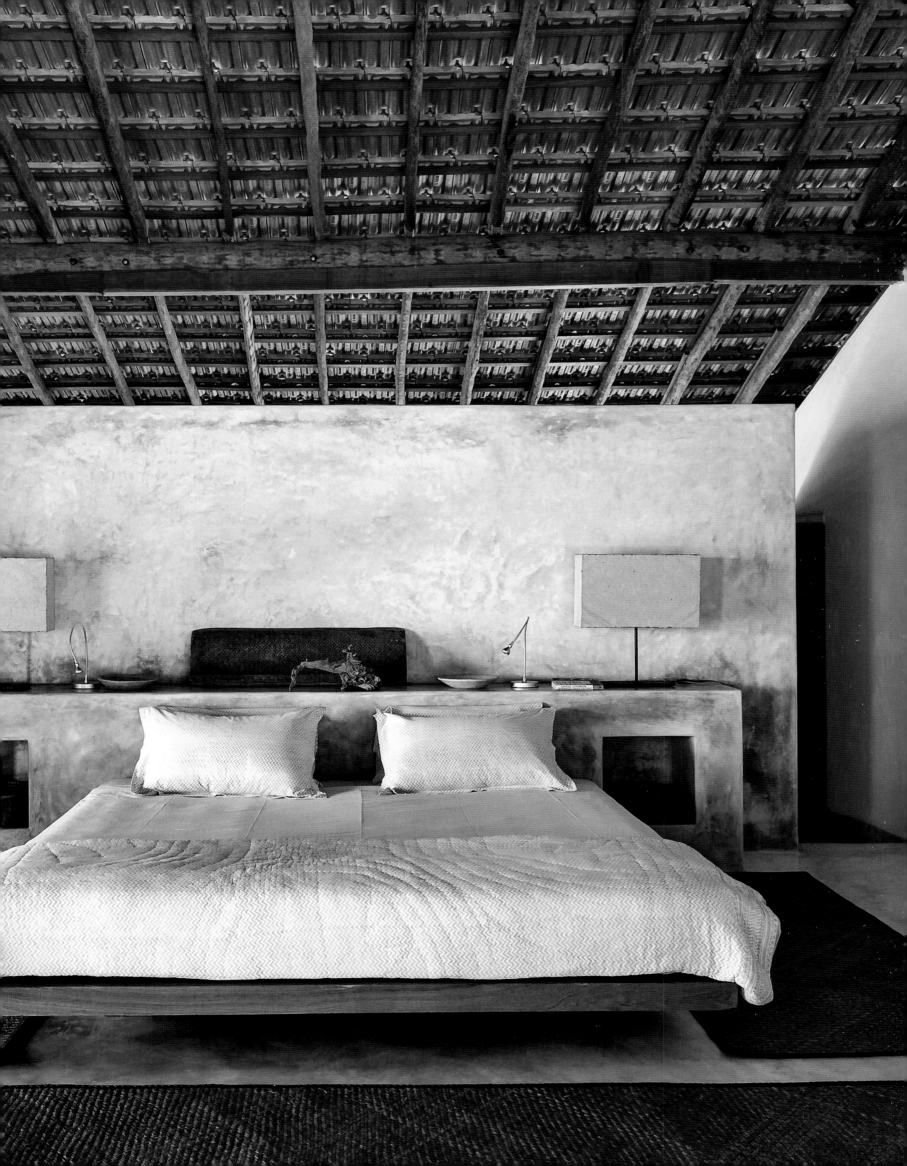

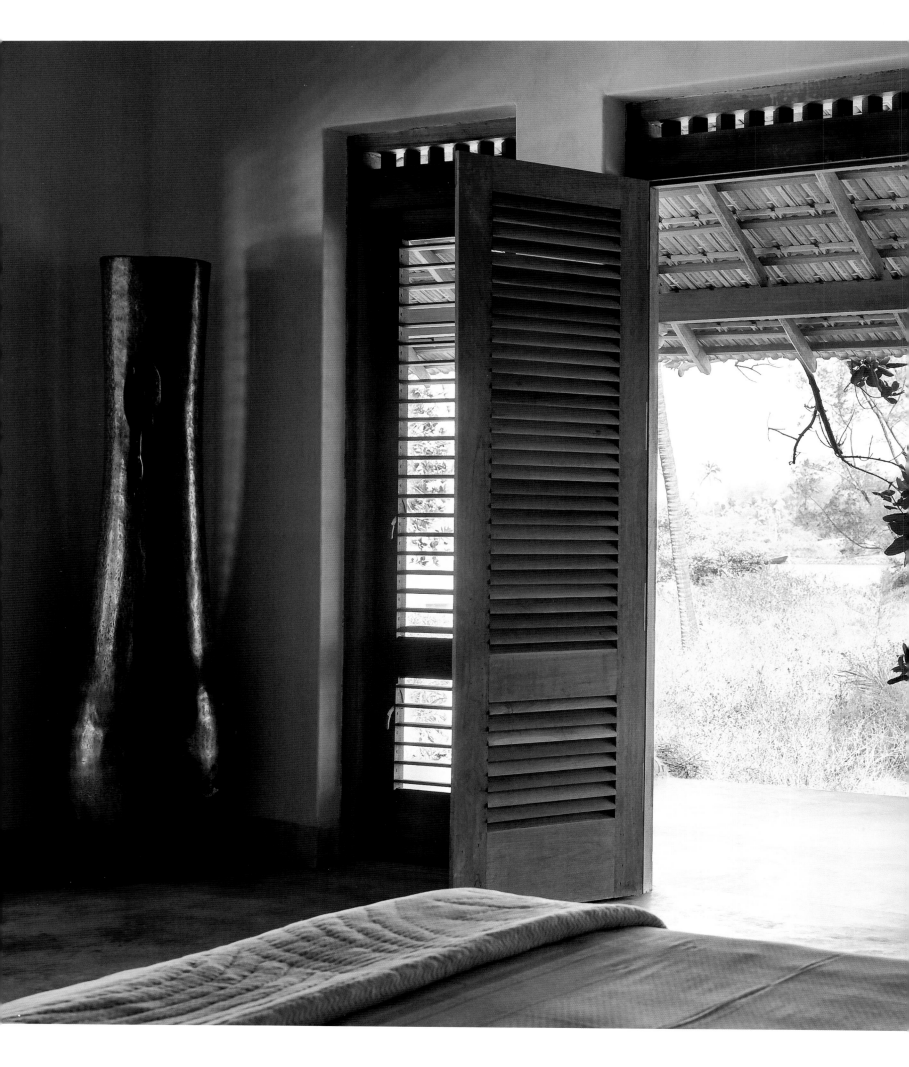

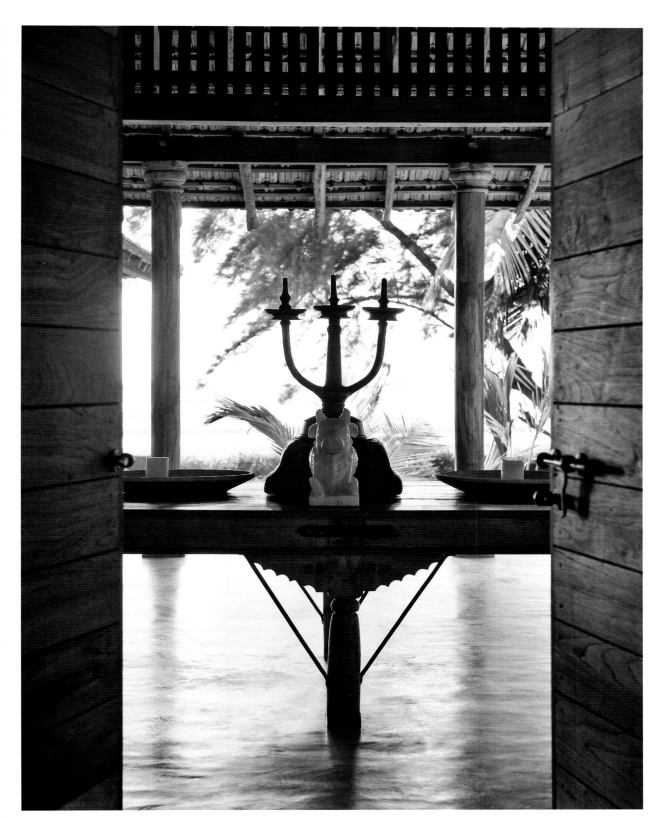

*A set of shutter doors lead to the veranda and another opens onto the front with views of the sea. Polished palm trunks stand in the corners of the room, adding a vertical accent.*

*Lamellentüren führen auf die Veranda und eröffnen den Blick aufs Meer. Die polierten Palmenstämme in den Zimmerecken setzen vertikale Akzente.*

*Une série de portes à claires-voies conduit à la véranda, une autre ouvre sur la mer. Les troncs de palmier polis dressés aux coins de la pièce ajoutent une touche de verticalité.*

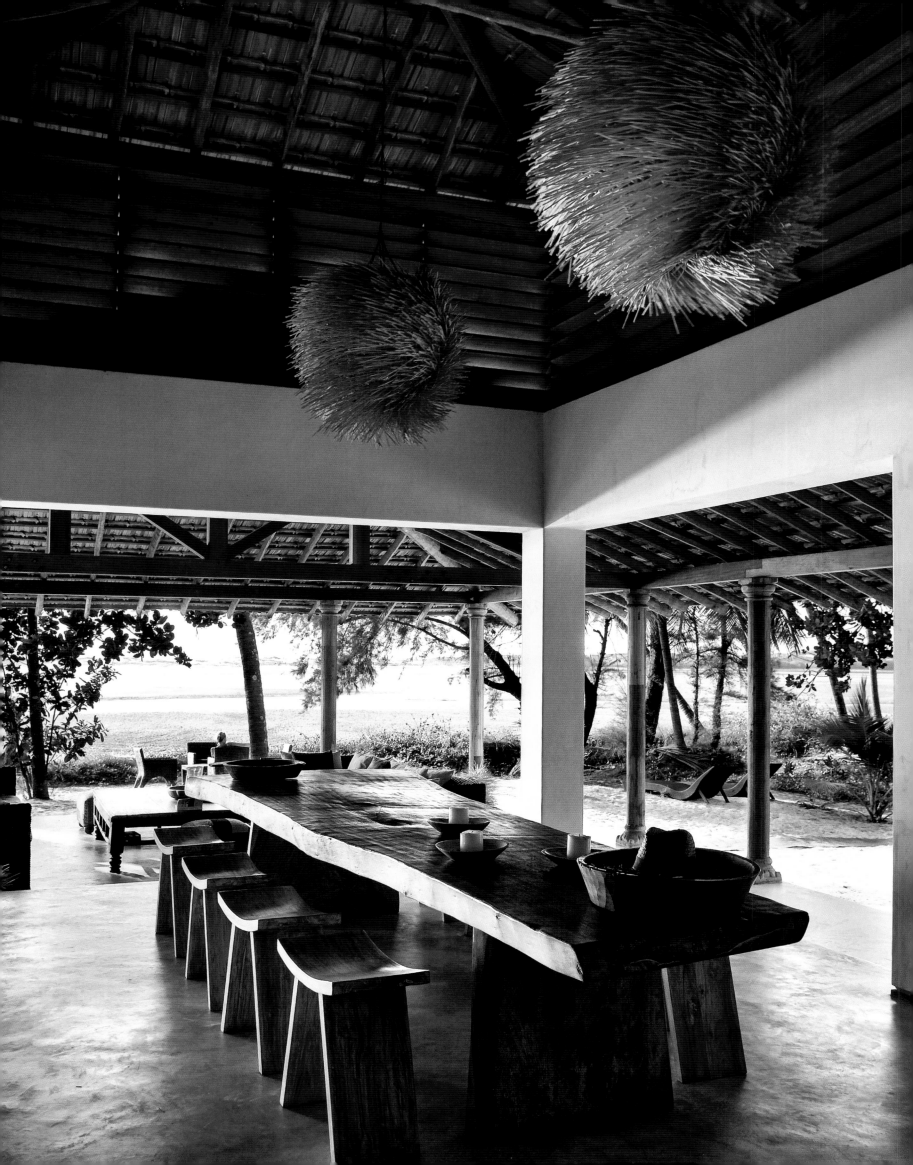

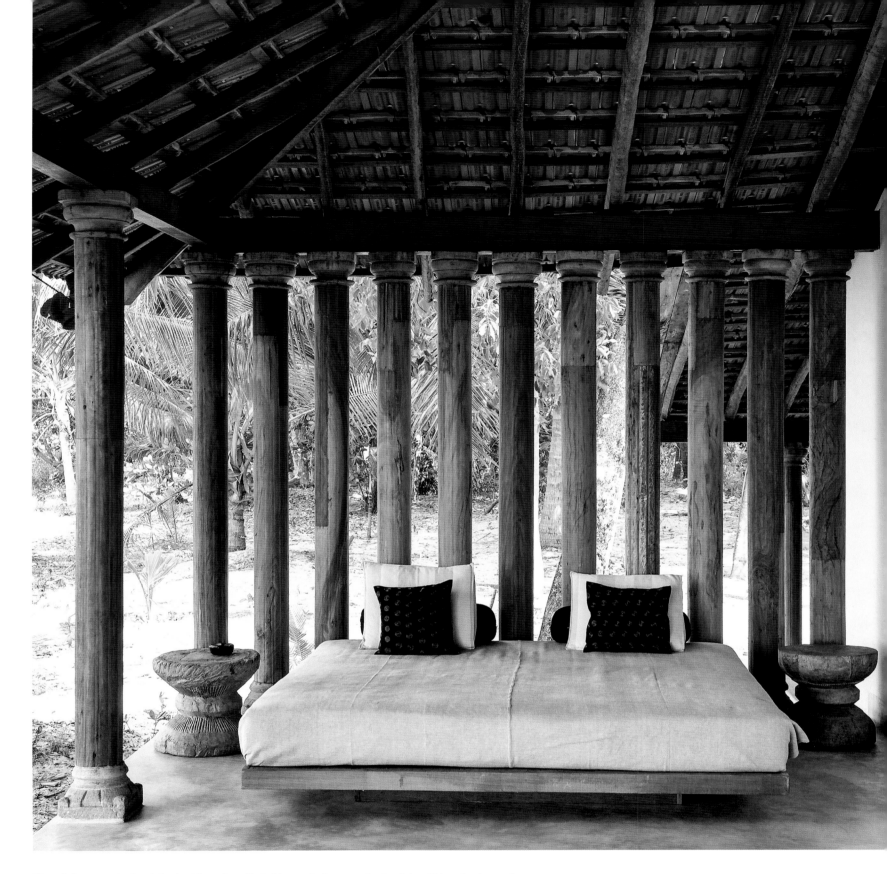

The dining area is furnished with a gigantic table made from a single slab of bleached wood.
Stools rather than chairs keep the space uncluttered and less formal.

Den Essbereich dominiert ein gewaltiger Tisch, der aus einem einzigen Stück gebleichten Holzes besteht.
Anstelle von Stühlen entschied man sich für Hocker, die luftiger und informeller wirken.

Dans le coin-repas trône une énorme table constituée d'une planche de bois blanchi.
Mieux que des chaises, les tabourets rendent l'espace sobre et moins formel.

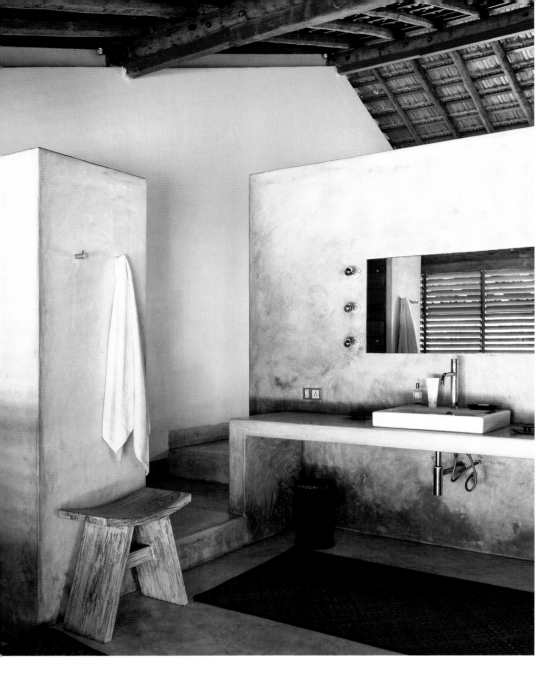
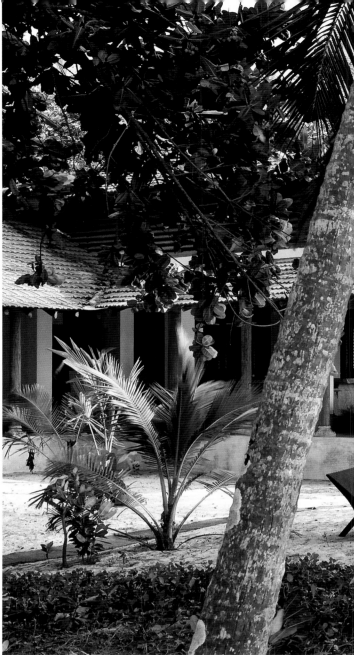

A pair of porcelain basins are set into a concrete vanity surface in the bathroom.
The house was designed for use during the dry season from November to March—
when the monsoon rains come, the property is wrapped up in coconut matting.

Im Badezimmer wurden zwei Porzellanbecken in einen Waschtisch aus Beton eingelassen.
Das Haus ist dafür konstruiert, in der trockenen Periode von November bis März bewohnt
zu werden. Wenn die Monsunregen einsetzen, wird alles in Kokosnussmatten eingepackt.

Dans la salle de bains, des lavabos en porcelaine sont encastrés dans la table de
toilette en béton. La maison a été conçue pour être habitée à la saison sèche,
de novembre à mars – lorsqu'arrivent les pluies de la mousson, la propriété est
enveloppée de nattes en fibres de coco.

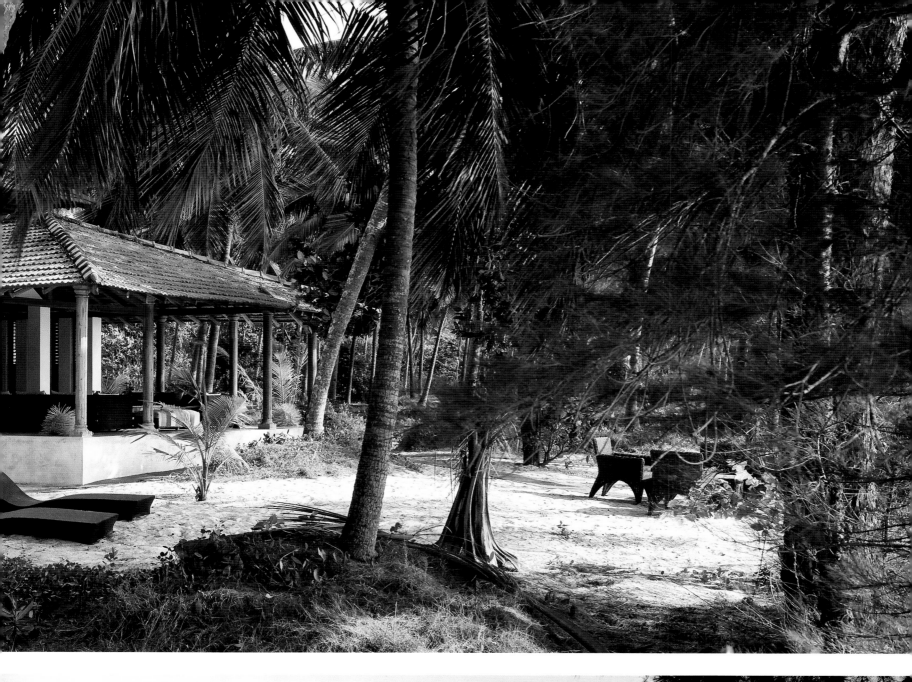
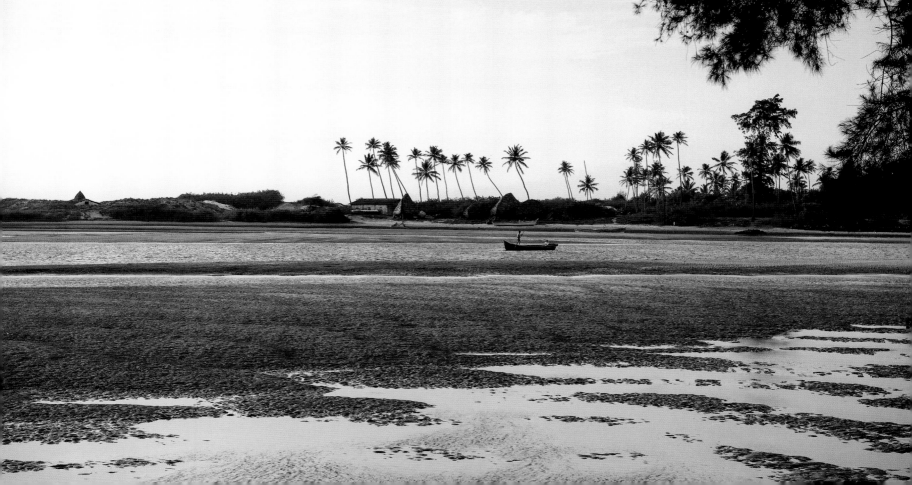

# New Life
## Umbria, Italy

IT'S NOT EVERY day that a reserved, established couple makes a bold move from a traditional townhouse to an industrial-style agricultural building. But with the help of Paola Navone, one of Italy's best-known architects, that's just what Andrea Falkner Campi and her husband, Feliciano, opted to do. The pair had been long searching for a location to move their family publishing company, Editoriale Campi, when they found an abandoned former silkworm and tobacco facility in the Umbria region of Italy. They readily envisioned converting the 31-foot-high structure into archival and office space on the ground level and dramatic loft-like living quarters on the upper level. Navone embraced the challenge to adapt the structure and presented the couple with a dreamy, all-white, open-plan design with living spaces divided mostly by filmy Khadi curtains and revolving around a sculptural fireplace, which floats above the floor and rotates 360 degrees. Earthy materials, such as warm oak floors, custom Moroccan tiles and a massive one-of-a-kind dining table, support the serene atmosphere.

ES KOMMT SICHER nicht alle Tage vor, dass ein gesellschaftlich verwurzeltes Paar sein traditionelles Stadthaus gegen ein Fabrikgebäude im Industrial Style eintauscht. Doch genau dies taten Andrea Falkner Campi und ihr Mann Feliciano mit der Unterstützung von Paola Navone, die eine der bekanntesten Architektinnen Italiens ist. Das Paar suchte schon seit Längerem nach einer neuen Heimat für den familienbetriebenen Verlag Editoriale Campi, als es schließlich in Umbrien auf eine leerstehende ehemalige Tabakfabrik stieß. Spontan konnten beide sich vorstellen, die 9,5 Meter hohe Struktur in zwei Stockwerke zu verwandeln: Im Erdgeschoss sollten Büro- und Archivräume Platz finden im Obergeschoss wurde ein loftartiger Wohnbereich eingerichtet. Navone schuf für die Campis ein magisches, ganz in Weiß gehaltenes offenes Wohnambiente, in dem die einzelnen Bereiche meist nur durch feine indische Khadi-Stoffe abgetrennt sind. Mittelpunkt des Hauses ist eine skulpturale Ofenkonstruktion, die knapp über dem Boden schwebt und sich um 360 Grad drehen kann. Natürliche Materialien wie Eichenholzdielen, speziell angefertigte marokkanische Fliesen und ein massives Esstisch-Unikat unterstützen die gelassene Atmosphäre des Hauses.

IL N'EST PAS fréquent qu'un couple discret et établi se risque à quitter une maison de ville traditionnelle pour un bâtiment agricole. Or, c'est justement le choix qu'ont fait Andrea Falkner Campi et son époux Feliciano, avec l'aide de Paola Navone, l'une des plus célèbres architectes d'Italie. Cherchant depuis longtemps un endroit où transférer l'entreprise d'édition familiale, Editoriale Campi, ils ont trouvé en Ombrie une installation jadis consacrée à la sériciculture et la production de tabac. Ils ont vite pensé transformer cette bâtisse de près de dix mètres de haut en espace d'archivage et de bureau au premier et en espace d'habitation spectaculaire de type loft au second. Navone a relevé le défi consistant à modifier la structure et proposé au couple un ravissant concept « open space » tout blanc avec des espaces de vie généralement délimités par de diaphanes rideaux Khadi et organisés autour d'une cheminée sculpturale, qui flotte au dessus du sol et pivote sur 360 degrés. Des matériaux de la terre, notamment de chaleureux planchers en chêne, des tomettes marocaines sur mesure et une table de salle à manger énorme unique en son genre contribuent à l'atmosphère de sérénité.

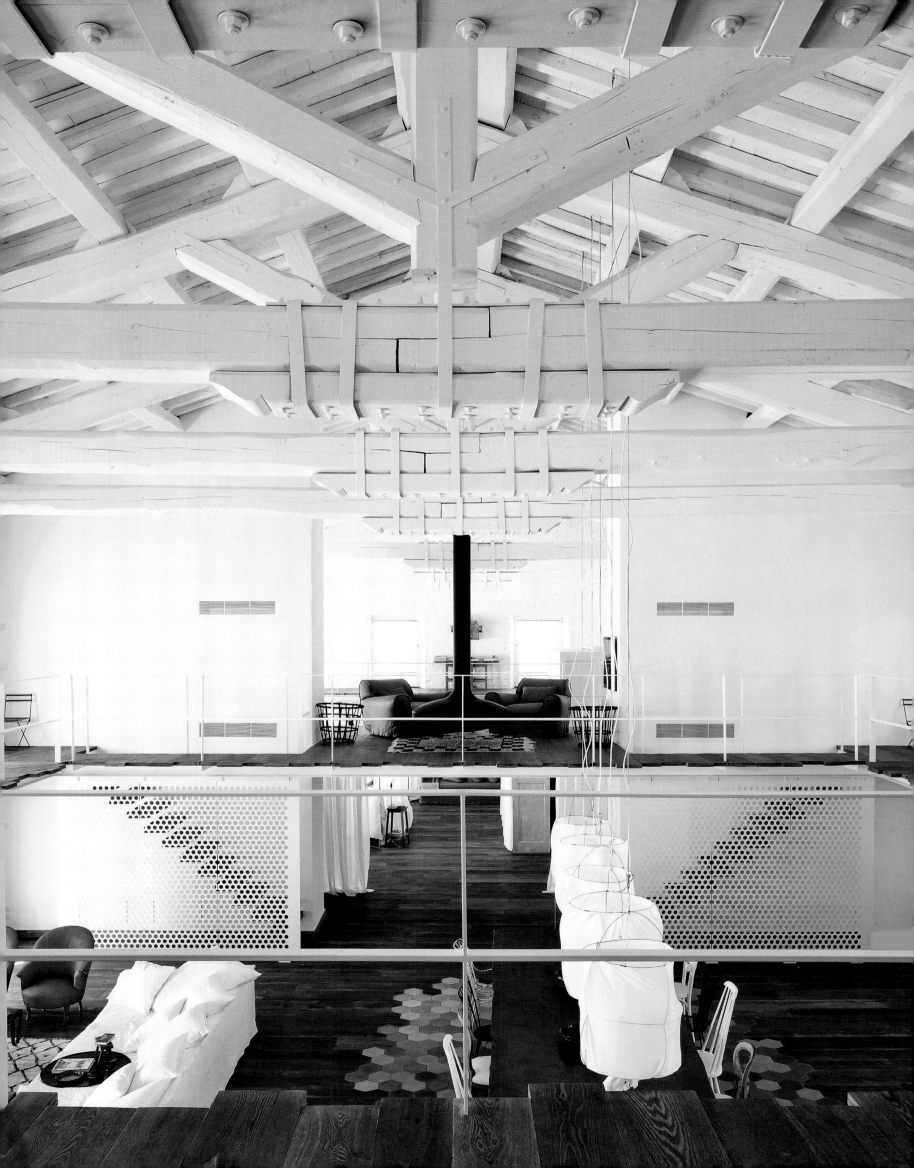

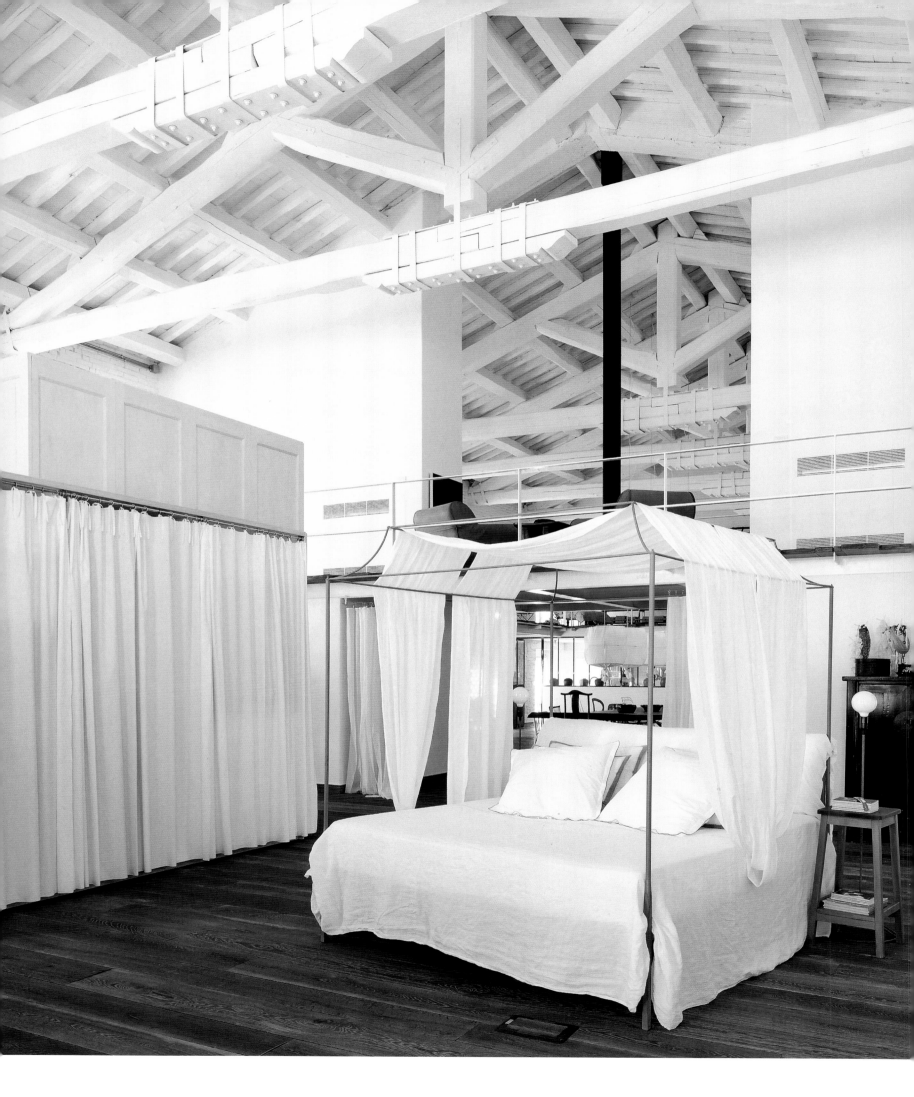

A white linen canopy shelters the home's only bed. A staircase joins
the office space below with the living area on the floors above.

*Ein weißer Leinenbaldachin beschirmt das einzige Bett des Hauses.*
*Ein Treppenhaus verbindet den Bürobereich im Erdgeschoss mit den*
*Wohnbereichen in den oberen Stockwerken.*

*Un baldaquin de lin blanc protège l'unique lit de la maison. Un escalier relie*
*l'espace de bureau en bas avec l'espace de vie aux étages supérieurs.*

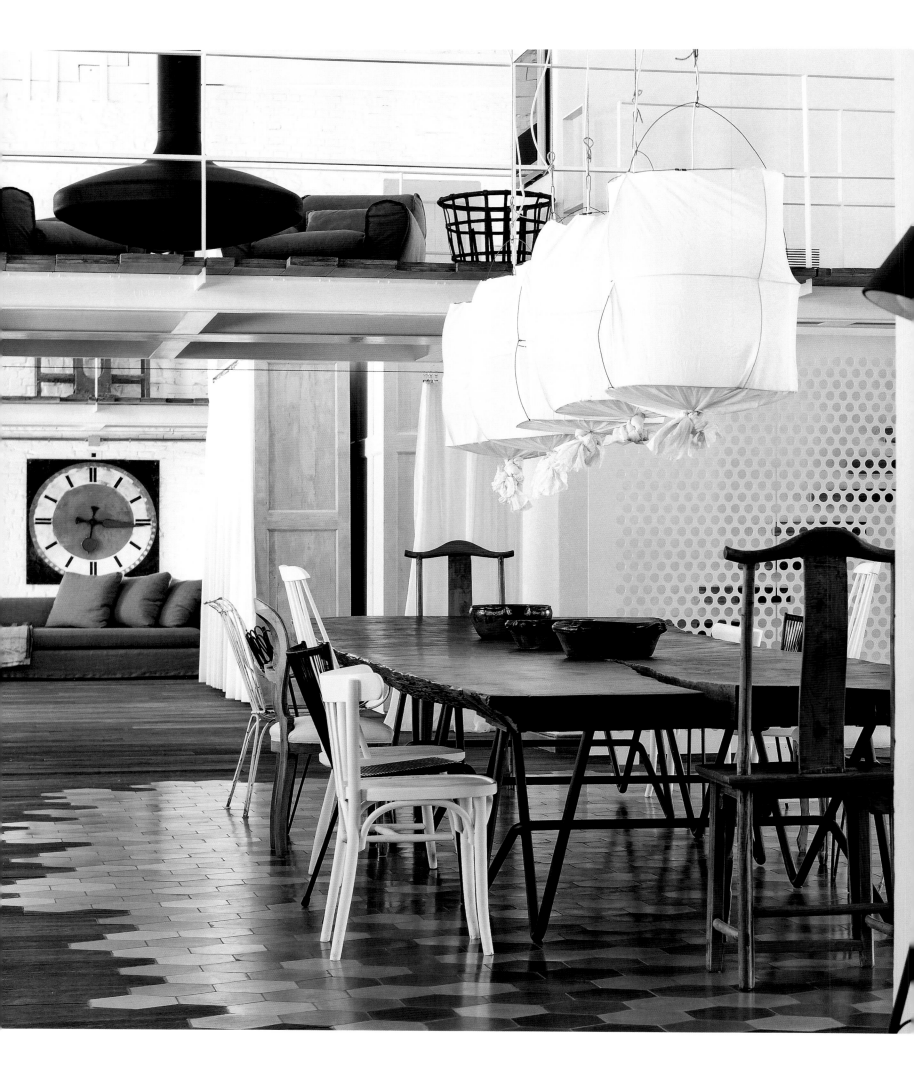

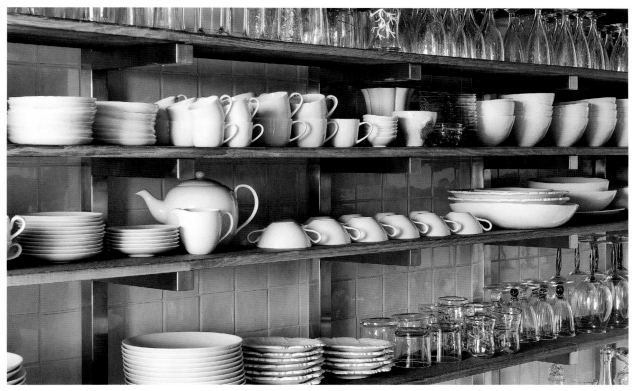

Topped with six fabric-covered pendant lamps from Design House Stockholm, the vast 21-foot-long
dining table from Italian furniture makers, Riva 1920, dominates the dining area and is surrounded by
a cluster of mismatched chairs.

Der gewaltige, 6,5 Meter lange Esstisch des italienischen Möbelherstellers Riva 1920 dominiert den Essbereich
und wird mit einer Ansammlung unterschiedlichster Stühle kombiniert. Beleuchtet wird die Tafel von sechs mit Stoff
verkleideten Hängelampen von Design House Stockholm.

Surplombée par six lampes suspendues couvertes de tissu de Design House Stockholm, la vaste table
de 6,5 mètres de long du fabricant de meubles italiens Riva 1920 qui domine l'espace repas est entourée
par un groupe de chaises désappariées.

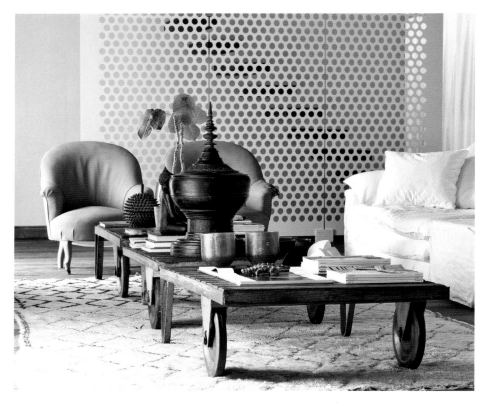

Custom Moroccan tiles in the dining room and master
bath seamlessly interface with wide-plank wood floors.
A quiet library and study is tucked into the mezzanine.

Die speziell angefertigten marokkanischen Fliesen
im Esszimmer und Hauptbadezimmer gehen nahtlos in
breite Holzdielen über. Eine kleine Bibliothek mit
Arbeitsbereich ist im Zwischengeschoss untergebracht.

Les tomettes marocaines sur mesure des salle à manger
et salle de bains s'intègrent parfaitement aux planchers
à larges lames. La mezzanine abrite une salle d'étude et
de lecture paisible.

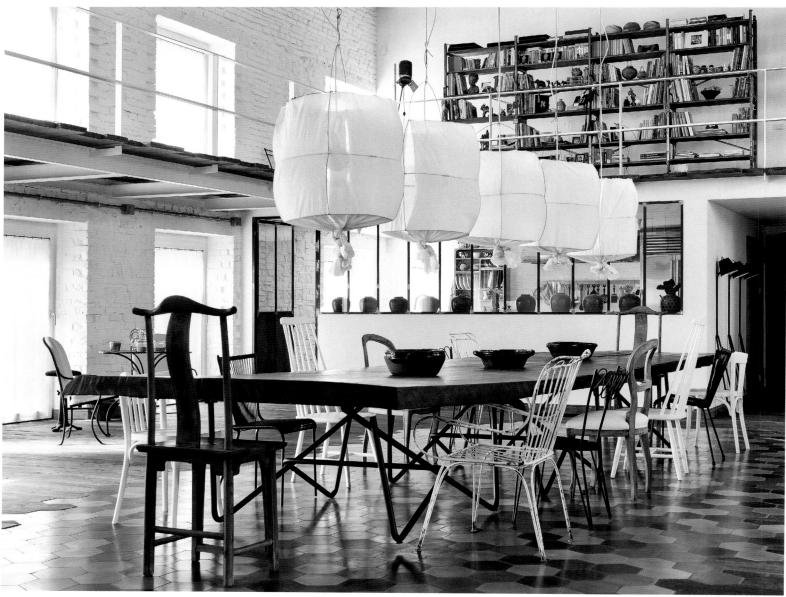

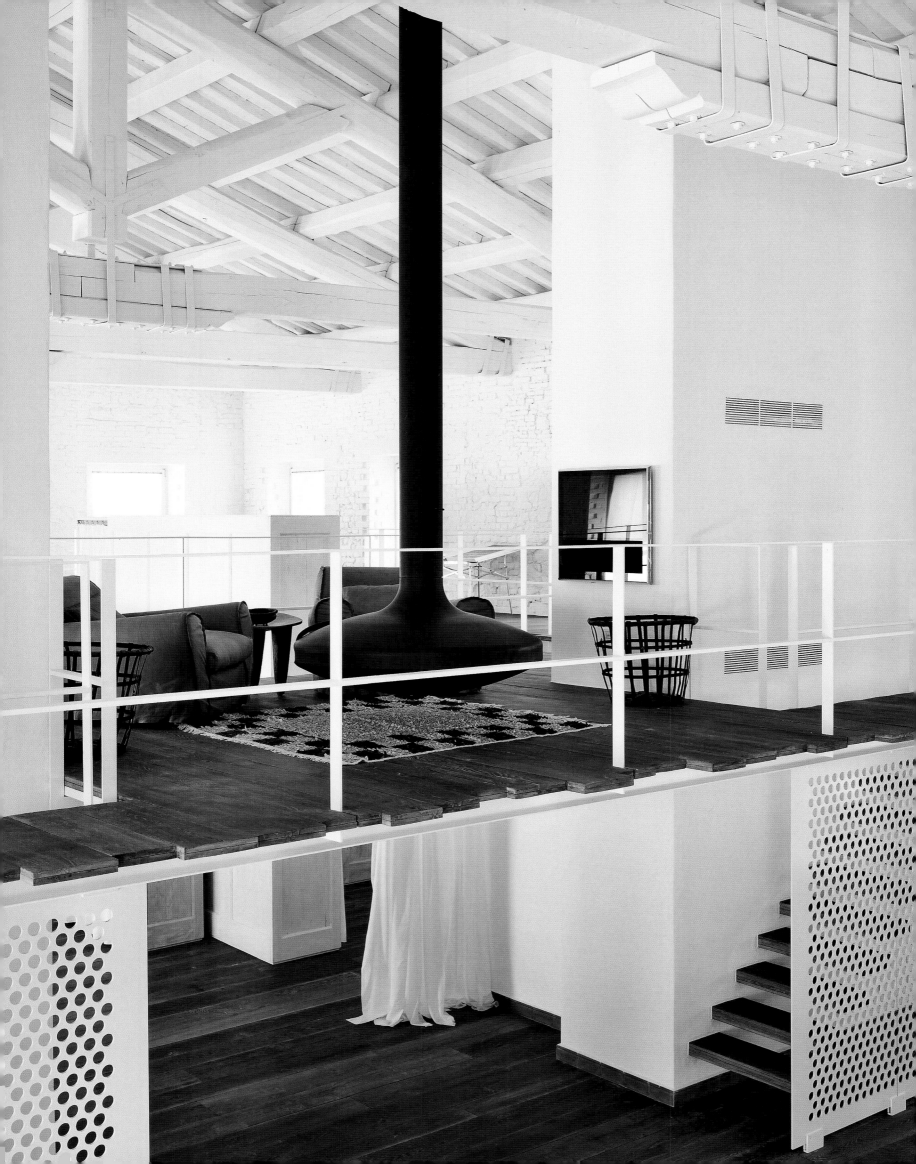

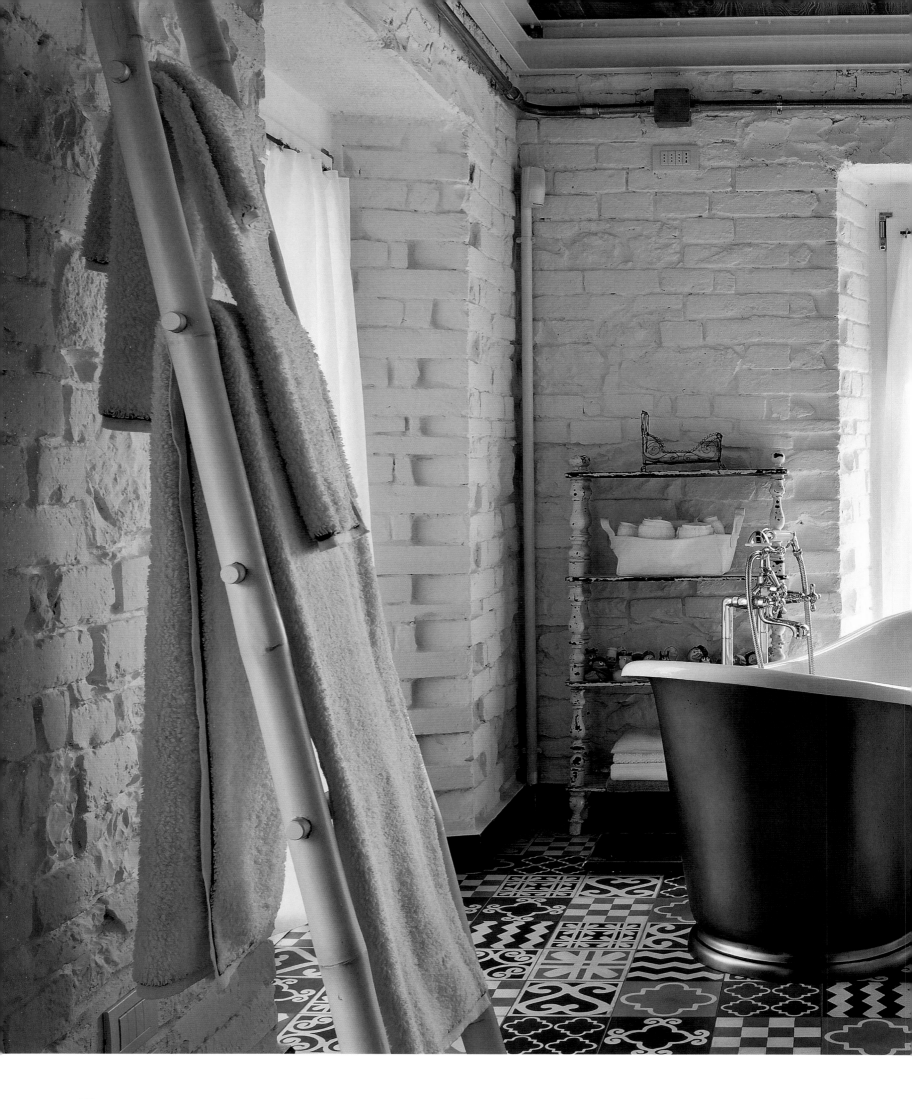

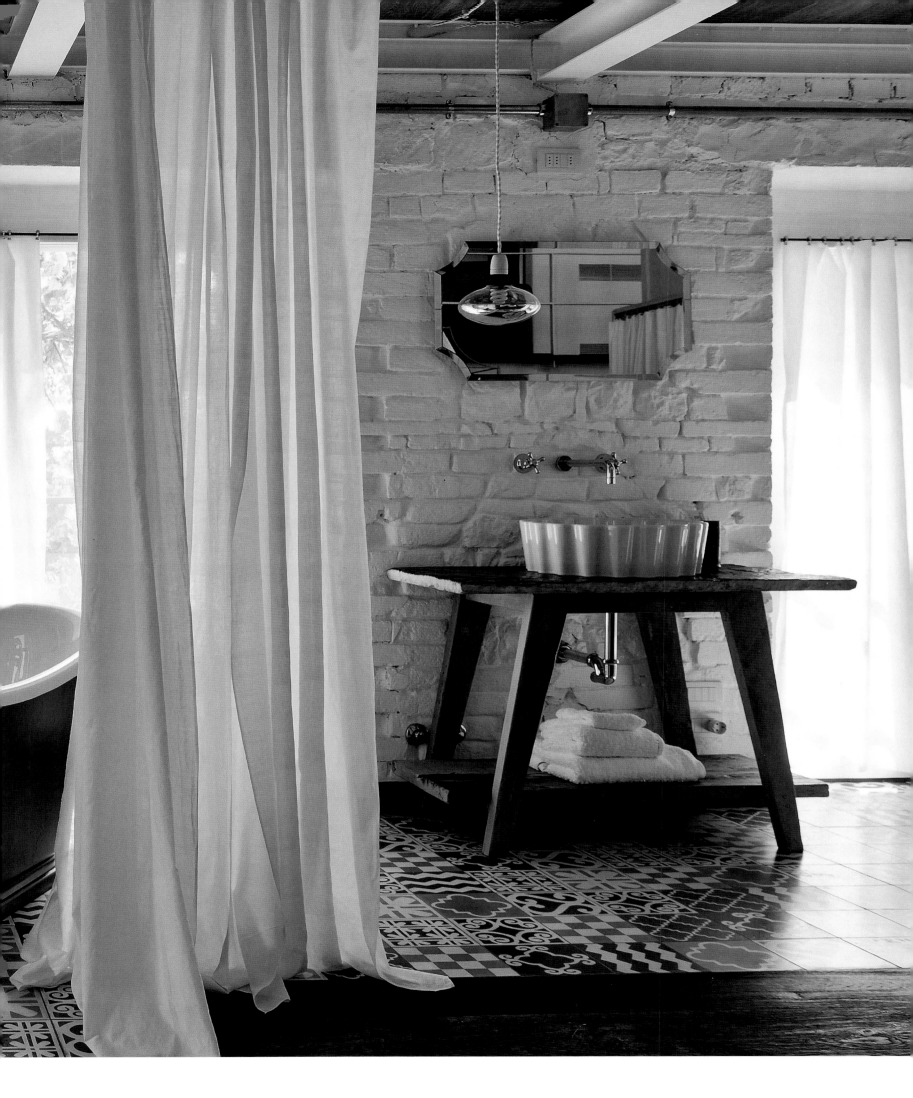

# Hillside Haven
## Umbria, Italy

GIVEN HER BACKGROUND as a hotelier, it isn't surprising that Andrea Falkner Campi would be inspired to create an enchanting inn in a hillside town in Umbria. Known as the "green heart of Italy," the region, with its spectacular, pristine mountains, valleys, and rolling wooded hills, is one of the most appealing holiday destinations in Europe. One of the other treasures in the area is Buonanotte Barbanera, a pink stone villa that Andrea crafted within a 14th-century church in Spello, a quiet town known for its robust cuisine and historic buildings. Situated between the ancient gates of Porta di Mastro and Porta Prato, the villa contains a living room, well-equipped kitchen, cozy dining area, and four bedrooms as well as a covered patio, garden, and swimming pool. Adorned with eclectic rugs, textiles, and furniture collected by Andrea on her travels, the villa is awash with character and what she describes as "an all-important sense of home."

ES ÜBERRASCHT KAUM, dass sich eine gelernte Hotelfachfrau wie Andrea Falkner Campi inspiriert fühlte, solch ein bezauberndes Ferienhaus in den umbrischen Hügeln zu eröffnen. Umbrien, das „grüne Herz Italiens" besticht durch unberührte Landschaften aus Bergen, Tälern und sanft bewaldeten Hügeln. Zu den Schätzen der Region gehört zweifellos auch die zartrosa getünchte Steinvilla Buonanotte Barbanera im beschaulichen Städtchen Spello, das für seine deftige Küche und historischen Gebäude bekannt ist. Die Villa, das ehemalige Pfarrhaus einer Kirche aus dem 14. Jahrhundert, liegt zwischen den alten Stadttoren Porta di Mastro und Porta Prato. Sie bietet ein Wohnzimmer, eine gut ausgestattete Küche, einen gemütlichen Essbereich und vier Schlafzimmer sowie eine überdachte Veranda und einen Garten mit Pool. Durch den bunten Stilmix aus Teppichen, Textilien und Möbeln, die Andrea auf ihren Reisen erwarb, verströmt die Villa eine gehörige Portion Charme. Gäste fühlen sich hier „wie zu Hause", worauf die Besitzerin besonders viel Wert legt.

L'EXPÉRIENCE D'HÔTELIÈRE d'Andrea Falkner Campi la prédestinait à créer cette charmante auberge dans une cité ombrienne à flanc de coteau. Avec ses magnifiques montagnes intactes, ses vallées et ses vertes collines vallonnées, cette région baptisée « cœur vert de l'Italie » est l'un des lieux de villégiature les plus prisés d'Europe. Autre trésor de la région, la villa de Buonanotte Barbanera en pierre rose a été créée par Falkner Campi au sein d'une église du XIVe siècle à Spello, cité tranquille connue pour sa riche cuisine et ses bâtiments historiques. Située entre les portes Porta di Mastro et Porta Prato, la villa comprend une salle de séjour, une cuisine fort bien équipée, un espace repas confortable et quatre chambres ainsi qu'un patio couvert, un jardin et une piscine. Décorée de tapis, tissus et meubles variés réunis par la propriétaire au cours de ses voyages, elle est empreinte d'un fort caractère et d'un « sentiment dominant de résidence familiale » comme le dit volontiers Andrea.

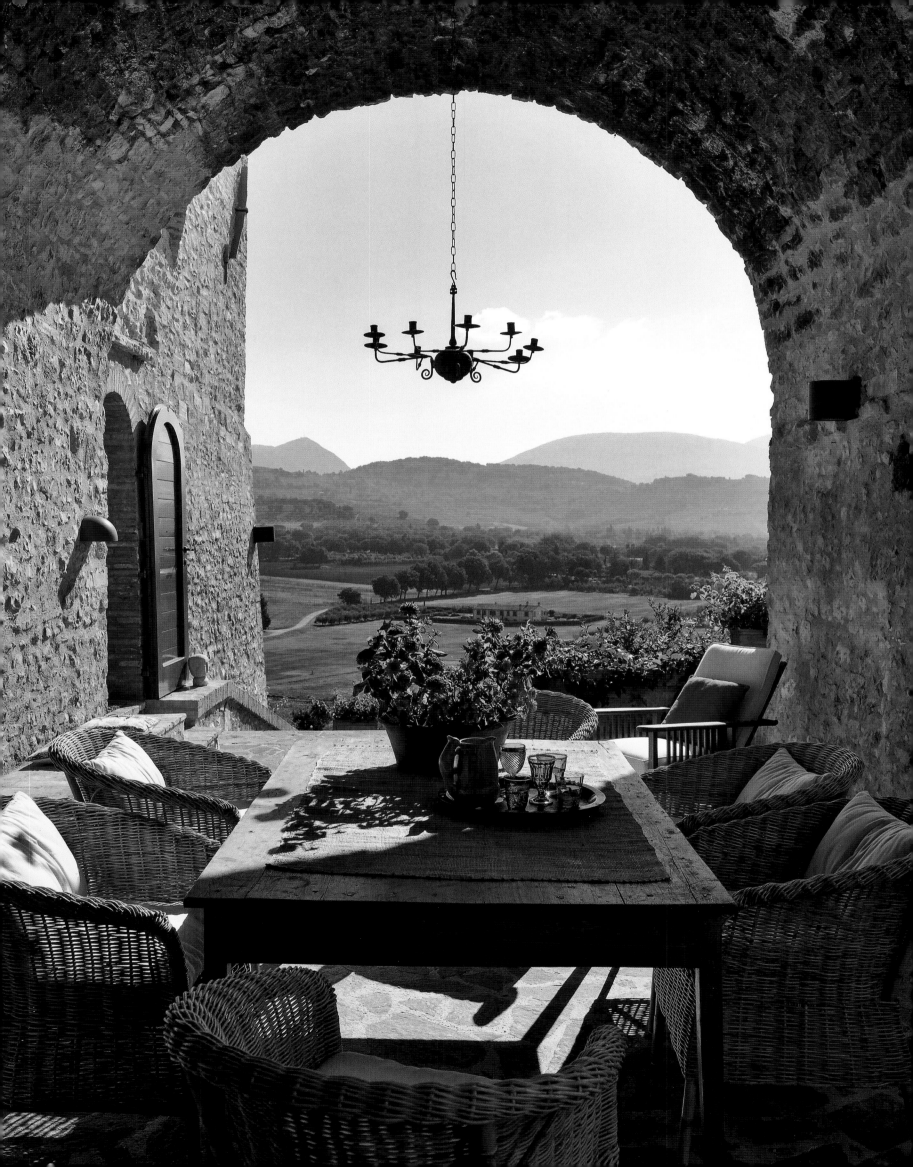

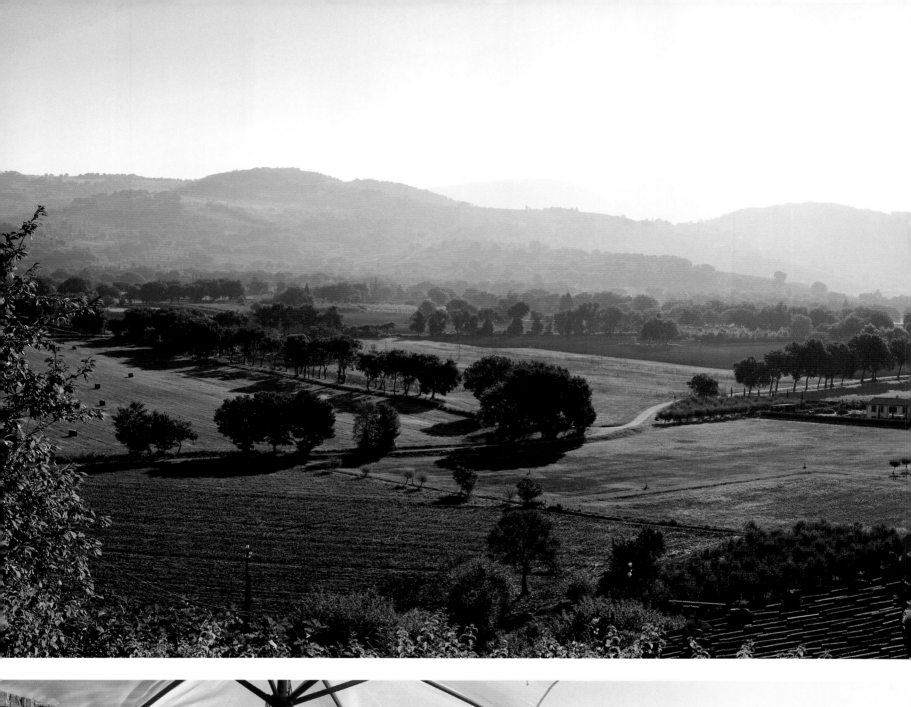
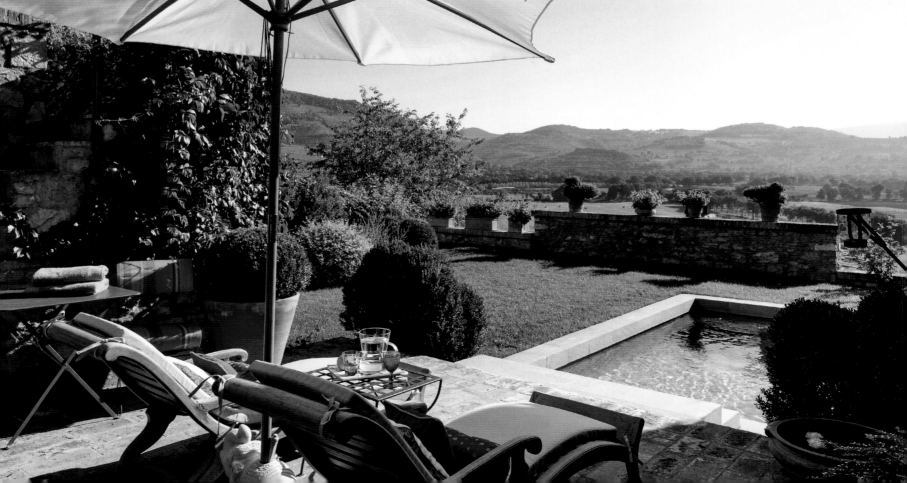

*The patio provides a stunning panorama of beautiful rolling hills beyond the garden and easy access to the kitchen and living room, or, via a flight of steps, to the pool and garden—an oasis planted with roses and olive and cypress trees.*

*Von der Veranda aus hat man einen atemberaubenden Panoramablick auf die liebliche Hügellandschaft jenseits des Gartens und Zugang zu Küche und Wohnzimmer. Über eine kleine Treppe gelangt man zum Pool und zum Garten – einer mit Rosen, Zypressen und Olivenbäumen bepflanzten Oase.*

*Ouvrant, passé le jardin, sur un splendide panorama de belles collines vallonnées, le patio est relié à la cuisine et au salon. Une volée d'escaliers mène à la piscine et au jardin – une oasis plantée de roses, d'oliviers et de cyprès.*

Soft lighting and ancient stone arches offer a palpable sense of history in the spacious open-plan living and dining rooms. Curios from around the world, such as a red-painted Chinese chest, vintage lanterns, and Moroccan rugs lend color and warmth throughout the living space.

Weiches Licht und antike Steingewölbe bewirken, dass in den großen offenen Wohn- und Essbereichen die Geschichte des Hauses zum Greifen nahe ist. Ausgewählte Einzelstücke aus der ganzen Welt wie zum Beispiel ein rotes chinesisches Schränkchen, alte Windlichter und marokkanische Teppiche verleihen Farbe und Wärme.

Par l'éclairage tamisé et les vieilles voûtes de pierre, l'histoire devient palpable dans le salon et la salle à manger décloisonnés. Des curiosités du monde entier, dont un buste chinois peint en rouge, des lanternes d'époque et des tapis marocains insufflent couleur et chaleur dans tout l'espace vie.

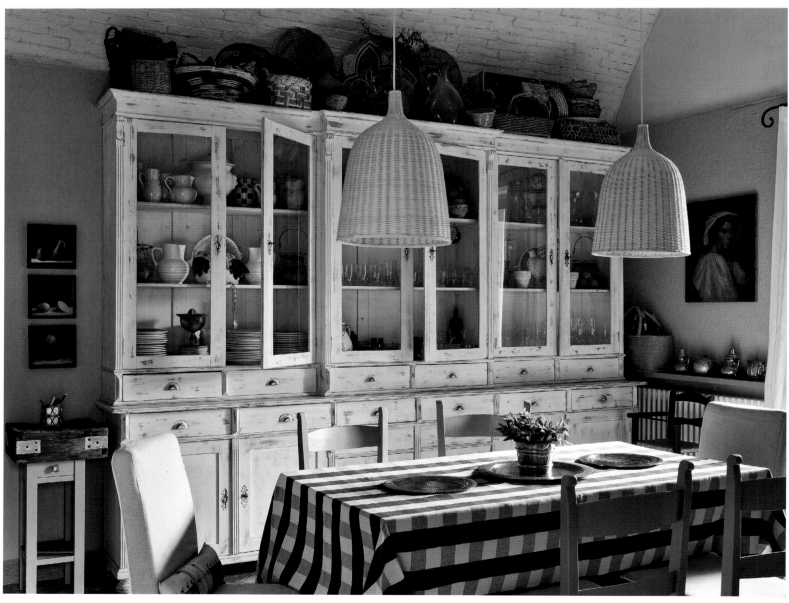

Set above the master bedroom, an ethnic-inspired bedroom offers dazzling country views and is vividly decorated with colorful Moroccan- and Indian-inspired textiles and contemporary rugs atop cool, limed oak floors.

Über dem Hauptschlafzimmer liegt ein Schlafzimmer im ethnischen Stil und mit einer spektakulären Aussicht. Die Dekoration besteht aus farbenfrohen Textilien, die marokkanisch und indisch anmuten, sowie modernen Teppichen auf dem kühlen, gekalkten Eichenparkett.

Au dessus de la chambre de maître, une chambre d'inspiration ethnique offre des vues merveilleuses sur la campagne. Les frais planchers de chêne blanchi sont décorés de tissus et de tapis contemporains d'inspiration marocaine et indienne richement colorés.

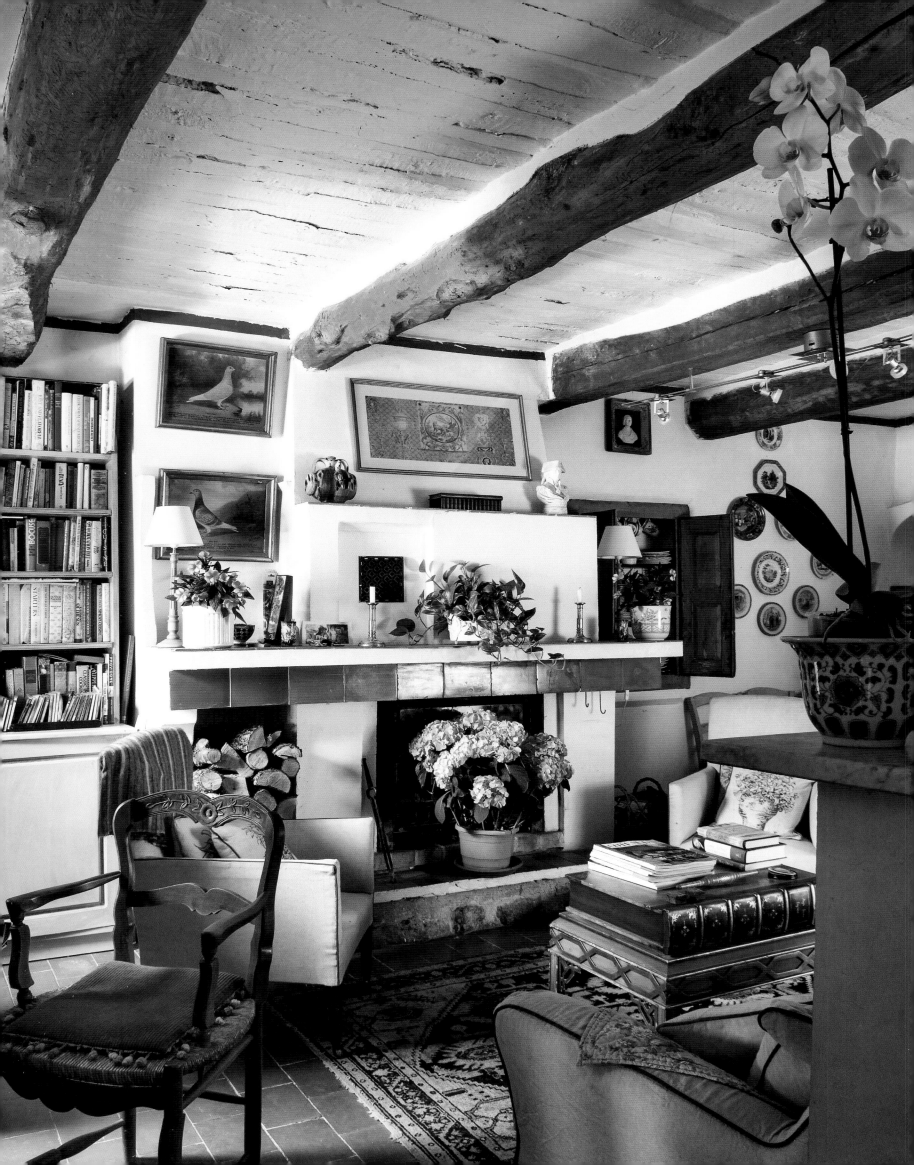

# At Home in Provence
## Provence, France

ALTHOUGH SHE'S LIVED all over the world, author and designer Mary Gilliatt has chosen to call this 17th-century stone house in Provence her home. While she continues to spend time in her native England, she had always wanted to live in France, where her daughter settled years ago. So when the opportunity to purchase this home next door to her daughter's house arose, she readily embraced it despite its need for a gut renovation. She set about its transformation by knocking down walls, unblocking fireplaces, and exposing original beams and floors. After shaping the home's shell to her liking, she furnished its rooms—including a sunny *séjour*, four bedrooms, and a grand salon—with antiques and art she acquired on her travels. The eclectic mix of furnishings and objects—18th-century French provincial chairs, 19th-century oil paintings, old English library chairs, and lots of books and curios—gives the house an air of "benign neglect" that makes Mary Gilliatt feel very much at home.

OBWOHL SIE SCHON überall auf der Welt gewohnt hat, machte die Autorin und Designerin Mary Gilliatt dieses provenzalische Steinhaus aus dem 17. Jahrhundert zu ihrem neuen Zuhause. Eigentlich wollte die Britin schon immer in Frankreich leben, schließlich war ihre Tochter bereits vor Jahren dorthin gezogen. Als sich die Gelegenheit ergab, das Haus gleich neben dem ihrer Tochter zu kaufen, zögerte Gilliatt nicht lange, obwohl es stark renovierungsbedürftig war. Sie ließ Wände einreißen, Kamine entrußen und die Originalbalken und -böden freilegen. Nachdem die Hülle ihrem Geschmack entsprach, füllte sie die Räume – darunter einen sonnigen *séjour*, vier Schlafzimmer und einen grand salon – mit Antiquitäten und Kunstgegenständen, die sie auf ihren Reisen erworben hatte. Die eklektische Mischung von Möbeln und Objekten – französische Landhausstühle aus dem 18. Jahrhundert, Ölgemälde aus dem 19. Jahrhundert, alte englische Bibliotheksstühle, viele Bücher und allerlei Kuriositäten – verleiht dem Haus einen leicht nachlässigen Charme, in dem Mary Gilliatt sich sehr wohl fühlt.

AYANT VÉCU AUX quatre coins du monde, l'écrivain et décoratrice d'intérieur Mary Gilliatt a décidé de faire de cette maison de pierre provençale du XVIIe son chez-soi. Même si elle passe encore du temps dans son pays natal l'Angleterre, elle a toujours voulu vivre en France, où sa fille s'est installée il y a des années. Aussi, lorsque l'occasion s'est présentée d'acquérir une maison près de celle de sa fille, elle l'a tout de suite saisie, malgré l'assainissement à refaire. Elle a commencé à transformer l'endroit en abattant les cloisons et en mettant au jour les cheminées ainsi que les poutres et les planchers d'origine. Après avoir remodelé la structure à son goût, elle a meublé les pièces – le séjour ensoleillé, quatre chambres et un grand salon – avec des meubles anciens et des objets d'art glanés lors de ses voyages. L'ensemble éclectique de meubles et d'objets – chaises provençales du XVIIIe, peintures à l'huile du XIXe, vieilles chaises anglaises de bibliothèque, nombreux livres et bibelots – donne à la bâtisse un côté « négligé » qui aide Mary Gilliatt à se sentir chez elle.

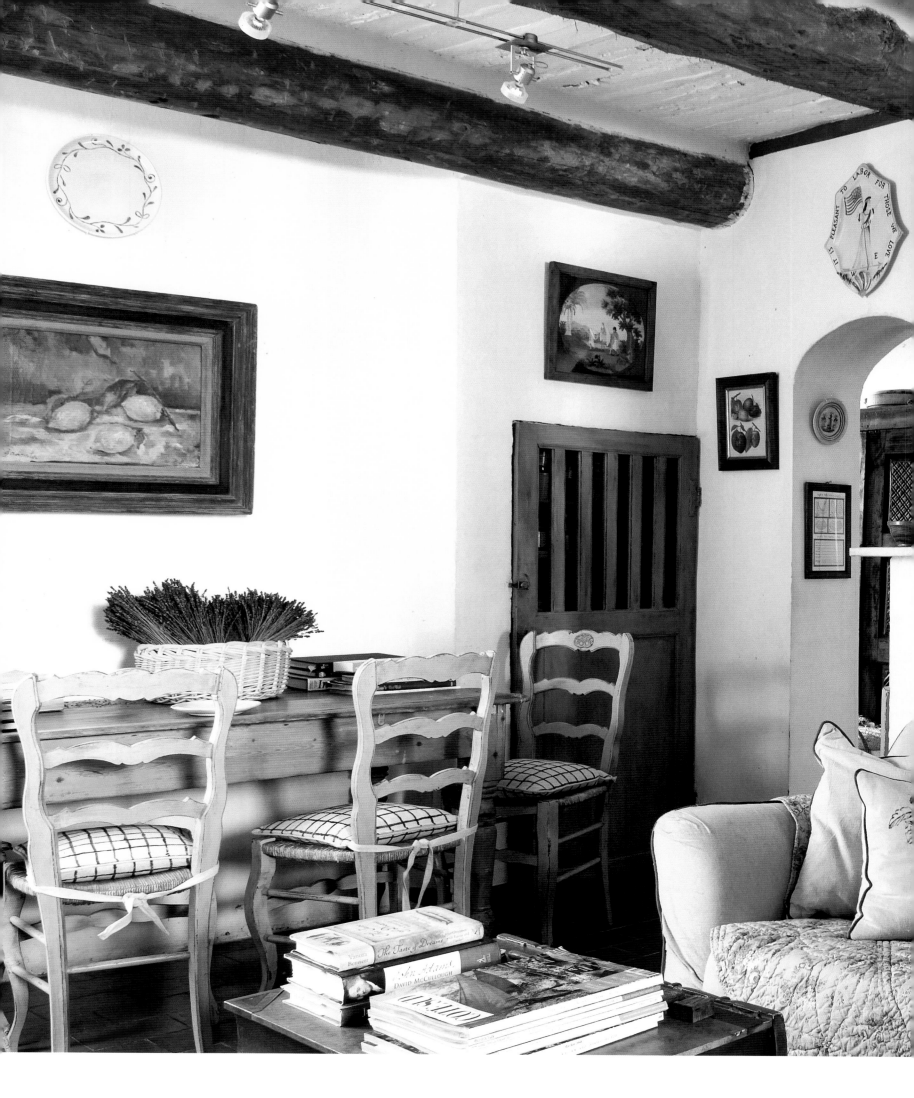

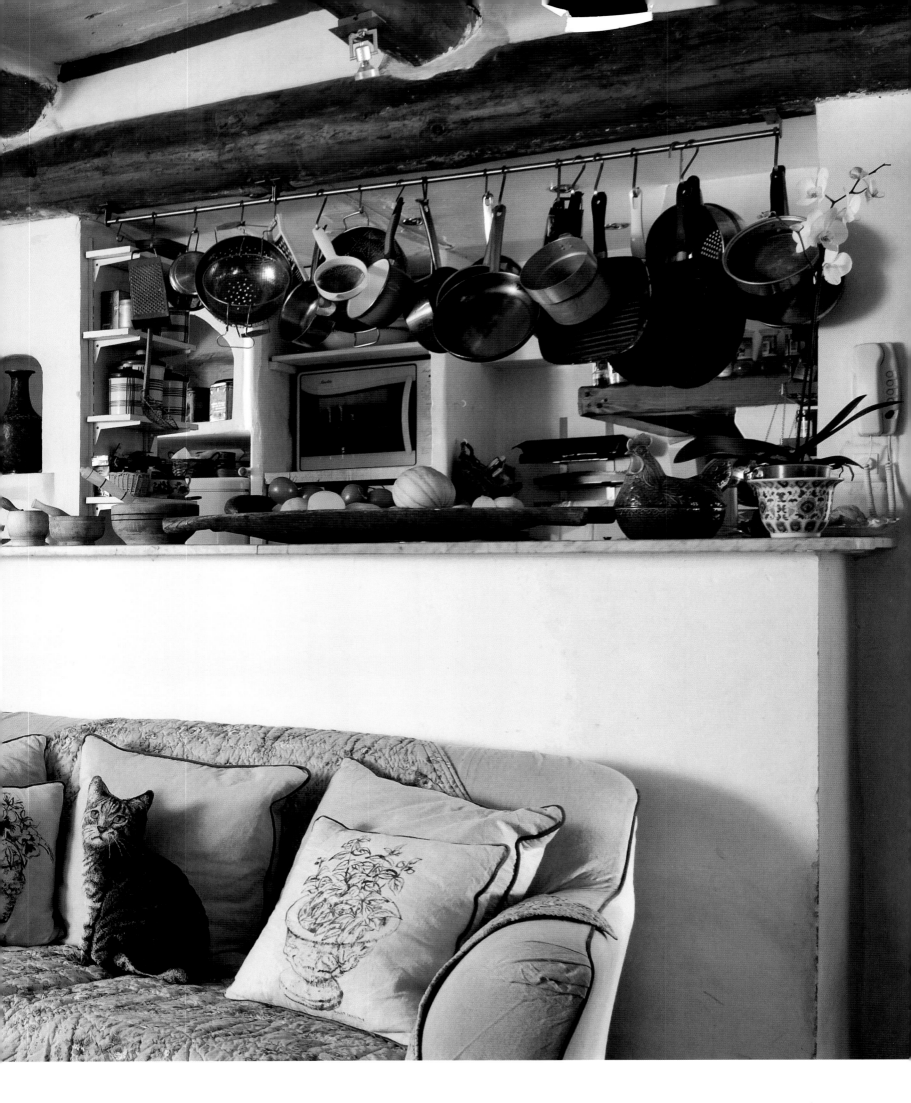

Mary refers to her provençal home's bright *séjour* as her "everything room," the place where she reads, writes, and entertains friends; it adjoins a tiny kitchen, where she prepares feasts for the guests she regularly entertains (previous two spreads). Toile bedding and pillows lend French flavor to the master bedroom and a guest room.

Den hellen *séjour* bezeichnet Mary als ihr „Zimmer für alles". Hier liest und schreibt sie und empfängt Gäste. Der Raum grenzt an eine winzige Küche, in der sie für ihre Freunde wahre Festmahlzeiten zubereitet (vorherige zwei Doppelseiten). Toile-Bettwäsche und -Kissen verleihen den Schlafzimmern ein französisches Flair.

Mary appelle le *séjour* lumineux de sa maison provençale sa « pièce à tout faire », où elle lit, écrit et reçoit ses amis ; elle jouxte une petite cuisine, où elle prépare des festins délicieux pour les invités qu'elle reçoit régulièrement (doubles pages précédentes). Le linge de lit imprimé toile de Jouy donne une touche française à la chambre de maître et à la chambre d'amis.

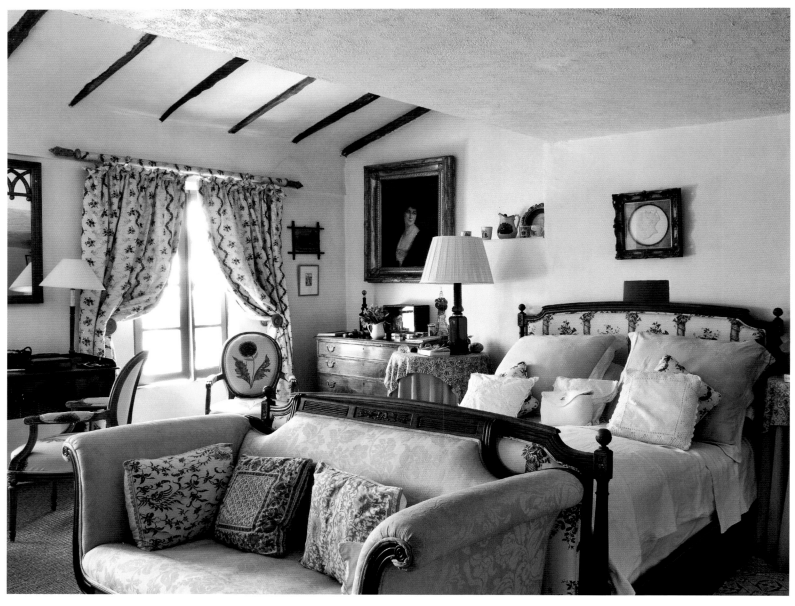

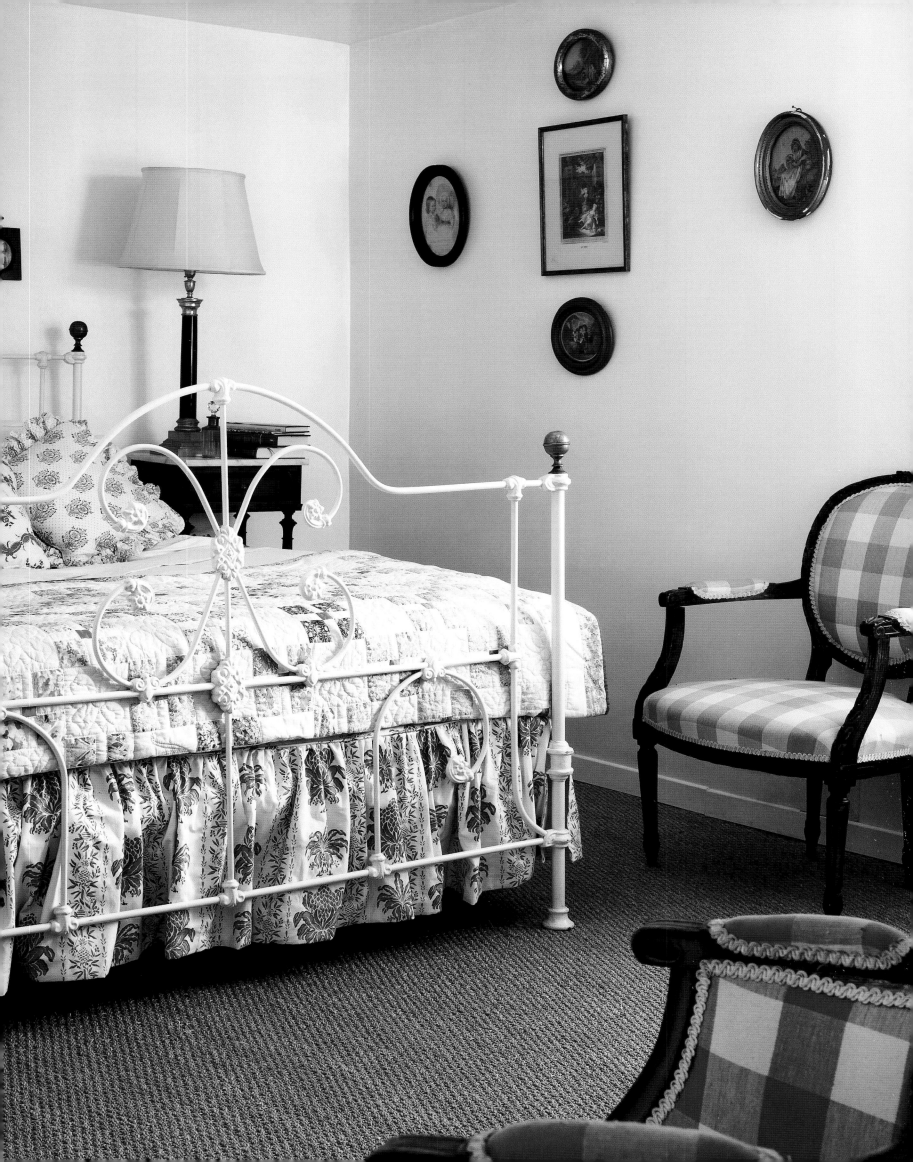

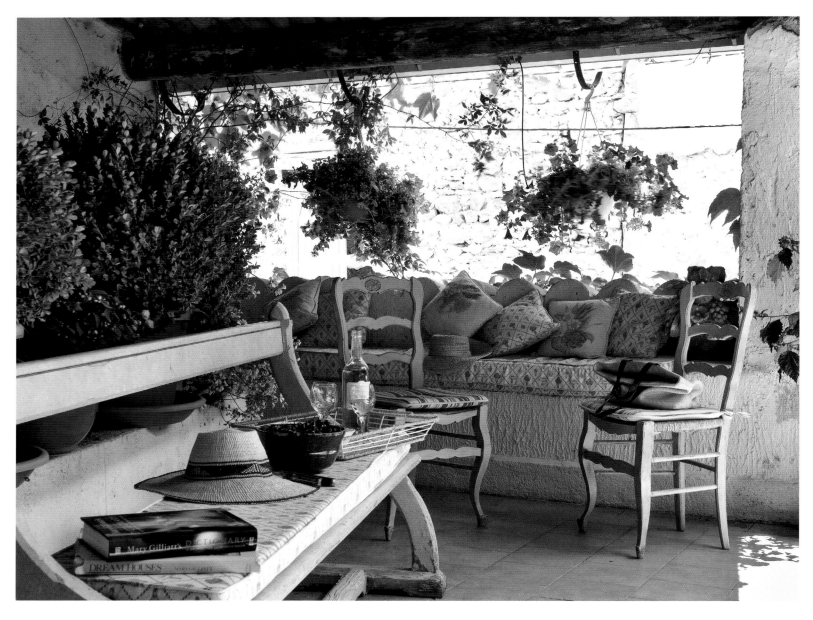

A first-floor terrace is the ideal spot to relax and enjoy a glass of rosé on hot afternoons. A mix of French provincial chairs here and in the cheery breakfast nook ideally suit the setting.

*Die Terrasse auf der ersten Etage ist der ideale Ort, um an heißen Nachmittagen bei einem Glas Rosé auszuspannen. Die verschiedenen französischen Landhausstühle auf der Terrasse und in der gemütlichen Frühstücksecke passen zum gesamten Ambiente.*

*La terrasse au premier est l'endroit idéal pour se détendre et siroter un verre par un bel après-midi d'été. Les chaises provençales ici et dans le coin repas enjoué s'accordent parfaitement au cadre.*

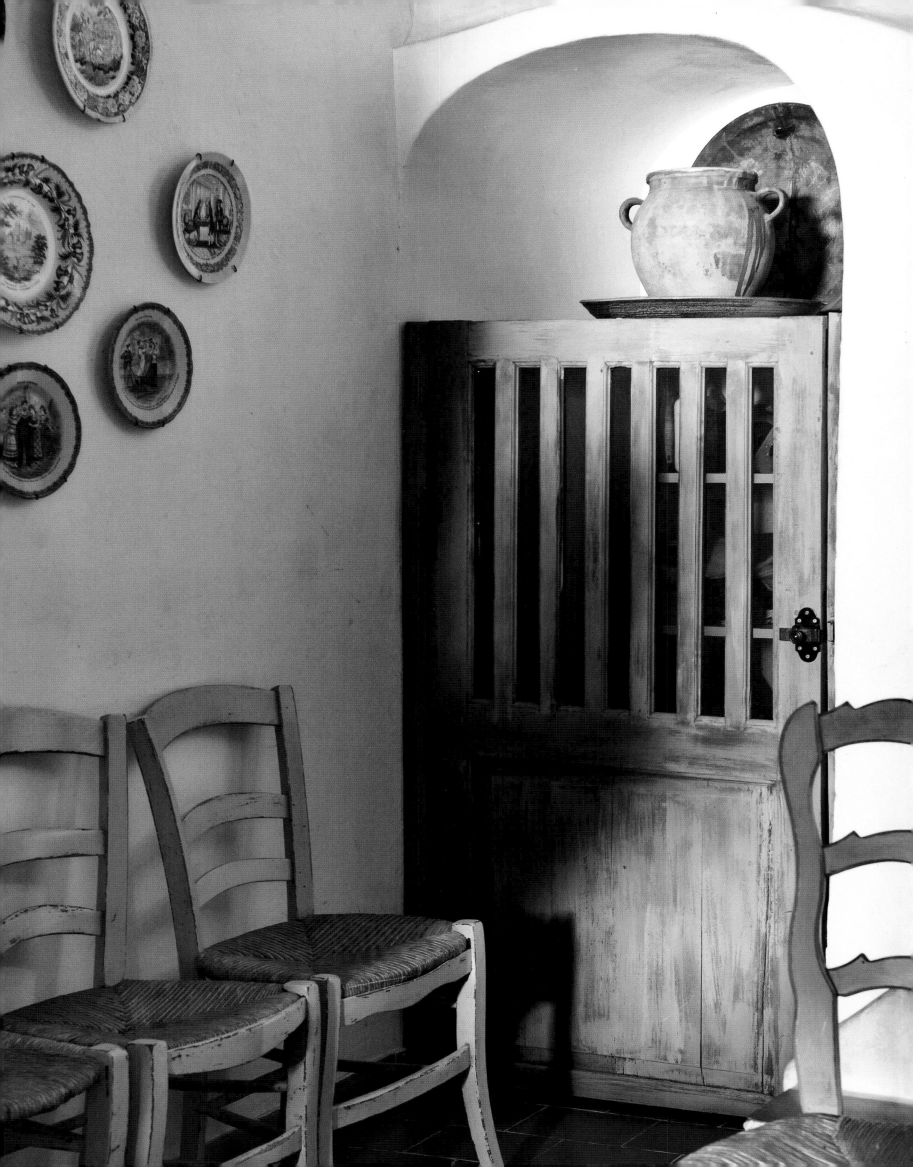

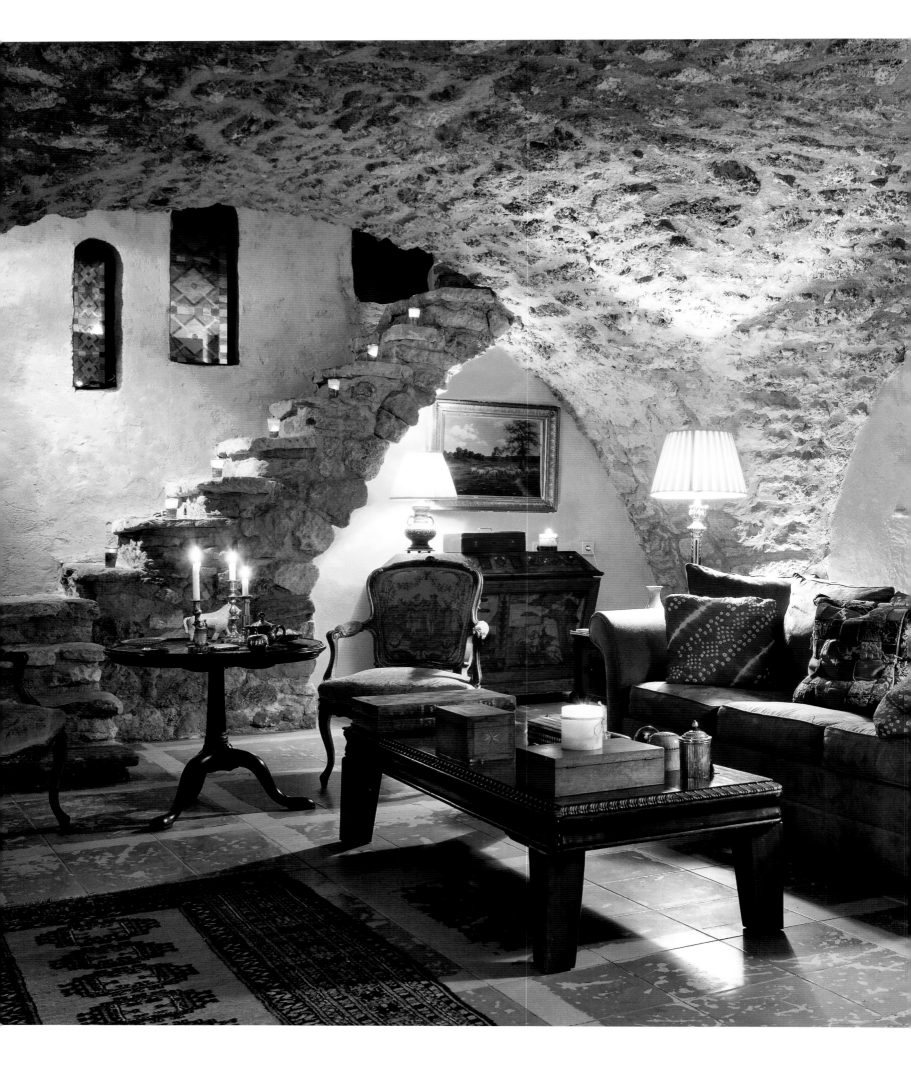

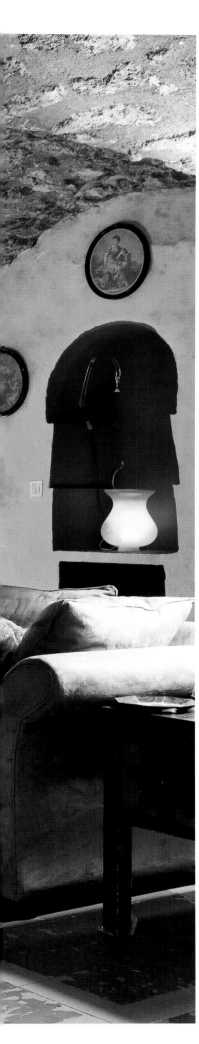

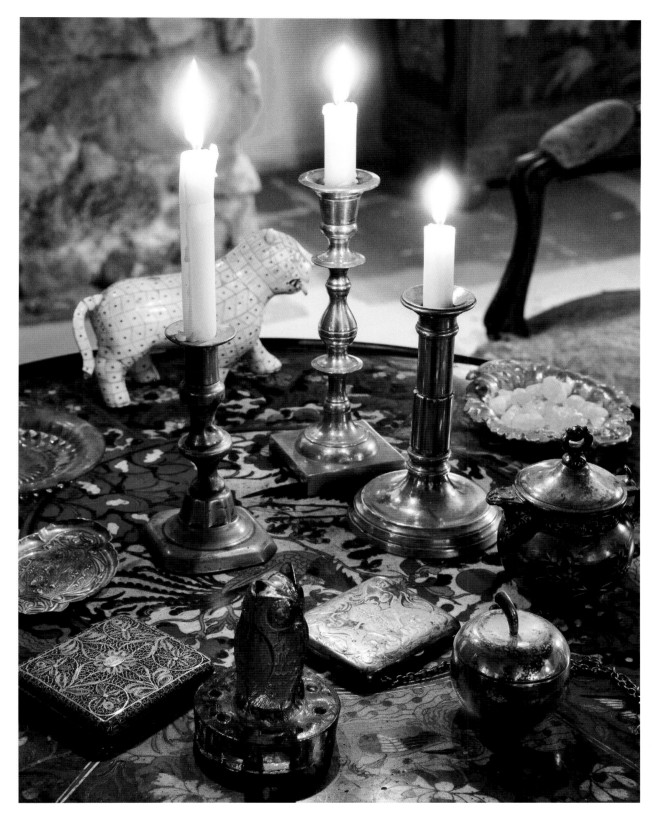

The grand salon on the ground floor—accessed via a candlelit medieval stone staircase—is where Mary Gilliatt hosts dinner parties for the many friends and family members who frequently visit.

Im Salon im Erdgeschoss, zu dem eine mit Kerzen beleuchtete mittelalterliche Steintreppe führt, gibt Mary Gilliatt Dinnerpartys für ihre zahlreichen Freunde und Verwandten, die häufig zu Besuch kommen.

Dans le grand salon au rez-de-chaussée – accessible par un escalier médiéval en pierre éclairé par des bougies –, Mary Gilliatt organise les dîners pour les nombreux amis et parents qu'elle reçoit fréquemment.

# Enchanted Hacienda
## Baja California, Mexico

DURING A VISIT to Todos Santos, an unspoiled village on the Baja peninsula, Sylvie Sabatier-Lanzenberg and her husband, Christophe, fell in love with the tiny colonial town. On a whim they decided to purchase 1.2 acres of land, including a former sugar cane plantation and groves of mango and avocado trees. Todos Santos, a surfer's paradise, proved to be the ideal home away from home. Taking cues from the local brick structures with *palapa* roofs made of palm branches, and combining them with elements of Greek, Ibizan, and Moroccan architecture, Sylvie drew up plans for the hacienda herself and worked with local builders and craftsmen. The getaway is composed of several separate structures, including living and sleeping quarters, guest rooms, a pool house, and a house for the caretakers. Finished with *polido* (treated plaster), colored tiles on some of the floors, and custom ironwork details throughout, the home is completely in tune with the relaxed lifestyle of its owners.

WÄHREND EINES URLAUBS auf der mexikanischen Halbinsel Baja California verliebten Sylvie Sabatier-Lanzenberg und ihr Mann Christophe sich in das Dorf Todos Santos, das noch seine ursprüngliche Kolonialarchitektur erkennen lässt. Spontan erstanden sie dort 5000 Quadratmeter Land, zu denen eine ehemalige Zuckerrohrplantage sowie Mango- und Avocadohaine gehören. Das Surferparadies Todos Santos entpuppte sich als ideales Wochenendziel. Sylvie Sabatier entwarf selbst die Baupläne für die Hacienda und arbeitete bei der Realisierung mit örtlichen Bauleuten und Handwerkern zusammen. Sie ließ sich von den regionalen Ziegelsteinbauten mit ihren *Palapa*-Dächern aus Palmenzweigen inspirieren und kombinierte diese mit Elementen griechischer, ibizenkischer und marokkanischer Architektur. Das Feriendomizil besteht aus mehreren separaten Gebäuden, darunter der Wohn- und Schlafbereich, ein Gästetrakt, ein Poolhaus und ein Anbau für die Haushüter. Die Interieurs mit ihren weiß verputzten Wänden und Möbeln, bunten Fliesen und speziell angefertigten schmiedeeisernen Arbeiten passen perfekt zum entspannten Lebensstil der Besitzer.

LORS D'UNE VISITE à Todos Santos, site préservé de la péninsule de Basse-Californie, Sylvie Sabatier-Lanzenberg et son époux Christophe ont craqué pour cette petite cité coloniale. Sur un coup de tête, ils ont acheté 5000 mètres carrés de terrain incluant une plantation de canne à sucre et des vergers de manguiers et d'avocatiers. Paradis des surfeurs, Todos Santos s'est révélé être un autre chez soi idéal loin de chez eux. S'inspirant des structures en briques locales coiffées de branches de palmier, des *palapas*, qu'elle a combiné à des éléments d'architecture de Grèce, d'Ibiza et du Maroc, Sylvie a dressé les plans de l'hacienda et travaillé avec des constructeurs et artisans locaux. Le logis comprend diverses structures distinctes, notamment des pièces d'habitation et de couchage, des chambres d'amis, un pavillon de piscine et une maison pour le personnel. Avec les finitions en béton ciré, les dalles colorées de certains sols et les multiples éléments en fer forgé, il est en synergie parfaite avec le mode de vie décontracté de ses propriétaires.

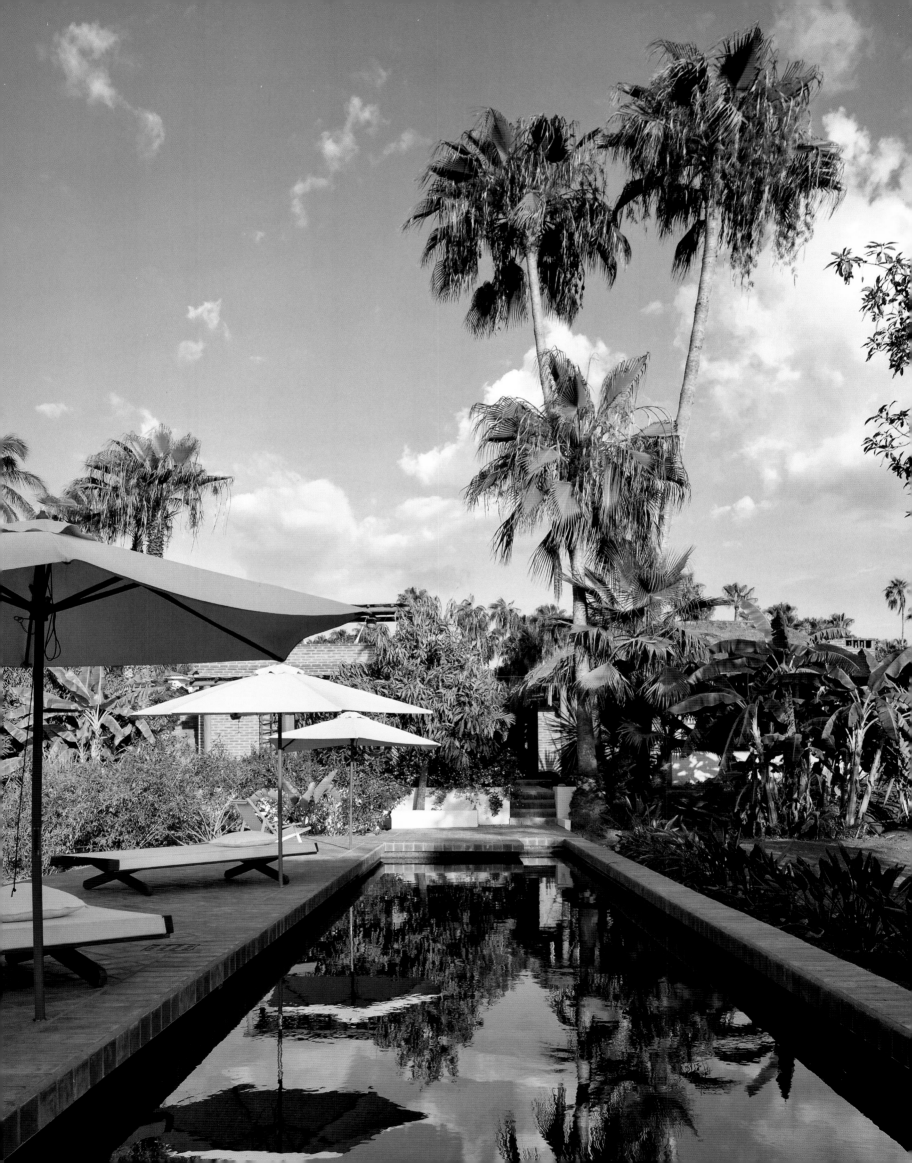

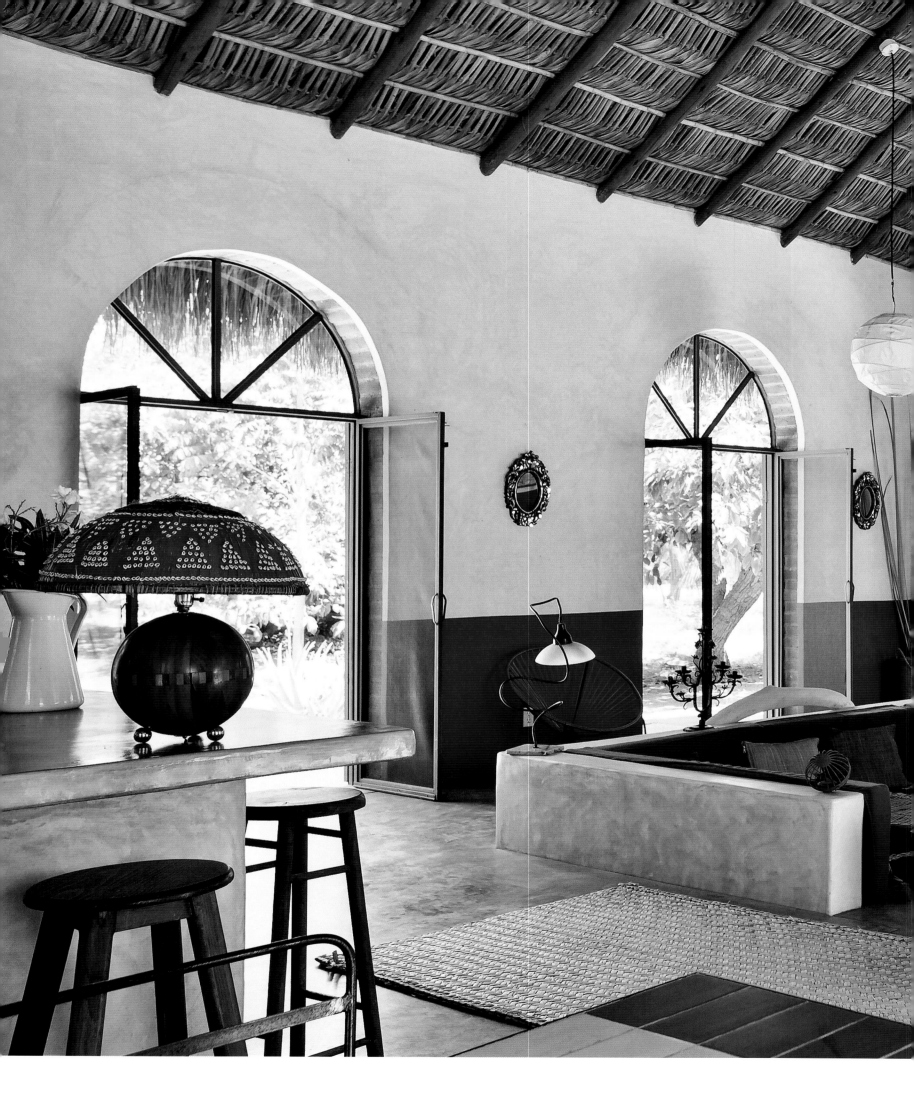

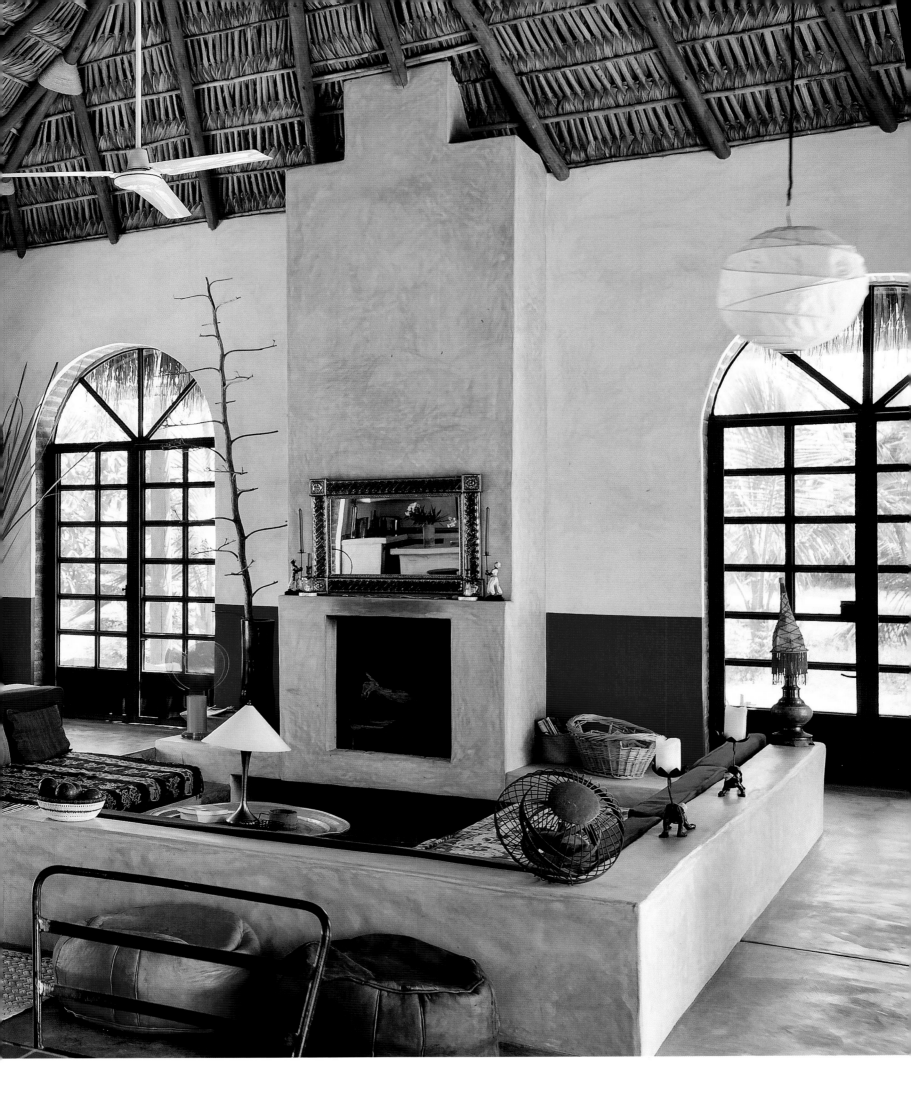

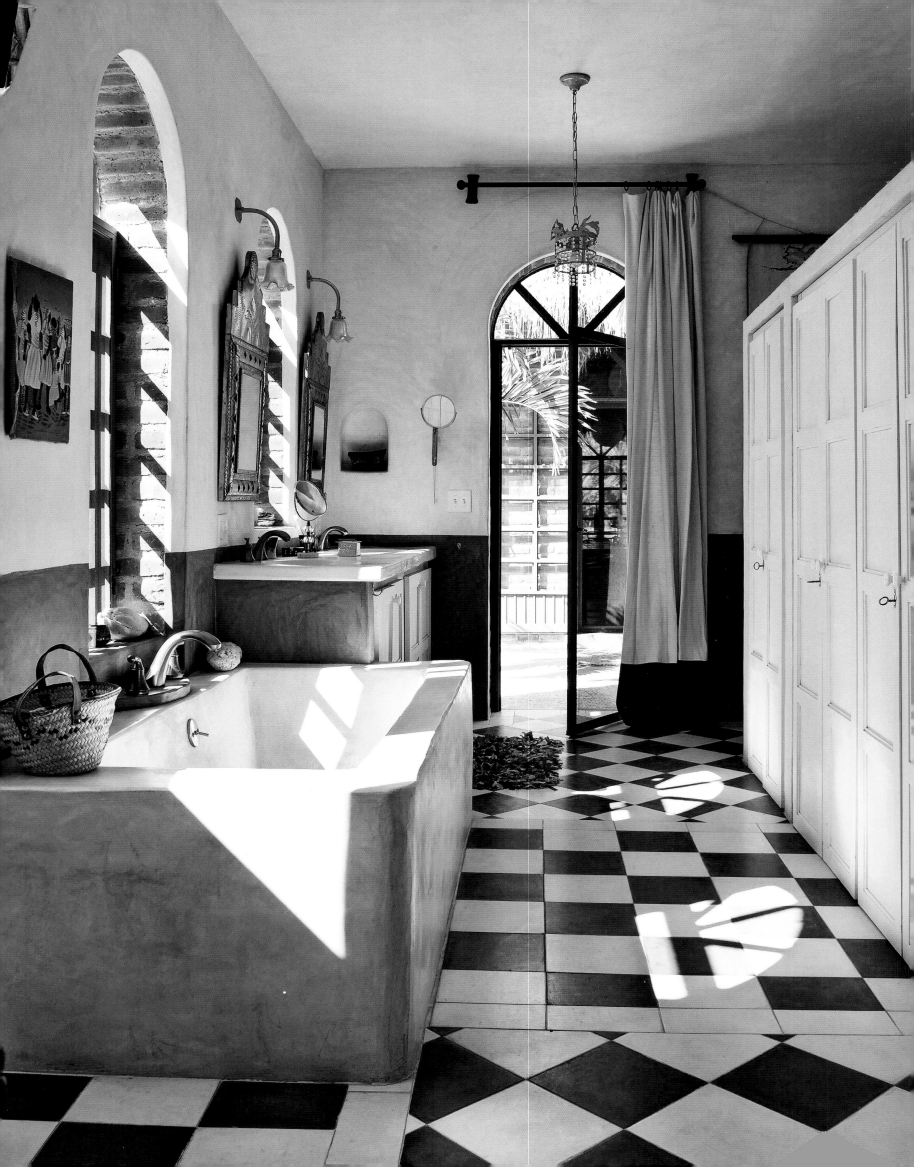

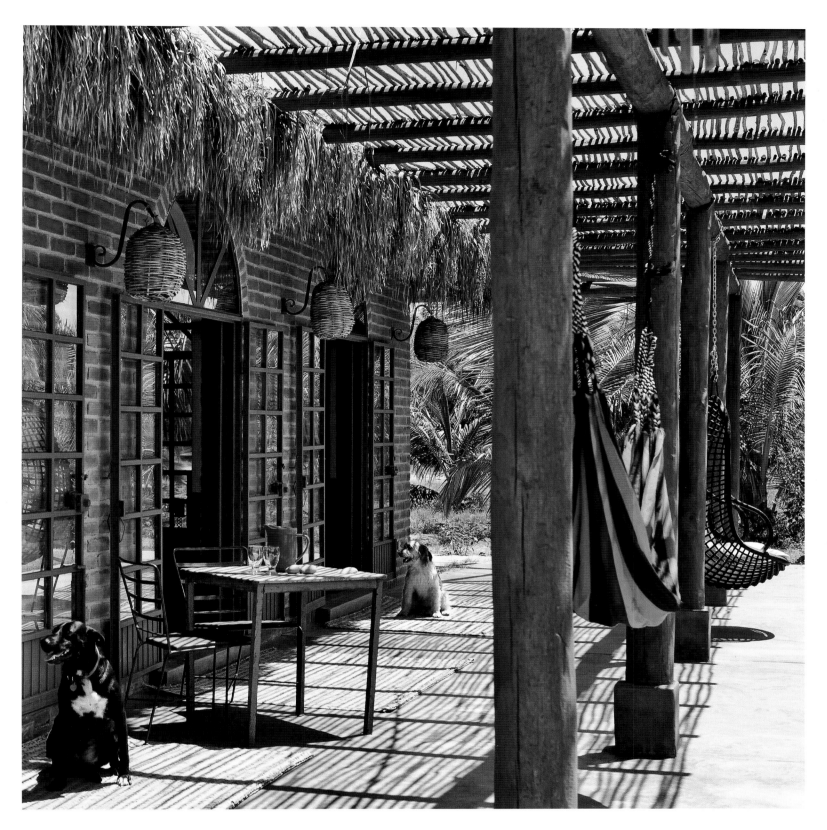

A long, linear pool merges crisp modernity with traditional brickwork (opening page). Most of the furnishings—oversized sofas, tables, and desks—were designed as built-in fixtures and made of polished cement like the floor (previous page). French iron windows and doors in every room complete the beach house ambience.

*Ein langer, linearer Pool vereint strenge Modernität mit traditionellem Backstein (Einstiegsseite). Die meisten Möbel – übergroße Sofas, Tische und Theken – wurden als fest eingebaute Elemente konzipiert und bestehen aus demselben polierten Beton wie der Boden (vorherige Seite). Fenstertüren mit Eisenrahmen in jedem Zimmer vervollständigen das Strandhaus-Ambiente.*

*La piscine rectangulaire associe épuration moderne et maçonnerie traditionnelle en briques (première page). La plupart des meubles – grands canapés, tables et bureaux – sont des éléments encastrés en ciment poli comme le plancher (page précédente). Les portes et les portes-fenêtres à la française en acier dans chaque pièce renforcent l'ambiance maison de plage.*

The painting made by an eccentric Mexican artist named Euva brings zest to the master bedroom. A few "exotic" pieces collected on trips to Bali, Morocco, and Mexico add additional flavor.

*Das Gemälde der exzentrischen mexikanischen Malerin Euva bringt Pepp ins Hauptschlafzimmer. Ein paar „exotische" Mitbringsel aus Bali, Marokko und Mexiko setzen zusätzliche Akzente.*

*Le tableau de l'artiste mexicaine Euva donne un certain piquant à la chambre de maître. Quelques objets « exotiques » ramenés de voyages à Bali, au Maroc et au Mexique rehaussent l'ambiance.*

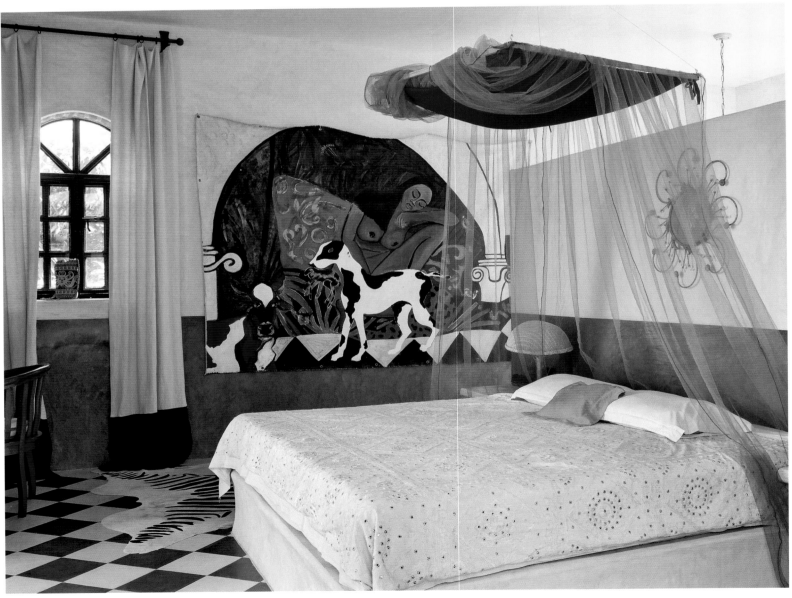

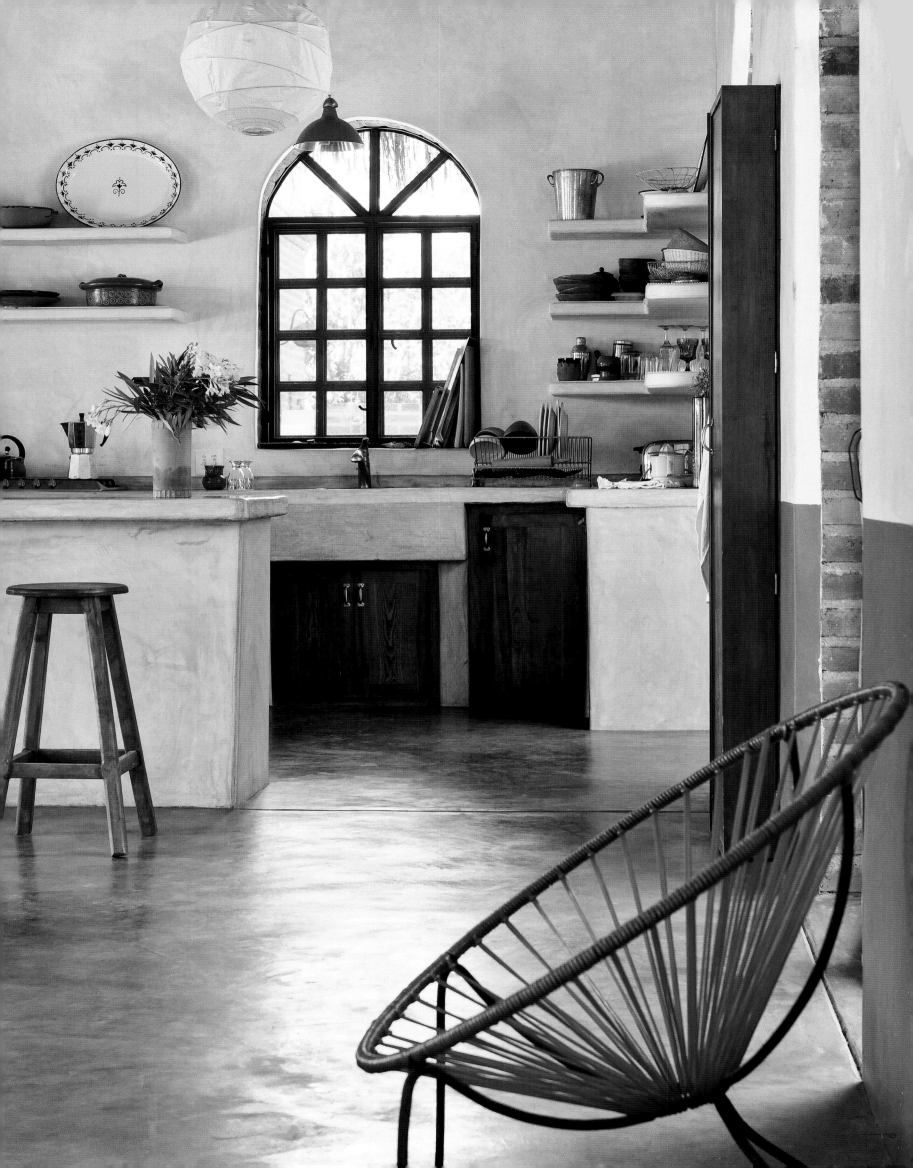

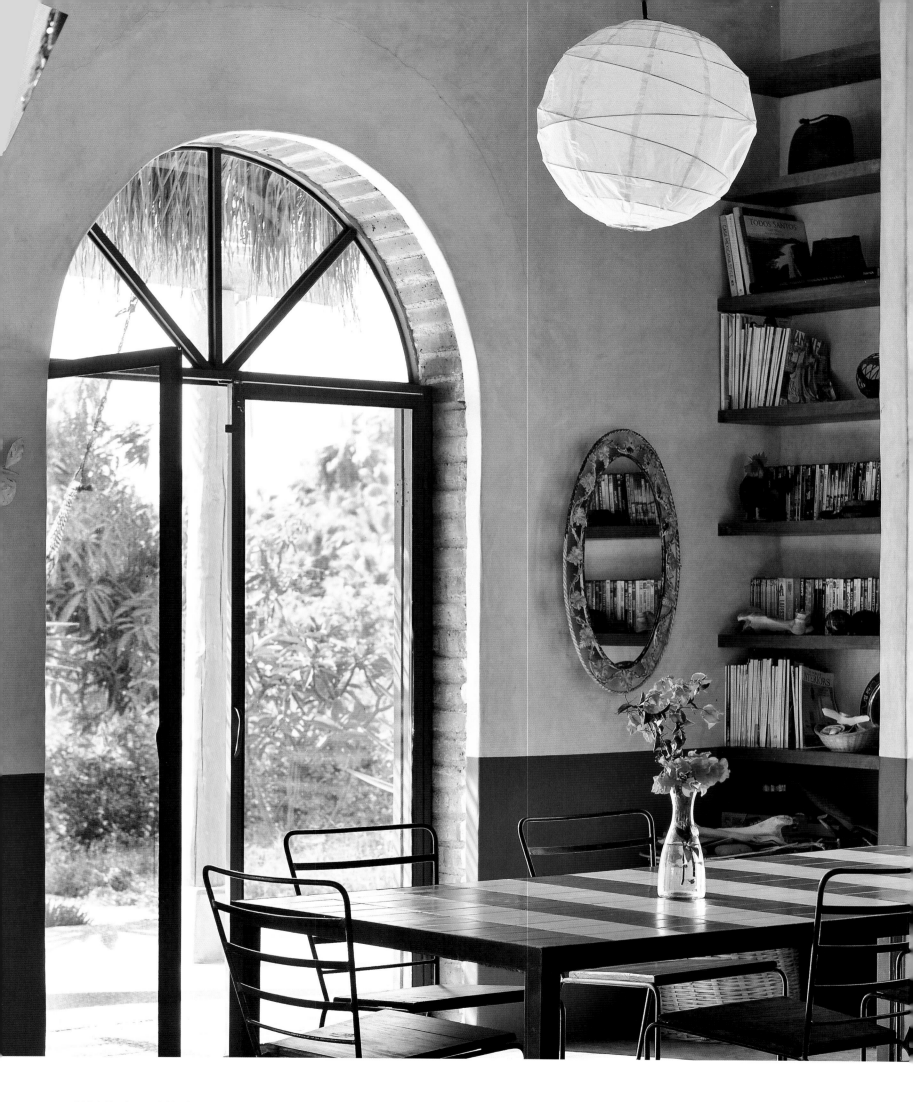

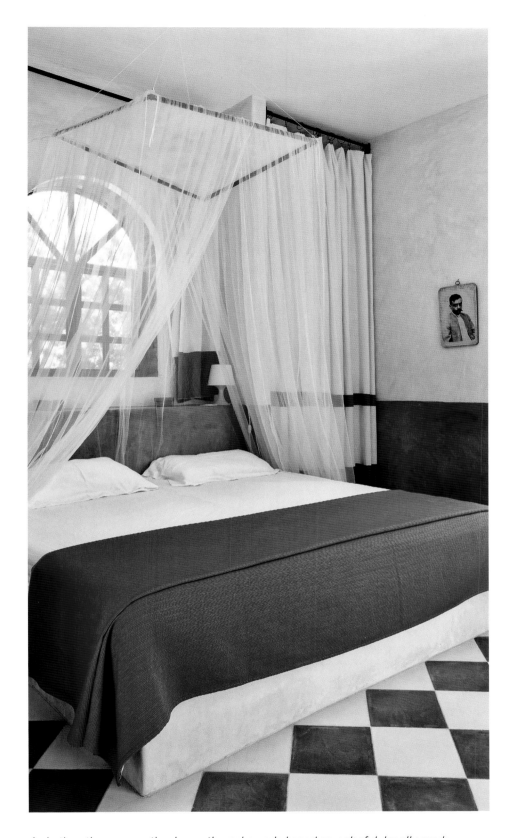

As in the other rooms, the decorative scheme is based on colorful, locally-made floor tiles laid on the diagonal with a painted band in the same color surrounding the room at chair rail height.

*Das dekorative Konzept des ganzen Hauses basiert auf bunten, lokal hergestellten Bodenfliesen, die diagonal verlegt wurden, und einem breiten Wandstreifen in derselben Farbe, der hüfthoch nach oben reicht.*

*Comme dans les autres pièces, la décoration s'appuie sur des dalles colorées locales disposées en diagonale et une bande de même couleur à mi-hauteur tout autour de la pièce.*

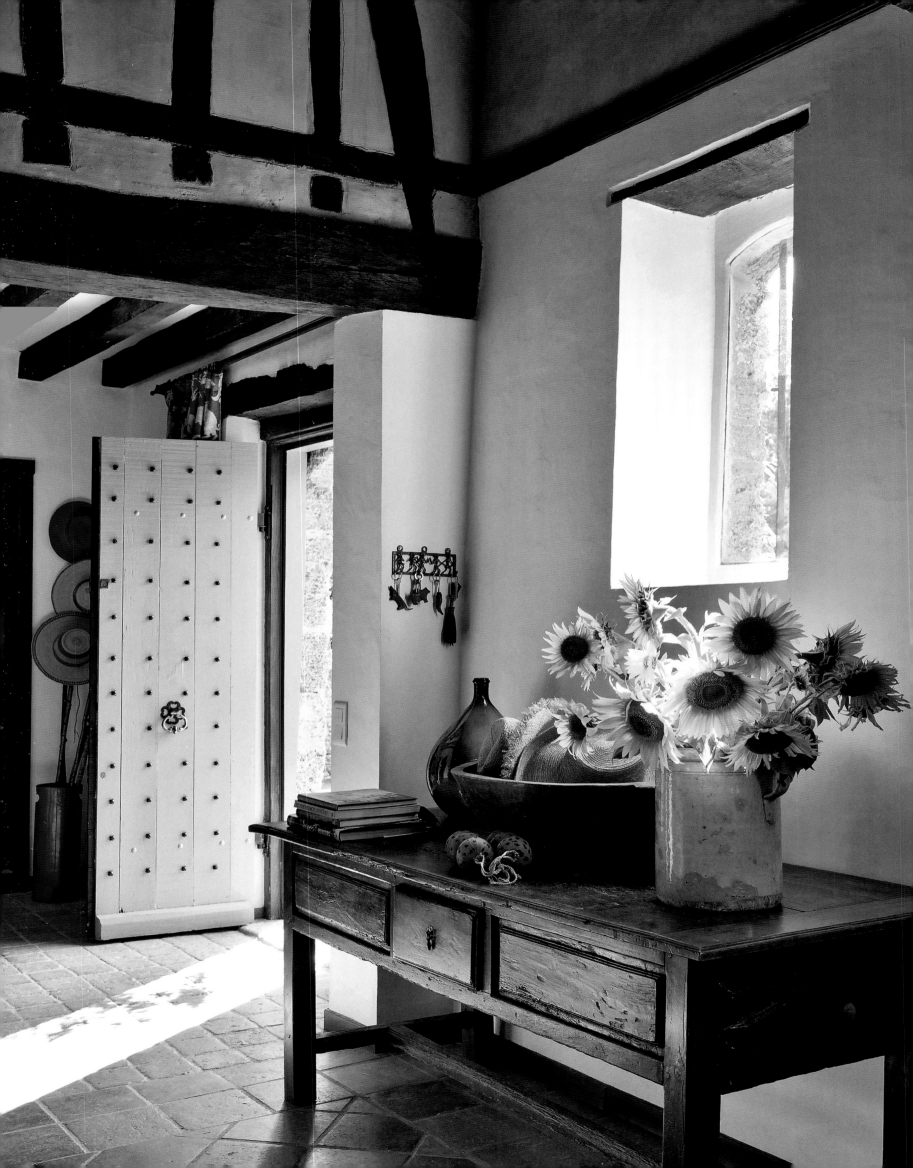

# Sweet Retreat
## Armagnac, France

AFTER DRAWING UP a wish list for a country house where they could relax and spend time outdoors, London-based interiors consultant Jane Slemeck and her husband, Mark, decided they'd get more for their money in France and lined up a visit to tour some houses in Gascony. By day two, after peering past a pair of metal entrance gates, Jane could see that she had found what they were looking for in La Forêt—a collection of stone and half-timbered structures, some dating from the 1600s, with a shaded terrace and a large courtyard. Its previous owner had haphazardly modernized parts of the house, but it was in desperate need of some TLC. So Jane enlisted the help of Josephine Ryan, a London-based dealer of French provincial furniture, and the two set off on a thrilling trawl through the antiques fairs of Southern France and assembled a collection of antique French furniture that looks tailor-made for the grand proportions of what is now the family's understated yet enchanting rustic country house.

NACHDEM DIE WUNSCHLISTE für ihr Traumhaus auf dem Lande zum Relaxen und Entspannen fertig war, stellten die in London lebende Wohnberaterin Jane Slemeck und ihr Mann Mark fest, dass in Frankreich eher die Aussicht bestand, mit dem vorhandenen Budget fündig zu werden. So begaben sie sich auf Besichtigungstour in die Gascogne. Schon am zweiten Tag der Reise erblickten sie durch ein rostiges Metalltor hindurch etwas, das ihnen gefiel und das sie nun La Forêt nennen: eine Ansammlung von Stein- und Fachwerkgebäuden, manche aus dem 17. Jahrhundert, mit einer überdachten Terrasse und einem großen Hof. Der vorherige Besitzer hatte recht wahllos einige Bereiche modernisiert, doch das Anwesen benötigte dringend eine liebevolle Umgestaltung. Jane bat Josephine Ryan, die in London französische Landhausmöbel vertreibt, um Hilfe. Gemeinsam durchstreiften sie die Antiquitätenmärkte Südfrankreichs und stellten eine schöne Sammlung antiker Möbel zusammen, die perfekt zu den großzügig proportionierten Wohnräumen des rustikal-zurückhaltenden, charmanten neuen Landwohnsitzes der Slemecks passen.

AYANT DÉFINI LE cahier des charges de la maison où ils pourraient se détendre et passer du temps dehors, les conseillers en décoration d'intérieur londoniens Jane et Mark Slemeck ont conclu que la France répondait le mieux à leurs critères et ils ont entrepris de visiter des maisons en Gascogne. Poussant au deuxième jour un portail métallique, Jane a compris qu'ils avaient trouvé leur bonheur avec « La Forêt », un ensemble de structures de pierre à colombages, certaines datant des années 1600, avec une terrasse ombragée et une grande cour. L'ancien propriétaire avait modernisé comme il avait pu certaines parties, mais il restait beaucoup de travail. Jane s'est adjointe les services de Josephine Ryan, une marchande de mobilier français provincial établie à Londres. Elles ont écumé avec passion les brocantes du midi de la France et rapporté plusieurs meubles français anciens qui semblaient faits sur mesure pour les grands espaces de ce qui est désormais la maison de campagne discrète mais enchanteresse de la famille.

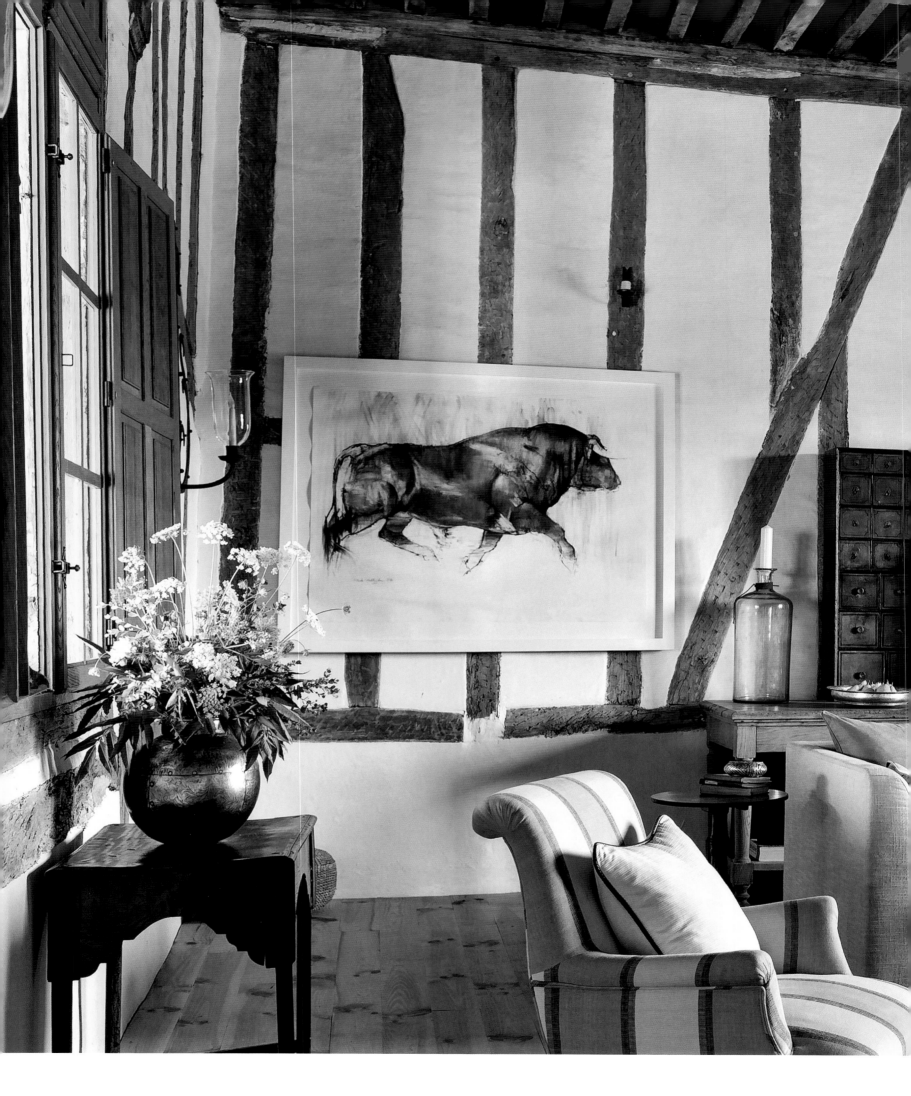

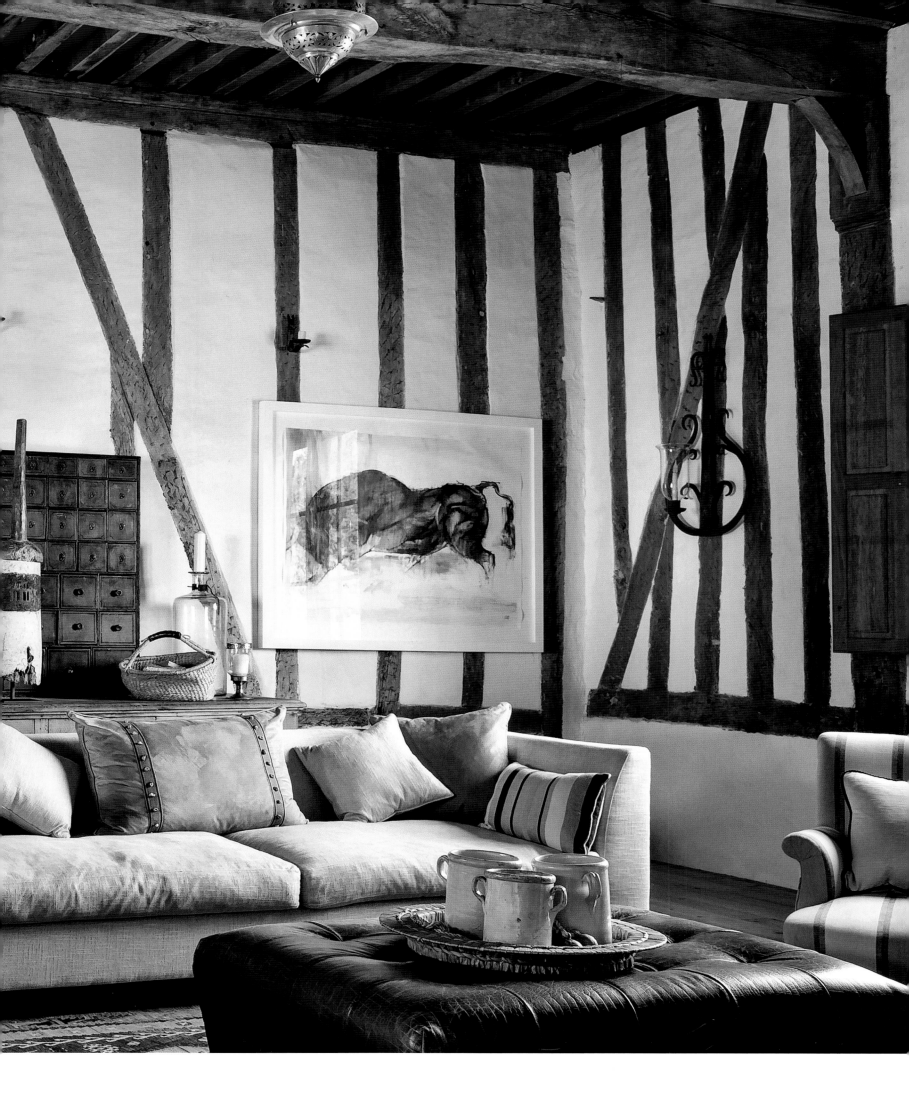

*Simplicity reigns throughout the interiors—from the terra-cotta tiled entrance hall to the timbered petit salon to the bedrooms, all of which are furnished with an unusual mix of ethnic and traditional French antiques.*

*Die Ausstattung der Räume ist durchgängig schlicht gehalten – von den Terrakotta-Fliesen der Eingangshalle über die Holzdielen des petit salon bis hin zu den Schlafzimmern, die alle mit einer ungewöhnlichen Mischung aus ethnischen und traditionellen französischen Antiquitäten eingerichtet sind.*

*Les intérieurs empreints de simplicité – du hall d'entrée en dalles de terre cuite aux chambres, en passant par le petit salon à colombages –, associent de manière singulière meubles ethniques et meubles français anciens.*

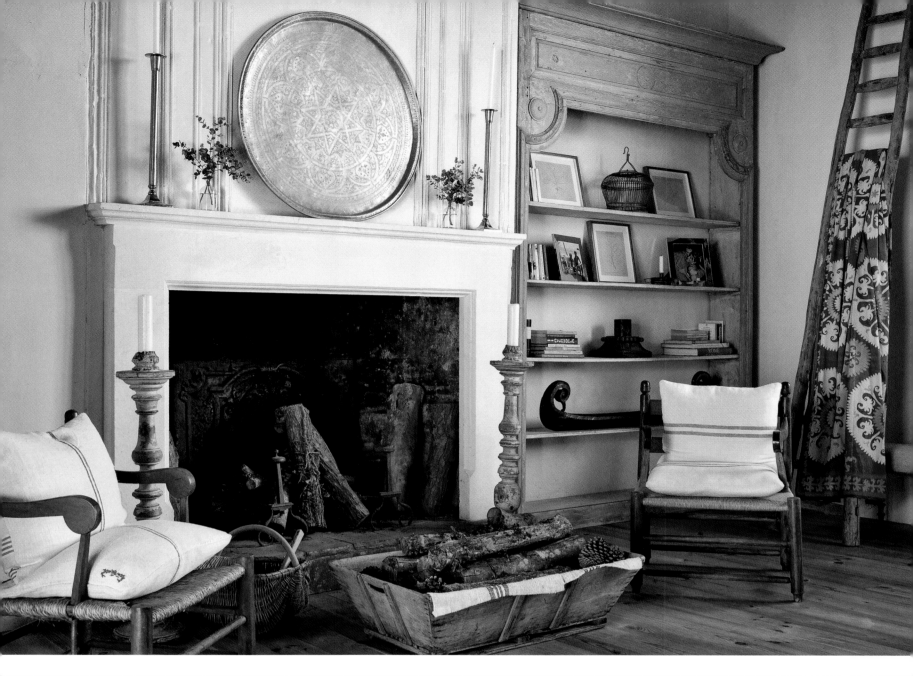
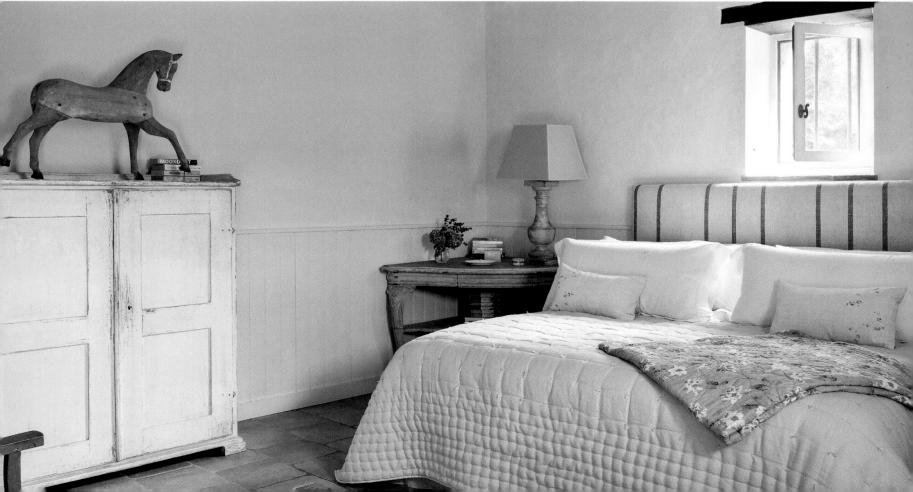

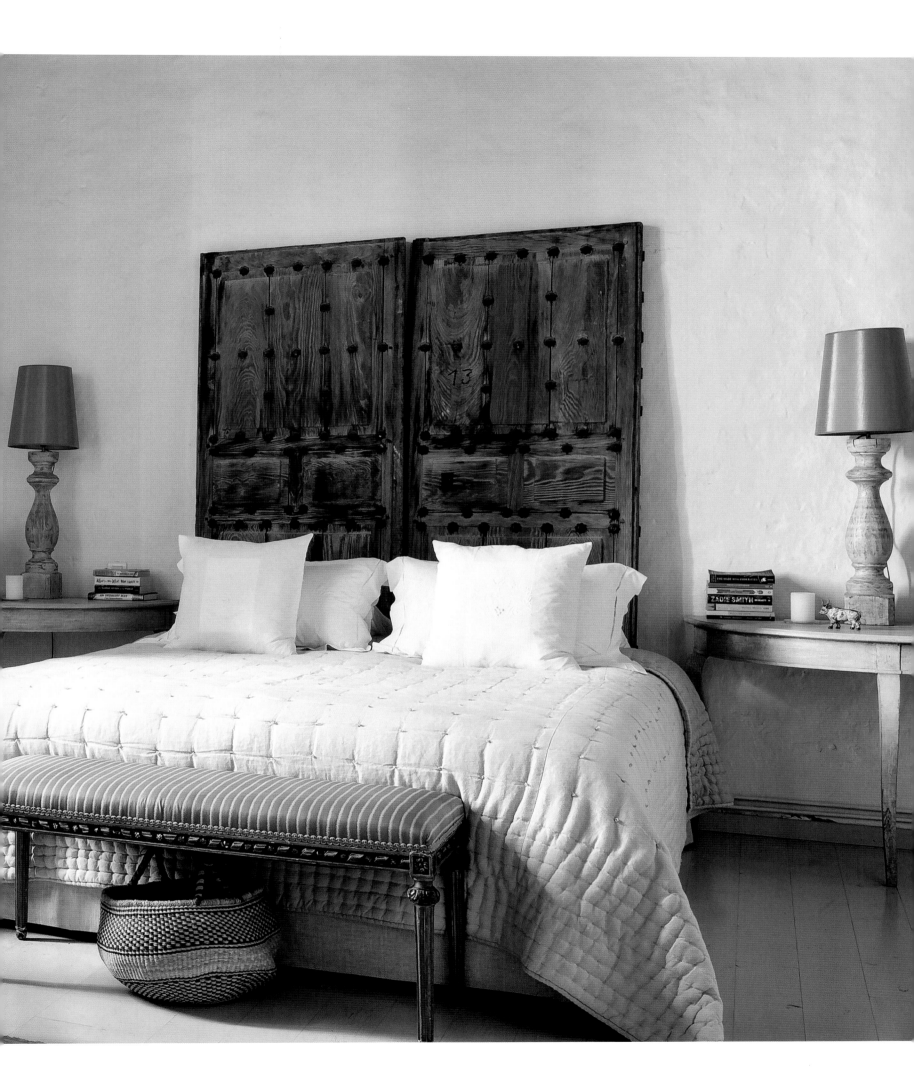

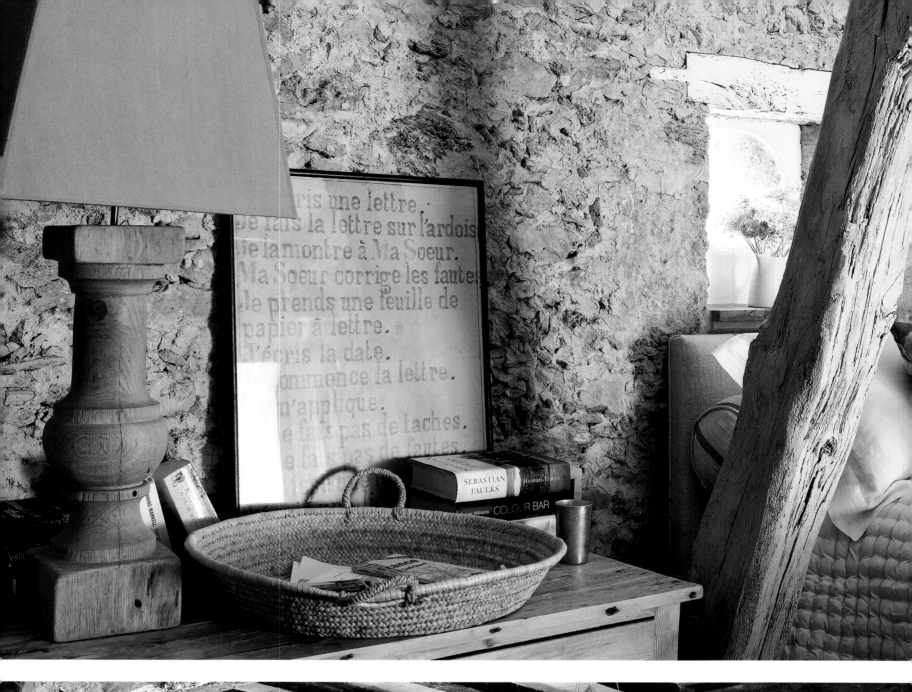

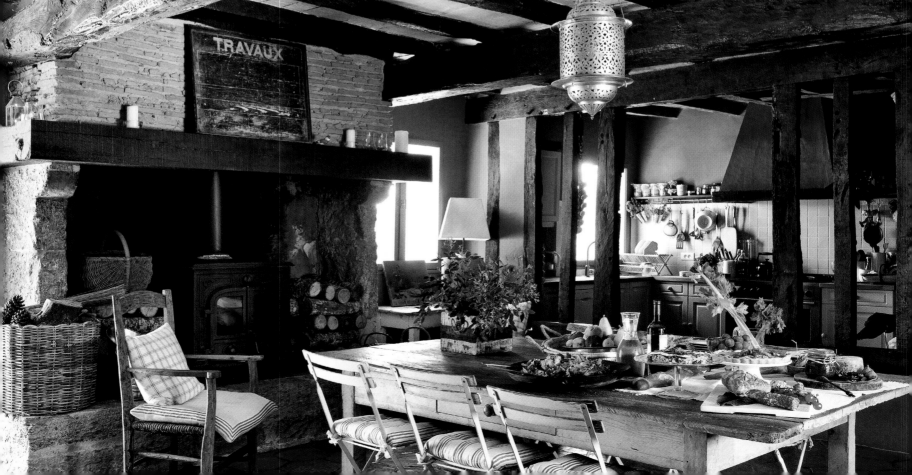

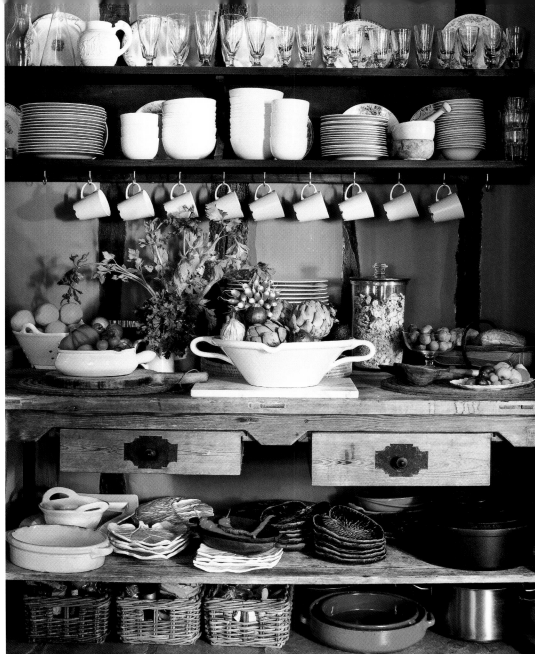

A pair of weathered Basquaise doors now form the impressive headboard in the master bedroom (previous spread). All of the walls are white, except in the kitchen, which was painted a color that Jane describes as "crushed damson."

*Zwei verwitterte baskische Türen bilden im Hauptschlafzimmer das imposante Kopfbrett (vorherige Seite). Alle Wände sind weiß, nur die Küche wurde in einer Farbe gestrichen, die Jane Slemeck als „zerdrückte Zwetschge" bezeichnet.*

*Deux portes basques patinées forment l'impressionnante tête de lit de la chambre de maître (double page précédente). Tous les murs sont blancs, sauf dans la cuisine, qui est peinte dans une couleur que Jane a baptisé « prune écrasée ».*

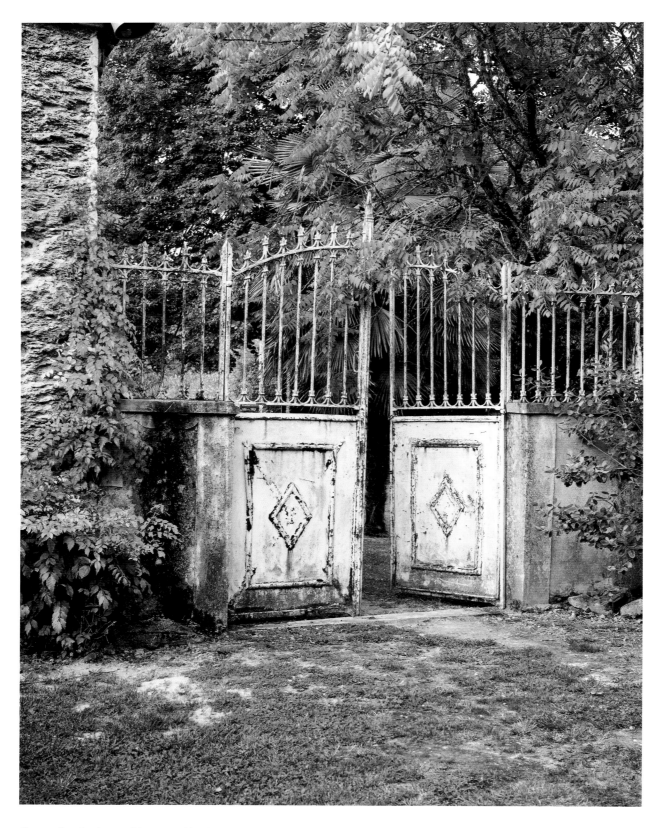

*Conveniently situated just outside the kitchen, a table in a shaded corner beneath the pergola is laid for a leisurely dejeuner.*

*Praktisch direkt vor der Küche gelegen, ist in einer schattigen Ecke unter der Pergola ein Tisch zum informellen* dejeuner *gedeckt.*

*Commodément située juste à l'extérieur de la cuisine, une table est dressée dans une partie ombragée de la pergola pour déjeuner paisiblement.*

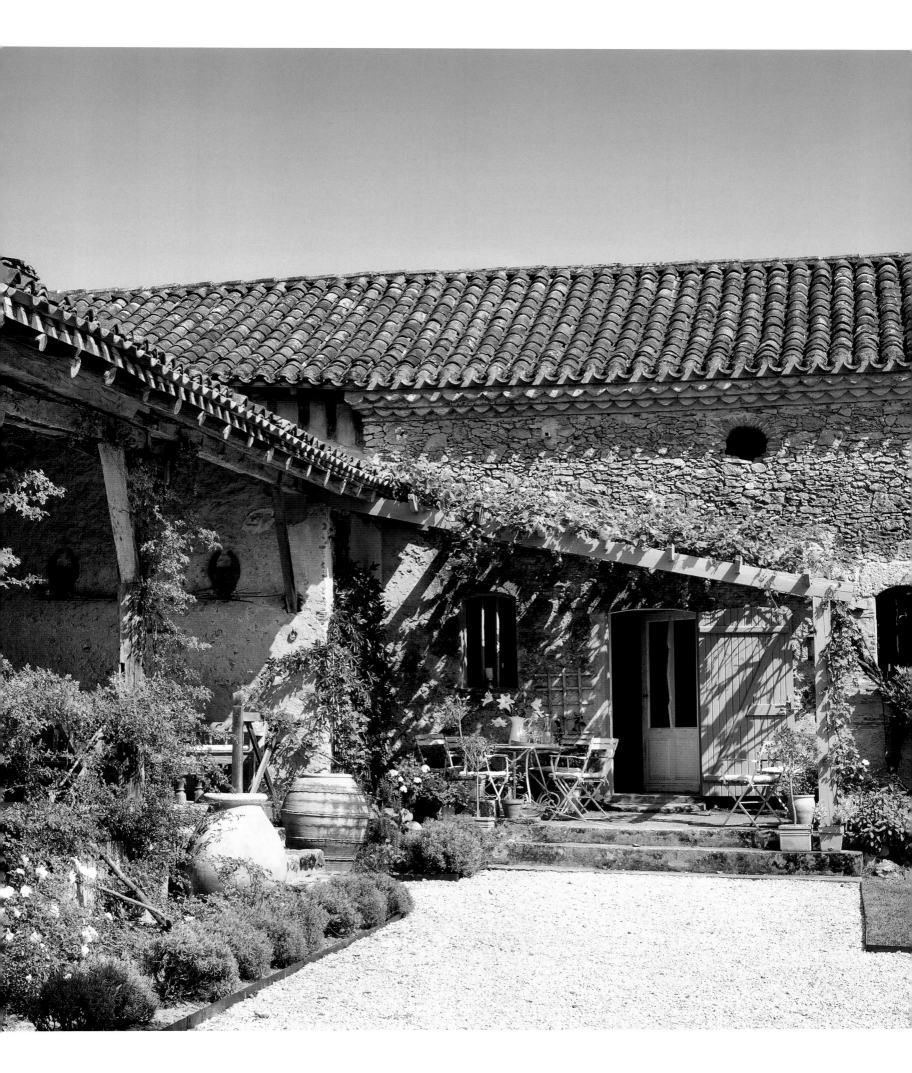

# A Dream Come True
## Umbria, Italy

AFTER STUMBLING UPON the ruins of a 16th-century stone farmhouse while walking through the hills above Città di Castello, artist Andrea Tana experienced what she describes as a "lunatic vision." Surveying the magical view of rolling Umbrian hills across a field of sunflowers, she decided this was the place where she wanted to live and work. So Andrea tracked down the owner of the house, who turned out to be a local priest, and swiftly came to terms to purchase it. She found a reliable *geometra*— a combination contractor, structural engineer, and surveyor—who added plumbing, electricity, hot water, and central heating to the house while preserving its historic integrity. The restored barn became Andrea's studio. Her daughter, Katerina, an interior designer, was enlisted to plan the layout of the guest accommodation on the lower floor. Since moving into the home, now known as Casale, Andrea Tana has been quick to form bonds with her neighbors, validating her madcap dream to start life anew in the Italian countryside.

ALS DIE KÜNSTLERIN Andrea Tana durch Zufall bei einem Spaziergang in den Hügeln oberhalb von Città di Castello auf die Ruinen eines Bauernhauses mit Steingemäuer aus dem 16. Jahrhundert stieß, hatte sie eine „verrückte Vision". Den bezaubernden Blick auf die sanften umbrischen Hügel jenseits eines Sonnenblumenfelds vor Augen, beschloss sie an Ort und Stelle, von nun an genau hier zu leben und zu arbeiten. Andrea spürte den Besitzer des Hauses auf, einen Priester aus dem Ort, und wurde schnell mit ihm handelseinig. Sie fand einen zuverlässigen *geometra* - eine Kombination aus Bau-unternehmer, Bauingenieur und Vermessungstechniker -, der Sanitäranlagen, Strom, heißes Wasser und eine Zentralheizung installierte, ohne die historische Integrität des Hauses zu beschädigen. Die restaurierte Scheune, wurde zu Andreas Atelier. Ihre Tochter Katerina, eine Innenarchitektin, plante anschließend die Ausgestaltung des Gäste-bereichs im Erdgeschoss. Inzwischen ist ihr neues Zuhause unter dem Namen Casale bekannt, und Andrea Tana hat sich mit ihren Nachbarn angefreundet. Aus ihrer verrückten Vision vom Leben auf dem Lande wurde ein erfolgreicher Neustart.

TOMBÉE PAR HASARD sur les ruines d'un mas en pierres du XVIe siècle en traversant les collines surplombant Città di Castello, l'artiste peintre Andrea Tana a connu ce qu'elle décrit comme une « folle vision ». Scrutant la vision magique des ondoyantes collines ombriennes à travers un champ de tournesols, elle a décidé que c'était l'endroit où elle voulait vivre et travailler. Andrea a cherché le propriétaire du mas, un prêtre de la région qu'elle a rapidement convaincu de lui vendre ce bien. Elle a trouvé un *geometra* fiable, à la fois entrepreneur, architecte et métreur, qui a installé la plomberie, l'électricité, l'eau chaude et le chauffage central au mas tout en préservant son intégrité historique. La grange restaurée est devenue l'atelier d'Andrea. Elle a fait appel à sa fille, Katerina, architecte d'intérieur, pour dessiner les plans de l'espace destiné aux invités à l'étage inférieur. Depuis son arrivée à la Casale, Andrea Tana s'est vite liée d'amitié avec ses voisins, réalisant ainsi son rêve insensé de refaire sa vie dans la campagne italienne.

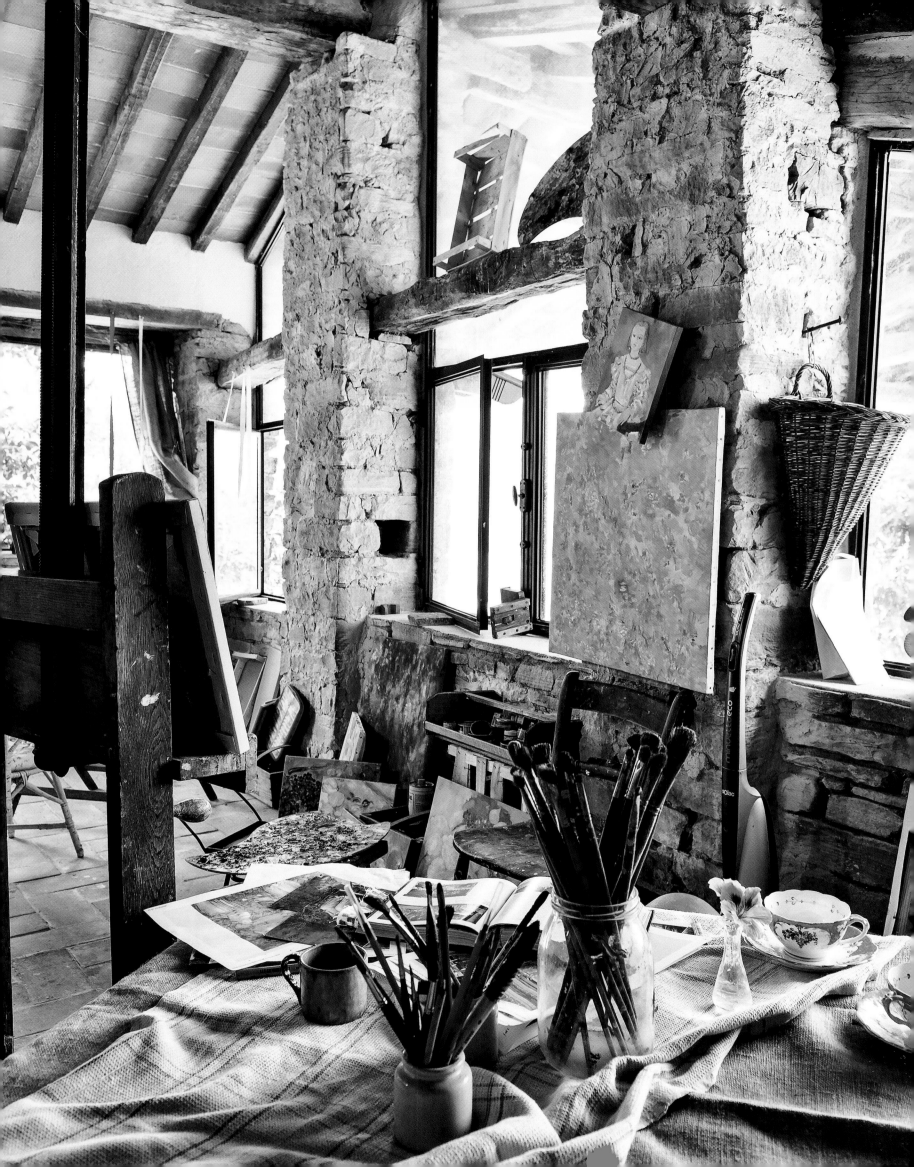

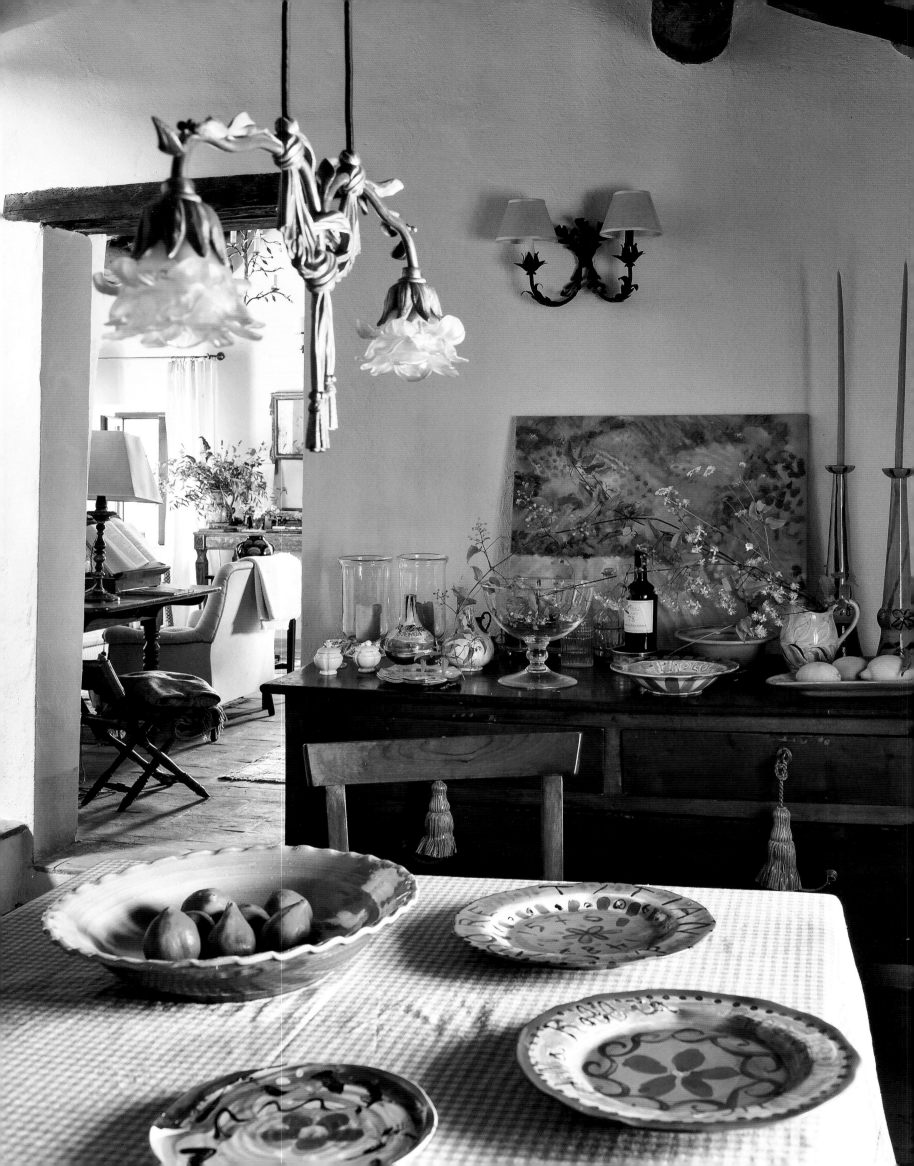

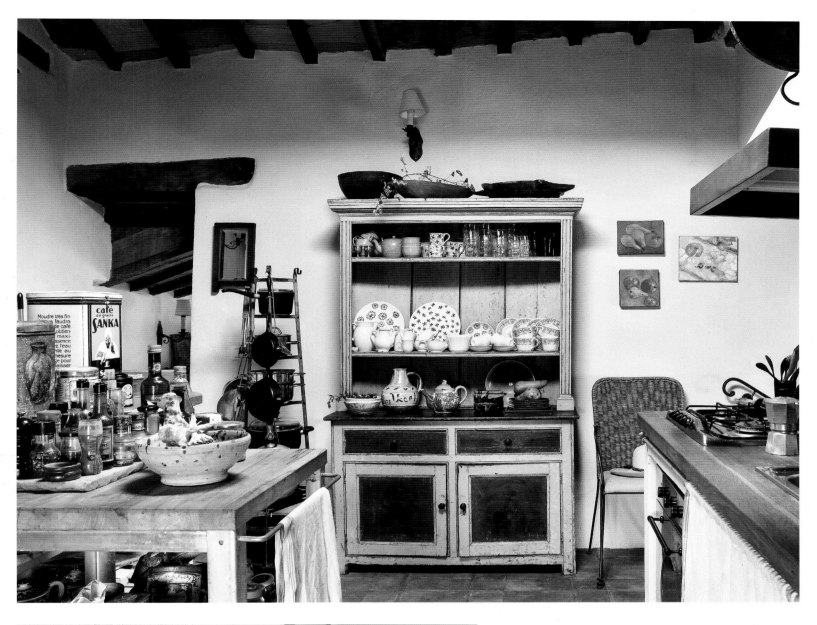

The barn on the property was restored and reinforced with new windows and converted into the artist's studio (opening page). The restoration was completed in several stages, starting with the upper level where the living room, dining room, kitchen, and main bedroom and bathroom are now located.

Die zum Anwesen gehörende Scheune wurde restauriert, mit neuen Fenstern ausgestattet und in ein Künstleratelier umgewandelt (Einstiegsseite). Die Restaurierungsarbeiten fanden in mehreren Stufen statt, angefangen beim oberen Stockwerk, wo sich jetzt Wohn- und Esszimmer, Küche, Hauptschlafzimmer und Bad befinden.

Restaurée et agrémentée de nouvelles fenêtres, la grange est devenue l'atelier de l'artiste (page précédente). Les travaux ont été réalisés par étapes, en commençant par le niveau supérieur où sont maintenant situés le salon, la salle à manger, la cuisine et la principale chambre avec salle de bains.

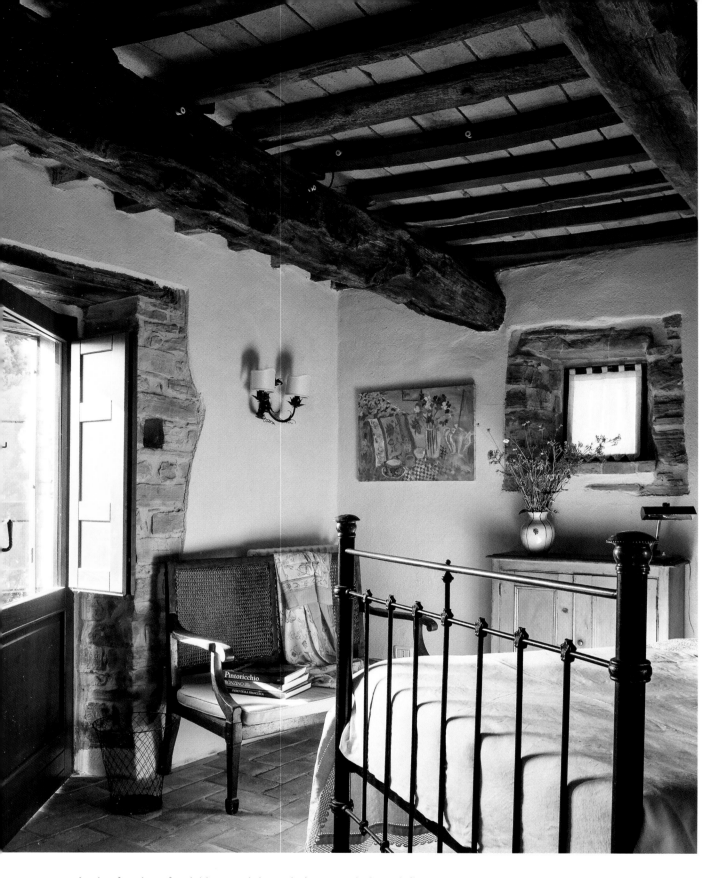

A mix of antique furnishings and the artist's own paintings define
the living and sleeping spaces with warmth and relaxed character.

*Eine Mixtur aus antiken Möbeln und eigenen Bildern der Künstlerin verleihen
den Wohn- und Schlafräumen eine warme und entspannte Atmosphäre.*

*L'association entre meubles anciens et peintures de l'artiste donne aux
espaces de vie et de repos un caractère chaleureux et décontracté.*

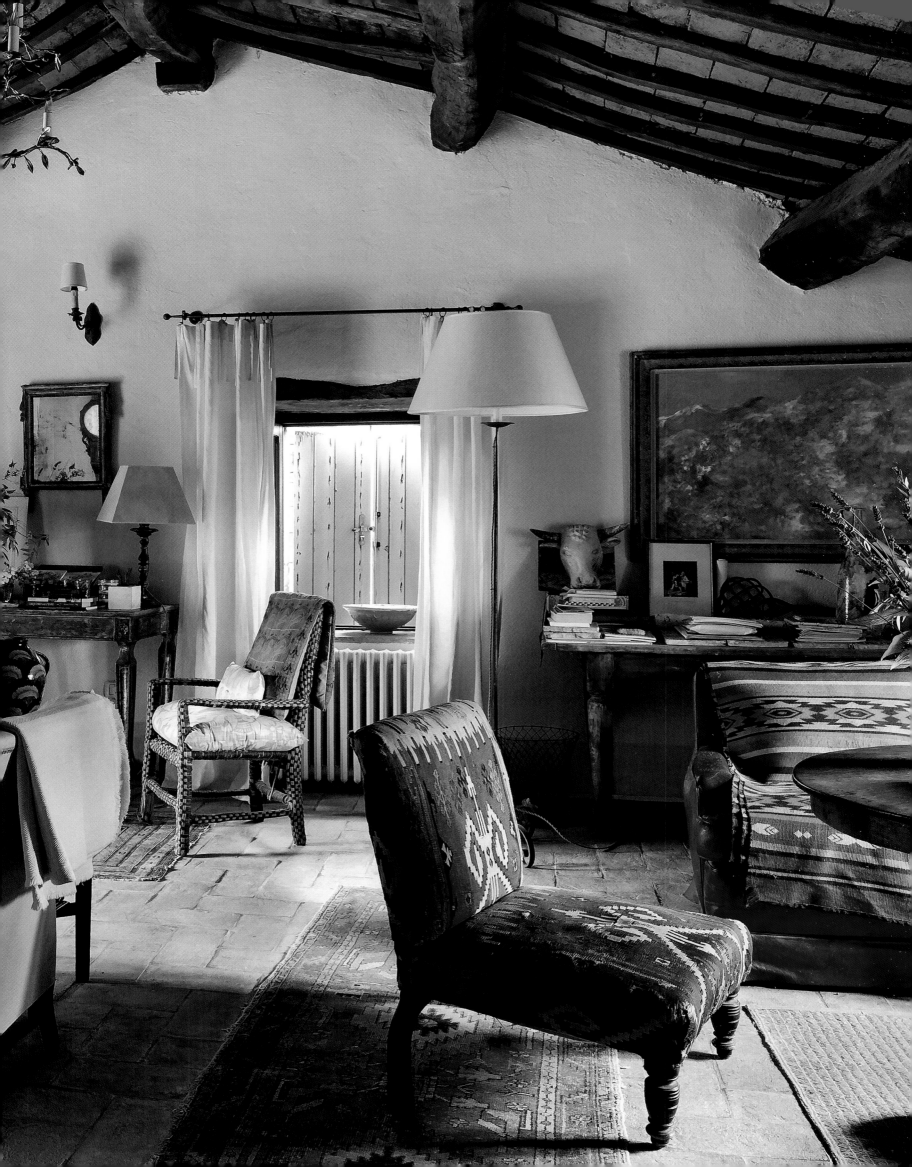

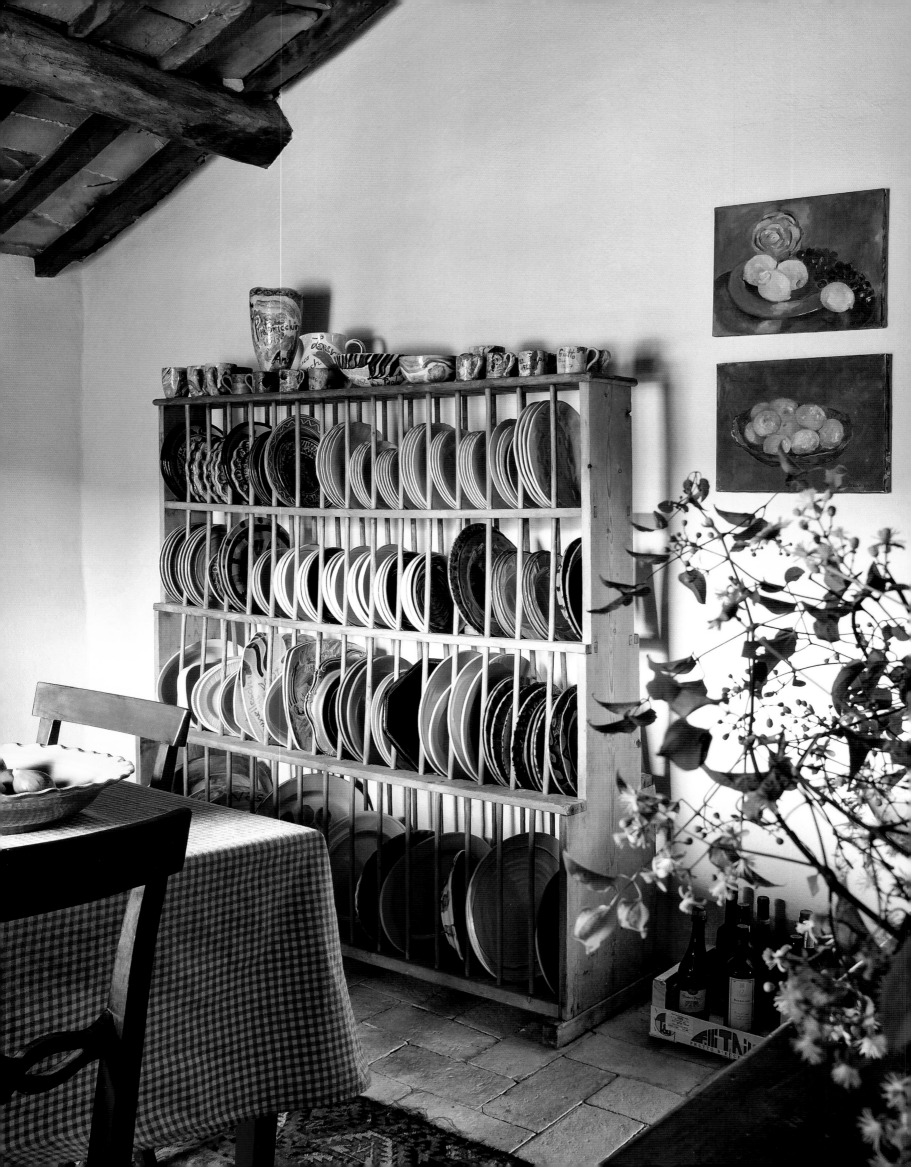

After moving into her home, Andrea met Sandra Baldinelli of Netas, an exporter of ceramic tableware worldwide, who offered to fire and glaze designs the artist produces. A collection of favorite pieces is stowed at one end of the dining room.

Nachdem sie in ihr neues Zuhause eingezogen war, lernte Andrea Tana Sandra Baldinelli von der Firma Netas, einem internationalen Exporteur von Keramikgeschirr, kennen. Sie bot an, die Entwürfe der Künstlerin zu brennen und zu glasieren. Eine Kollektion ihrer Lieblingsstücke wird an einem Ende des Esszimmers aufbewahrt.

Une fois installée, Andrea a rencontré Sandra Baldinelli de Netas, exportateur international de vaisselle céramique. Celle-ci lui a proposé de réaliser la cuisson et le glaçage de ses créations. Ses pièces préférées sont stockées dans un coin de la salle à manger.

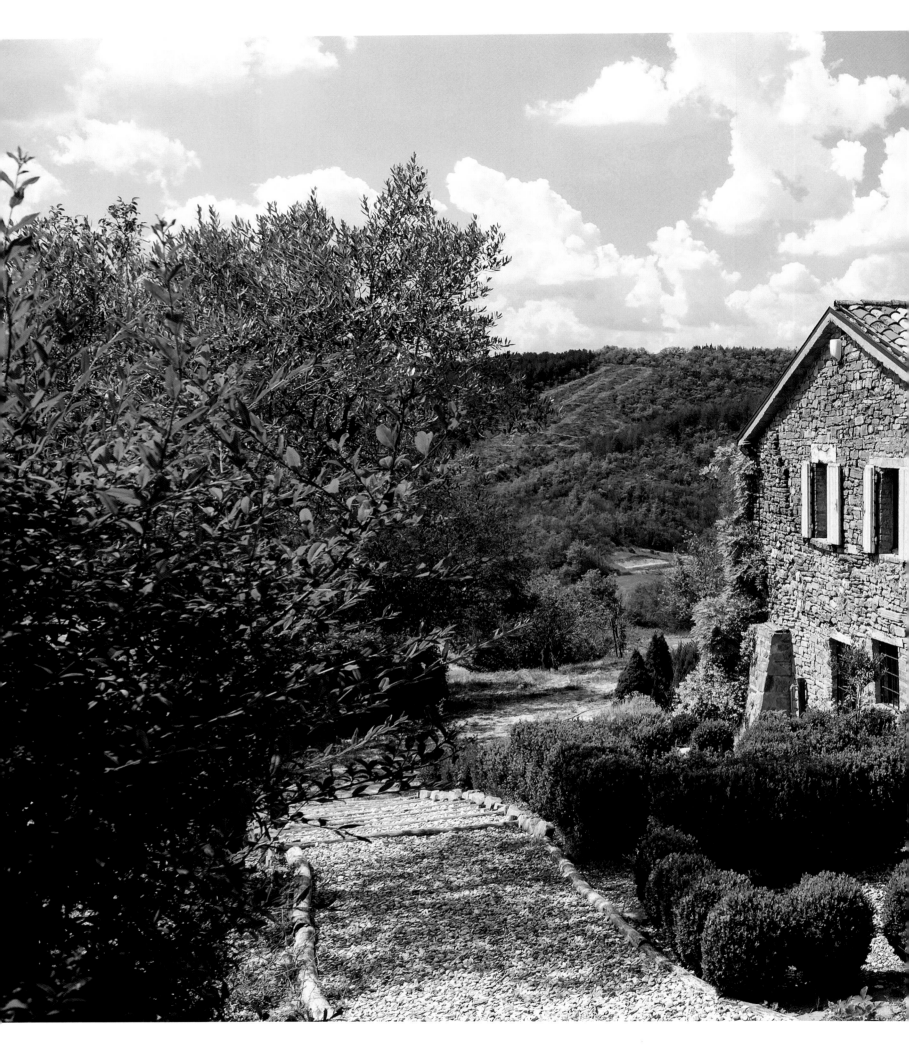

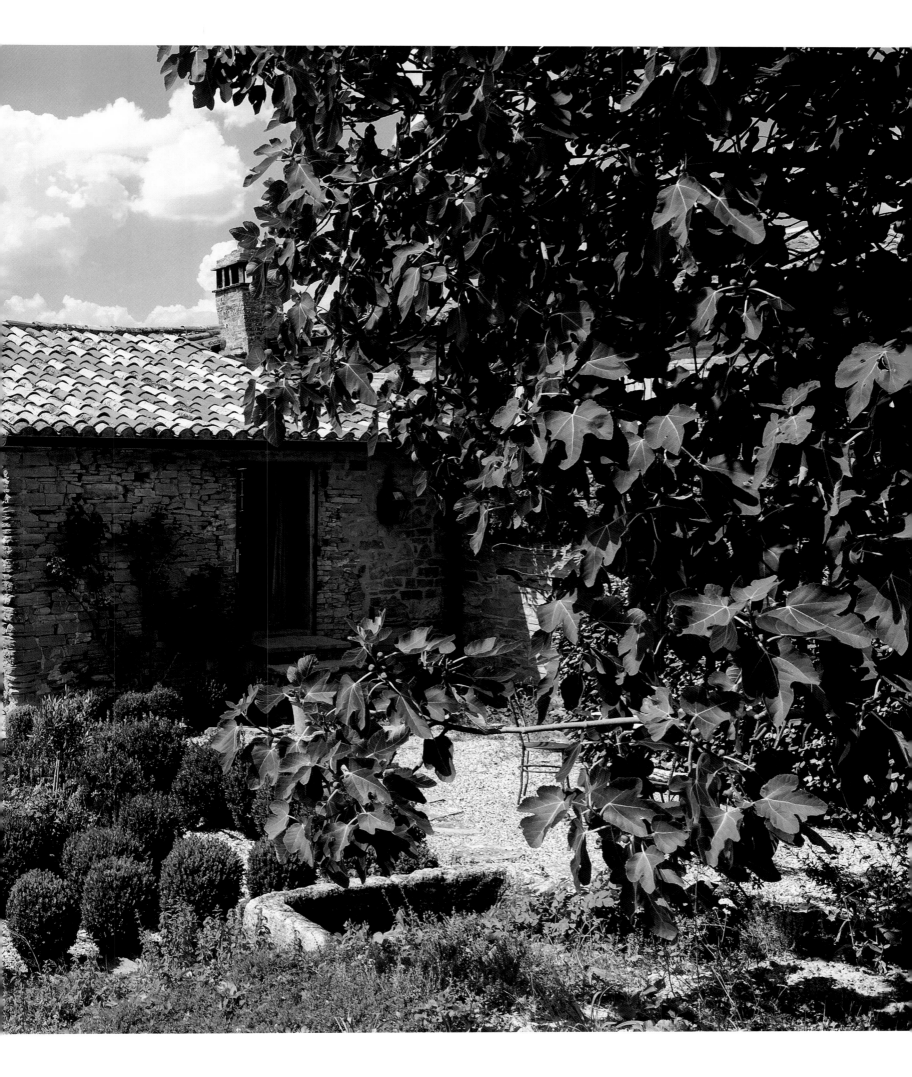

# An Artist's Fairyland
## Texas, USA

NOT UNLIKE HER ethereal paintings, the interiors of the circa 1900 cottage of Texan-born artist Salle Werner Vaughn evoke a dreamy quality that seem to transport all who visit to another time and place. For the artist, the fanciful atmosphere was entirely by design. She and her husband slowly transformed the house, giving it the air of a Russian dacha. Situated in an area of Houston known as Magnolia Grove, the cottage, along with several others she later acquired, is built around wood frames and balanced on stone foundations, which keep them cool in the hot climate. In the one she shares with her husband, she created an otherworldly atmosphere by painting walls and floors of rooms in colors and patterns that elicit specific moods that echo her paintings. The couple's collection of odd, exquisite *objets*—such as a tiny yellow marble sculpture of a Roman legionnaire or a pair of 500-year-old Italian chairs—enhance the transcendental ambience.

DIE AUSSTRAHLUNG, die Salle Werner Vaughns transzendente Gemälde haben, lässt sich auch in den Räumen ihres um 1900 erbauten Hauses spüren. Besucher fühlen sich gleichermaßen in eine andere Zeit und an einen anderen Ort versetzt. Salle und ihr Mann haben das Haus ganz allmählich nach ihrem Geschmack verwandelt und ihm die Anmutung einer russischen Datscha verliehen. Das Landhaus liegt in Magnolia Grove, einem idyllischen Viertel von Houston. Es ist, wie auch einige andere Häuser die sie später in der Nähe erwarb, mit Holz verkleidet und steht auf Steinsockeln, die in dem heißen Klima für Abkühlung sorgen. Indem sie die Wände und Böden in Farben und Mustern bemalte, die ganz bestimmte Stimmungen hervorrufen und an ihre Bilder erinnern, schuf die Künstlerin eine fast magische Atmosphäre. Ausgewählte kuriose und exquisite *objets* des Paares – zum Beispiel die winzige gelbe Skulptur eines römischen Legionärs oder zwei 500 Jahre alte italienische Stühle – verstärken noch das Gefühl, sich jenseits von Zeit und Raum zu befinden.

COMME SES TABLEAUX, les intérieurs de la petite maison 1900 de l'artiste texane Salle Werner Vaughn évoquent une atmosphère onirique qui semble transporter les visiteurs à une autre époque. L'ambiance éthérée est voulue par l'artiste. Avec son époux, ils ont patiemment modifié la maison pour lui donner un air de datcha russe. Située dans le quartier de Magnolia Grove, celle-ci s'articule, comme nombre de leurs autres maisons, autour d'une structure en bois portée par des fondations de pierre conservant la fraîcheur sous ce climat chaud. Vivant dans celle-ci avec son mari, elle a créé une atmosphère mystique grâce aux murs et planchers des chambres peintes de couleurs et motifs qui suscitent des ambiances faisant écho à ses peintures. Leur collection d'objets étranges et raffinés – dont une statuette en marbre jaune d'un légionnaire romain et deux chaises italiennes vieilles de 500 ans – renforcent cette ambiance qui nous transcende.

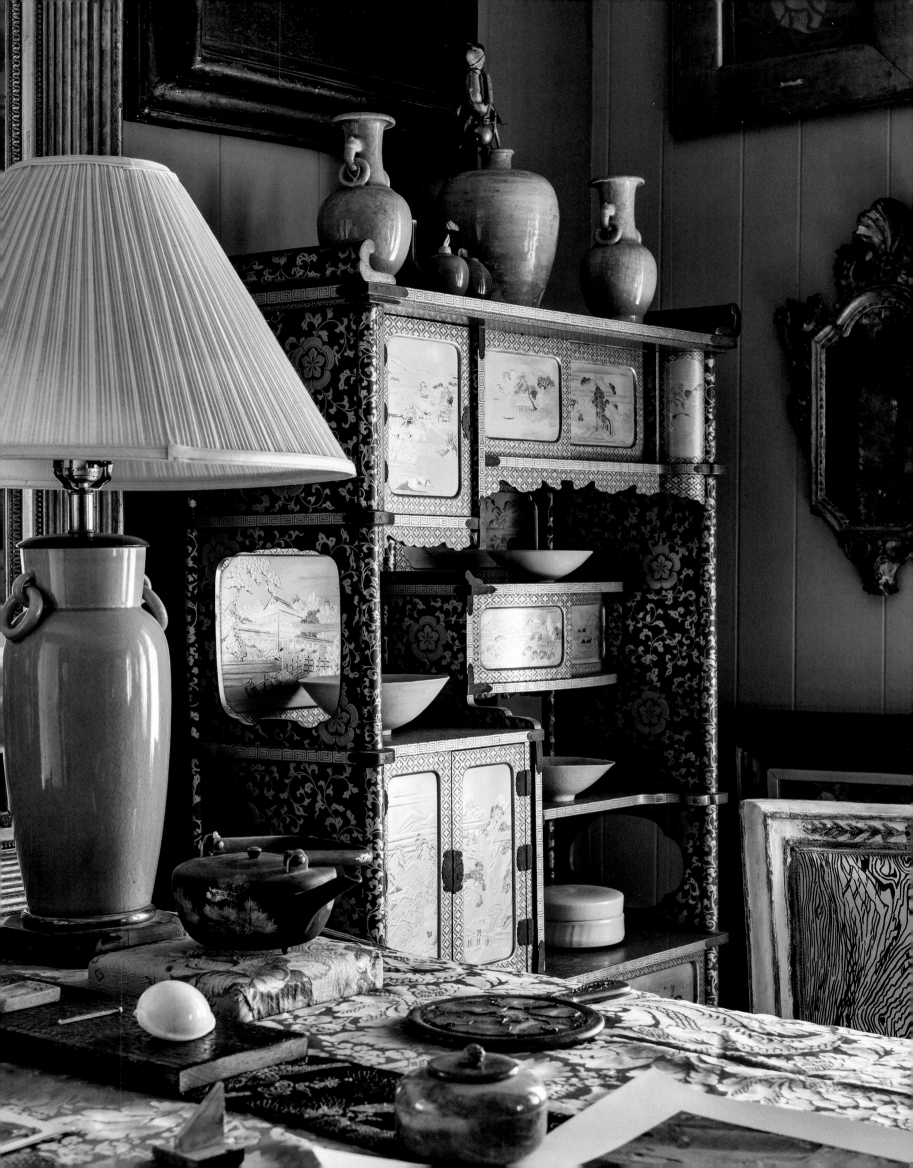

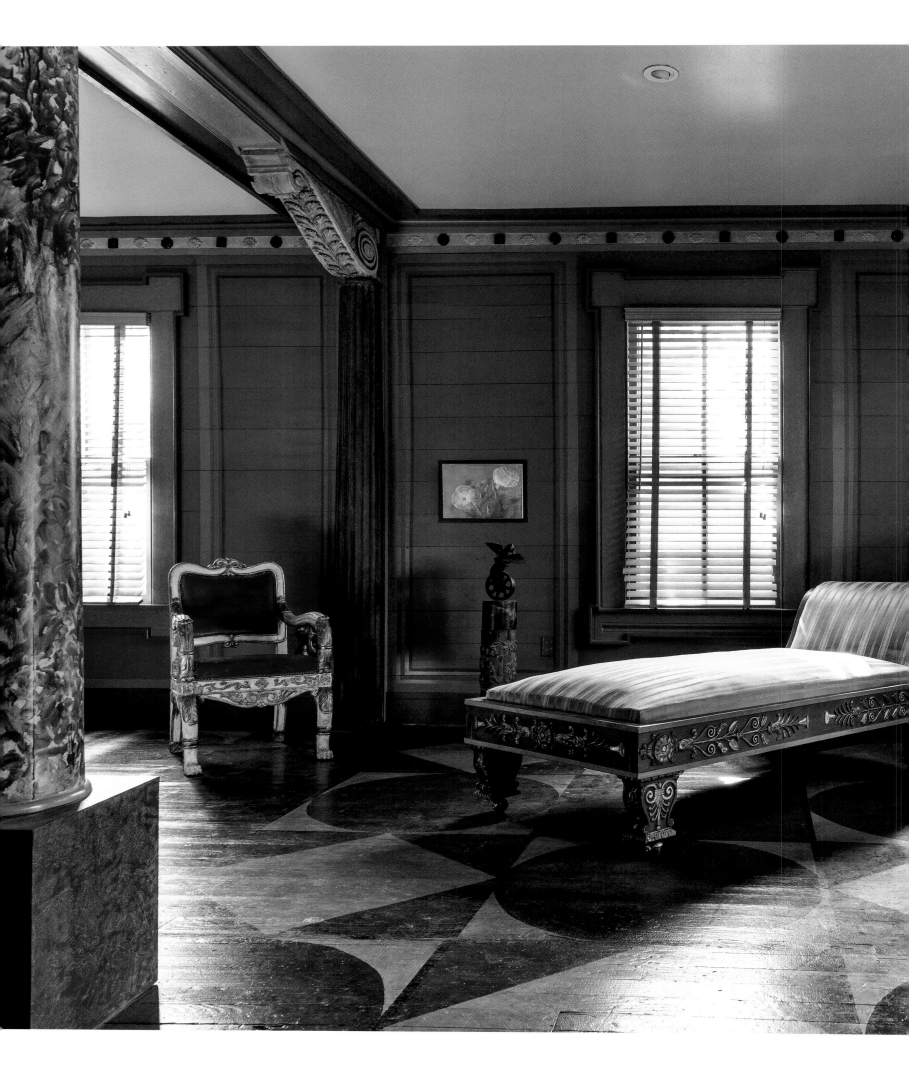

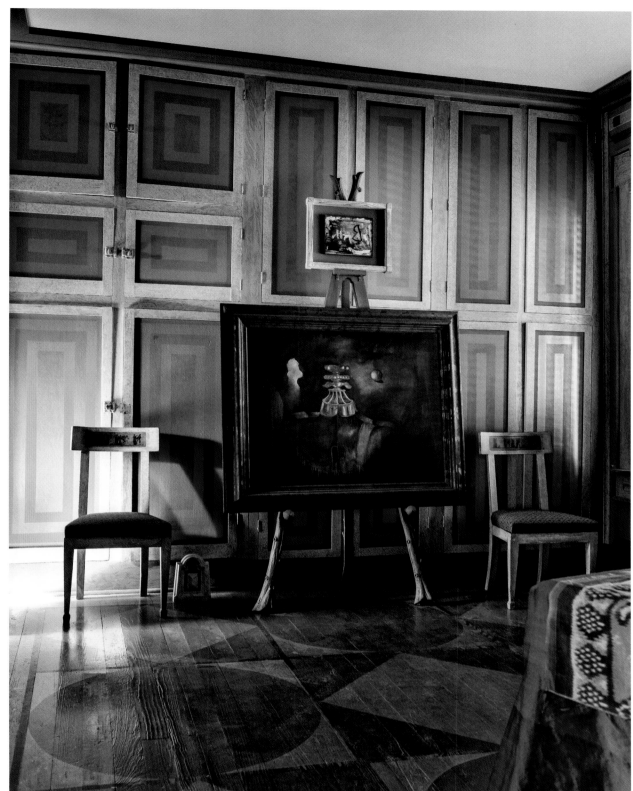

The main room in the second of Salle's cottages, used as a gallery, is inspired by the colors and designs of Pompeii, including a chaise longue—perhaps a Hollywood prop—she refers to as a "humble piece."

Der als Galerie verwendete Hauptraum ihres zweiten Hauses ist von den Farben und Mustern Pompejis inspiriert. Blickfang ist hier eine Chaiselongue - vielleicht eine Hollywood-Requisite -, die Salle Werner Vaughn als „bescheidenes Möbelstück" bezeichnet.

La pièce principale de la deuxième maison de campagne de Salle, qui sert de galerie, est marquée par des couleurs et objets de Pompéi, dont une chaise longue - peut-être un accessoire hollywoodien - pour Salle « un objet plein d'humilité ».

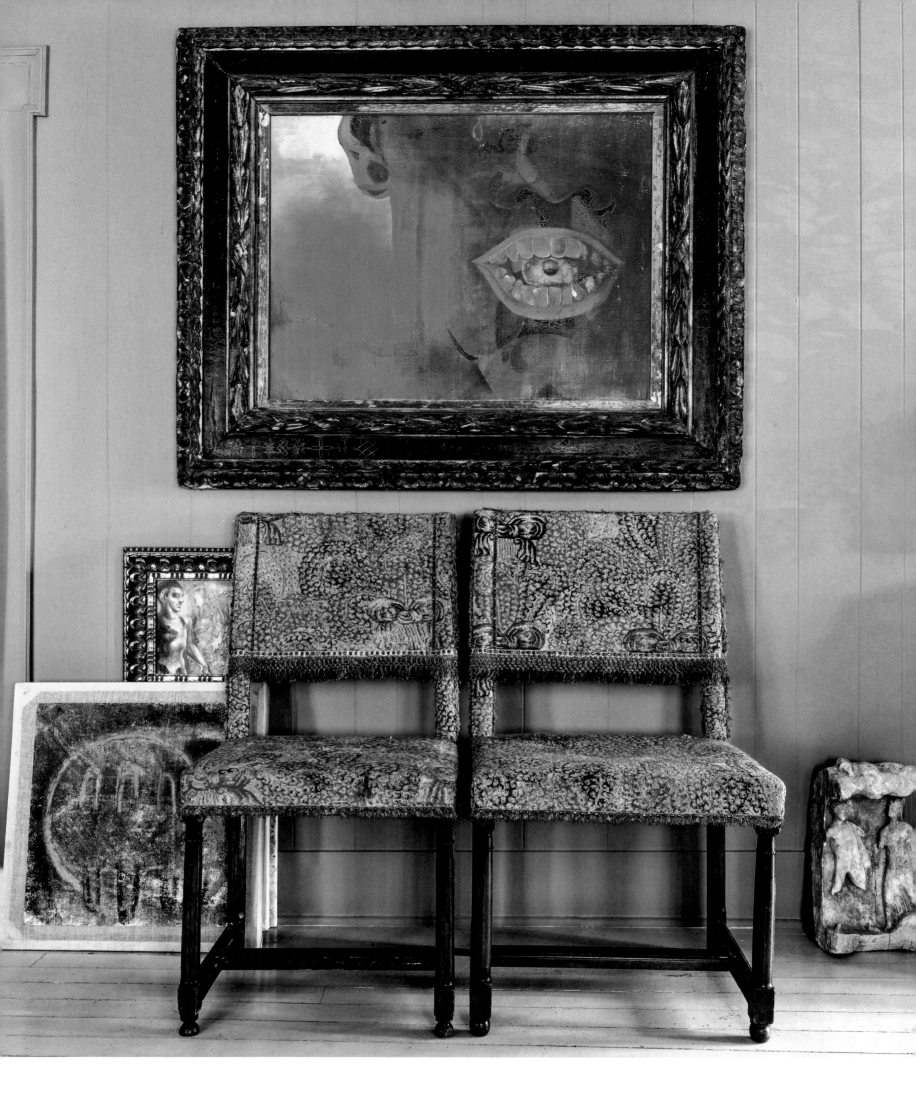

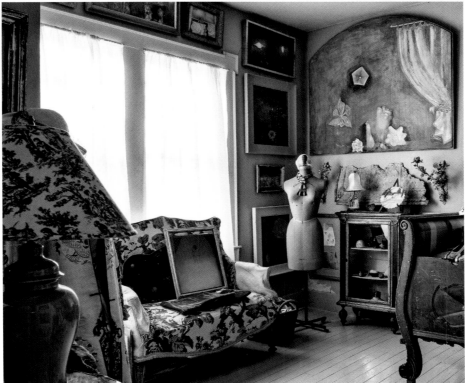

Salle says chairs are one of her signatures—"they express so much about their users."
Fascinating architectural, sculpture fragments, and art pieces can be seen in every room.

Für die Hausherrin haben Stühle eine besondere Bedeutung, denn „sie drücken so viel
über ihre Benutzer aus". Faszinierende architektonische und skulpturale Fragmente
sowie Kunstwerke finden sich in jedem Zimmer.

Les chaises sont pour Salle l'une de ses signatures, car « elles en disent beaucoup sur
leurs utilisateurs ». Chaque pièce contient des fragments d'architecture et de sculpture,
ainsi que des objets d'art.

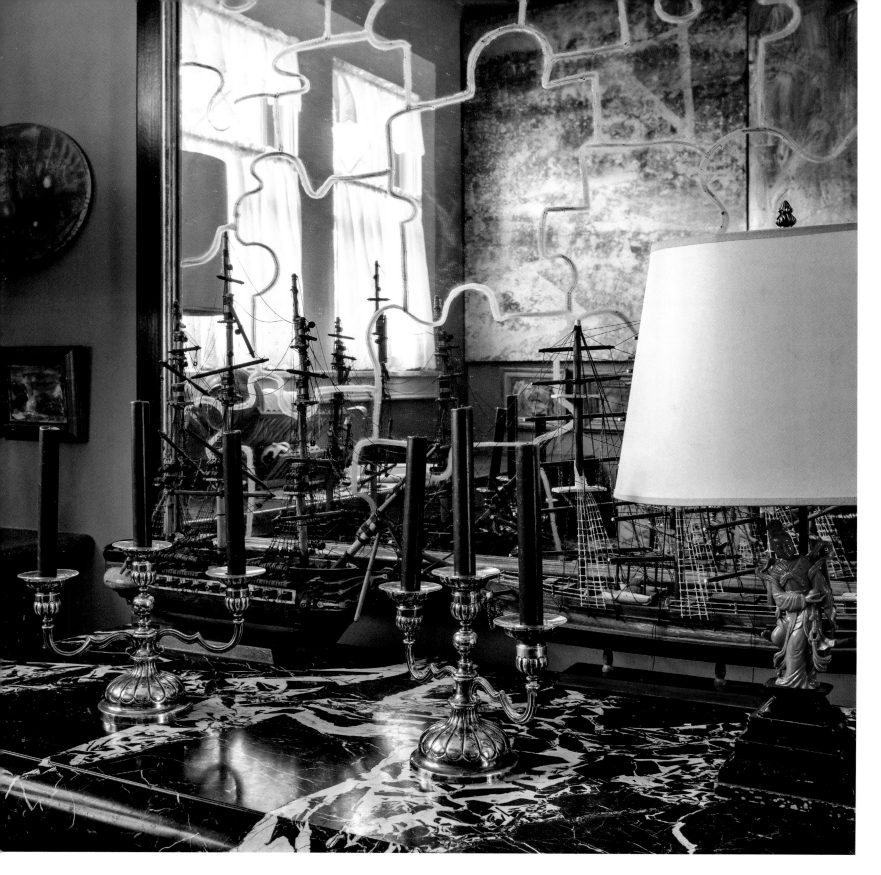

Three shades of lilac paint were mixed by Salle to obtain the right hue for the walls of the main room, which are hung with Salle's paintings—many in antique frames. Rare yellow marble tops an 18<sup>th</sup>-century gilded Italian table (following page).

Die Künstlerin mischte drei Lilatöne, um den richtigen Farbton für die Wände des Hauptraums zu erzeugen, an denen ihre Gemälde hängen – viele davon in antiken Rahmen. Auf einem vergoldeten italienischen Tisch aus dem 18. Jahrhundert liegt eine Tischplatte aus seltenem gelbem Marmor (folgende Seite).

Salle a mélangé trois nuances de lilas pour obtenir la teinte des murs de la pièce principale, où sont suspendus ses tableaux – la plupart dans des cadres anciens. Le plateau de la table italienne dorée du XVIIIe a été réalisé dans un marbre jaune rare (page suivante).

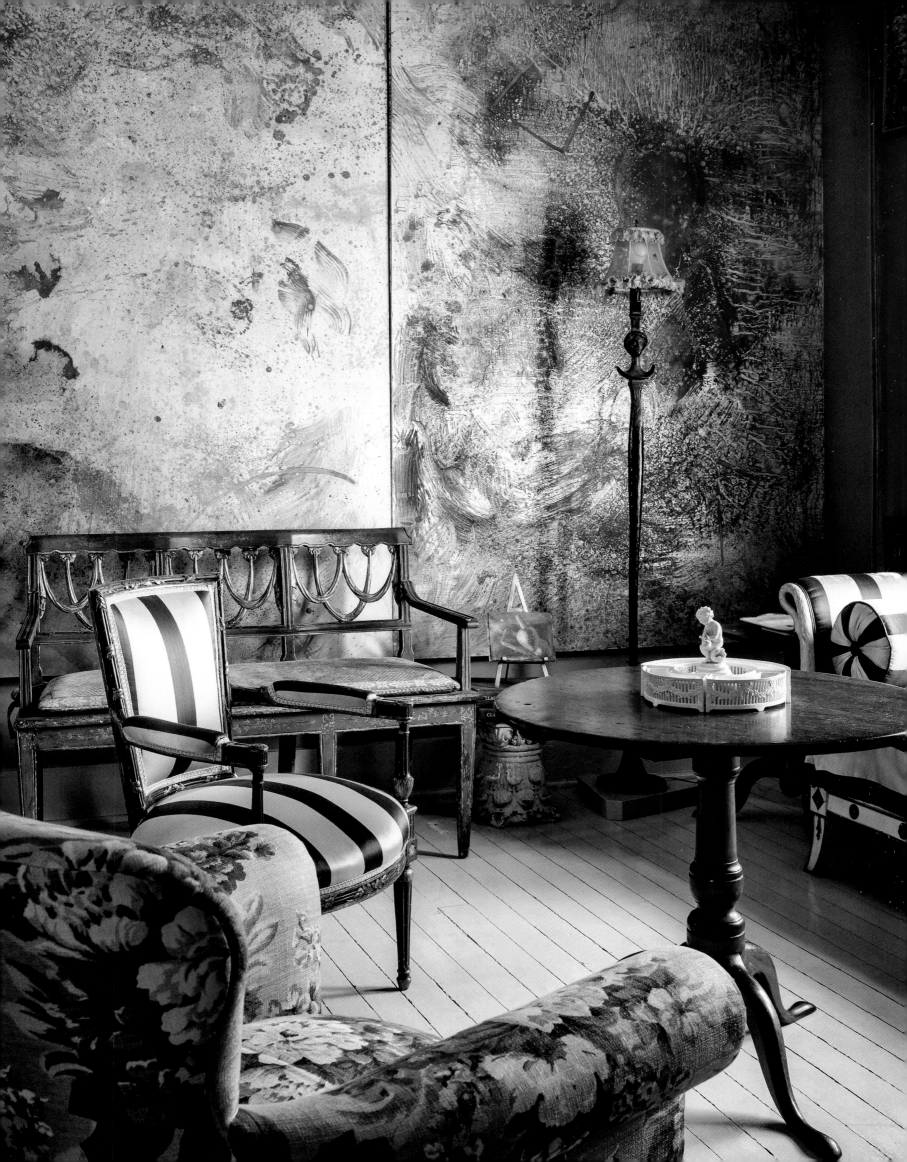

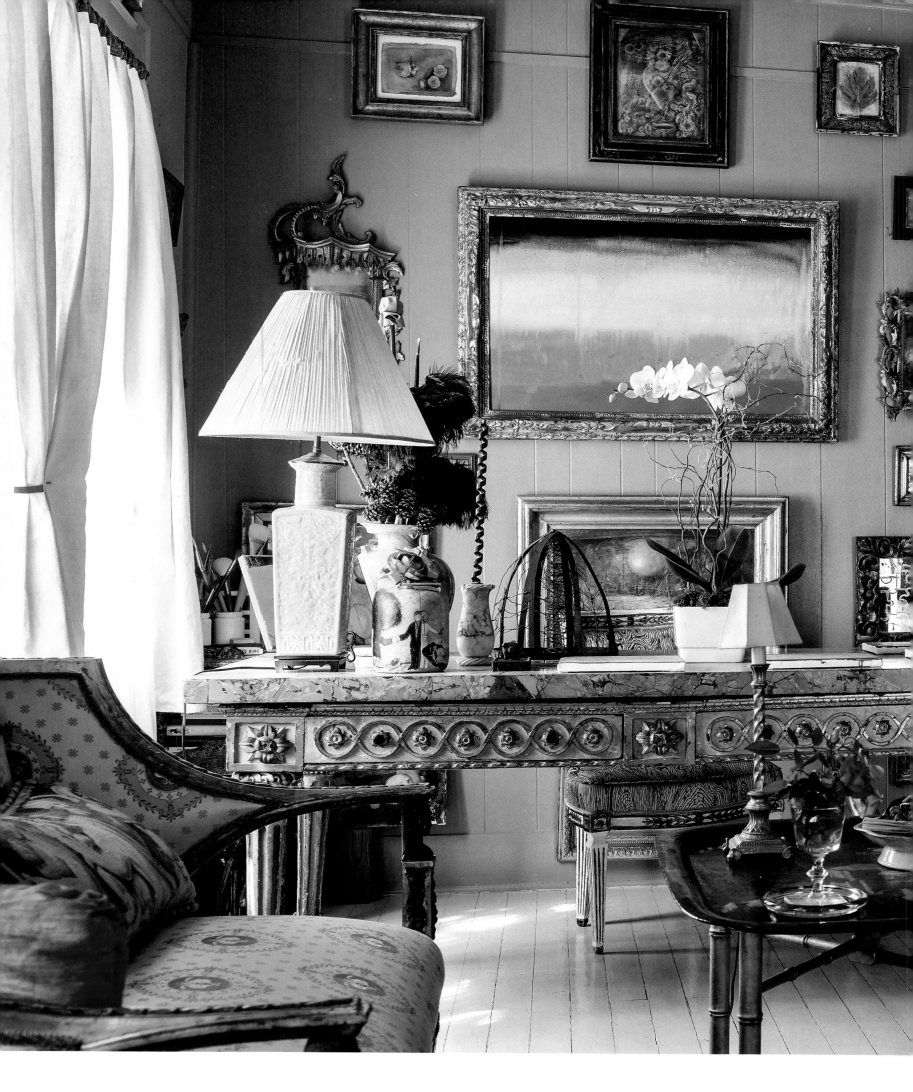

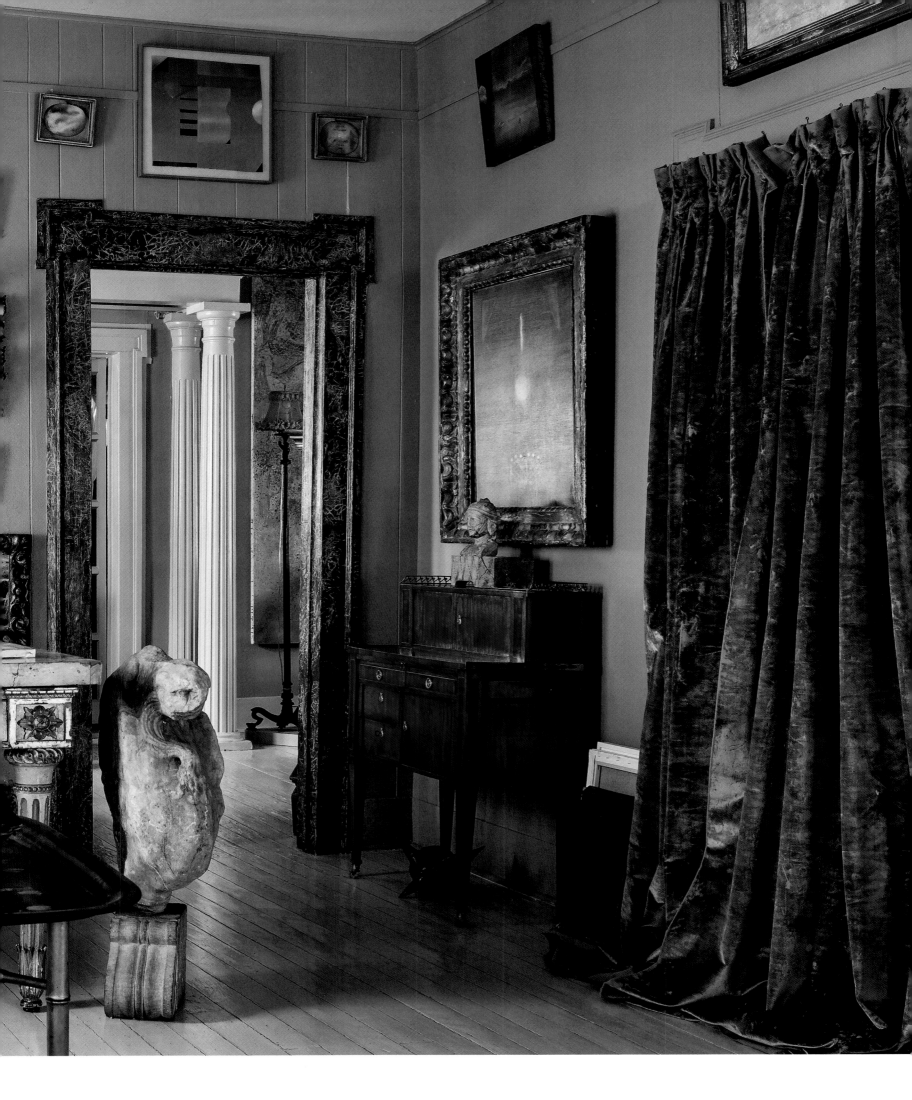

Sunlight filters through camouflage netting draped around the front porch with its painted antique rocking chair and 19th-century bread-making table.

Auf der vorderen Veranda filtert ein rundum drapiertes Tarnnetz das Sonnenlicht. Weitere prägende Elemente sind ein verwitterter antiker Schaukelstuhl und ein Tisch aus dem 19. Jahrhundert, an dem Brot gebacken wurde.

La lumière du soleil filtre à travers un filet de camouflage tendu tout autour du porche avant avec son vieux rocking-chair peint et sa table à pain du XIXe.

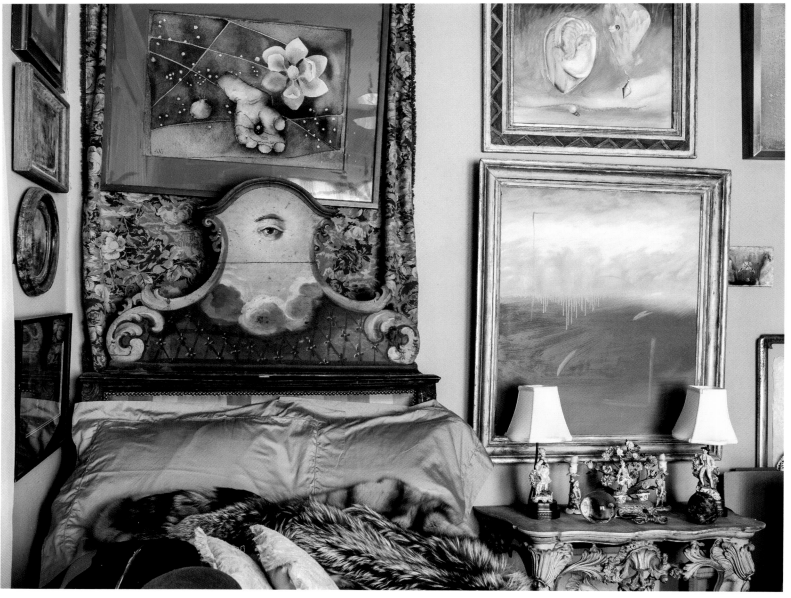

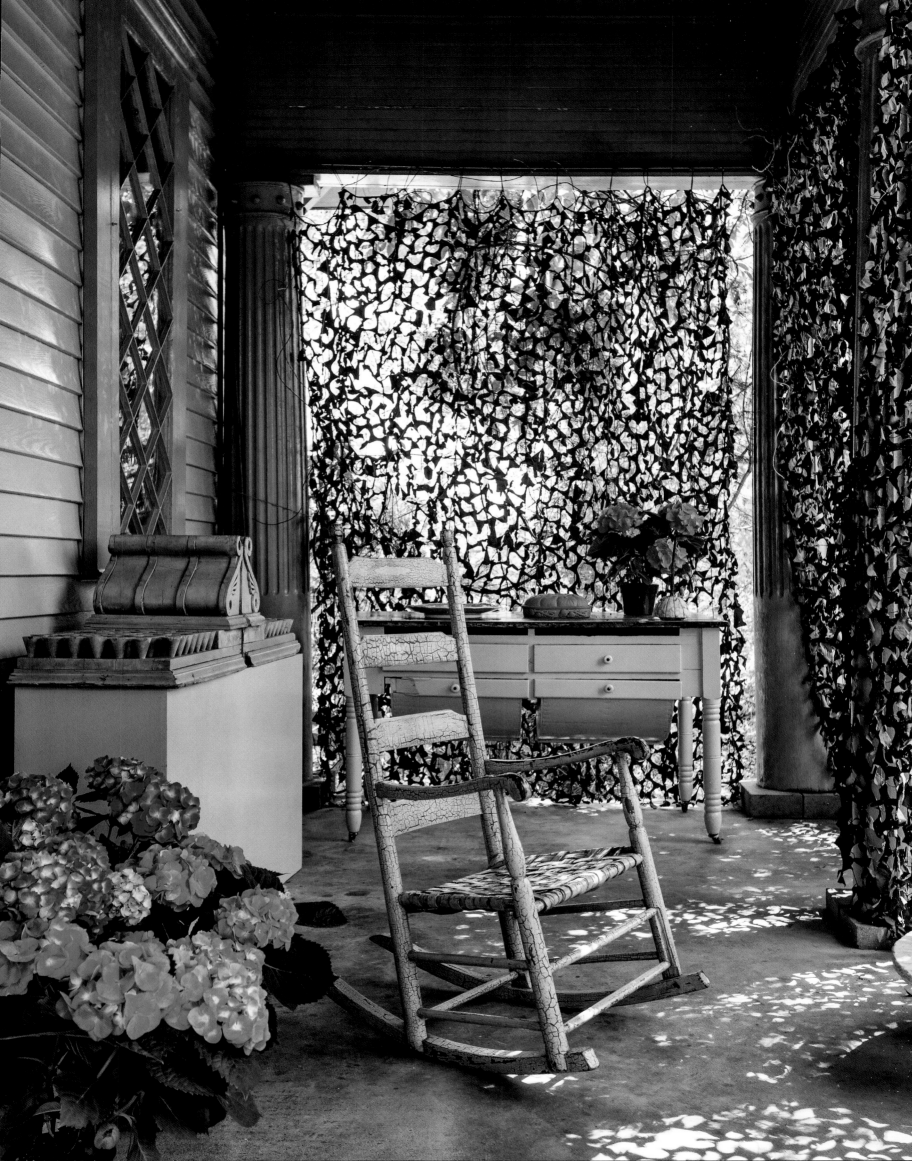

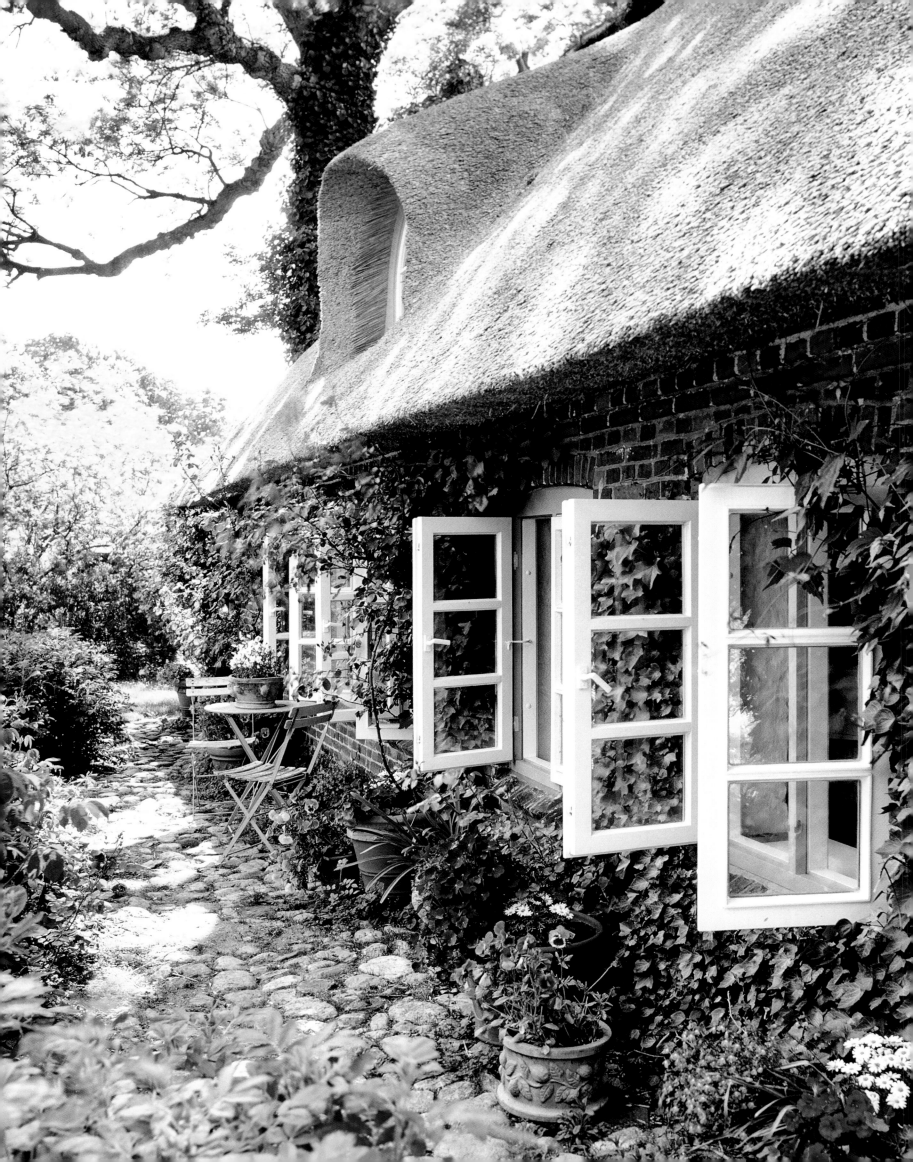

# Storybook Cottage
## Hamburg, Germany

IT ISN'T EASY to find an old, romantic country cottage like the one that belongs to Monique Waque near the Schlei Fiord in Northern Germany. The fact that it also had been thoughtfully restored to suit her tastes made it impossible to resist when she first saw it twenty years ago. So Monique purchased it on the spot as she began her career here as a model. She preserved the bleached pine floorboards, the layout of the rooms, and the old fireplace—all of which she loved. Yet, over time she made it her own with upgrades like a new thatched roof and improved bathrooms. She also chose to paint the rooms in a limpid palette to echo the pale, almost liquid northern light. Now the 200-year-old cottage is fueling a new passion—gardening—as Monique plans fresh plant schemes near the property's pond to complement two magnificent Ash trees, a local symbol of good luck, planted at the time the cottage was built.

ALTE ROMANTISCHE LANDHÄUSER wie das von Monique Waque in der Nähe des Schleifjords in Norddeutschland findet man nur noch selten. Als sie es vor mehr als 20 Jahren entdeckte, war es schon ganz nach ihrem Geschmack liebevoll restauriert und somit einfach unwiderstehlich. Das angehende Model kaufte das Haus auf der Stelle. Sie behielt die gebleichten Pinienholzdielen, die Anordnung der Räume und den alten Kamin bei, nahm jedoch im Laufe der Zeit auch Veränderungen vor: So ließ sie das Reetdach neu decken und modernisierte die Badezimmer. Außerdem verpasste sie den Zimmern einen blass-verwaschenen Anstrich, der an das helle, beinahe liquide Licht des Nordens erinnern soll. Inzwischen hat das 200 Jahre alte Haus in seiner Besitzerin mit der Lust am Gärtnern eine neue Leidenschaft geweckt. Monique plant nun eine Bepflanzung in der Nähe des zum Anwesen gehörenden Teichs, um zwei prachtvolle Eschen zu komplementieren. Diese Bäume gelten in der Region als Glücksbringer und wurden gesetzt, als man das Haus erbaute.

DIFFICILE DE TROUVER une vieille maison de campagne romantique comme celle de Monique Waque près du bras de mer de la Schlei, dans le Nord de l'Allemagne. Lorsqu'elle l'a vue il y a une vingtaine d'années, la maison venait d'être restaurée et correspondait à ses goûts. Elle l'a acheté sur-le-champ, alors qu'elle débutait comme mannequin. Monique a conservé les lames de parquet en pin blanchi, le plan des pièces et la cheminée – tout ce qu'elle aimait. Avec le temps, elle se l'est appropriée, avec un nouveau toit de chaume et des salles de bains modernes. Elle a décidé de peindre les pièces dans une palette de couleurs limpides pour répondre à la lumière pâle, presque liquide, du Nord. Dans cette chaumière de 200 ans, elle s'adonne à sa nouvelle passion : le jardinage. Monique prévoit d'ajouter de nouvelles essences près de l'étang pour compléter deux magnifiques frênes plantés lors de la construction de la maison, et symbole local de chance.

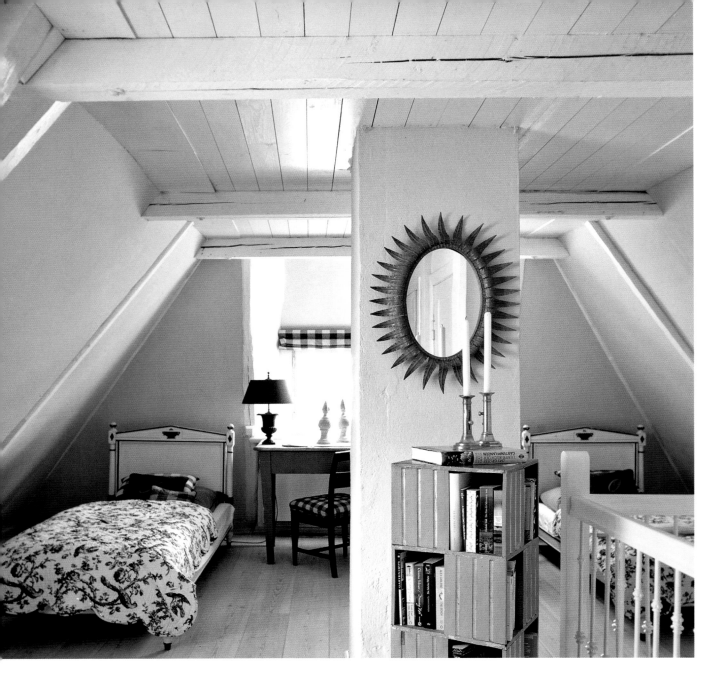

Furniture throughout the cottage is generally French and Scandinavian. The two directoire beds were made from one by using the footboard in reverse to form a headboard for the second. In the dining room, the Swedish clock with original paint is from Mora, famous for its clockmakers.

*Die Möblierung des Hauses ist größtenteils französisch und skandinavisch. Die beiden Betten im Directoire-Stil waren ursprünglich nur eines. Dafür wurde das Fußbrett umgedreht und zum Kopfbrett des zweiten Bettes gemacht. Die schwedische Standuhr im Esszimmer besitzt noch den Originalanstrich und stammt aus der Stadt Mora, die für ihre Uhrmacher berühmt ist.*

*Les meubles proviennent majoritairement de France et de Scandinavie. Les deux lits Directoire ont été obtenus à partir d'un seul lit, dont le pied de lit a été placé à l'envers pour servir de tête de lit au second. Dans la salle à manger, l'horloge suédoise aux peintures d'origine vient de Mora, aux horlogers célèbres.*

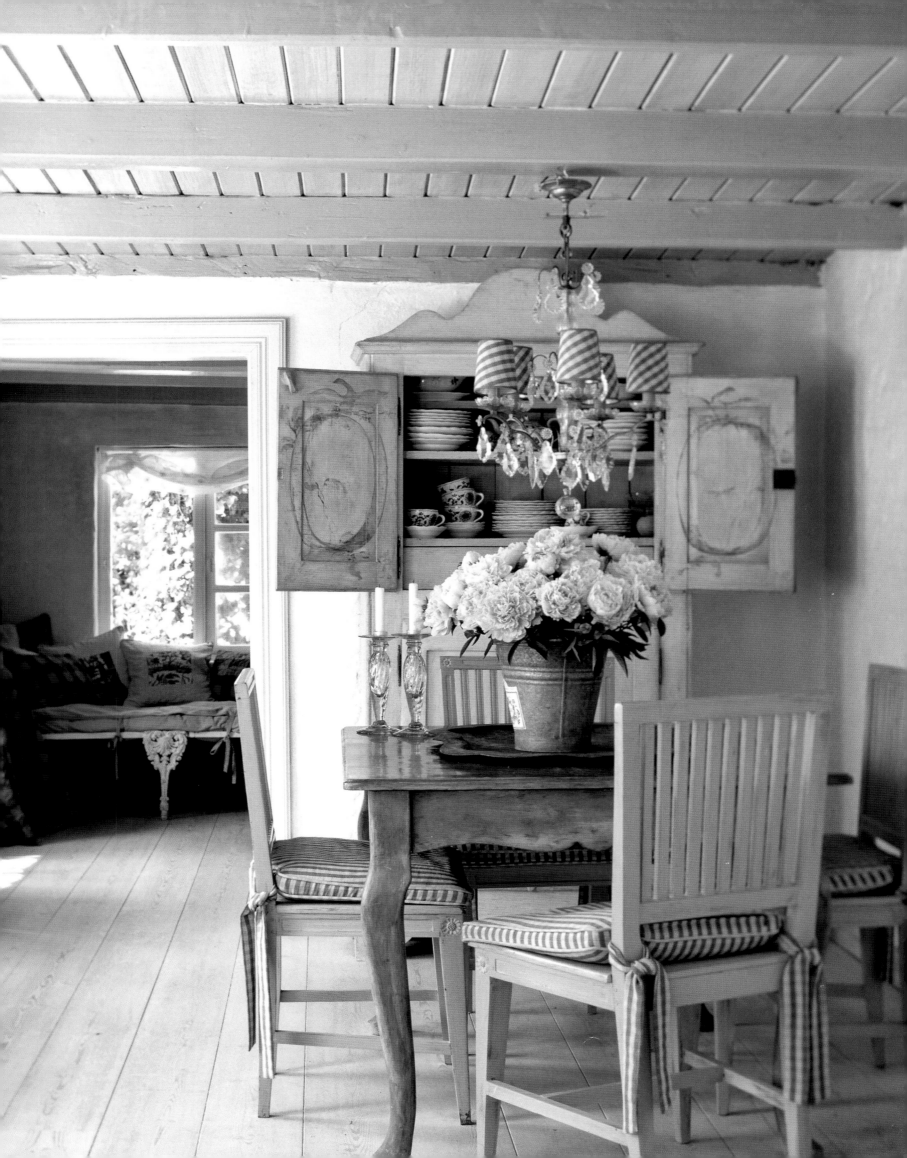

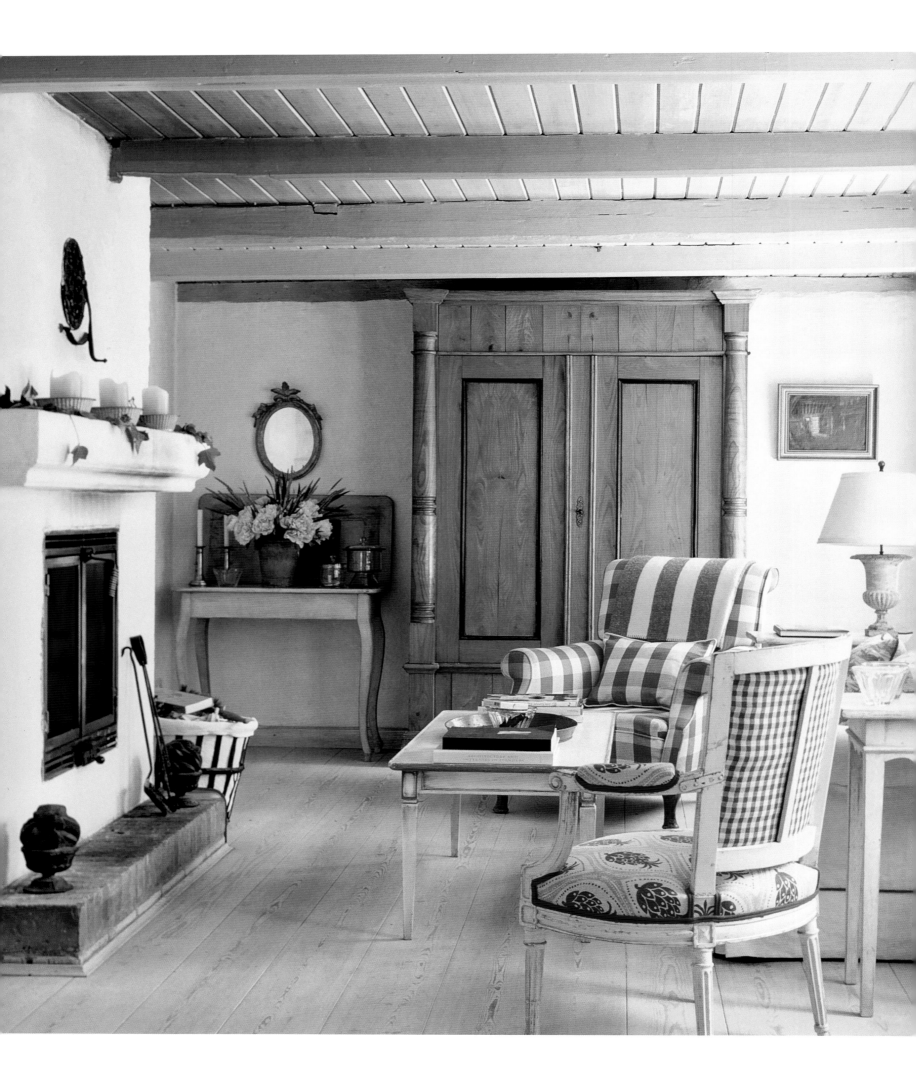

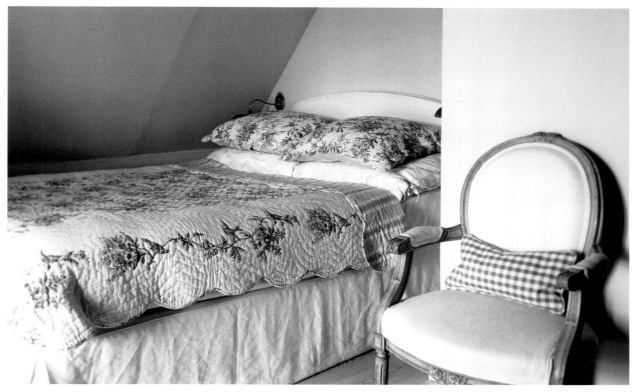

Against a pale gray and white backdrop in the living room, furniture was kept to a minimum of favorite pieces. Bold color is restricted only to touches of red.

Die Möbel vor dem blassgrau-weißen Hintergrund der Wohnzimmerwände sind auf einige wenige Lieblingsstücke beschränkt. Farbakzente werden nur in Rot gesetzt.

Sur le fond gris pâle et blanc du salon, le mobilier se compose de rares pièces de collection. La couleur vive se limite à quelques touches de rouge.

The country-style kitchen features pretty open shelving and a cupboard painted pale green by Monique. A rag rug in soft green tones links to the color of the cupboard.

Die Küche im Landhausstil enthält hübsche offene Regale und einen Hängeschrank, der von Monique Waque in Pastellgrün gestrichen wurde. Dazu korrespondiert der Flickenteppich in hellen Grüntönen.

Dans la cuisine rustique, les belles étagères ouvertes et le placard ont été peints en vert pâle par Monique. Le tapis en lirette aux teintes vert tendre rappelle la couleur du placard.

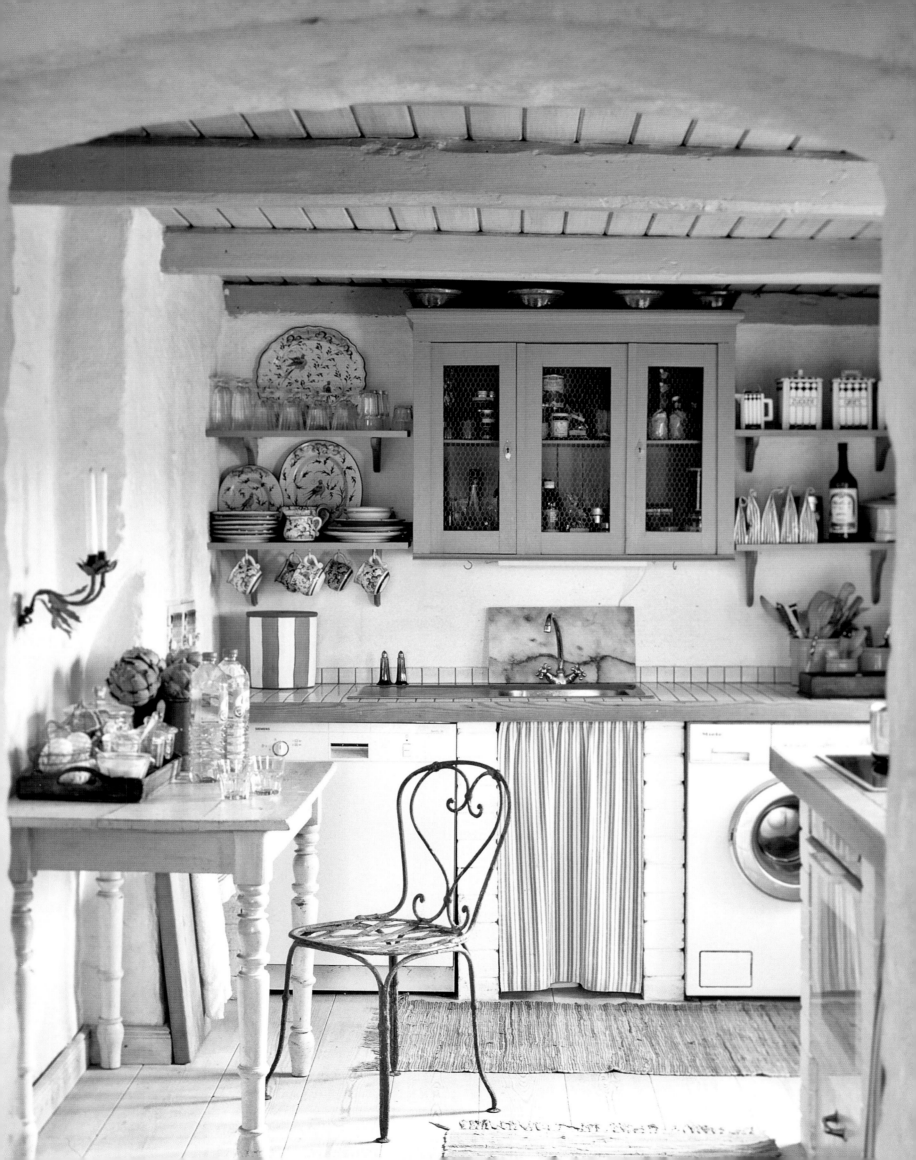

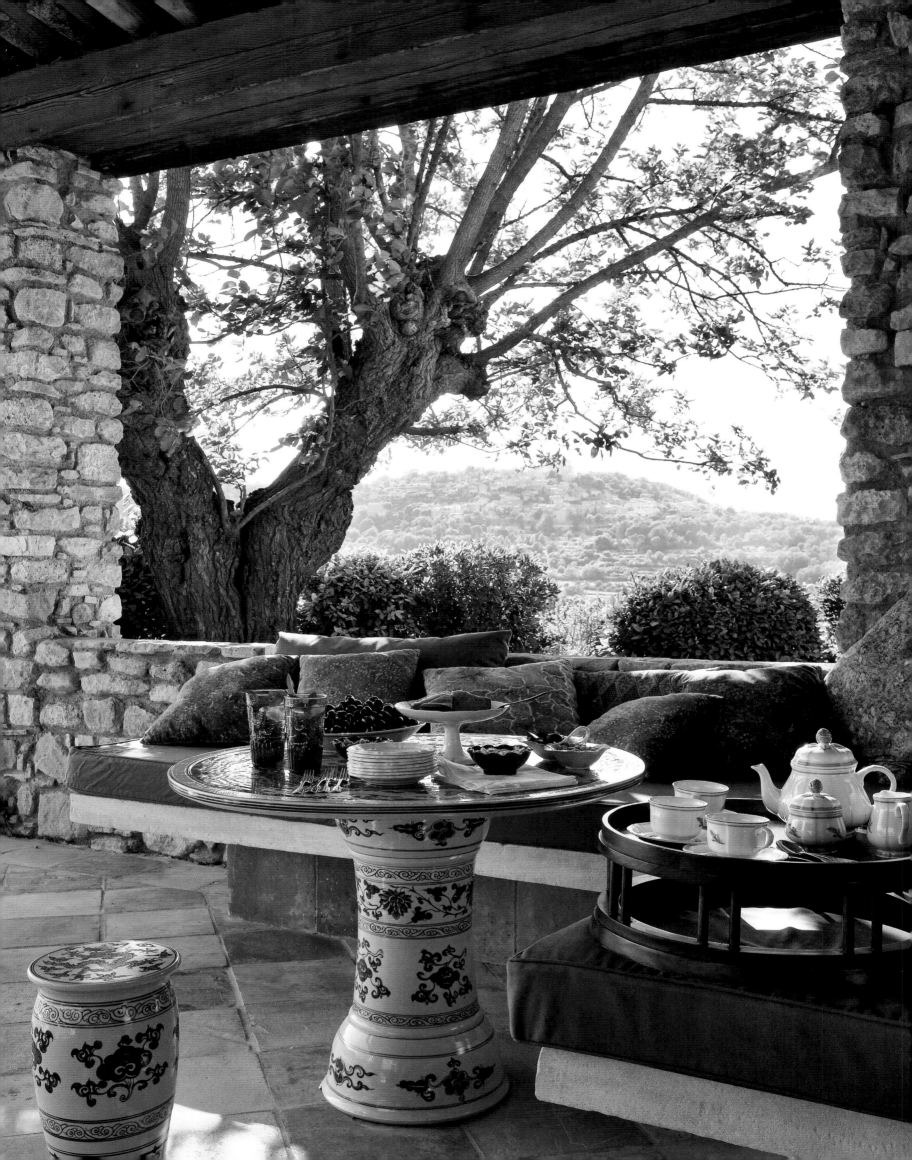

# In Tune with Nature
## Provence, France

NESTLED ON A slope between the Provençal villages of Bonnieux and Lacoste, the working farm known as Domaine de Pibernet gradually comes into view from a crushed limestone driveway flanked with lavender, cypress, and olive trees that leads to the property. American-born Donna Ward and her English husband, Rodney, spent several years rebuilding the farm's buildings. Originally, the property consisted of a smallish three-story house whose floors were connected via ladders, several barns and outbuildings, and an intact winery that they've since turned into a guest house. Their challenge at the start was to reconfigure the spaces and structures and link them in a cohesive manner. They did so by turning a tractor shed into a bright triple-aspect living room with double doors that lead to a library and an en-suite guest bedroom. They created an orangerie-style dining room and kitchen in what had been a garage. All the ground-floor rooms open onto a terrace overlooking the magisterial countryside.

AUF EINEM HANG zwischen den provenzalischen Dörfern Bonnieux und Lacoste gelegen, taucht das Gehöft Domaine de Pibernet erst allmählich im Blickfeld auf, nähert man sich ihm auf der von Zypressen, Lavendel- und Olivenbäumen gesäumten Schotterauffahrt. Die Amerikanerin Donna Ward und ihr aus England stammender Mann Rodney verbrachten mehrere Jahre damit, die Gebäude des Hofs zu restaurieren und umzubauen. Ursprünglich bestand das Anwesen aus einem eher kleinen Haus mit drei durch Leitern verbundenen Stockwerken, mehreren Scheunen und Außengebäuden sowie einer intakten Weinkellerei, die inzwischen ein Gästehaus ist. Die Herkules-aufgabe bestand darin, die Räume und Gebäude völlig neu zu konfigurieren und zu einem harmonischen Ganzen zusammenzufügen. Dies gelang den Wards, indem sie die Traktorscheune in ein helles Wohnzimmer umwandelten, von dem aus man durch Flügeltüren in eine Bibliothek und ein en suite-Gästezimmer gelangt. Die ehemalige Garage wurde zur Küche nebst Esszimmer im Orangerie-Stil umgestaltet. Alle Räume im Erdgeschoss führen auf die Terrasse mit atemberaubendem Blick in die wunderschöne Landschaft.

NICHÉE À FLANC de coteau entre les villages provençaux de Bonnieux et Lacoste, l'exploitation du Domaine de Pibernet apparaît doucement depuis l'allée de gravier bordée de lavandes, de cyprès et d'oliviers qui conduit à la propriété. L'Américaine d'origine Donna Ward et son époux anglais Rodney ont passé des années à restaurer les bâtiments. À l'origine, la propriété comportait une petite maison à trois niveaux accessibles par des échelles, plusieurs étables et dépendances ainsi qu'une cave viticole transformée en maison d'hôtes. Le premier défi a consisté à reconfigurer les espaces et les structures pour les réunir de façon cohérente. Pour ce faire, le hangar à tracteurs a été transformé en séjour lumineux à triple exposition avec des portes à deux vantaux conduisant à une bibliothèque et à une chambre d'amis attenante. On a par ailleurs créé une salle à manger de style orangerie et une cuisine à l'emplacement de l'ancien garage. Toutes les pièces du rez-de-chaussée donnent sur la terrasse surplombant la majestueuse campagne.

The floral print curtain fabric in the living room is from Pierre Frey. Groups of
small pictures include works by Mary Cassatt, Louis Legrand, and E. J. Burra.

Der florale Vorhangstoff im Wohnzimmer ist von Pierre Frey. Unter den kleinen Bildern
finden sich Werke von Mary Cassatt, Louis Legrand und E. J. Burra.

Le motif à fleurs des rideaux dans le salon est de Pierre Frey. Les groupes de
petits tableaux sont composés d'œuvres de Mary Cassatt, Louis Legrand et
Edward John Burra.

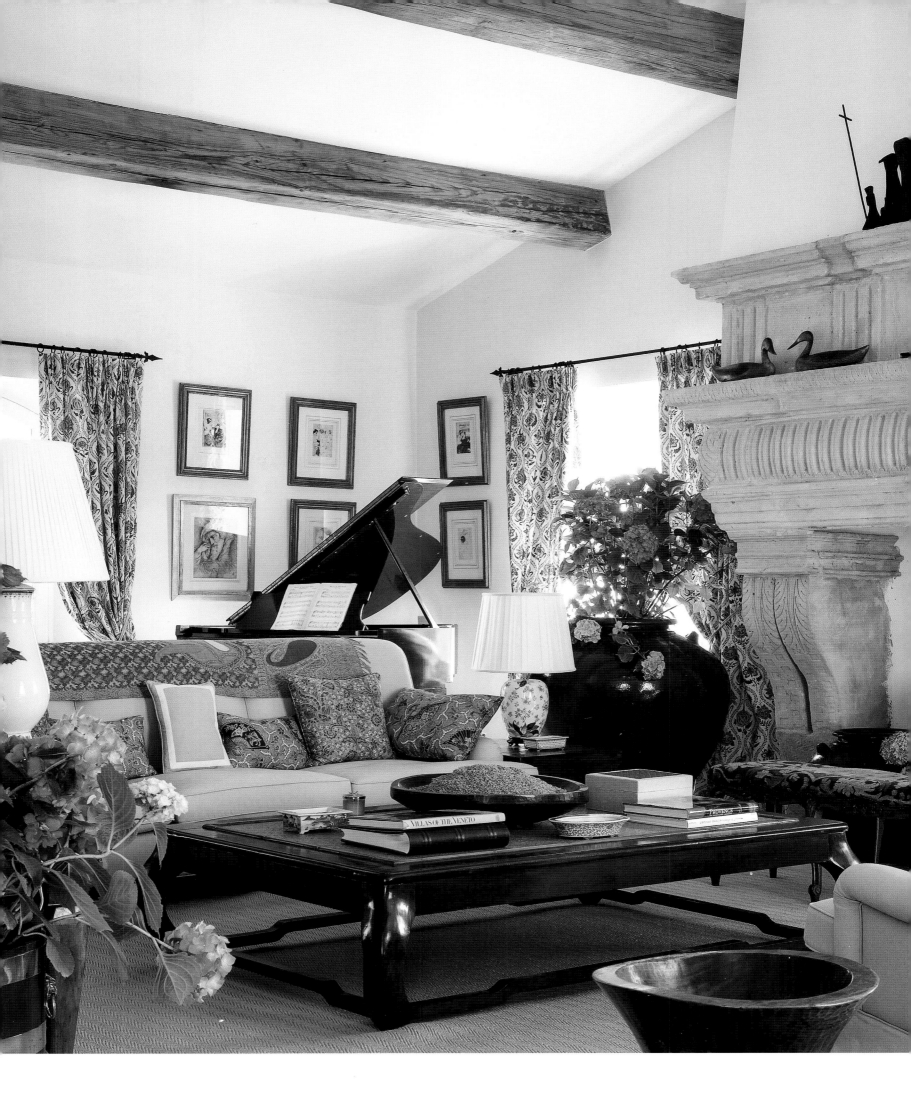

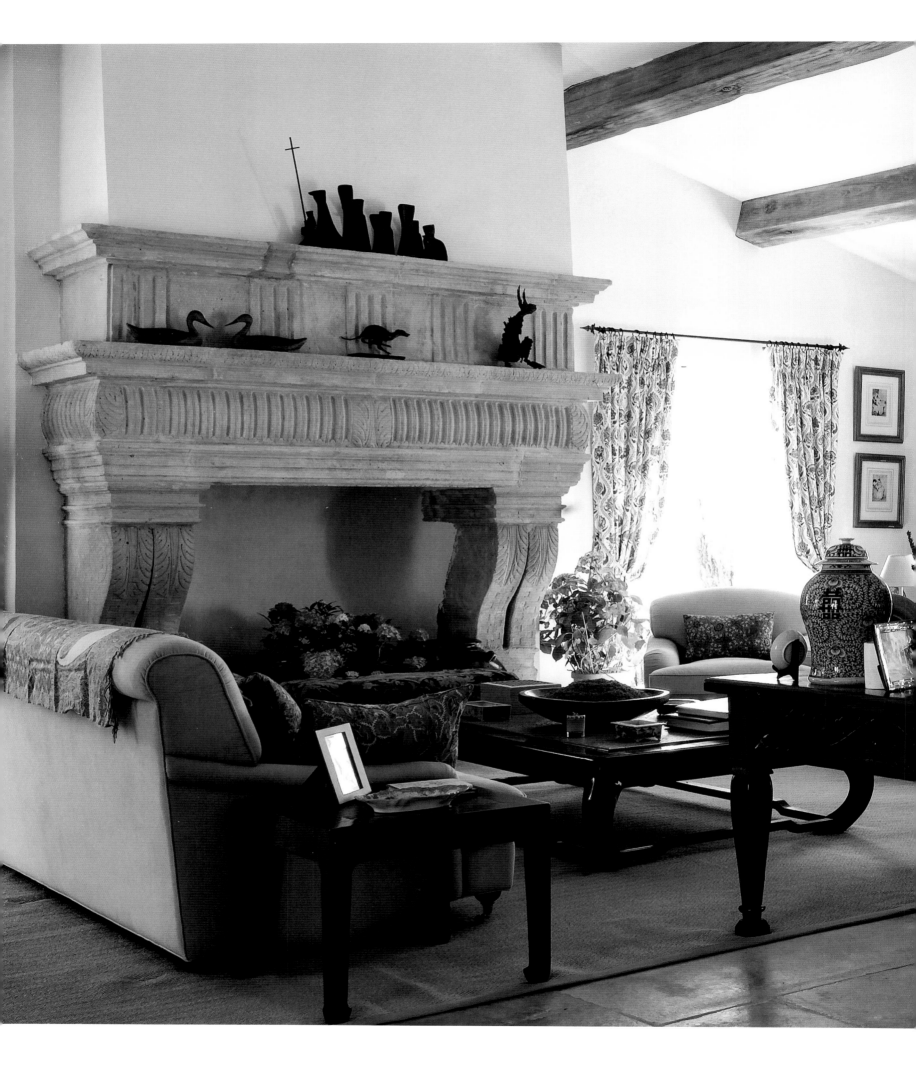

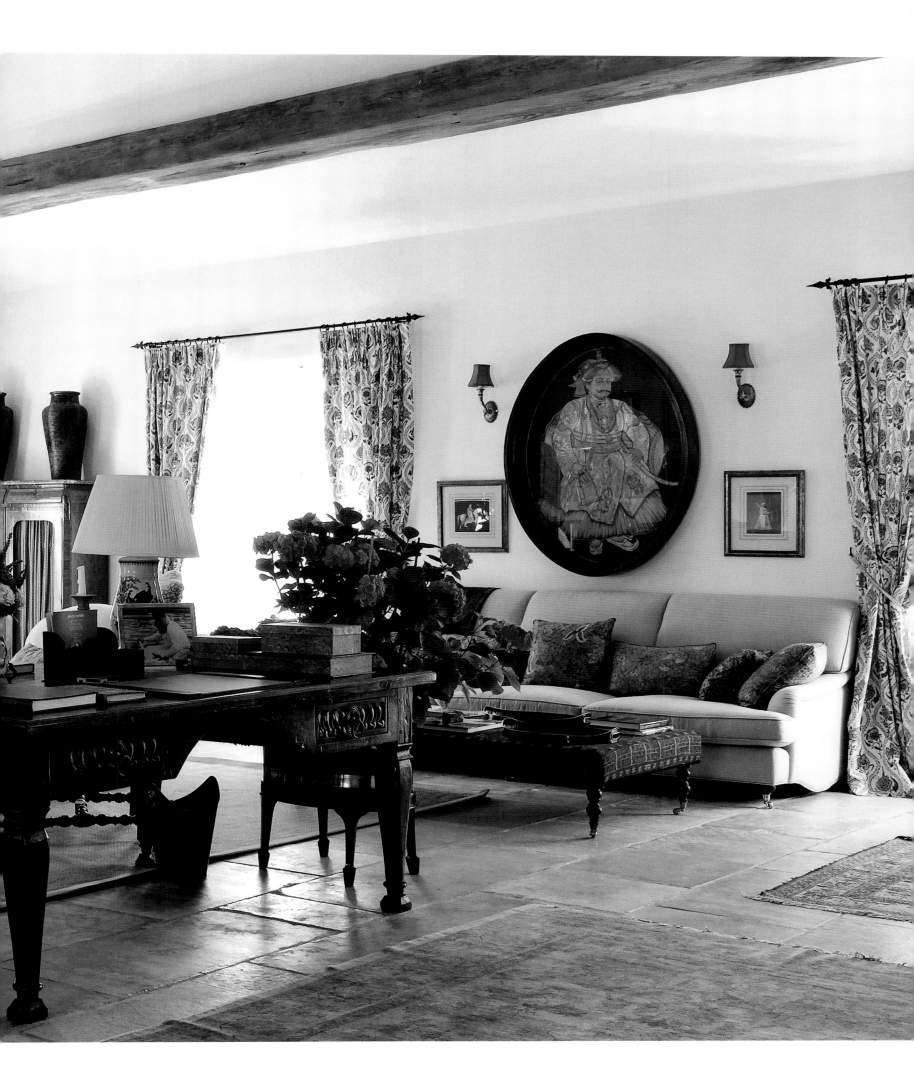

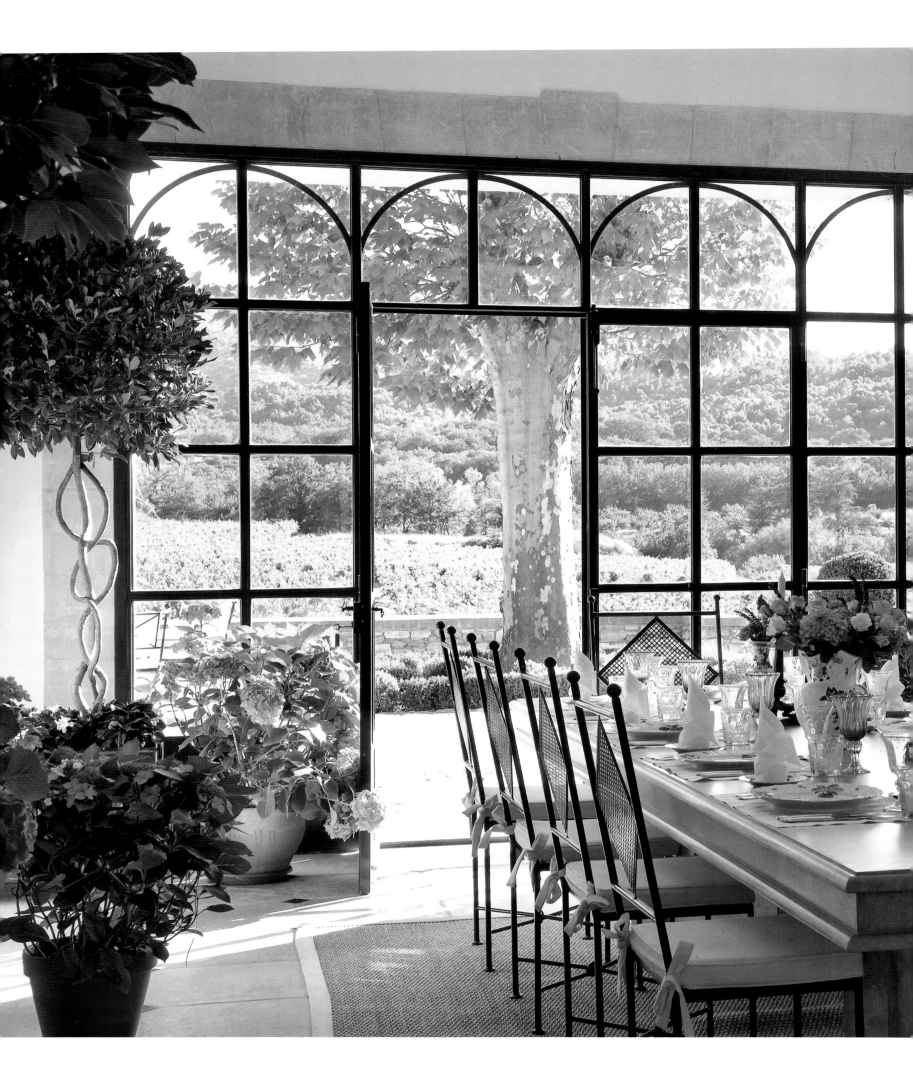

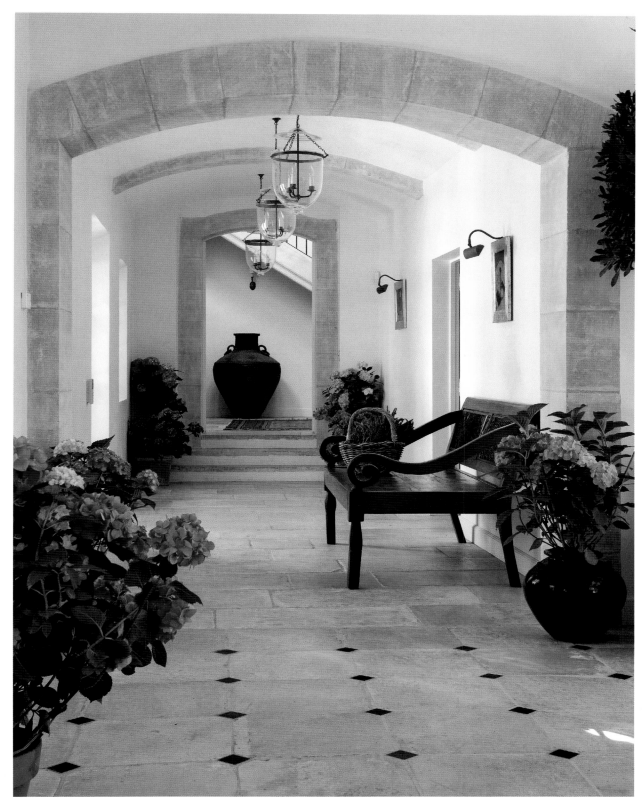

An almost double-height space was created as an orangerie-style dining hall with a glass wall facing a stunning view of the farm. An arched corridor links living and dining/kitchen spaces.

*Aus einer Garage von fast doppelter Höhe entstand ein Esszimmer im Stil einer Orangerie mit Glaswand, die einen fantastischen Ausblick auf das Grundstück bietet. Ein Bogengang verbindet den Wohnbereich mit Esszimmer und Küche.*

*Un espace quasiment en double hauteur a été aménagé en salle à manger de style orangerie avec une verrière offrant une vue éblouissante sur la ferme. Un couloir voûté relie le salon et l'espace repas/cuisine.*

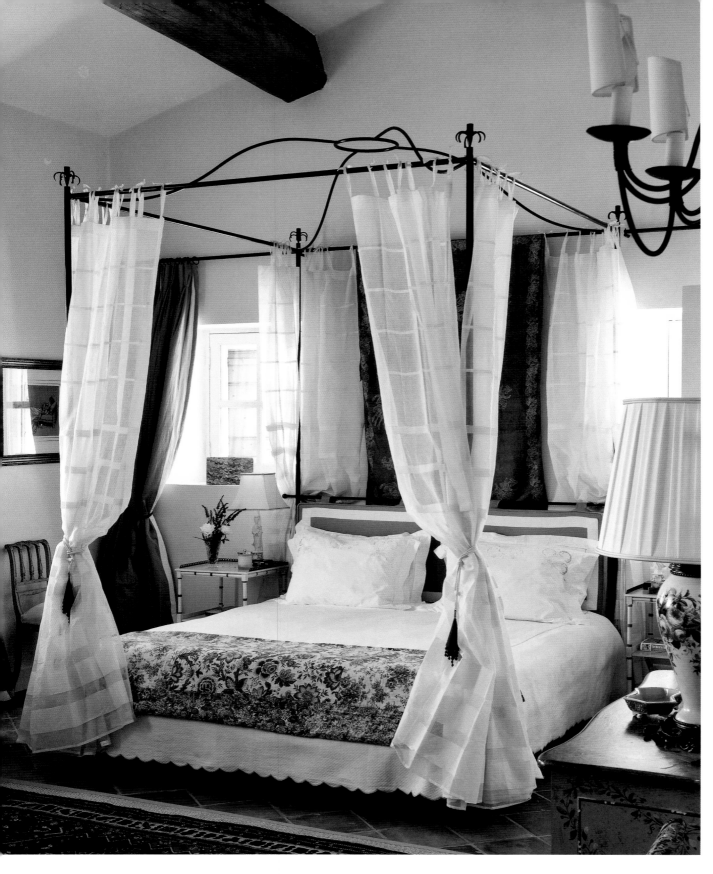

*A local* ferronnier *made the bed in the master bedroom. The large kitchen features a backsplash of green and white tiles, made in Apt, a reclaimed marble sink, and Avignon limestone worktops.*

*Ein* ferronnier *aus dem Ort hat das Bett im Hauptschlafzimmer geschmiedet. Die große Küche wurde mit einem Fliesenspiegel aus grünen und weißen Fliesen aus Apt, einer alten Marmorspüle und Arbeitsflächen aus Avignoner Kalkstein ausgestattet.*

*Le lit de la chambre de maître est l'œuvre d'un* ferronnier *local. La grande cuisine est équipée d'une crédence à carreaux verts et blancs, fabriquée à Apt, d'un évier en marbre de récupération et de plans de travail en pierre calcaire d'Avignon.*

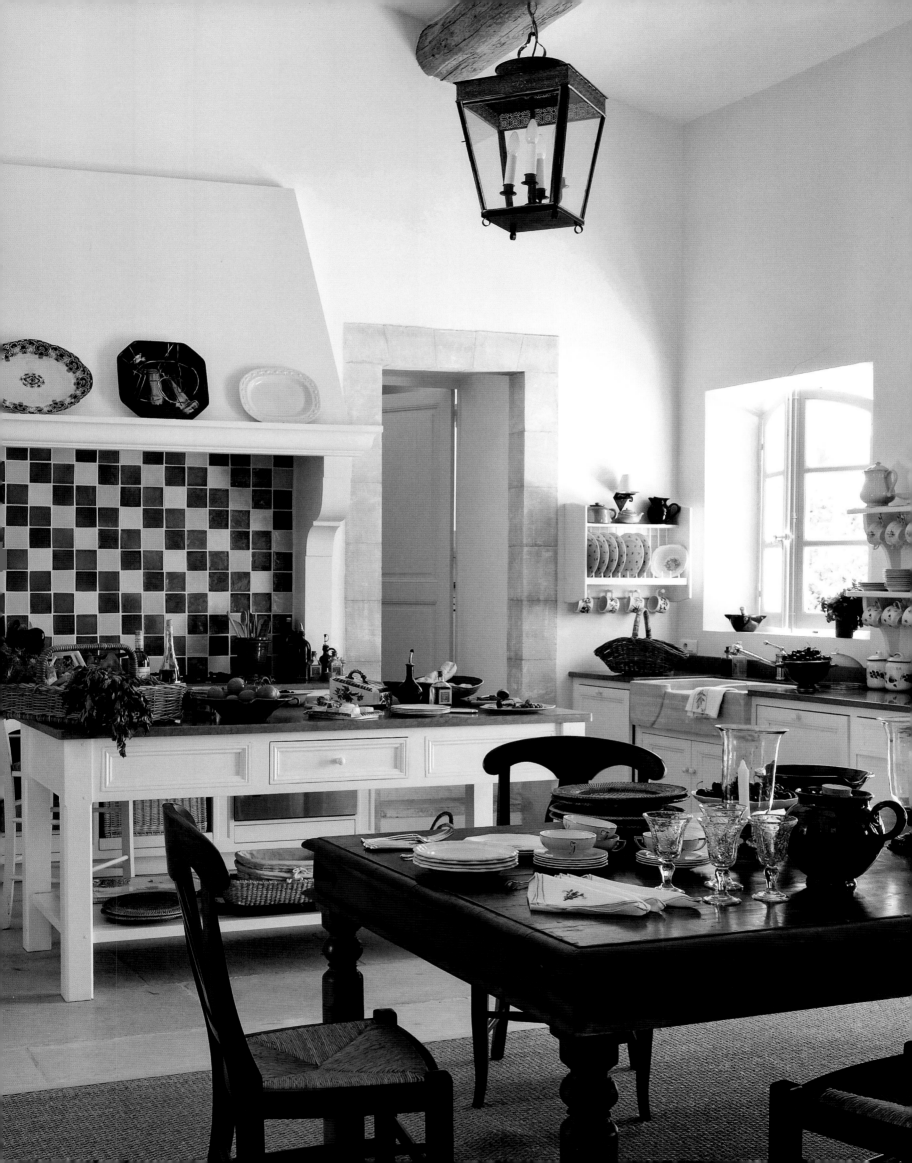

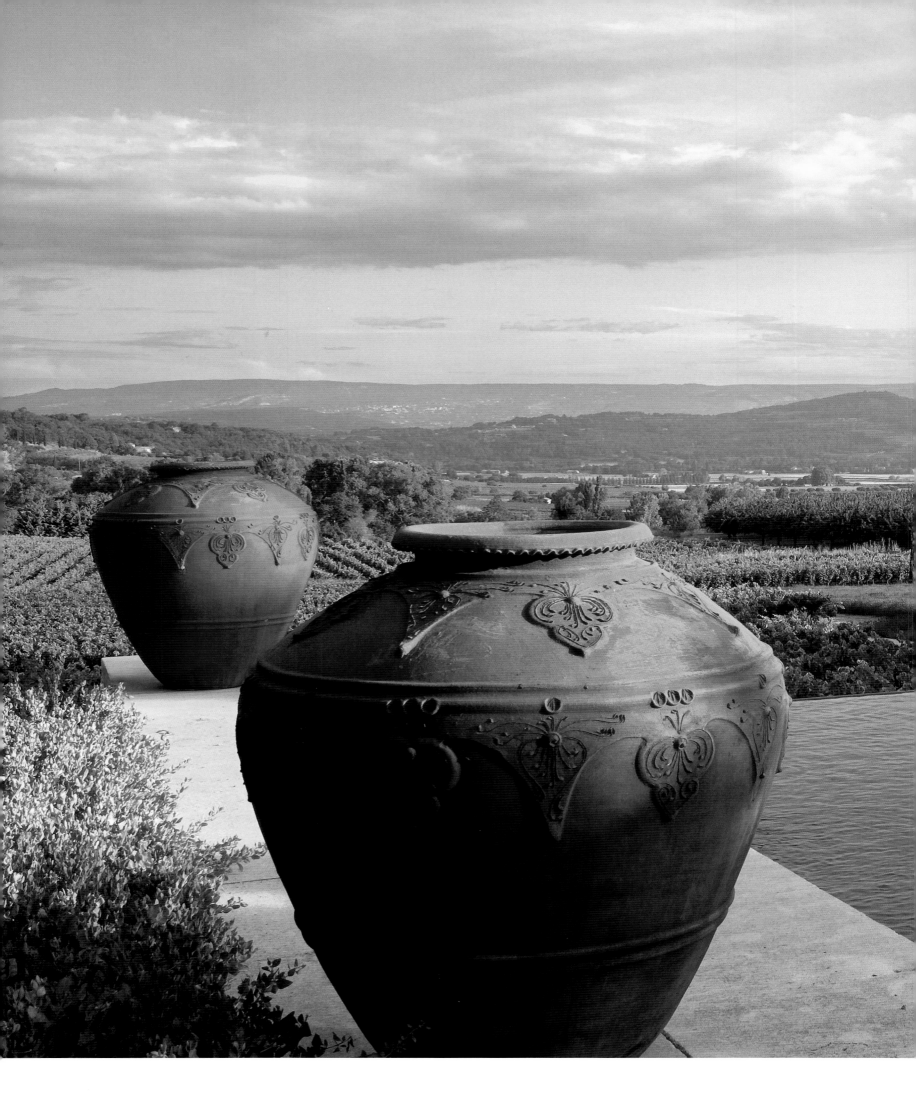

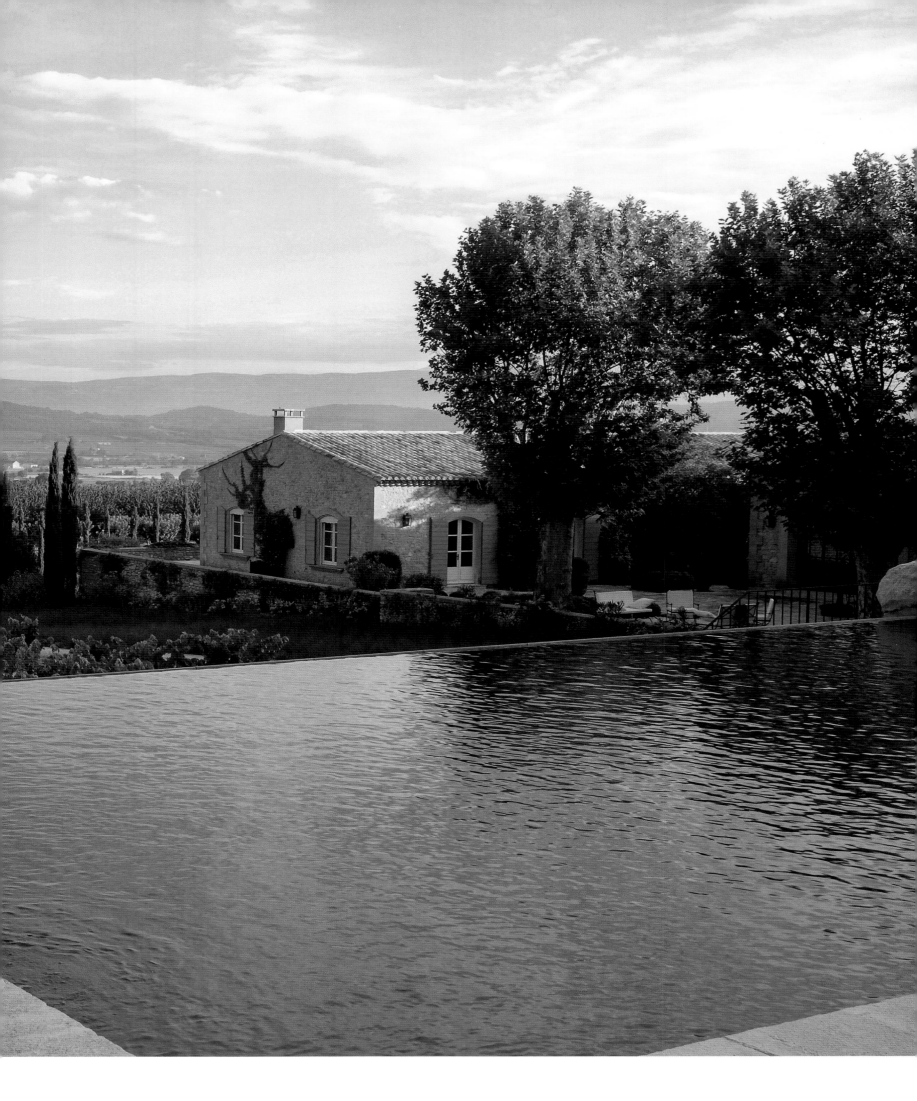

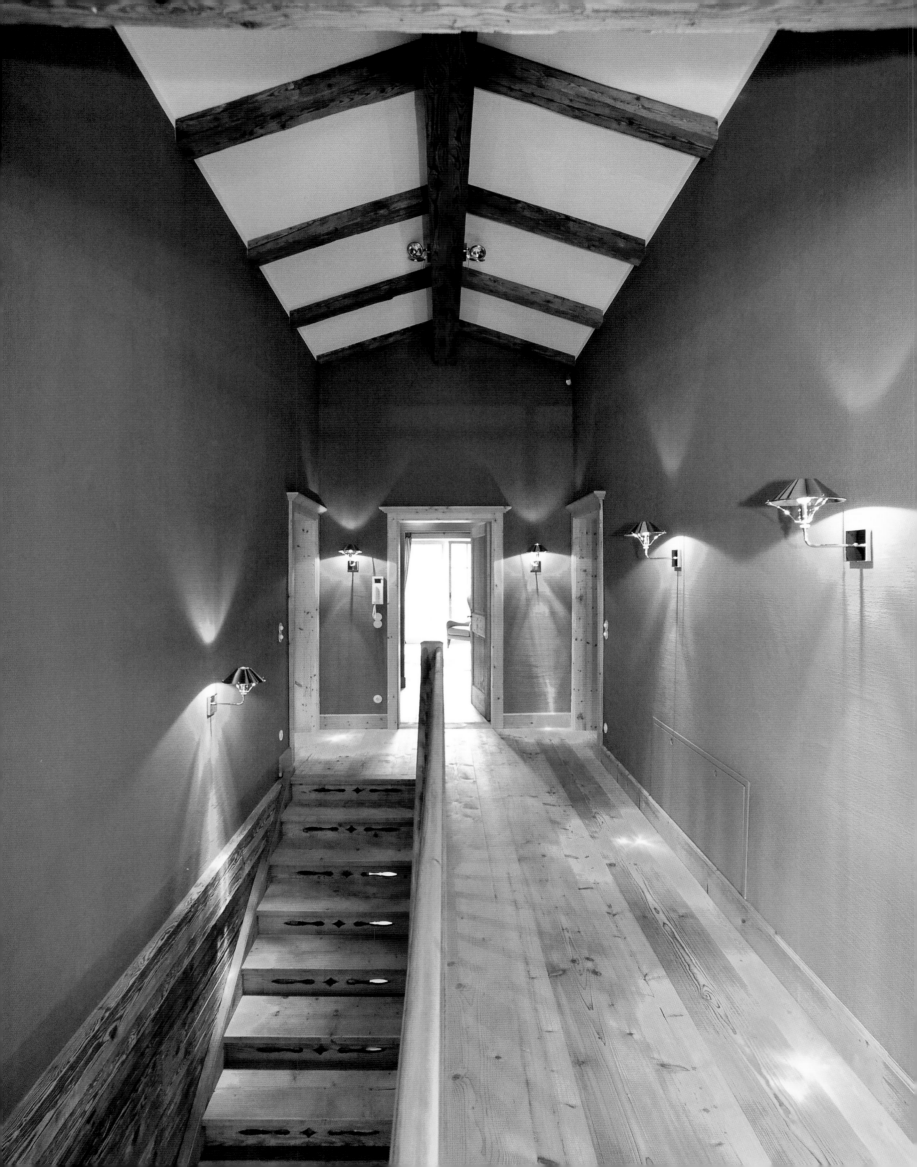

# Alpine Treasure
## Tyrol, Austria

GLAMOROUS KITZBÜHEL IS not only one of the most important ski resorts in Austria, but it is also renowned for its natural beauty and breathtaking panoramas. So it's no surprise that the people who live in this chalet in the mountains appreciate its spectacular setting. This enchanting house—with views of Jochberg and the mountains of Tyrol—is new construction, but it is built with wood salvaged from razed farmhouses nearby. As a result, its combination of natural and modern materials, elegant furniture, and the latest technology brings the house close to nature and at the same time reflects the zeitgeist. Hild Home Design handled the interior design with great care, finishing living areas with exquisite materials like Belgian blue stone floors and teak plank flooring, and using dark green Bisazza glass mosaic tile for the indoor pool. The spacious complex includes the main house and a guest house. With seven bedrooms and en-suite bathrooms, the chalet has plenty of space for large families to spread out and relax in a peaceful sunny spot.

DAS MONDÄNE KITZBÜHEL ist nicht nur einer der bedeutendsten Wintersportorte Österreichs, es steht auch für wunderbare Natur und sagenhafte Panoramen. Kein Wunder also, dass man beim Anblick dieses Hauses in den Bergen ins Schwärmen gerät. Das charmante Chalet mit Blick auf den Jochberg und die Tiroler Berge wurde aus Hölzern abgetragener Bauernhöfe aus der Umgebung komplett neu errichtet. Die Kombination aus ursprünglichen und modernen Materialien, edlen Möbeln und neuester Technik spiegelt eine besondere Naturverbundenheit und gleichzeitig ein Gefühl für den Zeitgeist wider. Hild Home Design widmete sich mit großer Sorgfalt der Innengestaltung und wählte exquisite Materialien wie Steinböden aus belgischem Blaustein, Schiffsböden aus Teak und dunkelgrünes Bisazza-Glasmosaik für den Indoorpool. Zum großzügigen Komplex gehört das Haupt- und ein Gästehaus. Mit sieben Schlafzimmern und en suite-Bädern bietet das Chalet genügend Platz für große Familien, die in ruhiger und sonniger Lage Entspannung suchen.

VILLE TRÈS CHIC, Kitzbühel n'est pas qu'une des plus grandes stations de sports d'hiver d'Autriche, elle s'enorgueillit d'une nature magnifique et de vues fabuleuses. Rien d'étonnant donc à ce que l'on succombe à ce charmant chalet montagnard. Donnant sur le Jochberg et les massifs tyroliens, il a été entièrement reconstruit avec du bois de charpente de fermes en ruines des environs. La combinaison de matériaux anciens et modernes, de meubles raffinés et des installations à la pointe de la technologie reflète un lien particulier avec la nature et un flair pour l'esprit du temps. Hild Home Design a apporté le plus grand soin à l'aménagement intérieur, choisissant des matériaux luxueux, notamment des sols en pierre bleue belge, des parquets à l'anglaise en teck et des mosaïques de Bisazza vert foncé pour la piscine intérieure. Le généreux complexe se compose d'une maison principale et d'une maison d'amis. Avec sept chambres à salles de bains attenantes, il dispose d'assez de place pour les grandes familles qui veulent se détendre au calme et au soleil.

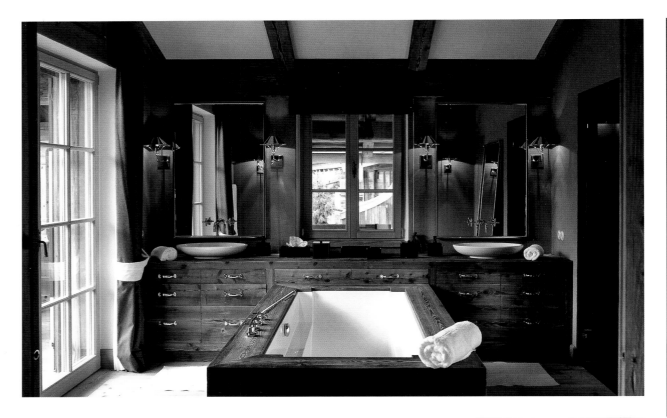

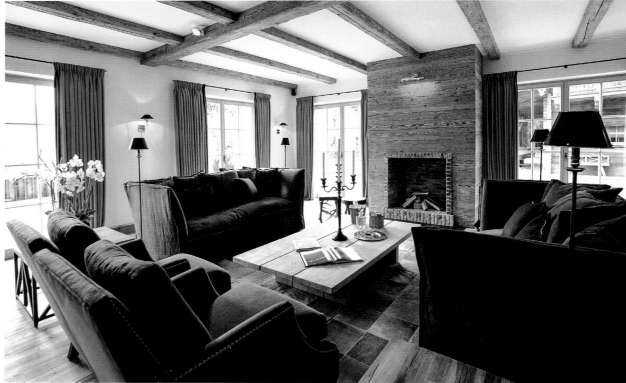

The monochrome palette combined with warm wood tones creates an elegant yet cozy space.

Monochrome Farben sorgen im Wechselspiel mit warmen Holztönen für Eleganz und Gemütlichkeit.

L'alternance entre les nuances de gris et les teintes chaudes du bois donne à ce lieu élégance et convivialité.

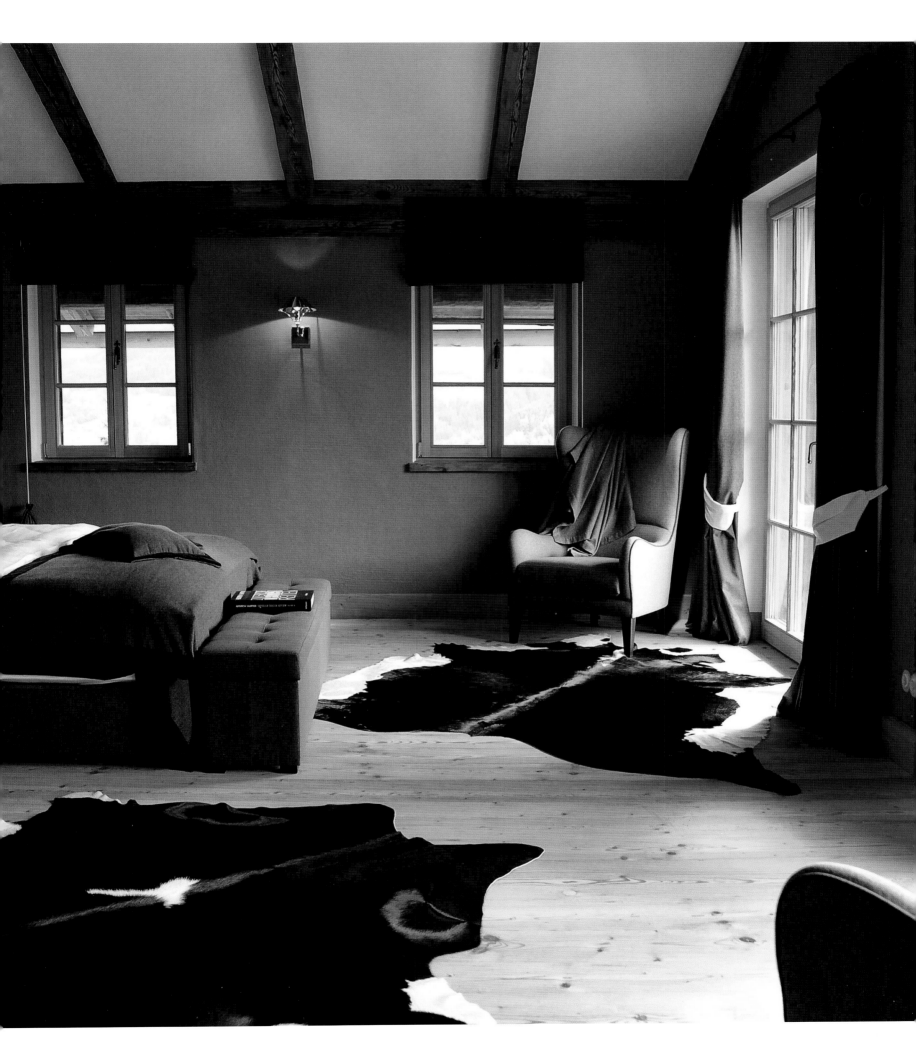

The minimalist, rustic interiors feature some surprising details, such as stools with legs made of antlers.

*Das gleichzeitig minimalistische wie rustikale Interieur überrascht mit Details wie den Hockerbeinen aus Geweihen.*

*L'intérieur à la fois minimaliste et rustique surprend par certains détails, comme les tabourets en bois de cervidés.*

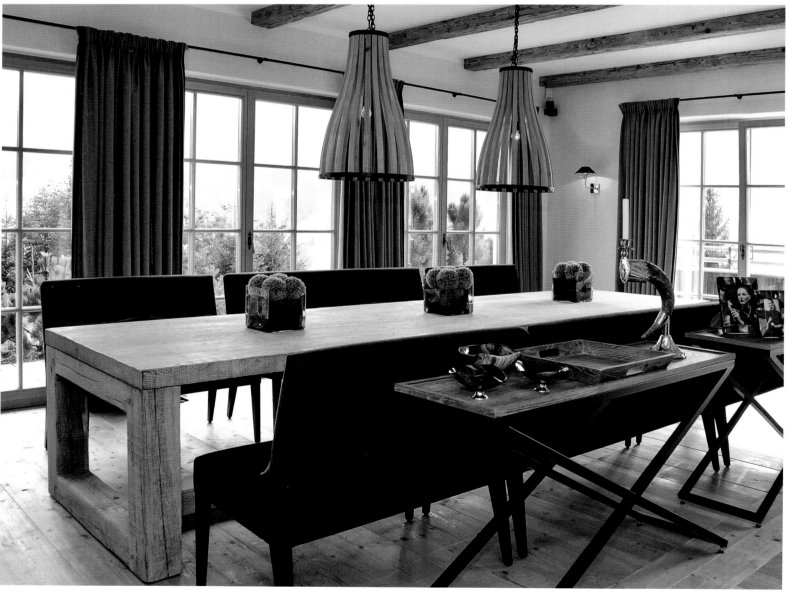

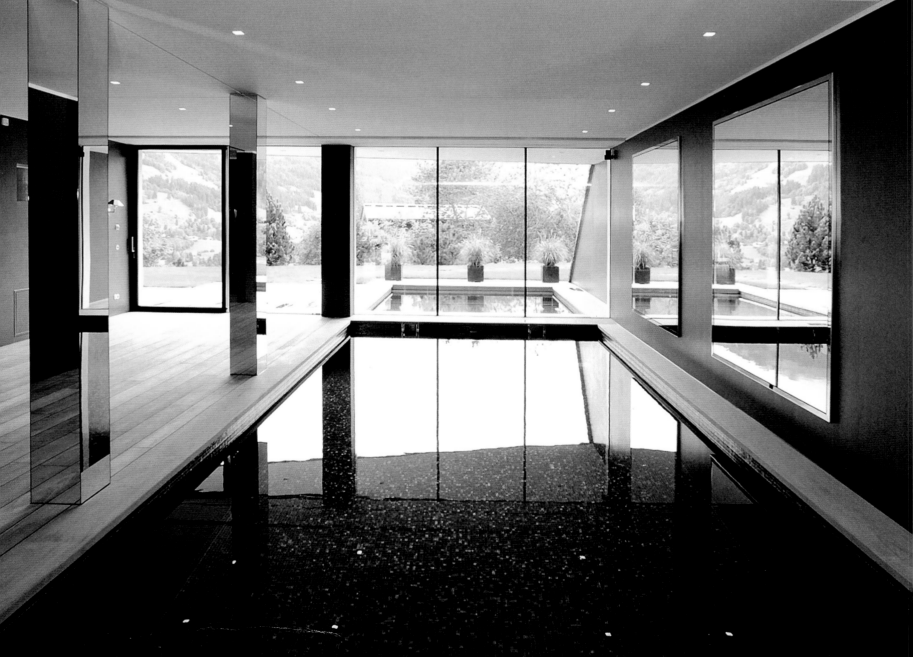

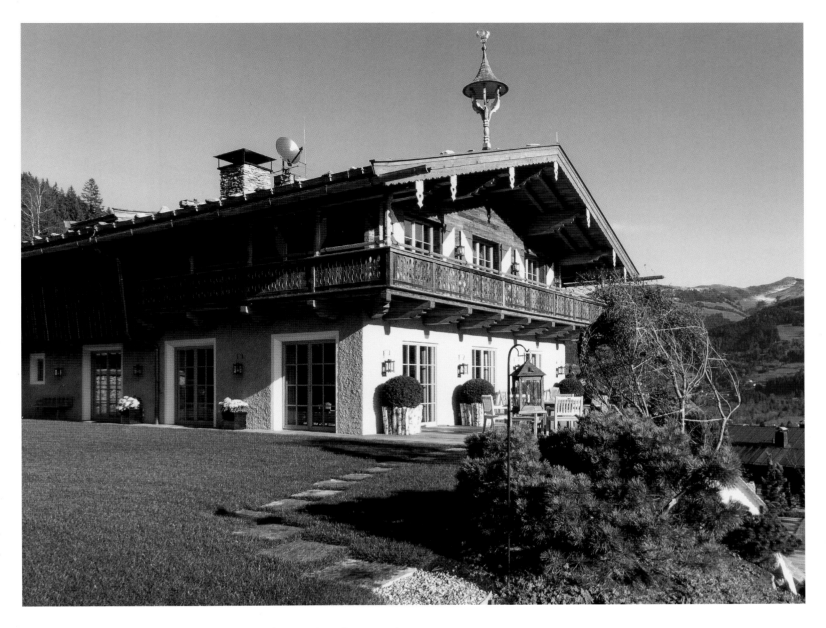

The spacious spa area includes indoor and outdoor pools, a fitness and massage room,
and a sauna with a magnificent view of the countryside.

Zum großzügigen Wellnessbereich gehören ein Indoor- und ein Outdoorpool, ein Fitness-
und Massageraum sowie eine Sauna mit grandiosem Ausblick in die Landschaft.

Le généreux complexe bien-être comprend deux piscines, l'une extérieure
et l'autre couverte, une salle de mise en forme et de massage ainsi qu'un sauna
avec une vue grandiose sur le paysage.

# Index

# Biographies

## Jean Nayar

A JOURNALIST AND AUTHOR who writes about design, architecture, art, and people, Jean Nayar regularly contributes to a variety of design and lifestyle publications, such as *Interior Design*, *Ocean Drive*, *Hamptons*, and *Luxe* magazines, and has written several books, including *Living in Style New York* (teNeues) and *The Happy Home Project* (Filipacchi Publishing). Dividing her time between Miami Beach and New York with her husband, she is also an international luxury real estate advisor.

JEAN NAYAR SCHREIBT regelmäßig zu den Themen Design, Architektur, Kunst und Persönlichkeiten für zahlreiche Design- und Lifestyle-Magazine wie *Interior Design*, *Ocean Drive*, *Hamptons* und *Luxe*. Darüber hinaus ist sie Autorin verschiedener Bücher, darunter *Living in Style New York* (teNeues) und *The Happy Home Project* (Filipacchi Publishing). Jean ist außerdem als Maklerin für internationale Luxusimmobilien tätig und wohnt mit ihrem Mann abwechselnd in Miami Beach und New York.

JOURNALISTE ET AUTEUR d'articles sur le design, l'architecture, l'art et les célébrités, Jean Nayar contribue régulièrement à de nombreuses publications sur le design et l'art de vivre, dont les magazines *Interior Design*, *Ocean Drive*, *Hamptons* et *Luxe*. Elle a écrit de nombreux livres, notamment *Living in Style New York* (teNeues) et *The Happy Home Project* (Filipacchi Publishing). Partageant sa vie entre Miami Beach et New York avec son mari, elle est aussi conseillère internationale dans l'immobilier de luxe.

## Andreas von Einsiedel

LONDON-BASED Andreas von Einsiedel is a freelance photographer who has specialized in interiors and architecture for 20 years. Highly regarded by magazines and publishers for his use of natural light and sense of composition, Andreas has photographed over 30 books featuring interiors, flower design, cookery, antiques, lifestyle, and architecture. He is a regular contributor to the world's most prestigious magazines, including *World of Interiors*, *House & Garden*, *Elle Decoration*, *Homes & Gardens*, *Vogue Living*, and *Architectural Digest.* He is frequently commissioned by (Britain's) National Trust to photograph the interiors of many of the countries greatest historic houses and their gardens.

DER IN LONDON lebende Andreas von Einsiedel ist als freier Fotograf seit 20 Jahren auf Interieurs und Architektur spezialisiert. Von Magazinen und Verlagshäusern für seine Verwendung von natürlichem Licht und seinen Sinn für Komposition hoch geschätzt, hat er bereits mehr als 30 Bücher zu den Themen Inneneinrichtung, Blumendesign, Kochen, Antiquitäten, Lifestyle und Architektur geschaffen. Er ist regelmäßig in den namhaftesten Zeitschriften der Welt vertreten – wie *World of Interiors*, *House & Garden*, *Elle Decoration*, *Homes & Gardens*, *Vogue Living* oder *Architectural Digest*. Er wird vom britischen National Trust regelmäßig beauftragt, die Innenräume einer Vielzahl der bedeutendsten historischen Anwesen des Landes und ihre Gärten zu fotografieren.

INSTALLÉ À LONDRES en free-lance, Andreas von Einsiedel photographie depuis 20 ans les intérieurs et l'architecture. Très apprécié des magazines et des éditeurs pour son recours à la lumière naturelle et son sens de la composition, il a signé plus de 30 livres de décoration, d'art floral, de cuisine, d'antiquité, de lifestyle et d'architecture. Il travaille pour les titres les plus prestigieux de la presse magazine mondiale : *World of Interiors*, *House & Garden*, *Elle Décoration*, *Homes & Gardens*, *Vogue Living*, *Architectural Digest*. Le National Trust britannique le sollicite régulièrement pour photographier l'intérieur et les jardins des plus belles demeures historiques de Grande-Bretagne.

# Credits & Imprint

## PHOTO CREDITS

All photographs by Andreas von Einsiedel
Except for pp 198-205 (Alpine Treasure)
courtesy of Hild Home Design
All rights reserved.

Every effort has been made by the publisher
to contact holders of copyright to obtain
permission to reproduce copyright material.
However, if any permissions have been inadver-
tently overlooked, teNeues Publishing Group
will be pleased to make necessary and reasonable
arrangements at the first opportunity.

## TEXT CREDITS

Introduction by Jean Nayar

pp 10–19 (Valley View)
    original text by Johanna Thornycroft
pp 20–29 (Pastoral Idyll)
    original text by Amanda Harling
pp 30–41 (Country Sophisticate)
    original text by Johanna Thornycroft
pp 42–51 (On Top of the World)
    original text by Johanna Thornycroft
pp 52–61 (Past Perfect)
    original text by Amanda Harling
pp 62–69 (Crafty Conversion)
    original text by Amanda Harling
pp 70–79 (Colonial Classic)
    original text by Johanna Thornycroft
pp 80–89 (Graceful Fusion)
    original text by Johanna Thornycroft
pp 90–101 (Perfect Escape)
    original text by Johanna Thornycroft

pp 102–111 (New Life)
    original text by Johanna Thornycroft
pp 112–121 (Hillside Haven)
    original text by Johanna Thornycroft
pp 122–131 (At Home in Provence)
    original text by Jean Nayar
pp 132–141 (Enchanted Hacienda)
    original text by Amanda Harling
pp 142–153 (Sweet Retreat)
    original text by Amanda Harling
pp 154–163 (A Dream Come True)
    original text by Amanda Harling
pp 164–175 (An Artist's Fairyland)
    original text by Johanna Thornycroft
pp 176–185 (Storybook Cottage)
    original text by Johanna Thornycroft
pp 186–197 (In Tune with Nature)
    original text by Johanna Thornycroft
pp 198–205 (Alpine Treasure)
    original text by Nadine Weinhold

Copy Writing: Jean Nayar
Translations:
  English: Amanda Ennis
  German: Ronit Jariv, derschönstesatz, Köln
  French: Claude Checconi
Copy Editing:
  English: Anshana Arora
  German: Stephanie Rebel, Nadine Weinhold
  French: Mireille Onon
Editorial Management: Nadine Weinhold
Design, Layout & Prepress: Sophie Franke
Imaging: Tridix, Berlin
Production: Nele Jansen

Published by teNeues Publishing Group

teNeues Media GmbH + Co. KG
Am Selder 37, 47906 Kempen, Germany
Phone: +49 (0)2152 916 0, Fax: +49 (0)2152 916 111
e-mail: books@teneues.com

Press Department: Andrea Rehn
Phone: +49 (0)2152 916 202
e-mail: arehn@teneues.com

teNeues Publishing Company
7 West 18th Street, New York, NY 10011, USA
Phone: +1 212 627 9090, Fax: +1 212 627 9511

teNeues Publishing UK Ltd.
12 Ferndene Road, London SE24 0AQ, UK
Phone: +44 (0)20 3542 8997

teNeues France S.A.R.L.
39, rue des Billets, 18250 Henrichemont, France
Phone: +33 (0)2 4826 9348, Fax: +33 (0)1 7072 3482

www.teneues.com

© 2015 teNeues Media GmbH + Co. KG, Kempen

ISBN: 978-3-8327-3221-9
Library of Congress Control Number: 2014958737

Printed in the Czech Republic.

Bibliographic information published by the Deutsche
Nationalbibliothek. The Deutsche Nationalbibliothek
lists this publication in the Deutsche Nationalbiblio-
grafie; detailed bibliographic data are available in the
Internet at http://dnb.d-nb.de.